T0329785

THE CALL OF THE HEART

HEART

John M. Stahl and

Hollywood Melodrama

THE CALL OF THE HEART

HEART

John M. Stahl and

Hollywood Melodrama

Edited by

Bruce Babington and Charles Barr

British Library Cataloguing in Publication Data

THE CALL OF THE HEART
John M. Stahl and Hollywood Melodrama

A catalogue entry for this book is available from the British Library

ISBN: 9780 86196 736 0 (Paperback)
ISBN: 0 86196 949 4 (ebook-MOBI)
ISBN: 0 86196 953 1 (ebook-EPUB)
ISBN: 0 86196 954 8 (ebook-EPDF)

Published by
John Libbey Publishing Ltd, 205 Crescent Road, East Barnet, Herts EN4 8SB,
United Kingdom
e-mail: john.libbey@orange.fr; web site: www.johnlibbey.com

Distributed worldwide by **Indiana University Press**,
Herman B Wells Library – 350, 1320 E. 10th St., Bloomington, IN 47405, USA.
www.iupress.indiana.edu

Printed and bound in the United Kingdom by Latimer-Trend.

Contents

TRANSITION: TIFFANY-STAHL

THE SOUND FILMS

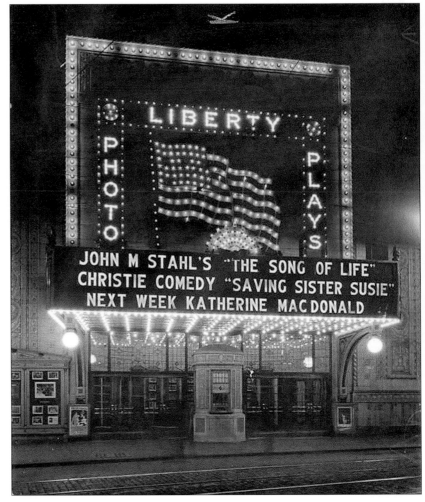

Foregrounding the director, New York 1922: the Liberty Theater at 234 West 42nd Street

Introduction

Charles Barr

The distinguished British film producer Michael Balcon, a bitter enemy of MGM's Louis B. Mayer, recounted with relish in his autobiography the story of Mayer's stubborn insistence on filming a 1930s play about the Irish nationalist hero Charles Stewart Parnell, and assigning his old associate John M. Stahl to direct it, with Clark Gable in the lead. Released in 1937, *Parnell* "was a dire failure, even in spite of Gable, who was probably the star of the time". And then the clincher: "I have been told that Stahl never worked in Hollywood again." (*A Lifetime of Films*: Hutchinson 1969, 108).

Who can have told him this egregious piece of fake news? It is strange that in that year of 1969, at the end of what was a foundational decade for modern film scholarship, Balcon and his reputable London publisher did not bother to check. John Malcolm Stahl had in fact gone on to direct no fewer than 12 more films in Hollywood at the rate of one a year between 1937 and 1949, all of them for major studios: Universal, Columbia, Fox. As the essays in this volume show, these films were far from negligible. But two decades on from his death in 1950, Stahl was only vaguely remembered.

This has hardly changed since. Despite intermittent attention to his work through Retrospective screenings and scholarly writings, of which we give some details below (and more fully in the Bibliography), this has never created any long-term impact or momentum. It is a fact that his name and career remain as unfamiliar to many film specialists as they were to Balcon half a century ago. To mention John M. Stahl as a focus of current research, even to experienced film academics, is quite often to be met with a blank look, and then the inquiry: how do you spell him, what did he make?

This Introduction needs briefly to address the twin questions: what accounts for Stahl's long obscurity, and why is it worth trying to pull him out of it?

His early death in 1950 made a big difference. Stahl had been a major figure among the formidable, and formative, "golden generation" of Hollywood directors who spanned the silent and sound periods; he had *his name above the title* as early as any of them, was well respected within and beyond the industry, and was never out of work. But virtually all the others lived on much longer than he did: remaining active, ready to become the subject of Retrospectives, of high-profile interviews, and of books – critical studies, biographies, autobiographies, any or all of these. Stahl was not around to help motivate any such publications, nor, surprisingly, does

he seem to have left any personal archive; if he did build up a store of correspondence and scripts and other memorabilia, it must have been quickly disposed of by his family.

The chart gives a selective list of some members of that formative generation, all born late in the 19th century:

	Born	First / last film		Died	Canonical silent film
Frank Capra	1897	1926	1961	1991	1927: *Long Pants*
John Ford	1894	1917	1966	1973	1924: *The Iron Horse*
Howard Hawks	1896	1926	1970	1977	1928: *A Girl in Every Port*
Alfred Hitchcock	1899	1925	1976	1980	1927: *The Lodger*
Henry King	1886	1915	1962	1982	1921: *Tol'able David*
Fritz Lang	1890	1919	1960	1976	1927: *Metropolis*
Leo McCarey	1896	1921	1961	1969	1927: Laurel & Hardy shorts
King Vidor	1894	1919	1959	1982	1928: *The Crowd*
Raoul Walsh	1887	1914	1964	1980	1924: *The Thief of Bagdad*
John M. Stahl	1886	1914	1949	1950	
Ernst Lubitsch	1892	1914	1948	1947	1924: *The Marriage Circle*

The early films of Hitchcock, Lang and Lubitsch were made in Europe, prior to long careers in Hollywood. Lubitsch died before completing his last film, *That Lady in Ermine*.

All made at least ten silent films; all, Stahl included, coped easily with the industry's conversion to sound, carrying over a mastery of the visual language of cinema into the dialogue medium. But the lives and careers of the first block of nine lasted at least a decade beyond Stahl's death.

None of their careers ended in a blaze of glory, any more than Stahl's had done, but their longevity and their late films had kept their names before the public, giving them an Elder Statesman status – eliciting affection, and creating an incentive to look back over the full body of their work; hence all the interviews, Retrospectives, and books.

One other difference is apparent from the chart. None of Stahl's silent films – 20 credited features plus two early uncredited ones – can be described as remotely canonical, in the manner of the titles listed for the others of that generation. Films like *The Iron Horse* and *The Lodger* and *The Crowd* have always had a place in the history books; in recent years they have had high-profile restorations, big-screen projection with large orchestras, and release on domestic video and then DVD. In contrast, no silent Stahl film has had this kind of treatment. It was sometimes assumed that none survived; even now, none are available on DVD, nor – pending the Pordenone silent film week of 2018 – are any viewable outside the specialist archives that have preserved them, whether in the UK (three) or in the US (nine). Moreover, DVD availability of Stahl's sound films remains very patchy: for several, one has to have recourse to Spanish imports (or to YouTube), and none has been made the focus of any kind of scholarly DVD edition by Criterion or anyone else.

All of this in turn raises the question: what are the reasons for this lack of any silent film by Stahl whose title is familiar, let alone canonical, and for the paucity of DVDs? It can't just be the sad accident of the early death; Ernst Lubitsch, another of the golden silent-to-sound generation, who died in 1947, has not exactly been neglected. Is Stahl's work just not strong or interesting enough to have stood the test of time?

Obviously if we believed this we would hardly have embarked on this book, nor would we have found so many enthusiastic contributors – nor a supportive publisher, nor a pair of international festivals ready to show a good range of the sound films and of the surviving silents.

But we have been here before – or rather, others have, in earlier decades. Two major examples are London 1981 and San Sebastian 1999.

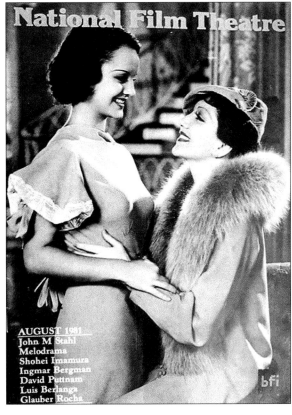

AUGUST 1981
John M Stahl
Melodrama
Shohei Imamura
Ingmar Bergman
David Puttnam
Luis Berlanga
Glauber Rocha

In August 1981 the British Film Institute mounted a big season at its repertory cinema in London, "John M. Stahl: the Romantic Image". It covered three weeks and 17 films: two early silent films held in their archive – *Her Code of Honor* and *The Woman Under Oath*, both from 1919 – followed by 15 of the 20 sound films.

John M. Stahl

An efficient programme booklet was backed up by a series of short but scholarly articles (listed in our Bibliography) on five of the 1930s films in the Institute's authoritative *Monthly Film Bulletin*, a slim magazine subsequently absorbed into the mothership of *Sight and Sound*. But this led nowhere very much, partly because the films remained so hard to access. The silents went back into the archival vaults, and with ill-timed clumsiness the BFI contrived, soon after, to lose its 16mm distribution copy of *Only Yesterday* (1933), arguably the highlight of the season, which never subsequently became available on VHS or DVD, until very recently in a modest way.

In 1999 the annual Film Festival at San Sebastian in Spain was even more

Stahl Retrospectives: London 1981, San Sebastian 1999. Cover images: Fredi Washington and Claudette Colbert in *Imitation of Life* (1934), Gene Tierney and Darryl Hickman in *Leave Her to Heaven* (1945)

thorough in its Stahl Retrospective, this time including coverage of more of the silent period. The sumptuous large-format dual-language book (Spanish and English) that accompanied the films is still available, well worth acquiring by anyone interested in Stahl – we give more details in the Bibliography, as well as listing there some serious essays published in France, notably by *Positif* magazine. But again, the Spanish book and Retrospective, and the French essays, have made a limited impact, even in specialist circles, partly through the difficulty of access to the films. Whenever, starting with Andrew Sarris in the US in the 1960s, a case is made for Stahl's status as a neglected director who deserves and rewards attention, it has to be done afresh. The boulder is pushed halfway up the hill but then rolls back again.

One problem over the years has been his close association with melodrama and the "women's film", categories which for a long time were commonly seen as of minor value, and in some quarters still are. An important critical landmark in countering this disparagement was the volume published by the BFI in 1987, *Home is Where the Heart is: Studies in Melodrama and the Woman's Film*, edited by Christine Gledhill; but although the main title is a Stahlian one – his 1941 film *Holy Matrimony* has a close-up of the words woven into a sampler on a domestic wall (see page 218) – and although Stahl's films get positive mention in some of the essays, it did little to make his work better known, in part because of the difficulty, still, of getting access even to some of the key sound films; and of course the book could not refer to the unknown silents.

From early in his career Stahl came to see himself as, and to be seen as, a maker of films primarily for women: writing about the importance of the female audience, privileging female characters and their problems and aspirations, and using strong female stars. Typical is the second of his credited features to survive, *The Woman Under Oath* (1919): for its title, its theme, its star, and a story that pivots on a sexual assault in the workplace by a boss who feels himself entitled. This radical feminine emphasis is repeatedly illustrated in the essays that follow, including those that assemble evidence about silent films that remain lost.

"John M. Stahl: the Man who Understood Women": this is the title of a major essay by George Morris in the American magazine *Film Comment* (May/June 1977). Predictably, he starts by noting and regretting the tendency to write conde-scendingly of the "women's film", and the concomitant neglect of Stahl. Discussing the characters played in the sound films by stars such as Irene Dunne and Margaret Sullavan, Morris notes that "Stahl's women display tremendous inner reserves of strength and self-assurance which enable them to cope with the most impossible situations". The silent films get just two lines in a regretful parenthesis, as being "unavailable for review". The main step forward in the present volume is the assembly of rich material on these silents, enabling the career of Stahl to be seen as a whole, both in its strong continuities – notably in the "understanding of women" – and in its always alert response to changes in and beyond cinema.

The continuities are not simply thematic. Arguing that "romantic melodrama", as practised by Stahl among others, "is one of the richest sources of expression in cinema", Morris explores his distinctive use of the long take in films like *Back Street* (1932), comparing this convincingly with the late films of Carl Dreyer, for instance

his final film *Gertrud* (1964). Long takes, two-shots and wide shots and staging in depth as opposed to fragmentation – these are strategies that are touched on in many of the essays that follow. One of the revelations of Stahl's silent work is the way these strategies are seen to be part of a wider-ranging sophisticated cinematic self-awareness. It is a delight to find him, in the first of his credited features to survive, *Her Code of Honor* (1919), referencing the Lumière brothers by locating the initial section, as an opening title tells us, in "Paris 1895", and then in the last of them, *In Old Kentucky* (1927), referencing Eadweard Muybridge through an elaborate scene of horses galloping; a reporter from the *Los Angeles Times*, visiting the set, was excited by his filming of the races, which brought to his mind "the origin of motion pictures", an observation quoted and endorsed in Imogen Sara Smith's essay on the film (see pages 123–124).

Elsewhere in the book (page 75), Imogen describes an early scene from another film recently unearthed from the archives, *The Song of Life* (1922). A prologue introduces the young Mary Tilden, already oppressed by the dreariness of her life as a housewife and mother in the middle of nowhere:

> Gazing out of the grimy window, she sees a private railroad car pausing on the tracks outside with stylish women framed in the windows, like a hallucination of the easy, luxurious life she yearns for. (The train as a rolling, cinematic vision of the good life reappears in Clarence Brown's *Possessed* [1931], dazzling factory girl Joan Crawford.)

It is precisely this scene from *Possessed* that Slavoj Žižek uses to open his three-part audio-visual essay *A Pervert's Guide to Cinema* (2006: directed by Sophie Fiennes), a work weightier than its title may suggest. The train windows at which Crawford gazes evoke, by their shape and brightness, film frames, and their movement evokes both the way frames succeed one another and the way they can transport us away from mundane drudgery into a world of fantasy. As an imaging of one of the functions of cinema, it works beautifully for Žižek's purposes:

> What we get in this wonderful clip from *Possessed* is commentary on the magic art of cinema… Reality itself reproduces the magic cinematic experience. We get a very real ordinary scene on to which the heroine's inner space, as it were, her fantasy space, is projected, so that although all reality is simply there – the train, the girl – part of reality in her perception, and in our viewers' perception, is as it were elevated to the magic level, becomes the screen of her dreams. This is cinematic art at its purest.

It is fascinating to find, now, that Stahl was there first, and that he and his female screenwriters – his wife Frances Irene Reels, and Bess Meredyth – may even have inspired Brown and his own female screenwriter on *Possessed*, Lenore Coffee.

As will be seen from the chronological narrative, the momentum of Stahl's career faltered in the late 1920s, just at the time when the silent medium can be argued to have reached its artistic height, producing so many of the films that remain, unlike any of his, in the classical repertoire. First there was the increasingly difficult relationship with his producer Louis B. Mayer, then the move in 1927 into a producer-only role with the company that became known as Tiffany-Stahl. After that interlude, and after the industry's conversion to sound, his career as director picked

up again in a big way with Universal, but the afterlife of these films would be problematic.

First came two of the great melodramas of what we now think of as the pre-Code years: *Back Street* (1932) and *Only Yesterday* (1933). Pre-Code, because they preceded the severe tightening up of the censorship rules enforced by Hollywood's Production Code Administration from 1934 onward. Both those films centre on strong and sympathetic women who engage, without shame, in adulterous relationships, following the call of the heart: for years, under the strict new Code, the films were forced out of circulation, and re-releases were blocked. Both were remade in the 1940s by the same studio, Universal, respectively as *Back Street* (Robert Stevenson, 1941) and as *Letter from an Unknown Woman* (Max Ophuls, 1948): this was a much less direct remake, but *Only Yesterday* had been based partly on the Stefan Zweig novella to which Universal owned the rights. The Stahl originals were inevitably eclipsed. Of course their pre-Code frankness now gives them an extra level of historical interest.

Comparable was the fate of Stahl's next, post-Code, pair of films, *Imitation of Life* (1934) and *Magnificent Obsession* (1935), both of which were remade for Universal, after Stahl's death, by Douglas Sirk, respectively in 1959 and 1954.

Sirk's critical standing is very different from Stahl's. Born in 1897, not moving from theatre to film until 1934, he lived till 1987, and was perfectly placed to become an admired figure in the rapidly expanding film culture of the 1960s and after. Those two remakes, and other films like *Written on the Wind* (1956), had a seductive combination of full-blooded exploitation of melodrama with a degree of ironic distanciation, and Sirk was around to talk about the films and their strategies engagingly and knowledgeably, a highly civilised figure who had built a 15-year Hollywood career and then walked away from it directly after *Imitation of Life*, his biggest commercial success. He was the subject of one of the first of the director-interview books (*Sirk on Sirk*, interview by Jon Halliday, 1972) and of well-documented Retrospectives, for instance at the Edinburgh Film Festival, also 1972, since when the publications and, later, the elaborate DVD editions have kept coming. No film academic, or well-informed student of film history, is likely to have to ask "Who was Douglas Sirk?" Stahl's role in all this was at best a marginal one, as the half-forgotten director of the original films remade by the master: three in all, in fact, including *When Tomorrow Comes* (1939), remade as *Interlude* (1957), a film so clearly inferior to the original as to be of no great interest to Sirk's admirers.

I mean no disrespect at all here to Sirk, whom I met in youth at Edinburgh in the year of the Retrospective when covering the film festival for Scottish Television. He was modest, articulate, and charming, and he never said anything to disparage Stahl, whose originals he claimed to have made a point of not seeing. It is just a bit sad that he had a role in Stahl's continuing marginalisation. And it is strange, nearly half a century on, to be playing a part now in restoring the balance, focusing attention on the work of that predecessor whose name then – typically – meant nothing to me.

All this is a reminder of the role of chance and fashion and timing in the construction of film histories. These factors have worked in favour of Sirk, and of many others,

and against Stahl – again, along with
many others. You have to catch the mo-
ment, and Stahl, so far, has repeatedly
missed the moment.

Perhaps the moment for him has come,
in this centenary year: the centenary of
the first film to give an on-screen credit
to John M. Stahl, *Wives of Men*, first
shown on 25 August 1918. Nobody was
motivated by the fact of this centenary
in planning the Retrospectives, indeed I
don't think anyone thought about it, but
there it is, and it could be exploitable. A
centenary is always a good peg for pub-

licity. Chance and timing may for once be working in Stahl's favour. Maybe enough
momentum will be created to stop the boulder rolling back down the hill once again.

John Libbey
(right) and
Richard Abel,
joint recipients of
the Jean Mitry
award at
Pordenone,
October 2017

How did the book come about? The annual week-long event at Pordenone in North
Italy, *Le Giornate del Cinema Muto*, now in its 37th year, is dedicated to exploring
and celebrating the riches of silent cinema. The programme generally includes an
authorial strand featuring the work of a silent-era director or two, ranging from the
famous (Alfred Hitchcock) to the less famous (John Collins). After becoming a
Pordenone regular some years ago, I occasionally expressed mild curiosity about
the long silent career of John M. Stahl: how many films survived, why they were so
unknown, what they were like, could he be a candidate one year for a Retrospec-
tive? A response of politely vague interest suddenly became stronger with the
advent of a new director of the event in Jay Weissberg, who knew enough about
Stahl's work to take the idea seriously, and was keen to know more and to find out
what was available – and he was keen, moreover, to forge firmer links with the other
great annual archive-based Italian festival, the Cinema Ritrovato week at Bologna.
Before long, on the basis of initial researches, an agreement was made to run a
coordinated Stahl Retrospective in 2018 – a selection of the sound films at Bologna
in June, and of the silent films at Pordenone in October – and to produce not just
standard catalogue entries on the two sets of films but a book spanning Stahl's full
career.

Having helped, however naively, to initiate the project, I could hardly refuse the
challenge to act as the book's editor, especially with the promise of support from
Jay as festival director, ready to chase up buried archival prints, and from John
Libbey as publisher, one with close links to Pordenone and with a track record of
scholarly publications on film history in general and silent cinema in particular: in
2017 he received the Jean Mitry award, named after the pioneer film historian and
given annually *"to individuals or institutions distinguished for their contribution to the
reclamation and appreciation of silent cinema"*.

Because of the time pressures – less than two years from original agreement to
publication – and of the existence of whole tracts of Stahl's life and work that were
largely unexplored, the result could easily have become a conventional collection
of scholarly essays on a selection of the films, held within a tentative overview of

the career, had it not been for the fact that Bruce Babington agreed to come on board as co-editor.

I think it's fair to say that Bruce was initially even less of an expert than I was on John M. Stahl and his work. But he quickly became enthused, and made it his business to trace Stahl's life and career in enormous detail, using a wide range of sources. The results are richly evident in the signed essays of his that punctuate the book, and in the unsigned linking material that fills the many gaps in the archival record of the silent period. Without his dedicated work, it would have been a far less substantial and less scholarly production.

Acknowledgments

For his role in getting the project up and running in such ambitious form, against a tight deadline, I am grateful above all to Bruce. Between us, we have a range of other debts to acknowledge. To Jay Weissberg for making it possible; to John Libbey for being a supportive and patient publisher; and to individual essayists, 14 in number besides ourselves, whose work speaks for itself in what follows. Without having had the resources to visit the US during the time-span of the research, we have relied greatly on assistance from US-based colleagues, notably the three who have written for the volume on a total of eight silents that are still, as far as we can discover, not available for viewing in Europe in any form: Richard Koszarski, Lea Jacobs, and Imogen Sara Smith. Imogen has been outstandingly helpful in agreeing at short notice at a late stage to view and write about some newly restored prints at the Library of Congress (LOC) in Washington DC – and in helping to track down some elusive still images held in the collection of the Museum of Modern Art (MOMA) in New York. David Pierce and Mike Mashon, Pordenone loyalists and Stahl enthusiasts, were instrumental in getting those LOC restorations done.

For other help with stateside research we are extremely grateful to Barbara Hall, formerly of the Margaret Herrick Library of the Academy of Motion Picture Arts and Sciences, Beverly Hills; to Ned Comstock of the Cinematic Arts Library at the University of Southern California, which houses the Universal and Stahl Collections; and to those who have advised and assisted with picture research, notably Derek Davidson from Photofest, Ashley Swinnerton from MOMA, and Faye Thompson from the Margaret Herrick Library. John Oliver, then of the BFI, did an indispensable initial round-up of information about worldwide archival holdings, including from the little-known Tiffany-Stahl period, which gave us confidence in going ahead. Richard Maltby, from Flinders University in South Australia, supplied valuable data on the handling of some of Stahl's 1930s films by the Production Code Administration; Bryony Dixon of the British Film Institute kindly organised some frame stills from the three silent Stahl films held at the BFI; and the staff of the Netherlands Film Archive (EYE) were as usual quick to co-operate, making a DVD of their footage from *Husbands and Lovers* and facilitating the use of frame stills in the pages on that film – special thanks to Leenke Ripmeester. Finally, it has been a pleasure to liaise with Mariann Lewinsky, director of the Cinema Ritrovato event in Bologna, and with Ehsan Khoshbakht, another eloquent Stahl enthusiast, programmer of their series of selected sound films.

The mention above of the number of the early films that are viewable only in archives in America is a reminder that the present book has to be seen as in many ways a work in progress. Neither we ourselves as editors nor others in Europe have had a chance, at the time of going to press, to see more than three of the twelve surviving silents – the three held at the BFI, plus the

incomplete *Husbands and Lovers* held in the Netherlands. And the same holds in reverse. Even in the countries where they have been preserved, the films remain almost unknown, since you still have to go to archives to watch them. The Pordenone 2018 series, covering ten of the twelve – an eleventh, *The Woman Under Oath* from 1919, will have been screened at Bologna as a prelude to their set of sound films – now looms up as a revelatory occasion, bringing the films together, and exposing many of them to a theatrical audience for the first time in nearly a century. We can hope that DVD producers take notice, and that someone, perhaps from among our contributors, may be moved to do a full critical study, embracing the full range of films, silent and sound, within a single perspective – in effect a sequel to this.

This book's title, meanwhile, is taken from the first words to appear on screen in the first surviving film that is credited to Stahl, *Her Code of Honor* (1919): "When the call of the heart is heard all else is forgotten" – the film was at one time actually shown as *The Call of the Heart*. The book's sub-title, "John M. Stahl *and* Hollywood Melodrama", is chosen in preference to, say, "The Hollywood Melodramas of John M. Stahl". Those two big words do need to be foregrounded; Stahl did make important melodramas in Hollywood; but his career was more varied. First, he did not move to Hollywood until 1920, to make his eighth film, *The Woman in His House*, after working for six years in the East. Second, his films covered a wider range, including biopic (*Parnell*, 1937), musical (*Oh, You Beautiful Doll*, 1949), and several comedies; indeed, as will be seen from the narrative of his early career, he was often typed in the 1920s as a maker of sophisticated comedies, in the manner of the Cecil B. DeMille of that period. Moreover, several essays stress the way in which Stahl in his sound films works against some of the conventions of melodrama, for instance by his coolly observational long-take style, and by the frequent avoidance of non-diegetic music.

Technical Notes

Credits: our practice has normally been, for films that survive, to reproduce credits as given on screen; in cases such as *Only Yesterday*, where actors are listed without saying who they play, we add the character names. Only rarely do we add cast members who are not credited on screen; longer lists, particularly for the sound films, are generally easy to find in one or both of two standard reference works, the free-access Internet Movie Database (IMDb) and the American Film Institute Catalog of Feature Films (AFI), which is now widely accessible online as well. The AFI plot summaries have also been useful for recording data on films that remain – at present anyway – lost.

Abbreviations

In addition to IMDb and AFI, these are among the abbreviations used from time to time in the text:

BFI: British Film Institute
LOC: Library of Congress
MOMA: Museum of Modern Art
MPN: *Motion Picture News*
MPW: *Motion Picture World*
SS: San Sebastian: the Stahl book that accompanied the 1999 Festival Retrospective

These abbreviations are used in the credits:

D: direction
P: production
Sc: script
Ph: photography
Ed: editing
AD: art direction
M: music
PC: production company
Dist: Distributor (for silent films only: from 1930 Stahl worked for vertically-integrated major studios, and a separate credit would be redundant).

Dates: we normally give the earliest recorded date of public screening that is available. The AFI Catalog has a standard entry for a film's "Publication Date", but sometimes an earlier date is given for a first screening, for instance in the case of *Leave Her to Heaven*: the AFI's publication date is January 1946, and the film is listed as a 1946 one, but the date given for the New York opening is 25 December 1945. In contrast, IMDb foregrounds the New York date and labels the film 1945. We have used the earlier date, even though the film itself announces "Copyright MCMXLVI" beneath the main title. IMDb often has information on the dates of initial screenings outside the US.

Film lengths: these are given in minutes for the sound films only. Discrepancies are found rather more often than with dates, films sometimes being cut for censorship or other reasons; in most cases we have simply recorded the longest of any conflicting running times, or else the standard current one, checked where possible against a DVD.

Silent films are of course more complicated, because of the lack of a standard speed of projection. Sources sometimes give a film's length in terms of 35mm film footage, at other times in the less precise measurement of reels, the standard length of a reel being 1000 feet. As anyone knows who has watched a film on a Steenbeck or similar viewing table, a six-reel film (say) often consists of five full reels and one short one, nor do the longer reels always measure exactly 1000 feet; measurement by reels is always imprecise, and we give the footage count where available.

At the sound speed of 24 frames per second, 90 feet of film equates to one minute, but a more common silent speed was evidently closer to 20 fps, meaning 75 feet a minute. The silent film week at Pordenone, which uses 35mm prints where possible, screens most of them at speeds of 22, 20 and even 18 fps. (For the definitive account of the topic, see Kevin Brownlow's article "Silent Films: What *Was* the Right Speed?" in *Sight and Sound*, Summer 1980, 164–167.)

To pick out an instance: Stahl's *The Song of Life* (1922) is listed by the Library of Congress at 6,920 feet. At sound speed, likely to be too fast, this would run 77 minutes; at 20 fps it runs 92 minutes; it remains to be seen what speed Pordenone decides on. The bottom line is that the figures on silent-film length, whether in reels or feet, are tricky to make sense of; but they are still worth noting.

Notes on Contributors

Jeremy Arnold is the author of *Christmas in the Movies: 30 Classics to Celebrate the Season* (2018); of Turner Classic Movies' *The Essentials: 52 Must-See Movies and Why They Matter* (2016); and of *Lawrence of Arabia: The 50th Anniversary* (2012). He has written hundreds of programming articles for the Turner Classic Movies website, and has appeared as a commentator on TCM, on the FilmStruck streaming service, and at various festivals.

Bruce Babington taught film for many years at Newcastle University. His publications include co-authored works with Peter W. Evans on Hollywood genres (the Musical, the Comedy of the Sexes, the Biblical Epic), and books on the British and New Zealand cinemas. His latest are *The Sports Film: Games People Play* (2015) and *The Family Film in Global Cinema* (co-edited with Noel Brown, 2015).

Charles Barr worked for many years at the University of East Anglia, Norwich, and has since taught in St Louis, Dublin and Galway. He was joint writer, with Stephen Frears, of *Typically British* (1995), Channel 4's centenary programme on British cinema. Publications include *Ealing Studios* (1977, third edition 1999) and *English Hitchcock* (1999); his most recent book is *Hitchcock, Lost and Found: the Forgotten Films*, co-authored with Alain Kerzoncuf (2015).

Tim Cawkwell is a freelance writer on film, with a particular interest in religion and the cinema. He was formerly chapter steward of Norwich Cathedral, and in 2014 published *The New Filmgoer's Guide to God*. He also wrote *Film Past Film Future* (2011), and maintains a website for his writing on film, www.timcawkwell.co.uk. In the 1970s and 1980s he was a film-maker, and in 2018 produced his own dvd "Light Years: film diaries 1968 to 1987". He also writes books on cricket and travel. He lives in Norwich, UK.

Edward Gallafent is Emeritus Professor of Film Studies at the University of Warwick. His last book was *Letters and Literacy in Hollywood Film* (2013), and his study of Bette Davis, Joan Fontaine, Kim Novak and Meryl Streep will appear in 2018 under the title *Adultery and the Female Star*.

Adrian Garvey teaches film at Queen Mary University of London. He has recently contributed a chapter on James Mason to *Lasting Screen Stars* (2016) and wrote an entry on stardom in British silent cinema for *The Routledge Companion to British Cinema History* (2017).

Pamela Hutchinson is a freelance writer, critic and film historian, who contributes regularly to publications including *Sight & Sound* and *The Guardian* as well as *Radio 4*. She is the founder and editor of the silent cinema website SilentLondon.co.uk and the author of a BFI Film Classic on *Pandora's Box*.

Lea Jacobs teaches film history and aesthetics at the University of Wisconsin-Madison. She is the author of *The Wages of Sin: Censorship and the Fallen Woman Film*; *Theatre to Cinema* (written with Ben Brewster); *The Decline of Sentiment: American Film in the 1920s*; and *Film Rhythm After Sound: Technology, Music and Performance*. Her essay on Stahl, "John Stahl: Melodrama, Modernism and the Problem of Naïve Taste," was published in *Modernism/Modernity* in April 2012.

Richard Koszarski is Professor of English and Cinema Studies at Rutgers University and Museum Curator for the Barrymore Film Center in Fort Lee, New Jersey – not far from the Benjamin Chapin studio site in Ridgefield Park. He is also Editor Emeritus of *Film History: An International Journal*, where his full account of the production and reception of *The Lincoln Cycle* appears in the Summer 2018 issue.

Lawrence Napper teaches at King's College London, and is the author of *The Great War in Popular British Cinema of the 1920s* (2015) and *Silent Cinema: Before the Pictures Got Small* (2017).

Tom Ryan has long been a regular contributor to the arts pages of Australian newspapers. His commentaries on film have also been published in magazines such as *Cinema Papers*, *Movie*, *Positif* and *Film Comment*, as well as online for *Senses of Cinema* and *Screening the Past*. He lectured in film from the 1970s to the 1990s at Coburg and Melbourne State Colleges and Swinburne University, as well as at the Universities of Warwick and East Anglia in the UK. He has edited volumes of the University Press of Mississippi's "Conversations" series on Baz Luhrmann and Fred Schepisi, and his new book, *Exquisite Ironies and Magnificent Obsessions: The Films of Douglas Sirk*, will be published early in 2019.

Neil Sinyard is Emeritus Professor of Film Studies at the University of Hull, UK. He has published numerous books and articles on the cinema, including monographs on directors such as William Wyler, Billy Wilder, Alfred Hitchcock, Fred Zinnemann, Steven Spielberg, Woody Allen, Richard Lester, Jack Clayton and Nicolas Roeg, as well as books on silent movies, film comedy, screen adaptations of literature, and representations of childhood in the movies. He is currently completing a book on the films of George Stevens.

Imogen Sara Smith is the author of two books, *In Lonely Places: Film Noir Beyond the City* (2011) and *Buster Keaton: The Persistence of Comedy* (2013). Her writing has appeared in *Film Comment*, The Criterion Collection, *Sight & Sound, Cineaste*, and elsewhere.

Tony Tracy is Lecturer in Film at the Huston School of Film & Digital Media, National University of Ireland, Galway. He has written widely on film history in the silent and sound eras, with a special interest in the construction of Irish and Irish-American identities. He is co-editor of *Masculinity and Irish Popular Culture: Tiger's Tales* (2014), and of *The Historical Dictionary of Irish Cinema* (2018); for the Irish Film Institute in 2012 he produced the documentary *Blazing the Trail: The O'Kalems in Ireland*, and the associated DVD *The O'Kalem Collection 1910–1915*.

Michael Walker is on the editorial board of *Movie: a Journal of Film Criticism*. His *Hitchcock's Motifs* (2005) and *Modern Ghost Melodramas: What Lies Beneath* (2017) are published by Amsterdam University Press. *Endings in the Cinema: Thresholds, Water and the Beach* is forthcoming.

Melanie Williams is Reader in Film and Television Studies at the University of East Anglia, and has particular research interests in gender, stardom, and melodrama in relation to film. Her books include (as author) *David Lean* (2014) and *Female Stars of British Cinema* (2017), and (as co-editor) *British Women's Cinema* (2009), *Ealing Revisited* (2012), and *Mamma Mia! The Movie: Exploring a Cultural Phenomenon* (2013). She is currently working on a major funded research project on 1960s British cinema.

All of the essays that follow appear here for the first time, but a few of them draw, in part, on material published by their author elsewhere:

Charles Barr: *Only Yesterday* in the online British journal *Movie: a Journal of Film Criticism*, issue 4 (2013).

Lea Jacobs: see her entry above.

Richard Koszarski: see his entry above.

Tom Ryan: essays on *Imitation of Life* and *Magnificent Obsession*, in the online Australian journal *Senses of Cinema*, respectively issues 77 (December 2015) and 73 (December 2014).

Imogen Sara Smith: "Women in Love: Three early '30s Melodramas by John M. Stahl", in *Bright Lights Film Journal*, 24 May 2016.

The
Silent
Films

Stahl, centre,
directing *The
Song of Life*
(1922). Georgia
Woodthorpe,
seated; Grace
Darmond and
Gaston Glass, in
doorway.

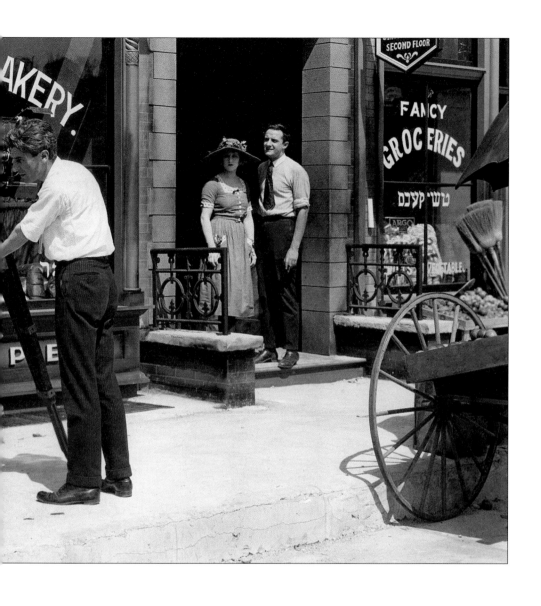

John M. Stahl: The Early Years (1886–1927)

Bruce Babington

Obscure Beginnings

uch of Stahl's early life and career up to the point in 1918 when, aged 32, he released his first credited feature film, presents problems for film historians. As regards his biography, these difficulties were in part created by Stahl's obfuscation, for reasons not entirely clear, of aspects of his early life.

Stahl repeatedly gave his birthdate as 21 January 1886 and his birthplace as New York City. This information became a fixture in the material released to magazines and newspapers from the time when he began to be written about or interviewed as a rising filmmaker. His obituaries in 1950 understandably accepted this information without question. The chronology he gave is largely validated by two publicly available documents, his World War I (1918) and World War II (1942) draft registration cards. The World War II card confirms the 1886 birthdate, though the WWI card gives 1884. A slip by a recorder on the earlier card probably explains the disparity. However, both cards agree in contradicting his claimed place of birth. On the 1918 card are entered a New York City address, his age as 34, a minimal physical description, slim, brown hair (not yet the premature grey of most photos of him), brown eyes, and his nationality as Russian. The 1942 card, in what is probably his own handwriting, gives his impressive Bel-Air address in Los Angeles and his occupation as film producer, and again reveals the origins he kept publicly hidden, this time specifying Baku in Russia (today Azerbaijan).

These details of his Russian birth were not until recently easily retrievable, so the story of their discovery bears retelling. When Stahl died aged 63, he left his substantial estate (approximately $500,000), to Roxana Stahl, his third wife, and the balance of his New York bank accounts to his only child, Mrs Sarah Appel (not to be confused with his step-children, C. Ray Stahl and Roxana Ray Stahl, Roxana's children from her first marriage to the film director Al Ray). Sarah was the daughter from the first of Stahl's three marriages, to a woman of whom only a few details have up till now been recovered.[*] She challenged the will, alleging that when Stahl made it in 1941, Roxana had procured it "by fraud, coercion, menace, undue influence and duress [...]" by threatening to reveal that his name was originally Jacob Morris Strelitzsky, that he was born in Russia, had emigrated to the United States and as a young man "had been convicted of and incarcerated in jail for several misdemeanors and felonies in the States of New York and Pennsylvania" under the aliases Jack Stall and John Stoloff. Research into the files of the Superior Court of the State of California at Santa Monica has accessed Stahl's last will and testament, Sarah Appel's "opposition to and contest of will after probate" quoted above, and "the answer of Roxana Stahl" denying "generally and specifically each and every statement contained in said paragraph II".[**] However, Sarah Appel did not file the necessary deposition, and the case eventually lapsed on that account, leaving a possible source of further biographical detail lost. While the naming of

* All that is known of Stahl's first wife at present is that in 1950 her name was Minnie Cooper (the surname probably that of a later husband) and that she was living in New Rochelle, New York. Requesting a delay in filing her deposition, her daughter presented the Santa Monica court with letters from New York doctors treating her mother for a very serious disease.
** Our thanks to Barbara Hall for research which has revealed details of Stahl's will and the court action.

Baku, Russia as Stahl's birthplace is supported by his draft cards, other details in her contesting have their source only in her statements. That said, there is no reason to doubt the name Jacob Morris Strelitzsky, and the claim of youthful felonies and imprisonment is quite possible. The matter is complicated by the fact that both Sarah Appel and Roxana Stahl made initial statements that are doubtful. For instance, Sarah Appel wrote that she was the only person who knew what she claimed, when her mother, Stahl's former wife, still alive, though gravely ill at that point, must have known, let alone any siblings Stahl may have had still living in 1950. And Roxana Stahl not only totally denied the "allegations" made against her but "every statement" made in the crucial part of the contestation, which would include his Russian origin, the one element corroborated by an external source.

Summarising what can be learned from the court and other records: Stahl was indubitably born in Baku in Russia and emigrated to the USA, his birth name was almost certainly Jacob Morris Strelitzsky, and it is possible but not proven that he had a minor youthful criminal past under aliases. In support of her allegations Sarah Appel's contestation claimed "Had said true facts been made known , as threatened by proponent, decedent's career would have been seriously damaged [....]". Whether this information would really have been "seriously damaging", as distinct from embarrassing, in 1941 is open to question. On the other hand a claim to American birth and therefore automatic American citizenship under false pretences, though this must have been common at the height of mass immigration, might have been thought more serious. Sarah Appel's claim that Roxana Stahl blackmailed her husband, though, sounds unlikely, in what seems to have been a stable marriage.

The basic details of Sarah Appel's claims were reported in Los Angeles newspapers (*Los Angeles Examiner* and *Los Angeles Times*, both 27 August 1950), but were not picked up by film historians, at the time largely uninterested in Stahl, all of whose silent films were believed to be lost, whose 1930s melodramas were yet to benefit from the 1970s revival of interest in melodrama and the woman's film, and who quickly became a marginal figure after his death despite some successes through the 1940s. So the official history remained as Stahl wished, though it is surely likely that Jewish immigrant colleagues, including Louis B. Mayer, knew of his origins. However, by the time of the San Sebastian Retrospective volume (1999) devoted to Stahl, his Russian origins had been traced through the Los Angeles newspaper reports by a writer in the French newspaper *Libération*, and were restated by Joe Adamson in his chapter "The Case against John Stahl" in that volume, though the newspaper reports rather than the court documents were the source.[*]

These facts – certain, probable and possible – are, however, still surrounded by mysteries. When and where Jacob Morris Strelitzsky arrived in the USA is unknown; Ellis Island, with its records, did not open till 1892, so it was possibly Castle Garden on Manhattan. Stahl claimed that his stage career began in 1901 at the age of fifteen. If so, he must have been in the US a considerable time for his English to be

[*] The 1900 Federal Census lists a John Stahl living in the Borough of Manhattan along with two brothers and a sister, with John's age fitting the future film director and his employment as a clerk possible. Unfortunately there is no information about the parents. This possible but not indubitable sighting was noted by Barbara Mennel in "Ming Wong's Imitations", *Transit*, v.9 n.2, 2014.

proficient enough for him to think of a stage career. So his claim that he was educated in New York City should be accepted. That there is no record of anyone remarking on him having a foreign accent, adds to the certainty that he was a young child when he arrived, easily able to adapt to his linguistic and other surroundings. However, much else remains obscure about his early life, in particular as regards his parents and possible siblings, of whom to date nothing has been found. Although there are many photos of Stahl from circa 1920 on, there is nothing before that, with the exception of a purported photo of him as a three-year-old which appeared in *Moving Picture World* (21 May 1921, 284) with the text "John M. Stahl, when he was young, innocent and at peace with the world – before he decided to produce 'King Lear' for 'Associated First National'".

(The reference was to a film version of *King Lear* to be directed by Stahl and produced by Mayer, for which there was enough pre-publicity for it to seem a serious project). Whether the photo is actually of Stahl or just any child is unde-cidable, but, if Stahl, was it taken in Russia or in America? Of course, the article may have been jocose, reflecting humorous scepticism at the idea of a film of *King Lear*, which would suggest that it was a photo of any child.

At some time Jacob Morris Strelitzsky changed his name to John Stahl and its fuller variants John Malcolm Stahl and, most commonly, John M. Stahl, as the film director later signed himself and became generally known. Such name changes in the attempt to join the mainstream were common (e.g. Meier to Mayer, Samuel Gelbfisz to Sam Goldwyn etc.), and Stahl's no doubt eased his path. Was the name Stahl that of relatives or family acquaintances already in America, or was it, as has been suggested, given to him arbitrarily on arrival?[*] Whether given or chosen, the connotations of the German for steel may have been attractive, long before WWI's anti-German feeling. The first name John was an obvious mainstream choice, but Malcolm (Gaelic Scottish) suggests Protestant derivation and must have been a personal choice, though Stahl always shortened it to the initial M. This name was seemingly at one with a desire to place himself within the mainstream WASP world, though he does not seem to have gone out of his way to hide his Jewishness, and intimate associates, particularly Jewish ones, must have known the truth, or parts of it. An anecdote told by Bosley Crowther, and repeated much later by Scott Eyman, has the agent Edward Small suggest to Louis B. Mayer that he should hire Stahl precisely because he was Jewish.[**] The facts that thirty years later his funeral service took place at the Little Church of the Flowers at Forest Lawn and that he was interred at that cemetery must mean that he had dropped Judaic religious affiliation, though not all Jewish identity, for he was a founding member of the West Coast B'nai B'rith Cinema Lodge in Hollywood along with figures such as Goldwyn and Schenck. That his funeral was conducted by Ernest Holmes of the Church of Religious Science, a figure who had connections with many Hollywood notables, may or may not be significant. Stahl and/or Roxana may conceivably have had connections with Holmes's movement, but it seems much more likely that he was chosen as a well-known Hollywood figure identified neither with religious Judaism nor with orthodox Christianity, but not scandalously atheist.

[*] Also suggested by Barbara Mennel, op. cit.
[**] Bosley Crowther, *Hollywood Rajah* (New York: Holt, 1960), 79; Scott Eyman, *Lion of Hollywood* (New York: Simon and Shuster, 2012), 56.

But the mysteries do not end here. Stahl never – with two fragmentary exceptions – mentioned in print his family, either parents or any siblings. One of many short biographical sketches quotes him saying that his father was a merchant, in another in 1938 he reportedly said that he was the second son of a civil engineer. Which is true, if either, there is at present no way of knowing. As far as can be known he never said in print anything more about his father, and said absolutely nothing about his mother and siblings, if he had the latter. With no journals and correspondence apparently left behind when he died, these contradictory statements are as much as there is for the biographer, given the present state of knowledge.

Stage to Screen

Every biographical piece about Stahl talks of a long period as a stage actor before he took parts in films and then graduated to direction. That he had a theatrical career is certain, but, typical of the difficulties of tracing his early life, there are only two objective facts to record as evidence of it. John Stahl is listed in the *Allentown Daily Leader*, Pennsylvania (7 September 1909, 8) in a play called *Cradled in the Deep*. That the *Adams County News*, Gettysburg, only two weeks later announced that this company had been disbanded, "business not justifying their staying on the road", (25 September 1909, 7) both emphasises the precariousness of acting outside the metropolises and the difficulty of tracing such a career. The only other record of him appearing in a play was in a minor role in the Broadway production of *Speed* (1911), actually directed by Cecil B. DeMille and with Sydney Greenstreet in the cast, which ran for only 15 performances). This suggests some earlier parts in New York that got him noticed for a minor role on Broadway.

Stahl claimed that he began his stage career aged fifteen in 1901 acting, doubtless as a "super", in the play *Du Barry* starring Mrs Leslie Carter, which ran between December 1901 and May 1902.[*] If his claim is true, rather than a romantic invention, the period from 1902 to 1908 is one in which he left no acting records that have been discovered. There are plausible explanations for this, e.g. that he was playing in New York City and State, and Pennsylvania, and perhaps further afield, in small stock companies whose records are difficult, or impossible, to trace; the same would be true also of minor vaudeville, if, as some biographical notes assert, he played in vaudeville and on the Chautauqua circuits. Given the likelihood of his speaking Yiddish as a child, a career in the New York Yiddish theatre seems possible, though unlikely if he was trying to mainstream-Americanise himself. Bosley Crowther, in the Mayer biography referred to above, asserted that Stahl was a notable Jewish theatre director. But he cited no evidence, and no New York records support any Yiddish theatre career. Despite the lack of further evidence, there are, however, strong reasons for thinking that Stahl did have a lengthy stage career, which might well have included some directing, though certainly without the leading Broadway roles sometimes claimed.

Throughout his film career he exhibited a passion for theatre, visiting New York from Hollywood to view new plays, and showed a partiality, despite writing about the need for original screen plays, for adapting plays into films. Further, his reported

[*] Data from the Internet Broadway Database (IBDb) a useful counterpart to IMDb.

method of directing actors, often himself acting out the part to them (an instance illustrates the essay on *Our Wife* in this book: see page 207), was very much like that of Lubitsch, another actor turned director. The distinguished journalist Hallett Abend observed Stahl working on the set of *Why Men Leave Home* (1924), and described him instructing an actor who has kissed a woman goodnight, and watched her go into her house, how to convey that she, offscreen, has invited him to follow her, showing him

> how he wanted him to balance a moment on his heels, swing his walking stick and then, by his expression, show a flash of conceited triumph. Time after time the actor tried the scene, and just missed the effect; time after time, Mr. Stahl acted it for him, putting over the business perfectly.

Later in the article Abend relayed a conversation in which Stahl compared theatre production with film production, arguing that theatrical script development and rehearsal practices allowed greater refinement of a production than was possible with the economics of film, the detail of what he said showing intimate knowledge of the theatre ("Days Spent with Great Directors ... John M. Stahl", *Los Angeles Times*, 14 November 1923, "The Preview", 5).

At some point Stahl must have moved from stage into film acting, though again there are no records to confirm this, only the various stories released by studios relating how the screen actor became a director. The dominant account of this transition – which could not have happened without experience as a film actor – relates, with minor variations, that on location for a film in which he was acting, the director became ill, and Stahl took over the direction of a big production so well that his future was decided. Perhaps it was that dramatic, perhaps less so. As for directing before his first actual credit as director in 1918, Stahl claimed two films that made some impact at the time of their release, though on neither of them was he credited. One of them, *A Boy and The Law* (1914), is lost, the other, *The Lincoln Cycle* (1917, actually a series of related films) is largely extant in an archival copy in the Library of Congress. *The Lincoln Cycle*, also called *The Son of Democracy*, is now firmly attributed to him, directed in 1915 and 1916. The less conclusive evidence linking Stahl with *A Boy and the Law* is discussed, like *The Lincoln Cycle / Son of Democracy*, in the film-by-film section of the book. Stahl said in the Brooklyn newspaper in which he chastised Benjamin Chapin for not giving recognition to the other actors or to himself that he was the general director of the Eminent Film Corporation in Brooklyn (*Brooklyn Daily Eagle*, 7 June 1917, 22). Stahl also said in the same interview that he was making a seven-reel film, *Love Thy Neighbor*; but no traces of this film have been found.

In his personal life, Stahl had already been married to a woman whose identity still remains unclarified, and had a child (the Mrs Sarah Appel who challenged his will in 1950). The dates of the marriage, the birth of Sarah and the divorce are unknown. Most probably in 1914, he was married again, to Frances Irene Reels, who contributed in a major way to the scripts of five of Stahl's films between 1919 and 1924, and possibly to others. Born in 1892 in Smithville, Mississippi, according to one source (*Find A Grave*), she was, like her mother, a stock company actress in New York City. If so, that may be how Stahl met her. Despite her prominence as a film writer, whose work was often credited in reviews and advertisements, and an

obituary saying she was "widely known in social circles" in Los Angeles, she remains a nebulous figure, with nothing seemingly written about her, and no photographs so far found. Her sudden death, in 1926, was brought on by an apparently minor operation. She was an important figure in Stahl's career, probably beyond the credits she has.

Silent Film Director

One of the contributing factors to the relative eclipse of Stahl's reputation after he died was that until recently almost all his silent films were thought lost. For instance Andrew Sarris's later essay on Stahl (1980) was written under the handicap of believing that the replacement scene supposedly shot by Stahl in Lubitsch's *The Student Prince of Old Heidelberg* (1927) – now thought almost certainly not Stahl's – "is thus far the only trace of Stahl's career to have survived from the silent era".[*] The situation was only marginally better in 1999 for the contributors to the important Retrospective volume *John M. Stahl* by the San Sebastian Film Festival.[**] In 2018 that situation is now changed in that over half of the silent films (12 out of 22) survive in archival copies, making it possible for a significant number of them to be written about in detail in this book. What has *not* changed is that they are still in effect lost to a wider public, and even to scholars interested in silent film who cannot visit the relevant archives. It is to be hoped that this book, building on an interest in Stahl that has been growing over the last decades, will result in at least some of his silent films becoming available on dvd or online as are, with only a couple of early exceptions, all his sound films. What has also changed is the enhanced availability of a mass of secondary information from trade papers, film magazines and newspapers about Stahl's films, information mostly only available formerly through visits to a few libraries, but now digitised online. Thus at this point it is possible, for all the lacunae that still exist, some of which – especially the lost films – will probably never be repaired, to write more accurately and comprehensively about Stahl's silents than in the past.

In 1918 Stahl emerged as a credited director with *Wives of Men*, which he wrote as well as directed, the former credit, along with later ones, reminding us that he was held in some regard as a screenwriter, as shown by a later announcement that an entrepreneur was organising a company "to be known as Stage and Screen Photoplays Inc." which was negotiating with Stahl "for original scripts" with the proviso that "The deal in no way affects Stahl's duties with Louis B.Mayer" (*Wid's Daily*, 15 February 1921). The deal seems to have fallen through, but sheds a light on Stahl's writing abilities, which were shared by his (second) wife Frances Irene Reels.

The film was produced by the actress Grace Davison, released in March 1918, but unfortunately lost. Davison related how she chose Stahl, "fortunately for her, she believes" (Lillian Montantye, "She Would and She Did", *Motion Picture Magazine*, August 1920, 35–36), presumably knowing of him through the *Lincoln Cycle*, which

[*] Andrew Sarris, "John M. Stahl", in Richard Roud (ed.), *Cinema: A Critical Dictionary* (London: Secker & Warburg, 1980), v.2, 948.

[**] *John M. Stahl*, Edición bilingüe español/ingles, Festival Internacional de Cine de San Sebastián, Filmoteca Española, San Sebastián-Madrid, 1999.

Florence Reed
and Frank Mills

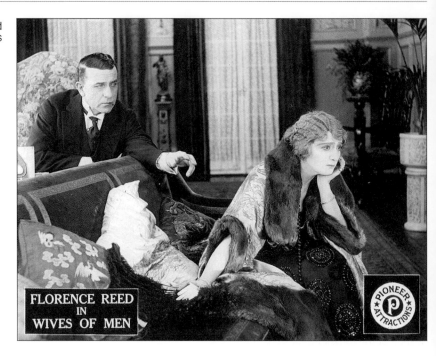

FLORENCE REED
IN
WIVES OF MEN

he had publicly claimed in 1917. The production secured a name star in the well-known stage and screen actress, Florence Reed, which made it commercially attractive. From here Stahl's career as an East Coast director took off. *Suspicion* (1918), also lost, starring Grace Davison, was followed by the second and third of his films with Florence Reed, *Her Code of Honor* (1919) and *The Woman Under Oath* (also 1919), both surviving. Stahl then made his last two East Coast films, with another well-known stage and screen actress Mollie King, *Greater Than Love* (1920), confusingly never issued under that title, but as *Suspicious Wives* in late 1921, extant, and the lost *Women Men Forget* (1920).

At this point Stahl signed a contract with Louis B. Mayer to direct for Mayer's recently-formed production company in Hollywood. The Edward Small anecdote (see page 18) might be suspect, as Stahl's successes with major stars are likely to have prompted Mayer's interest, having, as he did, two female stars, Mildred Harris Chaplin and Anita Stewart under contract. Stahl was reported in trade papers as arriving in Los Angeles on 3 January 1920, with *Moving Picture World* specifying that "Louis B. Mayer has Mr Stahl under a long-term contract which provides for his directing either Anita Stewart or Mildred Harris Chaplin in pictures for First National Exhibitors Circuit distribution" (94). This contract stabilised Stahl's career for the next seven years, for beginning with the film in question, *The Woman in His House* (another lost work) starring Mildred Harris Chaplin, he would make ten films with Mayer and the powerful distributors, First National, effective co-producers of the films (the last three at MGM's studio), and three more when he officially joined MGM in December 1925. The years 1921–1926 were ones of great success for the director who made in rapid succession *Sowing the Wind* (1921) *The Child Thou Gavest Me* (1921), *The Song of Life* (1922), *One Clear Call* (1922), *The Dangerous Age* (1922), *The Wanters* (1923), *Why Men Leave Home* (1924), *Husbands and*

Lovers (1924), *Fine Clothes* (1925) and *Memory Lane* (1926). These films, recognised for their box office potential, were advertised with great flair by both Mayer and First National. Stahl's early success led to Mayer giving him a unit of his own, "John M. Stahl Productions", which operated semi-independently and led to extra prestige for Stahl, now seen as producer-director, a step up from director. *The Child Thou Gavest Me* (1921) was the first of these special unit productions.

Semi-independent needs stressing, since Mayer was clearly an overseeing force, often on set, as publicity photos of the time show, though Stahl's formidable box office abilities clearly won his confidence. Anecdotal evidence suggests that the director's shooting style, with painstaking preparation, many retakes, consequent unused footage and long shooting schedules, caused some friction between the two, as it did later at Universal, something well documented in Universal's 1930s records, but, as Stahl is said to have said, such worries were dissipated by his box office returns. Publicising *One Clear Call*, Mayer even used the 200,000 feet of film edited

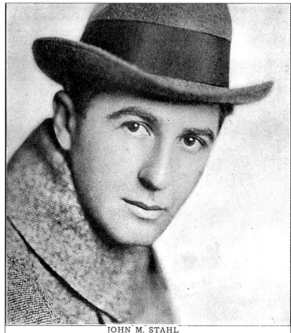

JOHN M. STAHL

Louis B. Mayer

Presents

John M. Stahl Productions

Associated First National Productions
Now Completed

"The Child Thou Gavest Me"
"The Song of Life"

THIRD PRODUCTION UNDER WAY

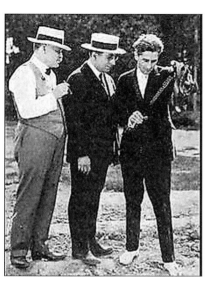

down to 8,000 feet used in shooting the film as a publicity boast to demonstrate the production's greatness (*MPN*, 18 March 1922, 1635). The simplest view of the early Mayer-Stahl relationship stresses the consonance between Mayer's family-values sentimentality and the films' sensationally disruptive events but eventually happy, moralistic endings, and there is some truth in this, though it neglects the larger patterns of cinematic melodrama to which Stahl's films belong. On the other hand, the younger Mayer seems in some of his attitudes to have been strongly influenced by Stahl (e.g. in his surprisingly liberal early attitudes to censorship) and

Partnership with Mayer, who looks over Stahl's shoulder; at left is pioneer producer William Selig, now working with the distributor First National.

in his ideas of what could be filmed, e.g. the *King Lear* that was to be directed by Stahl, and a version of *The Wandering Jew,* both to be produced by Mayer. True, both were very untypical, even unlikely, projects, but for a moment they clearly seemed possible.

With his successes and the backing of Mayer and First National, Stahl became a director given considerable coverage in the trades. Announcements of his film projects were followed by items on the signing of stars and supporting players, emphasising his reputation for taking pains to secure the right casts, and then by progress reports on the shooting, editing, intertitling, and release of the films. As a director, later producer-director, he was from the beginning associated with melo-drama and the "woman's film", and with directing major female stars such as Florence Reed, Anita Stewart and Mollie King. He developed an early reputation for being sensitive to, or exploitative of, material in the news (though he was far from alone in this), for instance the Great War-related spy plot in *Suspicion,* the revelation of wartime rape in *The Child Thou Gavest Me,* the woman juror contro-versy in *The Woman Under Oath,* and the Ku Klux Klan nightriders in *One Clear Call.* He was also a close follower of cinematic trends, for instance films celebrating "mother love", a trend which he joined with *The Woman in His House, One Clear Call* and *The Song of Life*, and the vogue for demonstrating the power of the spiritual over the material in the ending of *The Woman in His House* and the vision of the crucifix in *Suspicious Wives*. As well as becoming known as a presenter of extreme melodramatic situations – near-incest in *Her Code of Honor* culminating in a narrowly averted suicide pact, a daughter discovering her mother is a woman of ill fame in *Sowing the Wind*, murderous attacks by jealous husbands or vengeful women in *Wives of Men, The Woman Under Oath, The Child thou Gavest Me, The Song of Life* etc., mother love alone curing the dying child in *The Woman in His House* etc. – he became known, in addition to all this, as a masterly exponent of marital comedy, even in the age of his great peers DeMille and Lubitsch. Though it is the reputation for melodrama and the woman's film that has lasted, Stahl was in the mid-1920s as celebrated for witty marital "problem" comedies and "serio-comic" satires as for melodramas.

As Stahl became only a few years into his career a well-known, recognisable figure whose photo appeared in advertisements for his films and in publicity stills on and off set, he also became known for putting forward views on the industry and film making. His publicly aired opinions embraced repeated observations on the importance of the female audience, on the adaptation of novels and plays for the screen, on the need for original screenplays, on the need to combine entertainment with message, and on the cinema's dealings with sexuality: he replied to calls for banning of cinemas on Sundays with claims for the moral function of films, and was critical of naive censorship, arguing that films should not be made with a single all-ages audience in mind, but that adults and children should have different films. Stahl also took care to ingratiate himself with those who might help his films' success, even publishing letters in the trades thanking exhibitors and critics for their opinions on his work. While these last might suggest a film-maker wholly dominated by box-office motivations, opinions quoted in an interview reported in the *Ottawa Journal* (2 December 1922, 21) suggest that within the boundaries of the time's commercial cinema he saw himself as an innovator, going beyond "old traditions

about what can and cannot be done in motion pictures", giving as examples "Marshall Neilan [who] launched a genuine innovation when he produced a picture recently in which four separate and distinct stories were used" and Charles Ray who "has made a picture without the use of a single subtitle". The essays on the surviving films that follow are able to go beyond basic thematic and narrative description to examine Stahl's formal and stylistic procedures, and establish links and development across the silent output and into the sound films. And where films are lost – and indeed where they survive – an attempt is made to provide as much information as possible in a limited

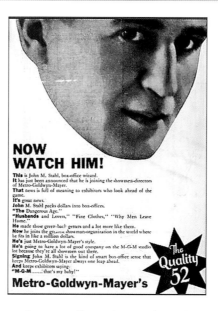

NOW WATCH HIM!

This is John M. Stahl, box-office wizard.
It has just been announced that he is joining the showmen-directors of Metro-Goldwyn-Mayer.
That news is full of meaning to exhibitors who look ahead of the game.
It's great news.
John M. Stahl packs dollars into box-offices.
"The Dangerous Age."
"Husbands and Lovers," "Fine Clothes," "Why Men Leave Home."
He made those green-back getters and a lot more like them.
Now he joins the greatest showman-organisation in the world where he fits in like a million dollars.
He's just Metro-Goldwyn-Mayer's style.
He's going to have a lot of good company on the M-G-M studio lot because they're all showmen out there.
Signing John M. Stahl is the kind of smart box-office sense that keeps Metro-Goldwyn-Mayer always one leap ahead.
And keeps exhibitors saying:
"M-G-M......that's my baby!"

Metro-Goldwyn-Mayer's The Quality 52

The official move of the "box office wizard" to MGM is heralded.

space about their genesis, production circumstances, writers, players, cinematographers, and reception through trade, magazine and newspaper reviews.

Metro-Goldwyn-Mayer was formed in April 1924, and Stahl moved there with Mayer – well ahead of the official announcement of his move a year and a half later – to make *Husbands and Lovers*, *Fine Clothes* and *Memory Lane*. Despite this, these films were designated Louis B.Mayer Productions and distributed not by MGM but by First National because of continuing contractual obligations. When Stahl's move to MGM was finally announced, his status at the time was demonstrated by a choker close-up portrait of him and the text "This is John M. Stahl, box-office wizard ... Now he joins the greatest showman-organisation in the world where he fits in like a million dollars" (*Film Daily*, 11 December 1925, 16).

At MGM he made three more films, *The Gay Deceiver* (1926), *Lovers* (aka *Lovers?*) (1927), and *In Old Kentucky* (1927). Though his previous partnership with Mayer had worked well for both parties, the move to MGM was, it seems, growing unsatisfactory for Stahl, who left the studio with time to run on his contract, finding, it may be speculated in the absence of concrete evidence, that he did not have the relative freedom of his earlier partnership, and was now no longer Mayer's star director/producer as he had been before. Stahl then took the surprising step of joining in late 1927 the smaller Tiffany studio as Head of Production, a move discussed in a separate essay. At Tiffany-Stahl he was involved with the transition to sound, and by the time he returned to direction in 1930 he had begun the sound-film half of his directorial career. ◆

A Boy and the Law

Early 1914 (or possibly late 1913). 5 reels. Presumed Lost.
PC: Youth Photo Play Co.
Dist: Pan-American Film Manufacturing Co.

In Czarist Russia, William "Willie" Eckstein's prosperous family faces persecution in an anti-Jewish campaign. While Willie is away at boarding school, the family is forced to move to a humble home in a distant part of Russia. There his father is killed by drunken Cossacks as he tries to protect a woman from them. Willie faces imprisonment when his role as the leader of a secret society among the schoolboys is discovered. He escapes in a chase down a cliff and flees to America, making his way to Salt Lake City, Utah, where his uncle lives. Willie starts his new life as a newspaper boy, but soon ends up as a streetboy, a smoker, an habitué of poolrooms, and a gang member – and in the hands of truancy officers. Summoned to the court of Judge Willis Brown, Willie at first defies the law, but later he realises that the judge sincerely wishes to help him. Judge Brown is instrumental in purchasing a farm for delinquent boys which he hopes will serve as a substitute for jail. A village called "Boy Town" is built on the farm, where the youths practise discipline and self-government; consequently, many of them grow into successful and law-abiding adults. The ways in which the boys organise their lives is shown in some detail. Willie is elected as the mayor of the town, and eventually is sent to the University of Missouri where he studies agriculture. He later becomes the manager of a large farm owned by the judge. Willie writes a letter containing money and photographs to his mother back in Russia, and has a vision of her receiving it. The film closes with Judge Brown delivering a little homily to his convert.

There is no incontrovertible evidence that Stahl directed this film, but he was reported on numerous occasions as having claimed it.[*] Although now lost, it was still extant in 1922, as is shown by advertisements offering it to "the non-theatrical distributor…. for church, school and community uses". (*Moving Picture Age*, April 1922, 36; May 1922, 24). That Stahl was its director was regularly stated over the years: in *Exhibitors Herald* (21 February 1920); in *Motion Picture News Booking Guide and Studio Directory* (October 1927, 96); in "John M. Stahl" by Robert J. Warren (*The Film Daily Cavalcade 1939*, 306); and in "Who's Who in Hollywood" in *Film Daily* (18 July 1947, 12). Though such information cannot be accepted unquestioningly, the assertion that Stahl made the film was repeated often enough to be taken seriously, even if not with the certainty attached to *The Lincoln Cycle*. It must be admitted that, in the piece in the *Brooklyn Daily Eagle* (7 June 1917, 22) where he first publicly claimed direction of Chapin's Lincoln films, he did not mention *A Boy and The Law*; but it is difficult to imagine why Stahl should falsely claim direction of that film when Brown, still a well-known figure, could have contradicted him.

A Boy and The Law, or at least most of it, was made in Salt Lake City: this is where its protagonist Judge Willis Brown was, or had been, in charge of the Juvenile Court, and it is also where, in the narrative, Willie ends up after his escape from Russia. Since 1912–1916 is very much a blank as regards knowledge of Stahl's where-abouts, there is no reason to think that he might not have been present in Salt Lake City, as well as wherever else the film was made – perhaps even at the Vitagraph studios in New York, where he is believed to have worked at some point, although no films or records survive.

A Boy and The Law had considerable publicity when released, and was claimed to have run for six weeks at the York Theatre on Broadway (*Motion Picture News Booking Guide and Studio Directory*: October 1927, 96). The film was the idea of Judge Willis Brown, a mixture of genuine social reformer and confidence man – he actually had no law degree – who rescued delinquent boys by setting up "Boy Cities" where they learned responsibility and self-direction through farm work and communal living. Selig made a short non-narrative film about his work in Charlevois, Michigan, called *City of Boys* in 1910 (see the Selig advertisement in *Film Index*, 26 November 1910). After writing later films that used different directors, e.g. *The Girl Who Won Out* (1917), *The Spirit of 17* (1917), and *The Saint's Adventure* (1917), in 1918 Brown hired the young King Vidor, who had no connection with *A Boy and The Law*, to make a large number of two-reelers (all but one lost) that directly and indirectly publicised his reforms.

Brown was clearly a writer who depended on others to direct his projects, and a successful five-reel film of considerable narrative complexity, back in 1913–14, with untrained lead actors, would, like Benjamin Chapin's Lincoln films, have been impossible without a director knowledgeable in film – and Stahl was always the only claimant.

[*] Kevin Brownlow refers to the film in his *Behind the Mask of Innocence* (New York: Alfred A Knopf, 1990), 173. He credits the direction as well as the project to the Judge, which for the reasons suggested above is unlikely. Stahl is not mentioned, unlike Vidor's later work for Brown.

If he did direct the film, its narrative – Russian boy emigrates to America, gets in trouble with the law, and eventually makes a great success of himself – might well, given his own early biography, especially his daughter's claim that he had been in trouble with the law when young, have resonated strongly with him.

Advertisements and reviews can be found in a variety of contemporary publications in a variety of states. *Motion Picture News* (25 October 1913, 18–19) has a piece by William W. Young on the origins of the film, with a very detailed synopsis, on which we draw above. The Salt Lake City connection meant that it was given a lot of coverage in local papers, particularly the *Salt Lake Telegram* (27 June 1914, 6), which reproduced crudely what appears to be a still from the film. As suggested by the way its showing was often accompanied by lectures, the film was clearly didactic, but reviews such as the *Wichita Beacon*'s (20 April 1914, 6), while applauding it on moral grounds, also pointed to its cinematic values. "'A Boy and The Law' is recognized as one of the cleanest pictures being shown from a standpoint of morality. It is filled with laughter and tears; thrills and surprises; Ellis Island with its mass of migrant humanity; Western landscapes and Eastern life; youth achievement, and above all events which actually happened."◆

Judge Willis Brown

A SLAYTON ATTRACTION

The Lincoln Cycle

A series of ten two-reel films produced by Charter Features Corp. dramatising events in the life of Abraham Lincoln.

Pre-release showing of one episode at the Belasco Theatre, Washington, DC, 4–10 March 1917. Four episodes were then shown as a group for one week at the Strand Theatre in New York, beginning on 27 May 1917, moving to the Globe Theatre on 3 June and running through 22 July. General release by Paramount as "The Son of Democracy" (one episode each week beginning 11 February 1918 for ten weeks; subsequently distributed non-theatrically by Famous Players-Lasky).

In 1921 the films were reissued by Lucile Ann Chapin, "co-author and collaborator with her brother", who established the definitive order of the ten episodes as follows:

1. My Mother
2. My Father
3. The Call to Arms
4. My First Jury
5. Tender Memories
6. A President's Answer
7. Native State
8. Down the River
9. The Slave Auction
10. Under the Stars

Posters and advertising say that the film has been "written, directed and produced" by Benjamin Chapin. Chapin also received screen credit for playing the adult Abraham Lincoln; his father, Tom Lincoln; and his grandfather, also named Abraham Lincoln. No other personnel were ever officially credited.

After sections of the film were screened at New York's Strand Theatre in 1917, John M. Stahl informed the press that he had directed *The Lincoln Cycle*, and continued to include it in his credits for the rest of his career. Stahl's claim to have directed the film was ignored by Chapin, but apparently never challenged by him or his estate. Stahl also claimed at the time that the part of Lincoln as a boy was played by Charlie Jackson, and that of Nancy Hanks Lincoln by Madelyn Clare.

At one time or another, Paul Bern, Monte Katterjohn, William B. Laub and Donald Buchanan all claimed to have had a hand in writing and/or editing the films. Cinematographers J. Roy Hunt, Harry Fischbeck and Walter Blakeley all listed it in their credits. Press accounts in the teens identified Alice Inwood and Florence Short as having appeared in the films. Unverified modern sources also credit Joseph

Monahan as "Willie Lincoln" and John Stafford as "Carter", as well as a cameraman known only as "Freyer".

The Lincoln Cycle was the creation of Benjamin Chapin (1874–1918), the culmination of a life-long obsession with the assassinated American president that began in childhood and progressed from church-sponsored recitations through the Lyceum circuit, Broadway, vaudeville and, ultimately, the cinema. By 1903 he was already presenting his Lincoln impersonation under Presbyterian Church auspices, and in 1906 he transformed his monologue into a four-act play and took it to Broadway. *Lincoln* opened at the Liberty Theatre on 42nd Street, where it immediately followed Thomas W. Dixon's production of *The Clansman*. The *New York Times* did not miss the opportunity to draw some obvious contrasts, hailing *Lincoln* as "an antidote" to Dixon's play, while attacking "the violent, antagonistic, theatric exposition of inflammatory sentiment" of *The Clansman*, which left the audience "boiling with indignation at the contemptible device". Chapin's play, although described as equally crude and lacking in subtlety, "gains in impressiveness by the very simplicity, unpretentiousness and apparent artlessness of its setting forth".[1]

Chapin had emphasised Lincoln as a man, settling quarrels among his advisers, bickering humorously with Mary Todd, and facilitating a romance between two of the minor characters. He had avoided not only the "inflammatory" and "contemptible" devices of Dixon's work, but anything that might be offensive to either North or South, including all mention of slaves or slavery. The play was not an unqualified success, but Chapin continued touring as Lincoln until 1917, appearing in every theatrical venue from vaudeville to Chautauqua. In 1913, a moment when the film business was just beginning to experiment with new forms of dramatic narrative, he began thinking about the movies.

Taking a few plot elements from his play, he wrote a ten-page scenario called *Lincoln's Thanksgiving Story*, which he copyrighted on 17 January 1914.[2] The script seems a straightforward attempt to turn his stage production into a photoplay ("They turn backs to camera, walk up stage", it says at one point), and two still

photographs submitted with it might just as well document action in his touring show. There is no record of any release.[3] Instead, Chapin made a radical decision to dump the crude theatrics of *Lincoln's Thanksgiving Story* – a linear narrative in which the President stars as the do-gooding hero of a conventional melodrama – in favour of something vastly more ambitious. In May 1914 Chapin incorporated the Charter Features Corp. in New York with an authorised capital of between $250,000 and $400,000.[4]

A full year passed before anything more was heard from Charter, and not until the Spring of 1915 did the unprecedented success of D.W. Griffith's *The Birth of a Nation* suddenly make Chapin's ambitious Lincoln scheme seem like the next new thing. A first wave of publicity began appearing in July. "There is nothing with which to compare the Lincoln Cycle", Charter's promotional material explained to exhibitors. "Those who know Wagner's Niebelungen Cycle may associate with it some impression of the idea. Those who know the 'Passion Play' at Oberammergau will realize something of its dramatic magnitude." What Chapin was proposing was not a serial or a great multi-reel film, but a cycle of related features, each four or five reels in length. At a time when individual feature releases of four reels or more were only beginning to establish themselves as the industry standard, Charter was attempting to create a new style of long-form screen narrative. Its publicity took pains to distinguish Chapin's project from what it saw as the limitations of the competition, citing not *The Birth of a Nation*, but *The Exploits of Elaine* and *Who Pays?*[5]

Eighth Chapter

"Down The River"

THE Mississippi in the olden days was infested by bands of slave-stealers who seized free negroes and sold them into slavery. While floating with the tide down the river on a long raft with a load of goods, young Lincoln becomes the central figure in a contest of craftiness and violence with the worst of these gangs who have stolen a free negress from New Salem, his home town. The antics and pranks of Rastus, a little black urchin, cause much excitement and furnish the side-splitting fun of this picturesque romance of the Mississippi.

Ninth Chapter

"The Slave Auction"

THIS shows the slave center at its worst. Here young Abe is at close quarters with the band of slave-stealers. To save the free negress, he again becomes the main figure of a drama of plot and counterplot, suspense, excitement and humor in their highest form. In the very shadows of the auction block a voodoo fortune-teller prophesies that he will become President, that he will be the leader in a great war and that through him will slaves be freed. Lincoln fails to save the free negress, and in righteous wrath he vows, "If I ever get a chance to hit slavery, I'll hit it hard!" Both the voodoo woman's vision, and young Abe's pledge come true, for, in thirty-one years, Lincoln, as President, signs the Emancipation Proclamation, abolishing slavery forever.

Chapin may have shot some footage, but he had neither a completed film nor the supporting staff needed to produce anything like the stream of 29 releases he was trying to sell to exhibitors. Instead, on 17 and 24 July, Charter Features placed a series of ads in *Moving Picture World* headed "WANTED DIRECTOR" and "WANTED 2 MORE SCENARIO EXPERTS." Now describing the films as being four to nine reels long, they sought "a Director of the most pronounced ability to take one of our companies to the various parts of the country while others of our companies are working in the East. The man we want may or may not have a big name but it is highly likely that he will, for we are ready to pay a salary for the best brains in America."[6] The director they found was John M. Stahl.

Chapin said that he had begun filming on an open-air stage in Fort Lee in 1915 but was forced to junk most of his footage due to "the varying climatic conditions in the east".[7] In January 1916 he took over a large new studio in nearby Ridgefield

Park that had been constructed by Gunby Bros., an independent film laboratory. *Motion Picture News* described it as "one of the largest glass-covered studios in the country".[8] Exteriors were shot on New Jersey locations, although occasional views of the White House and other points of historic reference would appear when appropriate.

Chapin's name remained on the studio for years, the 1925 *Film Daily Yearbook* still listing it as "Charter Films (Benj. Chapin)", while noting it was now used only as a laboratory. Chapin may not have realised how hard it would be to get widespread distribution for an independent production. To make matters worse, *The Lincoln Cycle* was no stand-alone feature, but a costly continuing series that required theatres to sign on for a commitment of months, if not years. Eventually, with no exhibitor commitments in hand, he decided to jump-start a wave of public interest by pre-screening a single episode of the *Cycle* at the Belasco Theater in Washington, DC in March 1917, the week of Woodrow Wilson's second inaugural.

With an audience filled with dignitaries in town for the inauguration, and Chapin's personal appearance in full character, the trial run proved a great success. Chapin headed for New York, where he arranged with Mitchell Mark for the 3000-seat Strand Theatre to clear its entire programme for a full week – feature, shorts, musical performance – to focus only on *The Lincoln Cycle*. But between the film's Washington try-out and its first appearance in New York on 27 May, the geopolitical situation had suddenly changed and the United States was at war with Germany.

In New York, Chapin presented four individual episodes of the *Cycle*: "My Mother", "My Father", "Myself" (later retitled "My First Jury") and "A Call to Arms". This last was the same episode he had shown in Washington, but under a different title. With debate over America's entry into the war now settled, an advertising campaign that in March had asked "What would Lincoln do?" was replaced by a full dose of militaristic patriotism. Lincoln would now be promoted not as a conciliator but as a dynamic wartime president, and Chapin, in full Lincoln regalia, would spend the next two months appearing at recruitment rallies.[9] Critics seemed to consider it a patriotic duty to encourage audiences to turn out for the film. "Patrons of the Strand should be condemned to seeing trashy modern photoplays all the rest of their days if they do not flock to see the Lincoln cycle", the *New York Times* announced, praising the film's "dignity" and "painstaking attempt at verisimilitude".[10] Most other reviewers also felt *The Lincoln Cycle* would be good for you, calling it "the most sincere and most uplifting feature picture ever seen at the Strand", and singling out its "inspiring appeal to the patriotism of the nation" and "splendid cast".[11] It was in the wake of reviews like this that John M. Stahl decided to go public regarding the way Chapin had – or actually had not – credited the work of the film's cast and crew.

Chapin frequently presented his Lincoln impersonation on stage as a one-man attraction, and insisted on promoting his film in much the same way. No other actors were credited, and prints and advertising noted only that the films were "written, directed and produced by Benjamin Chapin". On the Lyceum circuit Chapin could conjure up young Abe, or his sainted mother Nancy Hanks, through his own rhetorical skills. But on screen these characters were enacted by two skilled performers, Charlie Jackson and Madelyn Clare. By 1917 it was quite unusual for the supporting cast of an important release to remain anonymous, and when the

Cycle opened in New York critics began wondering who some of these other actors were. In a statement to the *Brooklyn Daily Eagle*, Stahl responded to this lapse by leaking the names of these actors himself, while also claiming that it was he who had "directed Mr. Chapin's Lincoln Cycle, but was given no credit whatsoever by Chapin". Stahl had just seen all the credit for *A Boy and the Law* given to that film's celebrity producer, and would have been wary of allowing the same thing to happen again. To bolster his status he told *The Eagle* that he was "general director of the Eminent Feature Film Corporation of 146 Montague Street … now at work on the seven-reel feature *Love Thy Neighbor*".[12] Another reason for his support of "these two artists who are the real stars of the picture" could have been that both actors continued to work for him: Madelyn Clare was apparently the star of *Love Thy Neighbor*, while child actor Charlie Jackson would soon appear in Stahl's 1918 film, *Wives of Men*.[13]

Chapin may have included tales of young Abe and his mother in his monologues, but because neither of them appeared in his stage play we must assume that their characters, and the size of their roles in episodes like "My Mother", were developed by the team responsible for the film project. He also failed to credit his writing staff, and various writers would claim credit for at least some of the *Cycle* over the years, including such familiar names as Monte Katterjohn and Paul Bern.[14] Chapin had launched the project by placing Lincoln at the centre, but Stahl may have felt that the relationship between mother and child that gives the film its emotional core was something he had developed himself (indeed, one wonders who else would have introduced so strong an element of female-centred melodrama into what would otherwise be a standard historical pageant). Along with the *Cycle*'s emphasis on the difficulty of reconciling one's public and private life (*Parnell*), the impossibility of evading the past (*Only Yesterday*), and the debilitating effects of small-minded social conventions (*Back Street*), this emphasis on the parent/child relationship may not have been invented by Stahl, but would certainly reappear in his own later films, notably *Imitation of Life*.

To see the true extent of the influence his new collaborators had on Chapin's Lincoln, we should really look at episodes eight and nine, "Down the River" and "The Slave Auction", which document Lincoln's encounter with slavery during his rail-splitter days, and his vow to "hit slavery, and hit it hard"; unfortunately, both are missing from the otherwise complete run in the Library of Congress [but see page 31 for synopses of both]. Since slavery was ignored in Chapin's stage play, the fact that over 25% of *The Lincoln Cycle*'s running time was devoted to the issue seems a remarkable turn-around. I say over 25% because "My First Jury" also raised the issue of racial justice, in the context of young Lincoln's defence of a neighbourhood boy, "Black Jim", accused of stealing a chicken. In a mock trial held before the other boys, Lincoln wins an acquittal by arguing that Jim and his mother are poor and hungry. Where did all this come from? I can't find it in Chapin, and concern for the fate of African-Americans didn't occupy much running time in other Lincoln films, at least until very recently. If Paul Bern or John M. Stahl was the source, we should look to see what role disenfranchised minorities might play in their own later films.[15]

After playing The Strand for a week, Chapin moved his film over to The Globe, a legitimate theatre about half the size, finally closing in July after 245 performances.

Unfortunately, he had little success in his main goal, which was to secure a distribution deal that might guarantee his ability to finish the *Cycle* and place it before audiences. In December he decided to cut his losses and turned over distribution to Paramount, which rebranded the films as *The Son of Democracy* and released them at the rate of one two-reel episode per week between 11 February and 15 April 1918 (Chapin had shown an eight-reel block of episodes during the 1917 New York run, which would have created a very different narrative density).[16] In fact, Chapin was suffering from a recurrence of tuberculosis, an ailment that had plagued him for years. He was taken to the Loomis sanitarium in Liberty, New York, on 12 February 1918 – Lincoln's birthday, the press noted – and died there on 2 June.[17]

It is unknown just who was responsible for shaping the twenty reels of film released by Paramount. Stahl would hardly have continued with the project after attacking Chapin in print in June 1917, so is this what Paul Bern meant when he told his draft board that same month that he was working for Chapin as "motion picture director"?[18] But it seems likely that the six "new" episodes included in *The Son of Democracy* were already in the can by then, along with who knows how much other material. Already dying of tuberculosis, Chapin may have lacked the fiscal resources and physical stamina to do anything more than tidy up the existing material and pass it along to Paramount. In any case, so many significant events in Lincoln's life are missing – the War never ends and Lincoln is never shot – that whatever was filmed must have fallen far short of Chapin's ambitions.

Trade papers reporting exhibitor reaction claimed that business was average to good, the loss of some younger audience members offset by new customers attracted by Paramount's promotion of the special attraction. After their 1918 release the films continued to be available in Paramount's exchanges, booked primarily for special holiday or educational functions, and in 1921 the series was taken over by the Community Motion Picture Service, one of the early distributors targeting the non-theatrical market.[19] The last mention I could find in *The Educational Screen* showed three distributors still offering 35mm prints in January 1932 (p. 20). There never seems to have been an official 16mm release, a factor which may have contributed to the films' historical obscurity.[20]

While Chapin had no future in the film business, John Stahl was only starting. Over the next few years, as he struggled to establish himself in the fading east coast motion picture industry, Stahl turned to the cast and crew of *The Lincoln Cycle* to staff his own productions. Even before the Chapin films were generally released he announced he was directing Madelyn Clare (Nancy Hanks Lincoln) in *Love Thy Neighbor*, a film also claimed by Walter Blakely, one of Chapin's cameramen. Over the next few years Stahl would cast Charlie Jackson at least twice more, and reunite with cameraman Harry Fischbeck and writers Paul Bern and Walter B. Laub on several other films. But the most important lesson Stahl learned from Benjamin Chapin was the importance of control, of commanding every aspect of production from script to screen; the one thing Chapin did not teach him was how to be a team player. Even though he had his name painted on the side of the Ridgefield Park studio, Chapin himself had never fully mastered this situation, and the subsequent development of the Hollywood studio system would make it harder for any director

to assert this degree of authority. Stahl would briefly see his own name on the side of a studio, but he would never prove to be a true company man, and would spend the next three decades negotiating a series of uneasy relationships with half the studios in Hollywood. ◆

Endnotes

1. "Abraham Lincoln as a Stage Figure", *New York Times*, 1 April 1906, X1.

2. Thanks to David Pierce and Zoran Sinobad for providing copyright registration material on *Lincoln's Thanksgiving Story* (LU1971), and to Donna Rose-McEntee of the Ridgefield Park Public Library, Matthew Souther of Lincoln Memorial University and George Willeman of the Library of Congress for all their aid and assistance on my *Lincoln Cycle* research.

3. Fifty feet of raw footage held by the UCLA Film and Television Archive under the supplied title "Lincoln's Thanksgiving Story – unedited or assembled footage" [OCLC #423131893] has been identified by Frank Thompson as a fragment of *Down the River*, episode eight of the 1918 release. *Abraham Lincoln: Twentieth Century Popular Portrayals* (Dallas: Taylor Publishing Co., 1999), 142–144.

4. "New Incorporations", *New York Times*, 16 May 1914, 14.

5. "Outline of Activities in Promoting the Cycle of Lincoln Photoplays" (New York: Charter Features, 1915).

6. "WANTED DIRECTOR", *MPW*, 24 July 1915, 611.

7. "Against 'Open Air' Producing," *MPW*, 27 October 1917, 514.

8. "Summer Weather Brings Added United Production," *Motion Picture News*, 26 June 1915, 62.

9. "Patriotic League at Lincoln Pictures," *New York Times*, 22 June 1917, 14.

10. "Chapin's Lincoln Pictures," *New York Times*, 28 May 1917, 11.

11. "Triumphed at the Strand," *New York Times*, 3 June 1917, 74. This is a large display ad filled with positive quotes.

12. "Madelyn Klare [sic] is 'Nancy Hanks'", *Brooklyn Daily Eagle*, 7 June 1917, 22. The *Eagle* claimed that "the actress who portrays Nancy Hanks … is easily the star feature of the photoplay".

13. John Stahl, Madelyn Clare and cinematographer Walter Blakely all claimed to have worked on both *Love Thy Neighbor* and *The Lincoln Cycle*. See "Madelyn Clare is Leading Woman in *Young America*", *MPW*, 3 August 1918, 702 and "Walter W. Blakely", *Motion Picture Studio Directory* (1918), 234. Blakely associated the film's production with Gaumont. A film of that title is listed by Universal as having been "Okayed in Washington" in *Moving Picture Weekly*, 1 September 1917, 10, but no further information is provided. If Eminent Feature Film Co. did make such a film there is no record of its release. Clare would later marry Thomas W. Dixon, after serving as his "researcher, confidante, and mistress", and appearing in his 1923 film *The Mark of the Beast*. Anthony Slide, *American Racist: The Life and Films of Thomas Dixon* (Lexington: University of Kentucky Press, 2004), 160–161.

14. "Monte Katterjohn", *MPN*, 30 December 1916, 4219; E.J. Fleming, *Paul Bern: The Life and Famous Death of the MGM Director and Husband of Jean Harlow* (Jefferson, NC: McFarland, 2009), 34–35. Fleming claims that Bern wrote the scripts for the Lincoln episodes directed by Stahl.

15. For example, Mel Watkins, in *Stepin Fetchit: The Life and Times of Lincoln Perry* (New York: Vintage, 2006), 64, claims that Stahl admired the actor's "stylized performance", and helped establish him in Hollywood by using him in several Tiffany-Stahl productions.

16. "Paramount to Issue Chapin Pictures", *MPW*, 22 December 1917, 1821; "*The Son of Democracy*", *MPW*, 26 January 1918, 481.

17. "Benjamin Chapin Dead", *Motography*, 22 June 1918, 1175; "Benjamin Chapin Dead at Forty-Four", *MPW*, 22 June 1918, 1699.

18. Fleming, *Paul Bern*, 34–35. Bern later claimed that he had spent three years "producing and cutting" the Lincoln films for Chapin. "Goldwyn Adds Paul Bern to Staff of Directors", *Exhibitors Herald,* 4 September 1920, 108.

19. Prints in the Library of Congress all seem to descend from the non-theatrical release. Each episode claims copyright dates of 1914, 1915, 1916, 1917 and 1918, although none of the films appears to have been officially registered.

20. The *Chronicles of America* series, by contrast, circulated for years in both 16 and 35mm.

Richard Koszarski

Wives of Men

25 August 1918. 7 reels. Presumed Lost.
D: John M. Stahl. **Sc**: Stahl. **Ph**: Harry Fischbeck. **Titles:** Tom Bret.
PC: Grace Davison Productions. **Dist**: State Rights; Pioneer Film Corp.
Cast: Florence Reed (Lucille Emerson), Frank Mills (James Randolph Emerson, Jr.),
Mr Wokoff (James Randoph Emerson, Sr.), Mathilde Brundage (Mrs James Randolph Emerson, Sr.), Edgar Lewis (Jim Hawkins), Charles Jackson (Charlie), Grace Davison (Grace),
Bessie Mar English (Mary), Robert Lee Keeling (Paul Harrison).

J*ust as Lucille is about to marry James Randolph Emerson, Jr. at a big wedding ceremony, she discovers him gazing at a photograph that bears the inscription "With love to my husband, Grace". Though shocked, she goes ahead with the wedding. Too proud to question James about the photograph, Lucille is tormented by the woman's image for many years. Finally she becomes involved in a flirtation with another man, whom she is merely using in order to find out what her husband feels for her. Her ploy misfires when her husband takes her flirting very seriously and threatens divorce. Insanely jealous, he is choking her when a small boy rushes into the room seeking refuge from a winter storm, and collapses. James leaves Lucille, who searches for the boy's parents and eventually returns him to his tenement home. While there, she finds a similar picture of Grace to the one her husband had been looking at and discovers that the child is James's son, born to a woman who died in childbirth, whom he had loved and wished to marry but was prevented by his promise of marriage to Lucille. The child becomes the means by which Lucille and her husband are reconciled.*

(It will be noted that the narrative seems to raise awkward questions about James's morality. Without any chance of seeing the film it is impossible to know whether such questions are deliberate and thought-provoking, or just the result of a confused scenario. Stahl will show his attachment to the surname Emerson by using it for the married couples of three later silent films, and of *Only Yesterday* in 1933).

Like all of Stahl's films made on the East Coast before his move to Hollywood, this was produced by an obscure and short-lived company: in this case, Grace Davison Productions. Davison was an actress with a career of eleven feature films between 1917 and 1922, the titles of which suggest female-centred melodramas, of which *Wives of Men* was the second, and Stahl's *Suspicion* the third. Biographical information about her after 1923 is lacking, but she had talked about her career to

a 1920 interviewer, saying she used money from her wealthy father to fund her company and to hire appropriate talent in Florence Reed and in Stahl, whom she called "a good choice"; she was probably familiar with his uncredited early films. (Interview with Grace Davison, Lilian Montantye, "She Would and She Did", *Motion Picture Magazine,* August 1920, 35–36). Her role in her own production, as the first wife, was small but clearly important, and she would star in Stahl's next film, made for a different company.

Wives of Men established a pattern continued throughout many of Stahl's silent films of working with major female stars; here, Florence Reed, a well-known theatrical actress who made fifteen films between 1915 and 1921, three of them with Stahl. Having this prestigious actress, known in her films' publicity as "America's greatest emotional actress", at the centre of his first mainstream film was a considerable coup for a young director as yet unknown to the general public; as we have seen, he had been given no credit by Benjamin Chapin for directing *The Lincoln Cycle/ The Son of Democracy*, or by Willis Brown for directing *A Boy and the Law*. The male lead, Frank Mills, was also well known on both stage and screen.

Story and screenplay were by Stahl himself, very possibly with input from his wife, Frances Irene Reels, who would have writing credits on several of his later films; and there is, unusually for this period, a credit for Titles, given to the experienced title-writer Tom Bret. More conventionally for the time, there is no editing credit; Margaret Booth's later testimony suggests that Stahl, at least on his early films, did the editing largely himself, or had very close control of it (see her interview with Kevin Brownlow in *The Parade's Gone By*).

That *Wives of Men* enjoyed commercial success is attested by posters which cited its six-month run at the Casino Theater, New York, as well as by financially-orientated material in issues of *Motion Picture News* in late 1918, reporting its overseas rights being sold. A compelling double-page advertisement (*MPN,* 28 September 1918, 1976–1977) features two stills from the film, and a view of Loew's theatre amid busy night-time streets, headed by the motto "The Proof of the Pudding is in

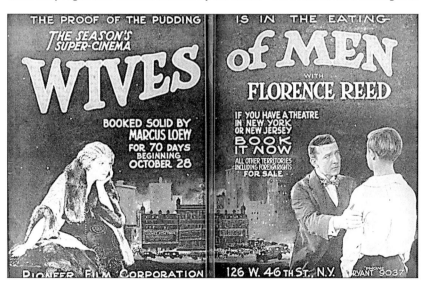

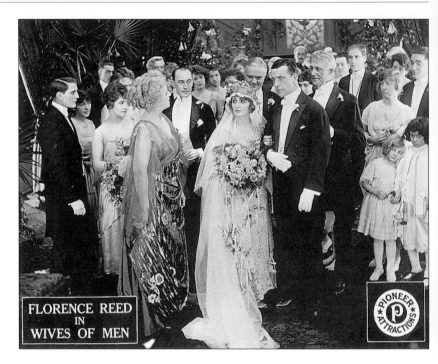

FLORENCE REED
IN
WIVES OF MEN

the Eating". Florence Reed is, of course, prominently named, but there is no mention of Stahl.

Reviews. Predictably, Florence Reed's performance and appearance were given priority in the reviews as well. The *New York Tribune* reviewer rhapsodised: "one would be entertained if he merely looked at Miss Reed. She is the epitome of elegance in dress – the last word in grooming. She always reminds one of a fine thoroughbred, eager to get away." Some reviewers went beyond praise of Reed and other cast members to comment on Stahl's work in this first film to be credited to him. Hazel Simpson Naylor in *Motion Picture Magazine* (December 1918, 78–79) wrote that the story "has been told with the power of conflicting motives under the very able direction of John M. Stahl". While praising the film for its dramatic force, the *New York Tribune*'s critic was the first of a number, over the years, to find Stahl's films too long and slow-paced: "So well produced and so beautifully acted that it might have been done in one less reel.... The ending is effective, but it would be much more so, if it were not so long deferred. The explanations seem at times interminable" (27 August 1918, 7). As against this, Walter Hill in his *MPW* review identified in positive terms a trait that Stahl would develop throughout his long career: "Director Stahl deserves commendation for his skilful work, and his tendency to 'long shots' with just enough 'close-ups' to deliver suspense and terseness in the dramatic progress of the story".◆

Suspicion

November 1918. 6 reels. Presumed Lost.
D: John M. Stahl* **P**: M.H. Hoffman, **Sc**: Thomas Bedding.
PC: M.H. Hoffman Co. **Dist**: State Rights; M.H. Hoffman Co.
Cast: Grace Davison (Madelyn Forrest), Warren Cook (Dr Allen Forrest), Wilmuth Merkyl (Leonard White), Mathilde Brundage (Mrs Pennington), Alma Dore (Olive Pennington), John O'Keefe (James Burns).

*Information on this film's credits, cinematography included, is very sparse. According to the *Wid's Daily* review of 1 December 1918, there was no screen credit for the director.

Shortly after Dr. Allen Forrest, who is involved with aircraft production for the United States government, invites his young nephew and business partner, Leonard White, to live in his home, idle gossips, the servants and friends of the family, begin to spread rumours about the doctor's pretty young wife Madelyn and the numerous situations in which they have close contact, such as Leonard giving her violin lessons. At first, Allen refuses to believe the stories, but gradually he becomes suspicious. Concurrently there are a number of moments in which German spies plot to steal aircraft plans held by the doctor. One night, the doctor hears a noise in Madelyn's room, and when he rushes in, thinking to find proof of her adultery, he is shot in the arm. The young man jumping from Madelyn's balcony resembles Leonard, and the doctor accuses his wife of infidelity. Madelyn is on the verge of killing herself when a secret service agent appears, reporting that the German spy who attempted to steal secret documents from the doctor's home the night before had been apprehended. Ashamed of himself for believing the local gossip, Allen apologises to his wife and nephew.

.H. Hoffman, important later in Stahl's career as one of the major figures at Tiffany Studios (later Tiffany-Stahl), announced *Suspicion*, "A Thrilling Tale of Today", as his first independent release, in *Motion Picture News* (27 July 1918, 643). The film was adapted, from his own story, by Thomas Bedding, who also wrote about films for *Moving Picture World;* he clearly took precedence over Stahl in the minds of advertisers and reviewers.

A piece reporting on Hoffman supervising the picture from hospital noted an aura of secrecy about the film, and even about its title. "The secret of this story has been well preserved and when the picture is seen it is believed that a surprise will be created" (*MPN*, 31 August 1918, 1407). This teasing was a feature of the publicity for Stahl's silent films, as well as for those of others, but Stahl's later history of

making frequent changes to working
titles also reflected his, Mayer's and
First National's care for finding effective
ones. As regards the teaser "A Thrilling
Tale of Today", the same piece also
noted that "War inspired the main
themes of 'Suspicion'. It is a wartime
drama , but there are said to be no battle
scenes." If *Wives of Men* showed Stahl
in step with socio-sexual material, and,
especially, the female audience, his
next two films demonstrated his use of
material currently in the news: here the
wartime spy plot, though he was hardly
alone in that, and then, in *The Woman
Under Oath,* the female juror question.
The same issue of *Exhibitors Herald and
Motography* (7 December 1918, 33–34)
that contained a short review of *Suspi-*

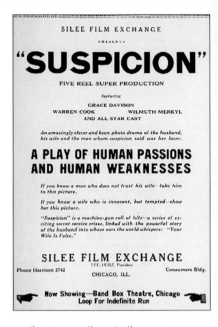

cion had reviews of four other films with narrative connections to the war.

Moving Picture World had information between August 1918 and July 1919 on the
selling of the film's rights. It claimed that it was "said to be running *Wives of Men* a
close race for booking honors and for business brought to the box office". On the
other hand, two contemporaneous films with "Suspicion" in the title, *Under Suspi-
cion* (1918) and *Shadows of Suspicion* (1919), eclipsed it in the trades and
newspapers. There do not appear to be any stills from the film in the publicity for it
in the trade magazines, and *SS* does not reproduce any.

An advertisement from the Silee Film Exchange (Chicago) promoted the film as
"An amazingly clever and keen photoplay of the husband, his wife and the man
suspicion said was her lover. A PLAY OF HUMAN PASSIONS AND HUMAN
WEAKNESS", and made much of the topic of suspicion: "If you know a man who
does not trust his wife – take him to this picture. If you know a wife who is innocent,
but tempted – take her to this picture" (*Exhibitors Herald and Motography,* 28 June
1919, 27). The very exhibitor-orientated review in *MPW* (16 November 1918, 762)
gives exhibitors such tips as Program and Advertising Phrases to use, e.g. "Grace
Davison, Warren Cook and Wilmuth Merkyl Starred in Strong Drama of Civilisation"
[Civilisation as opposed, presumably, to German barbarity] and "Thomas Bed-
ding's Screen Masterpiece Pictured in Gripping Episodes". This angle on the film
as essentially Bedding's, and the lack of a credit for Stahl in the Silee advertise-
ments, confirms that his reputation as a director was still in its early stages.

Reviews. A preview piece in the *Taylor Daily Press,*Taylor, Texas – "Grace Davison
is Starred in Thomas Bedding's Screen Success" (11 December 1919, 1) – clearly
recycled material put out by the producers, and thus gives a good sense of how
the film was presented to non-metropolitan audiences, stressing Davison's beauty,
highlighting the film's success in New York, emphasising the thought-provok-
ingness of the title, stressing the film's dramatic power, and promising a moral.

P.S. Harrison in *Motion Picture News* (18 January 1919, 447) was reviewing a film he had seen, it seems, twice. Though most of the review consisted of an outline of the plot, it was generally approving, in Harrison's typically highly moralistic way: "a clean picture and full of human sympathy. It is above the average program offering". Harrison notes that "bad points" in the last one and a half reels were criticised for "making the doctor appear weak minded", leading to re-editing. "As now re-edited the picture shows a vast improvement".

There were, however, less favourable reviews. *Variety* (8 November 1918, 46) mocked it as an old-fashioned melodramatic tearjerker. *Wid's Daily* (1 December 1918, 25) made two other specific criticisms. The first was that the "meller'"s narrative "started very well, but repetition of misunderstood situation made it funny. Had no plot to speak of; simply used misunderstood situation repeatedly until final clash when all was explained." The second was that the spy plot was handled ludicrously. A long mocking description culminated in this:

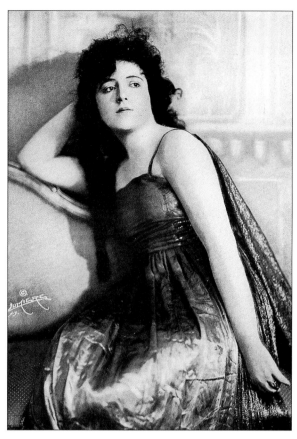

Grace Davison: a 1920 portrait.

> When Silk Hat Harry, the burglar, escapes from the home, a conveniently planted detective sees him, but instead of stopping him at once, the detective waits until the silk hat crook leaps into an auto. Then Mr. Detective, he leaps in too – he does – and they pull a little 10–20–30 [*sic*] 'movie' struggle of five years ago before our fashionably dressed spy is captured.

Because the film is lost, the accuracy of these rather damning accounts can't be tested. However, it should be noted that neither Harrison nor the *MPW* review (16 November 1918, 762) made anything like the same complaints. ◆

Her Code of Honor

6 April 1919. 5,800 ft. Held in BFI Archive.
D: John M. Stahl. **Sc**: Frances Irene Reels. **Ph**: Harry Fischbeck.
PC: Tribune Productions, Inc. **Dist**: United Picture Theatres of America, Inc.
Cast: Florence Reed (Helen/Alice), William Desmond (Eugene La Salle), Robert Frazer (Richard Bentham), Irving Cummings (Jacques), Alec B. Francis (Tom Davis), Marcelle Roussillon (Jane), George S. Stevens.

Tribune Productions of Manhattan was formed in August 1918, eight months before this film's release; it made three more films, including Stahl's next, with Florence Reed, before disappearing. The second of his three films with Reed, *Her Code of Honor* was also the first credit for his wife Frances Irene Reels, though she may have had some scripting input into his earlier films. A well-known critic of the day, Peter Milne, wrote in *Picture-Play Magazine* (August 1919, 277) that "its author Irene Reels – whoever Irene may be I haven't the slightest notion – has fashioned a scenario full of strong dramatic moments and high lights". This was also Harry Fischbeck's third film as Stahl's cinematographer. *MPN* (10 July 1919, 718) with its quoting of West Coast reviews, in an article about the film's equal popularity on both Coasts, reminds us that Stahl was still at this early date an East Coast director.

Released early in 1919, *Her Code of Honor* is the first of the narrative features directed by Stahl that is known to survive. Before that came the more fragmentary projects, *A Boy and the Law* and *The Lincoln Cycle*, and the two initial features that are presumed lost: *Wives of Men* and *Suspicion*. Reviews indicate that Stahl was already, with those two, operating in the way he meant to continue, with stories of love, primarily women's love, and its endurance in the face of severe obstacles. In the words of the title which opens and – slightly reworked – closes *Her Code of Honor*: "When the call of the heart is heard all else is forgotten".

The second image is a pictorial title locating us in *Paris 1895*, with on the left of the frame a sketch of the Eiffel Tower. How can one not think at once of the Lumière Brothers, and of that historic date and place for the start of cinema as we know it? Stahl had himself by that date reached the age of eight, and could well have seen some of the first Lumière programmes around that time in Europe or America.

Those two initial images are indeed prophetic. Old themes of romance, reworked in terms of the new medium.

Within the narrative of *Her Code of Honor*, Paris 1895 works neatly as a starting point. The main action will be set in Massachusetts in the year of the film's

production, 1918; the prelude allows for the birth in Paris of a female who, as she moves in her early twenties towards an American marriage, will be ready to unravel the mystery of her past. The dates fit, and so does the setting, for its bohemian associations: the mother is an unmarried American art student, the father a bourgeois Parisian husband and father who keeps both wife and mistress in ignorance of each others' existence.

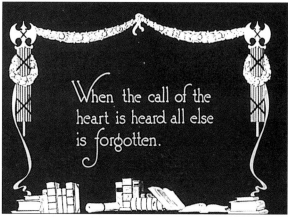

When the call of the heart is heard all else is forgotten.

The time and place for launching the narrative could thus have been set up fortuitously; if so, the coincidence has been artfully exploited. What makes the birth-of-cinema association so apt and satisfying is the confident foregrounding of the medium that Stahl demonstrates in this early film, as in many others, including the way in which he gives weight, at key moments early on, to static-camera wide shots which encompass the components of an 1895-set dramatic scene in the same manner in which the Lumières' shots of that same year encompassed an actuality scene.

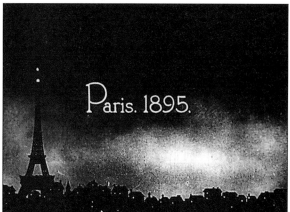

Paris. 1895.

When, a few minutes into the film, the youthful artist, Helen, played by Florence Reed, is abruptly alerted to the fact of the concealed domestic life of her lover, and is given his home address, she goes straight to that address to investigate. Stahl's camera observes from a distance, deep in the room, as she is shown in by the maid and moves forward from the back of the shot to talk to a small boy playing in the foreground. After a brief passage of editing in which a photograph of the boy's father is shown to us and to Helen – and is seen at once to be the same man (Irving Cummings) who visited her earlier – the mother enters, and the camera from this point reverts to a wide position, recording the encounter between the two women. Helen states that she must have come to the wrong address, and exits – ready, as we will soon find, to break dramatically with her lover. *

This brief meeting of the two women is handled in a way that will come to be recognised as characteristic of Stahl. The wife is shown only from behind, in this single static wide shot. Helen does not reveal anything to her, but leaves the house calmly after making her tactful excuse, and we learn nothing more about the wife. This strategy looks ahead to films like *Back Street* and *Only Yesterday*, where the mistress likewise refrains from confronting the wife, who remains a shadowy figure;

* Already an experienced actor, Cummings would soon begin a long career as a director: see the two references, pages 256 and 257, in the essay on *Oh, You Beautiful Doll*.

Tom's forlorn
proposal of
marriage to Helen.

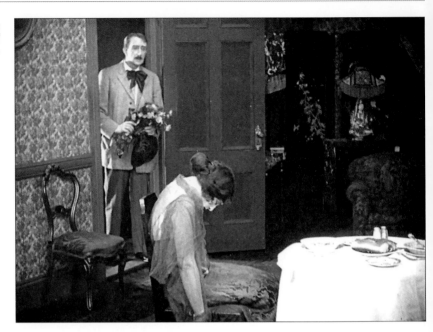

the husband is happy to keep her in ignorance of his other life, while the mistress stays the focus of the drama, following the call of the heart.

In *Her Code of Honor*, unlike in that pair of later films, the two-timing man is disposed of quickly. Helen goes back to her flat, and when he arrives complacently for another cosy dinner she challenges him, and he walks vindictively out of her life. But she does not, any more than the heroines of the later films, do anything so crude as to disabuse the wife, and she does stay loyal to the man's memory, even to this straw man's memory, as we will later learn from her deathbed message.

In the same Paris building as her lives Tom (Alec Francis), older than her, also American, also an artist, who has just been informed of a legacy and wants to bring her back to America as his wife. After the lover's departure, Tom comes to her with a bunch of flowers, intending a proposal, but finds her slumped despairingly at the table on which the abandoned dinner is still laid out. On this wide image, as strikingly composed and held as that of the two women in the smart Paris house, we fade out – and move forward to 1918.

Crucial information has been withheld. We don't yet know that Helen is pregnant, any more than, at this moment, Tom does: the full details of what-happens-next constitute a mystery that will only gradually be resolved. The fade-out wide image is unforgettably powerful, and our memory of it, and Tom's, are drawn upon later in the film when we return to it and belatedly wind forward. How much later this happens depends on the speed of projection, but it is at least half an hour, fully half of the film's running time. During this long interval we have struggled, along with the characters, to fill in the gaps in the history. On a first viewing of the film, I even wondered if some footage might have been lost in the gap between decades and continents, but not so. The struggle by the viewer to unravel histories and to work out identities and relationships is one of the recurring strategies, and pleasures, of Stahl's cinema.

The 1918 narrative, like the 1895 prologue, starts with written titles. "With the passing of the years Tom finds new happiness." He lives in a large house on Long Island, with "Alice, the daughter that his old love left behind". Mother and daughter are played by the same actress, Florence Reed: Tom's new happiness thus, on one level, feels like the positive fulfilment of the love that was frustrated in Paris. Here he is, living happily with the identical-looking woman, little attempt having been made to distinguish the two roles. This doubling of mother and daughter is found in a number of later melodramas, such as two British films directed by Victor Saville, *The Faithful Heart* (1932, with mother/daughter roles for Edna Best) and *Evergreen* (1934, Jessie Matthews), and, much later, Brian de Palma's *Obsession* (US 1976, Genevieve Bujold).[*] In all three films there are clear incestuous over-tones, most powerfully in *Obsession*, in which Cliff Robertson finds a delirious transgressive happiness with his own daughter. In *Her Code of Honor*, Alice, played by the unchanged Florence Reed, is the cause of Tom's intense new happiness, and grows up believing him to be her "Daddy"; but any anxiety around incest is here displaced into a new relationship, one which carries its own mystery, demanding in turn to be unravelled.

Alice in due course forms an attachment to a young man, Eugene (William Desmond). This triggers the opening of a letter which Helen has left for Tom, written on her deathbed soon after childbirth, accompanied by the order that he now loyally carries out: "When my baby grows up and finds the man that she really loves, give her this letter so that she may understand." The resulting conversation between Tom and Alice cues a return to the tableau image from Paris 1895, frozen as it then was without explanatory dialogue. It is now belatedly taken forward, playing out both the message of the letter and Tom's own memory: standing with his flowers over her slumped body, he pleads with her to "Come back with me to America". "I can't." "But why?" She slumps down even further, and her body language and the relentless static gaze of the camera convey the fact of her pregnancy, by Jacques, as decisively as words could have done. Only now does Tom, in 1918, feel free to reveal to Alice: "So you see I am not really your father".

The saved-up letter from the mother adds more details, centred on the enclosed gift of a particular ring: if you meet someone with a twin to this ring, you will know that they come from the same family background that has blighted my own life.

By the kind of coincidence familiar in melodrama, Alice's new lover turns out to possess the twin ring, and thus to come from the same Paris home, with the same presiding father, that Helen visited in 1895: he was surely the child that she, and we, met on that decisive occasion. Cue for despair and panic. Tom's line to Alice, "So you see I am not really your father", is soon followed by her line to Eugene, "You are my BROTHER!" She starts, with him, to make serious plans for a double suicide.

Just in time, however, we learn from Eugene that Jacques was in fact not his biological father, but adopted him when marrying his widowed mother. Eugene must have assumed that Alice knew this, and that she was naming the woman's

* On the Saville films, see Charles Barr, "Desperate Yearnings: Victor Saville and Gainsborough", in Pam Cook (ed) *Gainsborough Films* (London: Cassell, 1997).

first, not second, husband as her own father. Only when Alice calls down a curse on "Jacques!" does he realise the misunderstanding. So they are not blood relatives, and can marry after all, setting up a happy ending, with the blessing of Tom, who speaks a variant of the initial line: "When the call of the heart comes, all else is forgotten."

So the narrative has hinged on a succession of confusions and revelations. (1) In 1895 Helen learns that her fiancé, Jacques, is already married. (2) In 1918 Alice, at the age of 23, learns that her father is not Tom but Jacques. (3) Alice learns that her fiancé, Eugene, is evidently her half-brother, and tells him so. (4) Eugene learns that Alice believes him to be Jacques's son. (5) Alice learns that she was wrong in this belief.

When Helen entered Jacques's house, little Eugene identified him, in the photograph album, as "my Daddy", an identity we have no reason, until the very end, not to take fully on trust. Growing up, Alice has likewise accepted Tom as "Daddy", until told otherwise; but most audiences will have picked up the hints that he is not her father, in advance of the revelations of her mother's letter. That confusion over the father – not Tom but Jacques – helps to make the late surprise about Eugene's father – not Jacques but his predecessor – that much more plausible, in terms of the logic of melodrama.[*]

Secrets, revelations, questions of identity and parentage: these will remain familiar features of Stahl's melodramas, tied to the theme of "the call of the heart", the woman's heart especially. As will the formal element of the wide, held image, static or otherwise, left to the viewer to explore and consider. Taking these points briefly in succession:

"I am not your father": compare, most directly, the last words spoken by the man in *Only Yesterday*, "I'm your father", and the secret father-daughter relationship of *Letter of Introduction*, known to them and us but not to the world.

Her Code of Honor was the second of three successive films that Florence Reed, already a theatrical star, made for Stahl: preceded by the lost *Wives of Men*, and followed by the surviving *Woman Under Oath*. In that, rather than the artist of Paris 1895, she plays a "famous novelist", Grace Norton: we get no further details of her career or her work, any more than we get access to Helen's paintings, but it's as if the character's creativity informs the respective dramas, in which the woman has narrative agency through Helen's deathbed instructions to Tom, and through Grace's orchestration of the trial. Reed is certainly a key figure in the start of Stahl's film career, stronger and more sympathetic than any of the men around her, as Irene Dunne and Margaret Sullavan will be in the melodramas of the 1930s.[**]

In *The Woman Under Oath*, as in *Her Code of Honor*, we will be shown, early on, the image of a decisive moment, one which generates the jury trial and its

[*] It is never in fact stated that Jacques is the mother's second husband: Eugene could have been born out of wedlock. This would add to the tightness of the structure: the young lovers of 1918 would have illegitimacy in common as well as the confusion about their parentage, and Jacques would, ironically, have done the decent thing by the mother as, later, Tom did by Helen. But the late revelations come too rapidly, as it is, to allow space for this additional issue.

[**] Though she soon gave renewed priority to the stage, the screen would later exploit Reed's charisma by casting her in the spectacular character roles of Miss Havisham in Charles Dickens's *Great Expectations* (for cinema, 1934) and Mrs Danvers in Daphne du Maurier's *Rebecca* (for TV, 1948).

arguments. And again we will come back to the image later and be led to understand it better, differently. This is done in a remarkably sophisticated way for its time – for any time. From the start, Stahl shows himself ready to relish and play with the power of the encompassing image: what it reveals and what it may conceal. A craft with its roots in Paris 1895, and in the early film whose opening is set in that time and place.◆

Charles Barr

The Woman Under Oath

29 June 1919. 5,905 ft. Held in BFI Archive.
D: John M. Stahl. **P**: A.J. Bimberg. **Ph**: John K. Holbrook.
PC: Tribune Productions, Inc. **Dist**: United Picture Theatres of America, Inc.
Cast: Florence Reed (Grace Norton), Hugh Thompson (John Schuyler), Gareth Hughes (Jim O'Neill), David Powell (Edward Knox), Florida Kingsley (Mrs O'Neill), Mildred Cheshire (Helen), May McAvoy (Edith Norton), Harold Entwhistle (Judge), Thomas McGuire (District Attorney), Walter McEwen (Defence Attorney), Edward Brennan (Clerk of the Court), Frank De Camp (Jury Foreman), Edward Elkas, Jane Jennings (Jurors).

Stahl's next film was also a Tribune production, though by its release he had sold his interests in the company and joined the American Cinema Corporation to direct Mollie King in what was intended to be a series of films, though only two would be made. *The Woman Under Oath* was the last of Stahl's three films starring Florence Reed, which established him as a director of female stars in female-centred melodramas. There were no writing credits, so it is all but certain that Stahl wrote it himself with likely input from his wife, already credited on *Her Code of Honor*. The film's intense use of a topical controversy over the question of women jurors in New York is dramatised in an advertisement (*Wid's Daily*, 21 June 1919, 4087) which displays two newspaper extracts: "Women Jurors Bill Ready for Legislature. Measure Provides Exemption Privilege on Grounds of Sex – Brooklyn Sponsor Believes Intuition Will Make Females Better Arbiters than Men" (*New York Evening News*) and "WOMEN APPROVE JURY SERVICE. Club Presidents Approve Bill Providing for Elective System. Judges Support Move" (*New York Evening Mail*).

The opening intertitle asks a controversial question: "Is a woman temperamentally fitted for service on a jury in a criminal case?" At the time of the film's release, just a year before the 19th Amendment granted female suffrage in the US, women were legally barred from jury duty in most of the country. One of the loudly voiced objections to female jury service was the idea that women and men would be sequestered in the jury room late at night. That salacious scenario does indeed occur in this film (in fact, there is only one woman to eleven men in this fictional jury), which suggests Stahl was unafraid to skirt close to the source of the controversy. An earlier scene is set in a bar, with a poster on display protesting against another hotly debated Amendment of 1920: "America won the war under local option. Why foist prohibition on an unwilling people?"

A 1902 cartoon by Charles Dana Gibson (inventor of the Gibson Girl) poked fun at the idea of female jurors, with a line-up of twelve women on the jury bench

alternatively grouching and gasping at the evidence before them. The joke has become obscure now, but the humour was presumably to be found in the incongruous idea of femininity (of all varieties) in the traditionally male domain of a court of law. The storyline of *The Woman Under Oath* includes a little gag along the same lines, when a potential female juror answers sweetly "I do, if it's not too severe" to the question "Do you believe in capital punishment?" More importantly, though, as it progresses through all-male, all-female and gen-

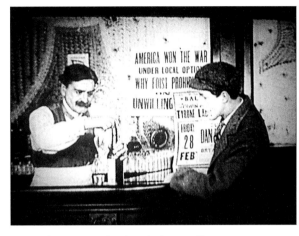

der-mixed environments, the film puts the case for women having their specific knowledge, as well as sympathy, to bring to bear on a trial. The case in question, the murder of one Edward Knox, cannot be solved entirely by men, their assumptions or their brute force.

An early scene: Jim (Gareth Hughes) orders a drink.

Reports in *Motion Picture News* emphasised the controversy surrounding the subject, with an early piece in April 1919, while the film was still being cut and titled, explaining:

> Because, it is said, of the nature of its title, early publication of which might lead to imitation owing to the timeliness and importance of its subject, no main title has yet been announced, but it is promised that the piece deals with a topic of new and vital public interest hitherto unutilized either on stage or screen.[*]

That report almost certainly refers to the film that would be named *The Woman Under Oath*. Another, while the film was nearly ready for release, expands on the question asked in the first intertitle, describing the subject as "of timely, public, and particularly feminine interest":

> Is a woman temperamentally fitted for service on a jury in a criminal case? Does femine [*sic*] intuition make females better arbiters than men? Will that intuition which women are conceded to possess in high degree prove a surer and safer guide than mere masculine logic? What would happen were a lone woman juror, holding out against the opinion of eleven mail [*sic*] co-jurors, to find herself bullied, brow-beaten, harrangued [*sic*, once again] and almost third-degreed?[**]

The Woman Under Oath answers all those questions, at least in relation to its small sample of one case. The film is set at Christmas-time, in what we can assume is 1918. It was released on 29 June 1919, when permission for women to serve on juries had been granted in only nine states, although it was by no means a regular occurrence even in those places. Momentum was gathering behind the idea, though. In 1920 and 1921, twelve more states would allow women, at least in theory,

[*] "United Secures Frank Crane to Direct Reed", *MPN*, 26 April 1919, 2646. The headline refers to *Her Game*, directed by Crane and released in October.

[**] "*Woman Under Oath* Florence Reed's Next", *MPN*, 17 May 1919, 3222.

The hand and the
gun.

on to juries. New York, where the film was made and is set, would not pass such a law until 1937.

Despite the fact that New York was lagging in this regard, the film's star, Florence Reed, was allowed into the courts to research her role, and the realism of the film was validated by a female court official, as was reported in *Motion Picture News*:

> Miss Reed, star of "The Woman Under Oath," is credited with having made a careful study of the juror procedure at first hand in the Tombs Court, New York City, her investigation and observation extending over a period of days. The effectiveness of this study was borne testimony to by Miss Helen McCormick, Assistant District Attorney of Kings County, New York, who made a special point of the excellence and trueness to life of the jury scene and who complimented Miss Reed on the technical and dramatic verity of her work in these court scenes.[*]

If the title card sets a topical theme for the film, the opening shot reveals much about its style and strategy. A gun is shown in a display case, and then lifted out and placed on top of the glass. There is here a strong suggestion, which is borne out by the ensuing storyline, that the film will offer two ways of looking at the same situation, and that even though the first seems transparent, the second perspective offers greater clarity. A hand reaches out to take the gun. We don't know it yet, but it is the hand of our hero, Jim O'Neill (played by Gareth Hughes). As his fingers curl around the gun, the shadow of a grating falls across his hand, putting him behind bars before a shot is fired. That is prophetic also.

In the opening sequence of the film, Jim will approach the home of a wealthy entrepreneur, Edward Knox (David Powell), who is preparing for his nuptials. Jim

[*] "United Picture Hangs on 'Mixed Jury'", *MPN*, 21 June 1919, 4187.

has vengeance in mind ("Getting married? He'll finish his wedding in hell!"), and indeed Knox has only minutes to live. However, although we see the lift attendant and switchboard operator in Knox's building react to the sound of a gunshot, and see Jim standing over Knox's dead body holding the gun, the murder is not shown. Jim will be arrested and charged with Knox's murder. Although a brutal "third-degree" interrogation scene, including the psychological trick of having a man pose as Knox in a doorway, breaks Jim's spirit, he maintains his innocence.

Knox's apartment building is populated by men, including his valet, lift attendant, and the switchboard operator. The home of Grace, a novelist and the film's female protagonist, is by contrast full of women: herself, her sick sister Edith (May McAvoy) and her "faithful housekeeper". Grace is first seen on her way home, outside the apartment building as Jim is led away. She shoots him a sympathetic glance – she will send more of these his way during the subsequent trial scenes, which establish an emotional relationship between the two characters even though they never directly interact. The true meaning of Grace's glances, and her sympathy toward Jim, will only become apparent with the film's final plot revelation.

Grace's return home, her discovery of a letter on Edith's dresser and her discussion with a doctor attending her sister, are intercut with Jim's interrogation. This begins Stahl's second strategy for establishing a connection between Grace and Jim. For example, they read the same newspaper stories, but in different locations, and sometimes their performances mirror each other's. The most striking moment in the interrogation scene is when Jim screams, facing the camera directly, and a brief insert of a tighter shot framing his face emphasises his anguish. A similar shot pattern, though undertaken at greater leisure, captures the look of horror on Grace's face when she later reads a letter summoning her to jury duty. When she is selected, she will be the first woman in the state to perform jury service. A journalist phones his newsroom saying: "A woman juror on the O'Neill case! It's a scoop!", and it is reported on the page as "A further sensational development".

This is the crux of the plot. Grace will be sworn in as the sole female juror at Jim's murder trial (accompanied by her friend John Schuyler, played by Hugh Thompson, who has a clear romantic interest in her); when the jury deliberates, she will be the only one to return a "not guilty" vote. It seems initially that she is simply a precursor of Henry Fonda's independent-minded Juror No 8 in *12 Angry Men* (Sidney Lumet, 1957), especially when she says "Surely you can't convict this boy on purely circumstantial evidence!", but it soon becomes more complicated. The pressure mounts on Grace as her peers resent her delaying their return home on Christmas Eve, and the staging of the group neatly reflects the earlier interrogation scene, another form of group bullying. Grace is indeed being "harangued and third-degreed". The arrival of a note telling Grace that Edith has died breaks the deadlock, as she tells the jury a different story, one beginning at a masked ball: "It was then that Edith Norton first met Edward Knox." This alternative story about Knox now unfolds in flashback, and at the climax, after Edward has toyed with Edith and left her pregnant and unmarried while he embarks on his society wedding, Grace reveals the reason she is sure of Jim's innocence: "So you see, it was I who killed him." Jim is acquitted, the jurors agree not to divulge Grace's guilt, and she and John have a romantic happy ending.

The truth of the case rests entirely in facts that are perceived by women, rather than the men (such as the lift attendant and switchboard operator, as well as the police), who are convinced of Jim's guilt from the outset. In an outburst during the trial, Jim's fiancée Helen (Mildred Cheshire) reveals that Edward sexually assaulted her at the shirtwaist factory where she worked.[*] This reveals a damning facet of Edward's character, but unfortunately gives Jim a motive. It was indeed for this reason that he entered Edward's apartment with a gun that day. When the jurors finally reach their Not Guilty decision, and refuse to turn Grace in, it is because "That fellow Knox was pretty rotten", a verdict, of course, that is reached following the testimony by both Helen and Grace. Viewed in the 21st century, the argument of the film is progressive, but publicity surrounding the film in 1919 did its best to appeal to conservative audiences. The previously quoted item in *Motion Picture News* just ahead of its release promised that the film "favors neither the advocates nor the opponents of women's legislation and aims only to present a vivid and intense drama that shall stand out as one of the strongest examples of screen art."[**]

The Woman Under Oath is not so neutral on the question of female jury service as that quote implies. Grace's belief in Jim's innocence is due not to her feminine sympathy or intuition (although her behaviour in court encourages that assumption) nor to her superior reasoning abilities, but to the fact of her own guilt. This way, the film may seem to undermine the theory that women are mentally just as suitable for jury service as are men. Instead, however, it argues that men and women are both equal in the judicial system – that if either gender can take the role of victim, witness, suspect or culprit, then they can both perform jury duty too. It also creates a realm of women's knowledge unperceived by men – facts and events that only one gender is aware of, and that may be vital in court.

Lone woman (Florence Reed) under pressure from male jurors.

The Woman Under Oath is a taut, humane and clever thriller, pre-empting the "final-twist" narrative of later acclaimed films such as *Diabolique* (Henri-Georges Clouzot, 1955) or *The Sixth Sense* (M. Night Shyamalan, 1999), not to mention *Twelve Angry Men*. In the context of Stahl's later career, the combination of a trial scene and a story told in flashback recalls 1945's *Leave Her to Heaven* [†], but Grace's story is also a forerunner of the speculative "flashback" at the conclusion of Stahl's 1932 melodrama *Back Street*. Grace's flashback shows what really did happen, instead of, as in *Back Street*, what might have transpired in a happier world.

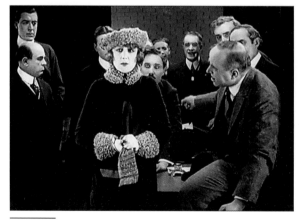

In 1929 Stahl produced for Tiffany-Stahl, but did not direct, a sound film with a

* The boxes of shirtwaists, seen in a brief love scene between Jim and Helen, is another suggestion of Knox's villainy: aligning him historically with the notoriously neglectful managers of the Triangle Shirtwaist Company, whose decision to lock the workers in the building led to a massive loss of life, mostly immigrant workers, when a fire broke out in 1911.
** "United Picture Hangs on 'Mixed Jury'", *MPN*, 21 June 1919, 4187.
† The jury in *Leave Her to Heaven*'s trial scene is gender-mixed..

very similar scenario. *Painted Faces* (Albert Rogell) is a jury-room drama with Joe E. Brown playing Beppo, a clown who becomes the only juror holding out for an acquittal in the trial following a murder backstage at a circus. Just as in *The Woman Under Oath*, the story leading up to the murder is revealed in flashback, including Beppo's confession of guilt. Beppo, like Grace, then offers to take the place of the innocent man on the stand, but the head juror implores the group to keep his guilt secret. The earlier film is clearly superior, not least because of its topicality – although *Painted Faces*, a decade later, also features a mixed jury. Stahl's own films are renowned for sympathetic, if flawed, female protagonists, and for featuring characters that stick to their convictions. *The Woman Under Oath* is a particularly elegant example, led by a heartfelt, if restrained, performance from Reed (an acclaimed film and stage star of the day) and a more passionate one from Hughes (best known for the melodrama *Sentimental Tommy*, which is now lost). Both their characters remain steadfast in their positions despite the bullying interference of the authorities and their peers. This film is unusual, though, in that it in some way politicises Stahl's respect for his female characters. Despite being proved a murderer in the long run, Grace is shown to be a compassionate and intelligent woman, with the strength of character to debate with her fellow jurors. The answer to the film's opening question is clearly "yes".

The initial review in *Exhibitors Herald* was scathing, summarising it as: "comically serious, amateurish and altogether disappointing. Full of inconsistencies, artificial, unconvincing, it scarcely deserves the consideration of the exhibitor who wishes to give his patrons the best that may be secured. Florence Reed is the featured player, but her work does not redeem the picture."[*] However, testimony from exhibitors in later issues of the magazine suggested that it in fact played very well with audiences, and the following year it was featuring heavily in trade ads announcing Stahl's forthcoming production. Certainly the film's parallel perspectives on the same events, its suspenseful cross-cutting and feminist thrust make it a fascinating and very successful film 100 years later. Although Stahl is best remembered as a master of melodrama, his successful marshalling of thriller technique in this film deserves to be more widely seen.◆

Pamela Hutchinson

[*] "Digest of Pictures of the Week", *Exhibitors Herald*, 19 July 1919, 54.

Women Men Forget

21 March 1920. 4,921 ft. Presumed Lost.
D: John M. Stahl. **P**: J.A. Berst. **Sc**: Paul Bern, from **a** story by Elaine Sterne Carrington.
Ph: John K. Holbrook.
PC: American Cinema Corp. **Dist**: United Picture Theatres of America, Inc.
Cast: Mollie King (Mary Graham), Edward Langford (Robert Graham), Frank Mills (James Livingston), Jane Jennings (his aunt), Lucy Fox (Helen).

When Mary Graham is visited by her old school chum Helen, Mary's husband Robert becomes infatuated with his wife's guest and soon openly avows his love for her. Mary is powerless to stop the affair and confides to an old friend, James Livingston, the expected arrival of her and Robert's child. Concealing her pregnancy from her husband, Mary goes to the country, where her son is born. Meanwhile, Livingston, learning that Robert is intent on filing for divorce, demands that the unfaithful husband redeem some promissory notes which he, Livingston, holds. Robert is unable to pay and Helen threatens to leave him. Mary offers to sell her jewels to help her husband, forcing Robert to realise her true worth. He begs his wife's forgiveness, and they are joyfully united as Mary proudly introduces her husband to his child.

Early in his career Stahl moved from one short-lived production company to another: in this case, to the American Cinema Corporation, which was only active 1919–1921. Information about production conditions at these companies, and about Stahl's dealings with them, is understandably hard to come by. Distribution in this case was affected by the closure of the company, United Picture Theatres of America, resulting in the film not being shown in many territories, as an advertisement by States Rights for its reissue makes clear (*Wid's Daily*, 23 February 1920, 102).

The star, Mollie King, originally a musical comedy star in vaudeville and on Broadway, made sixteen films between 1916 and 1924. She was variously advertised as "New York's Reigning Beauty" and as "The Most Beautiful Girl on the Stage". An advertisement in *Wid's Daily* (11 May 1919, 13) noted that she will be "appearing in Six Special Productions, Direction of John M. Stahl." In fact only two were made, and they were released in the wrong order: for more on this, see below, in the entry on *Suspicious Wives*.

Elaine Sterne (Carrington), writer of *Women Men Forget*, was an immensely prolific author across different modes, including, in the 1930s, pioneer radio soap operas. The scenario was developed from her story by Paul Bern in his second assignment for Stahl, following his script for *Suspicious Wives*, and the probability (see Richard

Koszarski's essay in this book on *The Lincoln Cycle*) of his having worked on *The Son of Democracy* after Chapin's death. Frank Mills, acting with Stahl for the second time, played not quite the good husband role in which he was apparently happily typecast (see Dorothy Scott, "Mrs Mills' Many Husbands", *Photoplay Magazine* September 1918, 97), but that of the wife's faithful friend, as recurrent a figure in these early films as the philandering false friend.

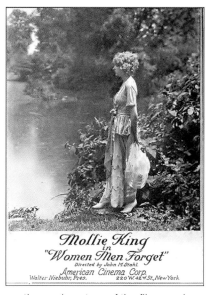

A series of small but intriguing adverts in *Wid's Daily* centres on a succession of introductory words, such as "Education", and "Cynicism". The one beginning "Laughter" emphasises the mixed dramatic-comic nature of the film, as does "Reciprocity": "a bit of Life and Love and Laughter Directed by John M. Stahl." This must be among the first instances where "serio-comic" aspects of the director's work are noted.

Reviews: As might be expected, Mollie King's return to the screen and the fineness of her gowns occupied reviewers, but other points were raised, notably moral ones. In the opinon of the *MPW* reviewer, "It is doubtful if the average head of a family will take kindly to the rather exaggerated example of marital infelicity which the picture presents". The approving *Wid's Daily* review (14 March 1920, 30) noted of the film's apparently modest resources: "The picture is an example of what can be done with a very good story, a small cast, and at little but no stinting expense". It also noted that "The manner in which he [Stahl] gets over the fact that Mary is to become a mother by using the dog and the kittens is a fine touch" – though, with the film lost, it is frustrating not to know how exactly he did this. The *Washington Herald*, (Washington DC, 10 May 1920, 14) called it "an especially convincing study of domestic difficulties and misinterpreted motives". The *Washington Times* (Washington DC, 8 May 1920, 8) commended the film particularly for being "out of the ordinary ... presenting as it does numberless outdoor scenes which were photographed in picturesque locations", adding also approval of its elaborate interior settings.◆

The Woman in His House

August 1920. 6 reels. Presumed Lost.
D: John M. Stahl. **P:** Louis B. Mayer. **Sc:** Madge Tyrone, from a story by Frances Irene Reels.
Ph: Pliny Goodfriend.
PC: Chaplin-Mayer Pictures Co. **Dist:** First National Exhibitors Circuit.
Cast: Mildred Harris Chaplin (Hilda), Ramsey Wallace (Dr Philip Emerson), Thomas Holding (Peter Marvin), George Fisher (Robert Livingston), Gareth Hughes (Sigurd), Richard Headrick (Philip Emerson, Jr.), Winter Hall (Andrew Martin, Hilda's Father), Catherine Van Buren (Emerson's assistant), Bob Walker (Associate doctor).

Hilda, a Norwegian fisherman's daughter, finds herself in New York, where she and Philip Emerson, a noted physician, fall in love and marry, but soon the doctor becomes increasingly involved in his medical work, neglecting Hilda and their young son, Philip Jr. The doctor then leaves her in the company of his friends, kind Peter and philandering Robert. When an epidemic of infantile paralysis breaks out, taking even more of the doctor's time, his own son contracts the disease, and by all appearances dies from it. Hilda is heartbroken, and collapses. However, the doctor discovers that the child is in fact alive, although paralysed. Believing that Hilda would be even more disturbed knowing that, he hides the boy away in his laboratory, working to try to cure him, but in vain. Finally, the doctor's friend Peter brings Hilda to the boy, and she discovers the truth. Her presence and the miracle of motherly love succeeds where science has failed – the little boy is cured, and walks toward his mother.

Chaplin-Mayer Pictures was a production company formed for films produced by Mayer starring Mildred Harris Chaplin, ex-wife of Charles Chaplin. The actress retained her husband's name for a while after their divorce (April 1920, before the film's release) and she and Mayer used this to gain extra publicity. *The Woman in His House* marked two major landmarks for Stahl: first, his translation from the East Coast to the West, and second, the beginning of his association with Louis B. Mayer, with whom he made his next ten films 1921–1926, before moving to Mayer's new company Metro-Goldwyn-Mayer, where he made three more films in 1926–1927.

When Mayer went into Hollywood production, he secured contracts with Mildred Harris Chaplin and Anita Stewart. *MPW* (3 January 1920, 94), reporting Stahl's arrival in Los Angeles, noted that Stahl was under a long-term contract "which provides for his directing either Anita Stewart or Mildred Harris Chaplin in pictures for First National Exhibitors circuit distribution". Stahl's first Hollywood film was the third of five Chaplin-Mayer productions; he did not direct any of the others. The original story for this one was by Stahl's wife, Frances Irene Reels, and the screen

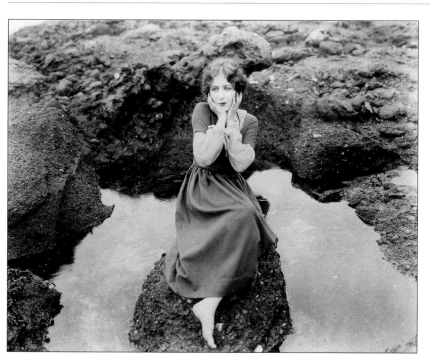

Mildred Harris
Chaplin – playing
a fisherman's
daughter.

adaptation of it by Madge Tyrone, who worked on Stahl's films in other positions – twice as editor, and once as titles writer.

Mildred Harris would not move successfully into talking pictures, but her silent career, first as a child star, then as a lead player, was impressive enough to stand without her famous ex-husband's name, though she may initially have profited from it. Stahl's highly affirmative comments on her acting go beyond dutiful publicity, and may also have been calculated to enhance his reputation as a director who understood women:

> Miss Harris has a role that intensifies her emotionalism as perhaps no other has done. Working with her was an increasing satisfaction, as each day's progress showed how extraordinarily fit for this particular role she was. Where many other actresses as young as she is would have had to assimilate an emotion, she reached into her own soul and reproduced what she found there. Some of her most exquisite moods are those in which mother love is theme…[*]

What the context makes clear is Stahl's claim that the actress's grief at the death of her own and Chaplin's three-day-old son played into Hilda's grief in the narrative. Among a strong supporting cast are three whom Stahl uses elsewhere: as Hilda's father, veteran New Zealand-born actor Winter Hall, seen again in *Husbands and Lovers*, and in *The Lost Zeppelin* at Tiffany-Stahl; as Sigurd, the Welsh actor, Gareth Hughes, memorable previously as the falsely accused Jim in *The Woman Under Oath*; and as the Emersons' apparently doomed child, the celebrated child actor, Richard Headrick. Stahl would use this fledgling star, who attracted great publicity, again in *The Child Thou Gavest Me* and *The Song of Life*.

[*] Stahl quoted in *MPW*, 25 December 1920, 1001.

Mayer's and First National's flair for publicity was evident in the film's advertising campaign. "News of the West Coast", by A.H. Giebler, described an elaborate preview at a Los Angeles hotel for local press and trade journalists, attended by "several hundred motion picture folks" including stars (*MPN*, 6 January 1921, 501). The December 1920 issue of *Photoplay* contained a novelisation of the film by Luliette Bryant. Richard Headrick was featured on the cover of *Camera!* (12 February 1921). The film was prominently advertised in the trades and newspapers; one instance in *MPN* (22 January 1921, 816) used the term "women's picture", a term with which, for better or worse, Stahl was becoming increasingly identified, and called this one "The Greatest Women's Picture Ever Filmed".

Reviews: These were generally positive, most of them stressing the film's emotionality and the mother-love theme. *Wid's Daily* had the headline "Very strong and sympathetic production dealing mainly with mother love – will get them crying and they'll like it" (15 August 1920, 17). *MPW* (4 September 1920, 109) had a "Concensus of Trade Review"' in which all of *MPW, MPN, Exhibitors Trade Review* and *Wid's* are favourable. *Exhibitors Herald* (18 September 1920, 86), after praising Harris Chaplin, says "From a technical standpoint it is far above the average of the standards required today and the direction of John M. Stahl is most praiseworthy". The *Washington Herald* (10 October 1920, 24) in "A Great Storm" addressed an audience who might not have thought about the differences between stage drama and film and automatically think stage drama superior. The piece is particularly interesting in referring precisely to visual effects."The marine scenes and atmosphere in 'The Woman in His House' are conceded to be among the finest yet developed in motion pictures". The article ends by praising the wild coastal exteriors of the film. It is worth quoting this at length since it demonstrates Stahl's films becoming bigger productions with more exterior shooting, and is informative not only about the visuals seen on screen but also about their manufacture.

> While some were taken in rough sea off the California coast, some of the"stormiest" were produced in the placid waters of Balboa's inland sea by the use of hose, wind machines, searchlights, sunlight arcs and artificial lightning; full control of the elements was placed in the hands of John Stahl the director. Practically every person living within a radius of many miles of Balboa saw these scenes taken. Nearly all the male population of the town, including the fire department, was on the company payroll for several days and nights while the scenes were being shot. Cameras were mounted on floats and anchored astern the magnificent yacht 'Comfort' for the close-ups. High-powered motor machines were turned on and water deluged the yacht and bay for yards about. ◆

Sowing the Wind

April 1921. 7191 ft. Held in George Eastman House.
D: John M. Stahl. **P**: Louis B. Mayer, Anita Stewart. **Sc**: Franklin Hall, from the play [1893] by Sydney Grundy. **Ph**: René Guissart.
PC: Anita Stewart Productions, Louis B. Mayer Productions. **Dist**: Associated First National Pictures.
Cast: Anita Stewart (Rosamond Athelstane), James Morrison (Ned Brabazon), Myrtle Stedman (Baby Brabant), Ralph Lewis (Brabazon), William V. Mong (Watkins), Josef Swickard (Petworth), Ben Deely (Cursitor) + Harry Northrup, Margaret Landis, William Clifford.

As the production credits, shared between the film's star, Anita Stewart, and Mayer, declare, Anita Stewart was a big name with a controlling interest in her films. A major advertising campaign centred on dramatic stills of the star and on promises of highly-wrought melodrama, "From Love's first kiss to Hell's Abyss" (*MPN*, 5 February 1921, 543). By now portraits of a still young but maturely distinguished Stahl were part of the publicity arsenal. Debate about *Sowing the Wind*'s sensational aspects was fanned by its endorsements from a Methodist pastor as well as by "unqualified approval of clergymen and former army chaplain" (*MPN*, 23 April 1921). A rather prurient article about screen nudity, "The Great Undraped", in *Photoplay Journal* (November 1920, 10–13, 53), equally fuelled publicity with its reporting of an on-set dispute between Stewart and Stahl over the presence of nudes on the set, a "vulgarity" condemned by the actress who refused to continue work till the set was cleared, despite the director's reported appeals to "art" and "sex".

Sowing the Wind, pre-released in April 1921, and more fully released in May, was the second film Stahl directed for Mayer. Made with Mayer's biggest star at the time, Anita Stewart, it was based on a play by Sydney Grundy which dates from the 1890s. While the film was not extensively reviewed in the popular press – it was not discussed in either the *New York Times* or the *Los Angeles Times* – *Variety* was at least polite, characterising it as a "sex drama" that was handled "with delicacy and good taste and gorgeously mounted" (24 June 1921, 36).

The story begins with Baby Brabant (Myrtle Stedman), a notorious demimondaine and junior partner in the Palace of Fortune gambling establishment run by Petworth (Josef Swickard). She has sent her daughter Rosamund (Anita Stewart) to boarding school to be raised, keeping her in ignorance of the fact that she is her mother. When Rosamund shows up unexpectedly at the Palace of Fortune, Baby warns Petworth not to tell the girl that she is her mother. When Rosamund finally realises the kind of work that Baby does, she runs away. In despair, Baby turns on Petworth and the men in the establishment and is fired.

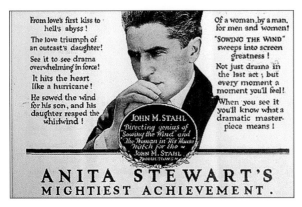

ANITA STEWART'S
MIGHTIEST ACHIEVEMENT.

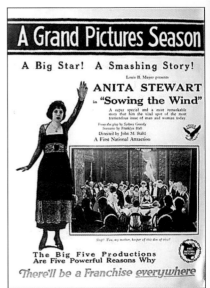

Above: Moving Picture World, 5 February 1921, 643.

Right: The film linked to Mayer's wider marketing campaign.

Sometime later, Baby, now an old hag, walks the streets of Chinatown and frequents an opium den. Meanwhile Rosamund has become a success on Broadway and attracted the attentions of Ned (James Morrison), the adopted son of the wealthy Brabazon (Ralph Lewis). Petworth informs Rosamund that Baby is sick and needs her. Ned watches, in alarm, as Rosamond leaves the theatre in the company of the notorious gambler. Petworth takes Rosamund, reluctant and nervous, to an apothecary's shop in Chinatown. At a signal from Petworth, the owner presses a button that reveals a secret passageway to a hidden cellar where Baby, among other denizens of an opium parlour, is revealed. Rosamund is touched and tries to make contact with her mother, who denies the relationship and angrily turns on Petworth for bringing Rosamund to the den. She attempts to choke the man, but falls down dead herself.

Ned's father Brabazon and his friend Watkins come to New York city from his country home, determined to break up the young man's romance with Rosamund. His father tells his son that marriage is impossible, that his own marriage to an actress lasted little more than a year. He advises Ned to have a fling with the girl if it pleases him, but no more than this. Ned is shocked that his father would ask him to make a plaything of the woman he loves. Meanwhile, Petworth sends a note demanding that Rosamund come to speak with him at the Palace of Fortune. When Ned tries to find her at the theatre, to discuss his argument with his father, he is again dismayed, finding that she has gone to the notorious gambling establishment. Meanwhile, Rosamund talks with Petworth who demands that she come frequently, mix with the crowd, and make the fame and fortune of the club. When she refuses, he says that he will reveal to everyone that Baby Brabant was her mother. Ned arrives and fights with a man who is gossiping about his girlfriend. When she appears with the club owner, Ned asks her about the gossip and she calmly explains in front of the crowd that Baby Brabant was her mother.

With Petworth's blackmail threat effectively derailed, Ned's father, Brabazon, becomes the chief antagonist. He asks Rosamund to give up Ned, offers her money to do so. She refuses the father's request. But in a later scene with Ned, she refuses his proposal of marriage, adding that if, after a month of waiting, he can not bear to be without her she will become his mistress. After a month's wait, Ned leaves

his father's house to go to Rosamund. Brabazon is sanguine, convinced that his son will confine himself to having an affair but Watkins, concerned about the situation, reveals that Brabazon's own brief marriage to the actress Helen Grey led to the birth of a child whom Brabazon never knew. At the thought of this possibility Brabazon decides to follow his son to New York. The next morning, Brabazon confronts Rosamund and insultingly brings up her relationship to Baby Brabant. In the course of their quarrel it is revealed that Baby Brabant's real name was Helen Grey, and that Rosamund is, in fact, Brabazon's daughter. Ned enters with a pastor and the couple receive his father's blessing to marry.

Several aspects of the film associate it with old-fashioned melodrama and what would have been considered naïve taste by the industry trade press. The plot is both highly convoluted and highly stereotyped. It includes two recognition scenes, both of which are implausibly delayed. The first is the death scene in the opium den at the end of the second act, when Rosamund finally realises that the woman who has been supporting her at a distance for years is her mother. The second occurs at the denouement, when Brabazon realises that his estranged wife Helen Grey was the notorious Baby Brabant and that Rosamund is his daughter. The film also includes a scene, familiar from no less a warhorse than *La Dame aux Camélias,* of the father asking the heroine to give up his son (in this case his adopted son) for his own good.

The film virtually abandons any attempt at plausible character motivation and psychology in order to orchestrate big dramatic climaxes. For example, when Rosamund initially arrives at the Palace of Fortune nightclub, one might expect that even a girl raised in a convent school would be able to figure out that it was a place of bad repute, and that Baby Brabant made her living by dubious means. But Rosamund lingers in ignorance and insists on leaving Baby's quarters, against advice. This allows Stahl to set up a racy contrast between mother and daughter within the setting of the nightclub, one that is driven home by the staging. Having put aside her school clothes for one of Baby Brabant's dresses, Rosamund comes down the wide central staircase that dominates the set just as her mother, unaware of her presence, is unveiling a painting of a naked woman to a group of male admirers gathered around. As a crowd of men toast Baby, Rosamund is visible on the stairway at the rear, flanked by her own admirers. The doubling of the two women within the mise en scene, seconded by the use of the portrait, emphatically underlines the threat facing the heroine as well as playing up the moral contrast between mother and daughter.

In addition to its sensationalism, *Sowing the Wind* is highly moralised. After Rosamund runs away, Baby Brabant cannot keep up her efforts to entertain the men in the club, and hysterically denounces them. She is fired that night, and walks down the central stair and stands in front of the double front doors, head bowed. An image of a young girl in a white dress with flowers is superimposed on the left side of the frame. Baby reaches out to her, followed by a narrative title: "Poor Baby Brabant, you've had beauty and youth and the world at your feet, and you've chosen – ." Here the superimposed image on the left points to the right, where another superimposed image appears, this one clearly Baby Brabant, in a black dress with pearls, holding up a drink. The girl in the white dress girl disappears, leaving the

other. The titles resume: " – the primrose path." The superimposed image of Baby in the black dress disappears, as do the wall and doors of the club. We see an old woman in the rain, motioning toward Baby in the foreground to join her. The titles resume: "Now come with me into – the future!" The old woman presses her hands to her breast and then extends her arms out to Baby as she advances. The titles resume: "*As ye sow [...]so shall ye reap*." The old woman walks forward until she reaches Baby, whereupon they dissolve into a single image, of an old woman, walking away from the camera in the rain. Superimposed over this image are the words, in much larger type than is usual for titles:

Sowing the Wind!

Reaping the Whirlwind!

The title disappears and the image fades to black.

The scene is remarkable for the spectacular and visceral way in which it represents Baby's physical and moral decline. The superimpositions, at first apparently Baby's subjective impression (at least she reaches out to the first one), take on a life of their own, approaching her and eventually swallowing up the space of the night club and even her own presence. While trite in terms of the moral they express, the titles are also used in an extremely interesting way – identifying the meaning of the superimpositions ("the primrose path"), speaking for them ("now come with me") and growing in size, perhaps to mimic the effect of the old woman approaching the camera, when they enunciate the film's title. At this point the titles no longer seem to be addressed to the character, who has dissolved into the symbolic representation of her decline, but to the spectator.

Myrtle Stedman,
Anita Stewart,
Josef Swickar.

The treatment of the first recognition scene is similarly sensationalistic and played for maximum effect. When Petworth takes Rosamund to the opium den, they discover Baby Brabant sitting on a bed and holding a pillow as if it were a baby. Aged and infirm, she appears to be doped up and speaks to the pillow: "If only once I could have heard you call me – 'mother'." Moved, Rosamund asks Petworth what is going on and he replies: "You thought yourself too good for my house! Now look and see – just who and what you are! That woman is – your mother!" Rosamund expresses shock, then tenderness as she calls out and tries to embrace her mother. When Baby Brabant backs away, Rosamund begins to cry. Baby slowly turns away from Rosamund and very slowly looks down at the pillow, then drops it. After indicating mental weakness and distress, Baby Brabant stares at the impassive Petworth. Then, trying to protect her daughter, she wildly denies being Rosamund's mother, accuses Petworth of lying and, assuming a hunched, almost ape-like posture, she threatens him. The stress is too much for her and she falls, dead. Rosamund kneels in long shot behind Baby's corpse. Cut to a close up of the pillow, then back to the long shot of the two women. Rosamund speaks: "You wanted your baby to call you 'Mother'." She caresses her mother's hair, then realising she is dead, she pulls back, rises.

Many elements contribute to the heightening of this scene which, while certainly far fetched and perhaps somewhat risible in description, I actually find quite compelling. First, the dimly lit and seedy opium den is a fantastically incongruous place for Rosamund to discover her mother. Second, Myrtle Stedman's performance as Baby Brabant is quite carefully calibrated: beginning in a slow-moving, drug-induced daze, she shifts into a different register, moving more quickly and gesturing more and more vividly as she tries to deny Petworth and take revenge on him. This is abruptly cut short by her death and Rosamund's gruesome realisation that she has been caressing a corpse.

Sowing the Wind is the work of a young and fairly inexperienced director, and there are points where the pacing falters and the plotting becomes obscure. Nonetheless, it is a well mounted production, and individual scenes, especially the opening in the Palace of Fortune and the first recognition scene, show great dramatic sense and visual flair. The film is typical of old-fashioned stage melodrama in its explicit didacticism and stark symbolic contrasts, and is sensationally overstated in its use of performance, decor and staging to drive home the emotional resonance of narrative conflict. ◆

Lea Jacobs

The Child Thou Gavest Me

August 1921. 6,091 ft. Held by Time-Warner (5,922 ft.)
D: John M. Stahl. **P:** Stahl, Louis B. Mayer. **Sc:** Chester Roberts, from a story by Perry N. Vekroff. **Ph:** Ernest G. Palmer. **Ed:** Madge Tyrone.
PC: Louis B. Mayer Productions. **Dist:** Associated First National Pictures.
Cast: Barbara Castleton (Norma Huntley), Adele Farrington (her mother), Winter Hall (her father), Lewis Stone (Edward Berkeley), William Desmond (Tom Marshall), Richard Headrick (Bobby), Mary Forbes (Governess).

Stahl's already established reputation as a female audience director was stressed in publicity: an advertisement in *MPN* (10 September 1921, 1307) asserted "How Women Love a Good Cry", and underlined Stahl's box-office powers. Reviews by now not infrequently commended his directorial skills, e.g. *MPN* (7 January 1922, 445):

> You can always trust John M. Stahl in providing a rich production for his pictures, whether he has a fitting story or not does not enter into the scheme of things…. If the subject happens to be weak it will offer some appeal through its artistic dressing. If it happens to be strong, then the picture takes a form which stamps it as something exceptional.

A review in the *South Australian Register* pointed to a growing international reputation, referring to him as "that gifted director". Reviews closer to home also made much of the four-year-old Richard Headrick, used earlier in *The Woman in His House*, and later in *The Song of Life*. The *Altona Tribune* (21 January 1922, 6) recorded the child's popularity; "'Little Itchie' as he is familiarly known, puts to shame many moving picture stars who are many years his seniors". Stahl's reputation as a director of children was now consolidated. The film was also the first of six photographed for him by Ernest G. Palmer.

The *Child Thou Gavest Me* was the third film made by Stahl for Mayer. Released in August 1921, it was the first "John M. Stahl Production" from the special production unit Mayer had given Stahl after the success of *The Woman in His House* and *Sowing the Wind*. The film's story is credited to Perry Vekroff, a director of society dramas in the 1910s who may have influenced Stahl's casting of Barbara Castleton in the role of the female lead: she had been directed by Vekroff in *What Love Forgives* (World Film, 1919). William Desmond, one of the two male leads, had already worked with Stahl in *Her*

Code of Honor. Of greater consequence for Stahl was the other male lead, the great Lewis Stone. They would go on to make five more films together: *The Dangerous Age*, *Why Men Leave Home*, *Husbands and Lovers*, *Fine Clothes* and *Strictly Dishonorable*.

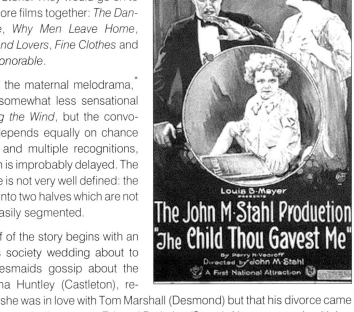

See page C2 for the original colour version of this image

A variant of the maternal melodrama,[*] the film is somewhat less sensational than *Sowing the Wind*, but the convoluted plot depends equally on chance encounters and multiple recognitions, one of which is improbably delayed. The act structure is not very well defined: the plot breaks into two halves which are not otherwise easily segmented.

The first half of the story begins with an upper-class society wedding about to begin. Bridesmaids gossip about the bride, Norma Huntley (Castleton), revealing that she was in love with Tom Marshall (Desmond) but that his divorce came too late and now she is to marry Edward Berkeley (Stone). Norma quarrels with her mother about whether or not to reveal a secret from her past. Her mother counsels her not to tell Edward about the birth of an illegitimate baby who she asserts has died and should be forgotten. The film then commences an alternation between the wedding preparations and the tenement where Norma's mother has actually lodged the child, Bobby, with Mrs. Donnelly. Following some comic footage introducing the boy, it is revealed that Mrs. Donnelly is ill and has to go to the hospital. She asks a neighbour to take care of the boy, and reveals the identity of his grandmother. Later, commenting on a picture of Norma in the society pages of the newspaper, the neighbour reveals her identity to the boy.

Cut back to Norma and her mother. Her mother repeats the injunction to forget the past. Norma receives a gift of white camellias from Edward with a note that compares the purity of the flowers with the purity of her soul.

Back in the tenement, Bobby asks for his mother, and the neighbour decides to send him where he belongs. In the company of the one of the neighbour's older daughters, he is sent off to the mansion where the wedding is taking place.They are admitted to the grounds and view the ceremony. Reviews in both the *Motion Picture News* (7 January 1922, 445) and the *Moving Picture World* (22 October 1921, 943) commented on the sumptuousness and elaborate staging of the wedding ritual, but did not note the irony of having it witnessed by the children, a point

[*] On maternal melodrama, see Christian Viviani, "Who is Without Sin? The Maternal Melodrama in American Film, 1930–1939", originally published in French in *Les Cahiers de la Cinémathèque* (28 July 1979) and variously reprinted in English, e.g. in *Home is Where the Heart Is: Studies in Melodrama and the Woman's Film*, ed. Christine Gledhill (London, British Film Institute, 1987).

emphasised by the intertitles: "And just as Bobbie thought he had found the very gates of happiness leading to his mother – there was a wedding within".

As is typical of the maternal melodrama, the recognition between mother and son is immediate and without much explanation. After the children gain entrance to the room where Norma is changing following the ceremony, she seems to know who Bobby is even before he says: "My mama!" When Edward enters the room, she is still holding on to the boy. He refuses to listen to any of her explanations (thereby delaying them for us as well) and castigates her for her lying pretence of purity and respectability. She is ready to go downstairs and reveal all to the waiting crowd, but he insists that they put on a show of happiness instead: "You're going to live the lie you started!" Downstairs, Edward watches suspiciously as Tom shows sympathy to Norma. Later, as Norma puts her son to sleep in her bed, the film all too rapidly winds up what one would expect would be a dramatic confrontation between Norma and her mother, who sent the baby away. Edward then agrees to take care of the boy and proposes to give out that the boy was adopted. He makes clear that he wants nothing to do with his wife emotionally or sexually, and threatens to search out the boy's father and kill him.

The second half of the plot takes place at Edward's country estate. It begins with comic business involving the antics of the boy and his dog, as well as the child's unsuccessful attempts to connect with Edward, who he assumes is his father. Meanwhile Edward invites Tom to stay for the weekend and surreptitiously watches his interactions with Norma. This section is very well staged and composed, with characters frequently framed in long shot. Edward deals coldly with Bobby while observing the mirrored reflection of Norma and Tom at a distance. Edward and Norma quarrel about his lack of affection for the boy, and Tom, in turn, watches them from off screen. Later that night, Edward again observes Norma and Tom alone together and carries through with his threat, shooting Tom. A doctor is called, the outcome uncertain.

As husband and wife wait, Edward voices his suspicions for the first time, precipitating the explanation that he stopped Norma from making on the day of their wedding. It takes the form of a flashback interspersed with some dialogue titles from Norma's perspective in the present. A nurse in Belgium at the beginning of the war, Norma sees a wounded soldier being brought into a military hospital, apparently a German from his uniform. The orderly carrying the stretcher says that they saw him cross the lines, and that he claimed to be an American. Amid the chaos of the retreat, with the hospital in ruins, the nurse has been thrown to the floor. The soldier approaches her. The film returns to the present and Norma castigates Edward for shooting his friend.

Edward escapes into the attic where he examines his own arms and military uniform, touching the edge of the holster. He has a flashback of motioning to Norma, in this military uniform, while Norma holds a gun and shakes her head back and forth in refusal and panic. She shoots the gun and the bullet touches the edge of the holster. Two dissolves make the transition between the bearded, dirty, soldier in the past and Edward in the present in his tuxedo. Downstairs, the doctor assures Norma that Tom will live. Upstairs, Edward lifts his gun to his temple only to be interrupted by his son. They embrace. Norma enters and witnesses their interaction.

He speaks: "My little son, think kindly of me. I didn't know – I didn't understand – My son – my own flesh and blood – ". Norma gasps when she hears this. She slowly extends a finger and an arm and mouths "You!" She stands erect and looks at him accusingly. Lewis Stone gives a half-mad stare. He speaks: "My search is at an end. I've found the man I swore to kill!" Edward explains that he

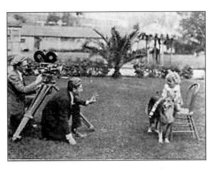

Stahl directing the child (Richard Headrick), and his dog

was visiting family in Alsace when the war started and was unwillingly drafted by the Germans. He was stupified by drink at the time of the attack. Norma dissuades him from suicide and pledges to remain his wife.

The trade press seems to have been less than impressed. *Camera!* judged that "the unusually involved plot is too very coincidental to convince the more incredulous..." (24 September 1921, 5) while *Moving Picture World*, in the review quoted above, gently noted that: "When Norma Huntley tells her husband of her war experience which forced her to become an unwilling mother and he recognizes himself as the guilty man, the question arises as to the probability of a previous mutual recognition". However, the reviewers commented favourably on the sets and the staging as well as on Richard Headrick's performance as Bobby. *Camera!* wrote: "Little Richard Headrick in the name part is featured and he is the picture's best asset. That Bobby, his offering, is shamelessly padded is really an excellent thing in that it is the one entertaining, happy piece of action in the play." The same review pointed out the difficult part assigned to Lewis Stone, playing an unsympathetic and "almost violent" man. One of the most interesting things about the film may be Stahl's and Stone's efforts to make sense of this character on whom so much of the denouement depends. In retrospect, it is clear that Stahl was impressed enough to seek out the actor for many other roles.◆

Lea Jacobs

Suspicious Wives

1 September 1921. 6,240 ft. Held in the BFI Archive.
(originally made as **Greater Than Love**, but not released under its original title).
D: John M. Stahl. **Sc**: Paul Bern, from a story by Robert F. Roden. **Ph**: Harry Fischbeck.
Titles: William B. Laub, Harry Chandlee.
PC: Trojan Pictures. **Dist**: World Film Corp.
Cast: Mollie King (Molly Fairfax), Rod La Rocque (Bob Standing), Warren Cook (James Brunton Sr.), H.J. Herbert (James Brunton Jr.), Ethel Grey Terry (Helen Warren), Gertrude Berkeley (Old Woman), Frank De Camp (Old Man).

This was the eighth of Stahl's credited features to be released, but in fact the fifth made, in 1919 – after *The Woman Under Oath* and before *Women Men Forget* – under the title *Greater Than Love*; this confused the IMDb and AFI sites, both of which erroneously list *Greater Than Love* and *Suspicious Wives* as two different Stahl films. Advertised for imminent showing in June 1919 (*Wid's Daily,* 29 June 1919, 19 and *MPW,* 28 June 1919, 1834), its release under the new title did not take place until September 1921. This long delay was disastrous for the film's box office; its star, Mollie King, who had returned to the New York musical stage, was less of a screen celebrity than in 1919, as witness the beginning of the preview in the Rochester (New York) *Democrat and Chronicle* (9 April 1922, 51): "Molly (sic) King, a popular actress a year or two ago returns to the screen [....]". Without the benefit of Mayer's and First National's publicity expertise, which boosted *The Woman in His House* and *Sowing the Wind*, it received little advertising and few reviews in the trades. The few advertisements offered the territorial rights for sale. There appear to be only two trade reviews, a rather negative caption piece in *MPW* (16 September, 1922, 11) and T.S. Da Ponte's review, also in *MPW* (14 January 1922, 204), so that more of the film's undeserved commercial fate, as it slipped to double-feature status, is revealed in provincial newspapers, with newspaper advertisements in Natchez and Wilmington, Delaware, advertising it being shown with comedian Larry Semon's "The Show". Da Ponte's lukewarm review did commend "beautiful sets" and "'shots' of a magnificent estate and views of a fashionable feast that is bound to make for good word-of-mouth advertising among the feminine contingent". It was cinematographer Harry Fischbeck's fourth and last film for Stahl.

Suspicious Wives, as noted above, took a convoluted route to the screen, not unlike the circuitous path its central couple takes towards married bliss. Filmed, and advertised, as *Greater than Love* in 1919, it was intended to be the first of five pictures Stahl would direct with King in the lead ("Stahl joins American Films", *Motion Picture News*, 31 May 1919, 3575). However, a dispute over rights meant that the film was

shelved and not released until late in 1921. As Fred Niblo's film of the same title had recently been distributed, its title was changed to the less striking, though enjoyably innuendo-laced, *Suspicious Wives*.

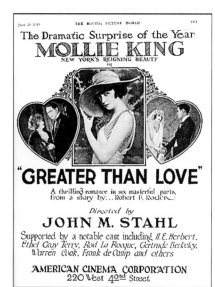

The film advertised under its initial title in June 1919, more than two years ahead of the eventual release.

Shortly after filming what was then known as *Greater than Love,* King married Kenneth Dade Alexander, a millionaire horse owner with a plantation in Kentucky. The fan magazines announced that the marriage meant King had retired from acting and was living in New York. In fact, after the birth of their son, King went back to work on Broadway and in films. She filmed *Women Men Forget* with Stahl in 1920 (the second and last, though shown first, of the proposed series) and then retired for good after 1924's *Pied Piper Malone* at the age of 29. Reporting on the impending production of *Women Men Forget*, *Motion Picture News* joked that the infant's "consent to her taking up the work again was harder to secure than that of Mr Mollie King" ("Live notes from the studios", *Motion Picture News*, 25 September 1920, 2455), implying heavily that the roles of wife and mother were not often considered compatible with a career as a film actress. There was a serious side to this joke. Gloria Swanson, who had her first child in 1919, faced fierce opposition from her studio for trying to combine film stardom and motherhood. Billie Dove explained the situation to Michael G. Ankerich: "If you were in motion pictures, you could be married, but if you had a baby you were no longer considered romantic."[*] It's an intriguing background to *Suspicious Wives*, in which King's character goes into hiding to be a mother, and whose husband must reconcile his perception of her as a flirt or adulteress with her private fidelity and wifely virtue.

King plays Molly Fairfax, a beautiful, wealthy young socialite (she believes weekend parties "should last until Tuesday morning") who is being courted by both dashing young Bob Standing (Rod la Rocque) and James Brunton (stage actor Henry Herbert, usually credited on film as Henry Hebert, but here named as H. J. Herbert), an altogether more serious man – the title card that introduces him is illustrated with an image of Auguste Rodin's "Le Penseur". James is the preferred suitor, and the first to propose, by a few hours. Their expensive wedding breakfast is interrupted by a gunshot. James's father and namesake is killed by the unseen shooter who shouts: *"Jim Brunton – this is your punishment!"* Dying, James Sr tells his son that he knows which of them was the target and why, but he refuses to divulge this information, in order to keep the family name free of scandal. In a previous scene, we have been introduced to Helen Warren (Ethel Grey Terry), a wronged woman living in a tenement with her mother and uncle, who sums up her predicament thus:

[*] Michael G Ankerich, *The Sound of Silence: Conversations with 16 Film and Stage Personalities Who Bridged the Gap between Silents and Talkies* (Jefferson, NC: McFarland, 1998), 86.

Mollie King in
Suspicious Wives.

"It's a crooked deal for her to live in this dump while another woman becomes the mistress of that mansion!" He threatens Helen's mother: "if you don't do something, *I will!*"

A year into married life, Bob is still a regular visitor to the Brunton home, and Molly is a dissatisfied wife ("Happiness, Bob? Is there such a thing?"), who suspects James is hiding something from her. Her suspicions are confirmed when she discovers he has been writing four-figure cheques to a woman named Helen. Molly leaves James, and coincidentally Bob goes to Mexico on confidential business at the same time. Thus Molly is convinced that James is having an affair with Helen (and the audience has enough information to strengthen that suspicion) and he in turn believes that his wife has run away with Bob. James files for divorce on grounds of desertion (Helen grows furious reading this in the newspaper), while Molly is living in the countryside, alone except for an African-American maid, in a "little grey house". We swiftly learn that she has given birth to James's baby, but the infant has died. One night, James has a car accident while speeding down a country lane ("a man seeks forgetfulness") and goes to the nearest house, the grey house, to recuperate from his severe injuries. He is blind and his face is bandaged, but Molly recognises her husband. She hides her true identity, calling herself Marion Grey instead, as she nurses him back to full health.

Like the appearance of infidelity in the Brunton marriage, the film's second christening, too, was rather misleading. As Shelley Stamp has pointed out, *Suspicious Wives* joined a "rash" of films released that year with "Wives" in the title, capitalising on the trend for marital sex comedies started by Cecil B. DeMille and Erich von Stroheim's capers such as *Old Wives for New* (1918) and *Blind Husbands*

(1919).[*] As Lea Jacobs explains, these sophisticated comedies were preferred by critics to sentimental or moralistic dramas, such as *Suspicious Wives*.[**] Yet again, there is a parallel with the Bruntons' appearance of vice masking their true virtue. Despite this misdirection, the title of *Suspicious Wives* sums up its plot rather nicely, with a wife both suspecting her husband and herself appearing to act suspiciously. It fits neatly alongside other Stahl silents on the theme of marital or romantic misunderstandings and perceived infidelities such as *Husbands and Lovers* (1924) and *Her Code of Honor* (1919). More specifically, it has similarities with the former, as here too a woman is thought to be unfaithful to her husband, only to be proved innocent in the long run. *Suspicious Wives* has plenty of attractions – it is laden with incident, spectacle (the elaborate wedding scene was shot at the ballroom in the famous Sherry's restaurant in New York, just before it moved to the Hotel New Netherland) and intrigue. Certain aspects of its plot (fast cars, blindness) could even be seen as a fore-runner to Stahl's *Magnificent Obsession* (1935).

The film announces its theme as not suspicion or honesty, but coincidence, portrayed as a demon in the intertitles. This could mean the whims of fate that guide our real lives, or the essential machinations of melodramatic narratives, such as Molly and Bob leaving town on the same day, or James and his father having the same name: "Is chance at times an angel as well as demon – or is it always evil, hiding its grinning lips behind a mask of seeming kindliness?" James has been delivered to his wife's home – and although they love each other still, there are barriers to their reunion. Those barriers are Bob and Helen (who both arrive at the house), and James and Molly's entrenched distrust. When James sees Bob in Molly's house the men fight and Molly swoons to her sickbed. Slowly, however, Bob and Helen begin to explain themselves: Helen reveals herself as the daughter of James's uncle, who was exiled from the family because James Sr disapproved of his marriage to Helen's mother. The uncle further disgraced himself by criminal activity, though thankfully under another name, Warren. It was "Helen's half-de-mented mother" who shot the older man, hoping foolishly for a legacy. Bob, as we know, was in Mexico, protecting his family's oil interests from the local "rebels". Eventually man and wife are reunited, but not before Molly comes near to death, has a vision of a crucifix, and credits her repaired trust to a supernatural experience: "Someplace – as if beneath deep waters – I heard a voice – telling me that it was suspicions – unfounded – eating my heart away – that you have always been true."

We must credit the many writers of *Suspicious Wives* with the success of its neatly contrived plot. However, two of the film's most interesting tactics are the staging of the action within the "little grey house", and its approach to Molly's pregnancy, both of which are shaped by Stahl's direction. The suspense in the film stems partly from the mystery of Helen's identity, and James Sr's murder, but mostly from the fear that the lovers will be separated for ever. The tension is achieved by keeping elements of the narrative apart, which is mainly accomplished by editing. That first cross-cut to Helen and her family gives the audience privileged information that the Brunton household are unaware of, for example. The strategies for keeping Molly's motherhood separate from the rest of the narrative, and how it eventually intrudes

[*] Shelley Stamp, *Lois Weber in Early Hollywood* (Oakland: University of California Press, 2015), 187–188.

[**] Lea Jacobs, "John Stahl: Melodrama, Modernism, and the Problem of Naïve Taste", in *Modernism/ Modernity* v.19 n.2, April 2012, 303–320.

on the physical space of the other characters, are more interesting. We suspect that Molly is pregnant about halfway through the film, when she leaves James, and she collapses at the train station. Pregnancy is represented as an illness, a debilitating condition, rather than a healthy blessing. One shot of Molly with the baby and a couple of intertitles ("A woman – happy with woman's greatest happiness"; "and a woman suffers woman's greatest sorrow") are all that we are shown of the baby's short life. These are cross-cut with James filing for divorce, and Helen reading about that in the newspaper.

The nursery, with the dead baby's crib still in it, is on the ground floor of the little grey house. There is a portrait of the mother and child in that room. From the window, Molly looks at the child's gravestone in the garden; there too she embraces her maid and cries "I want my baby!". Molly's identity as a mother and her suffering as a woman (which, we infer, is a deeper suffering than that experienced by James or Helen) is mostly kept within that space. Molly goes to the nursery when she despairs. When she first sees James after his accident she goes there to weep in front of the portrait. When Helen arrives she picks up the baby's rattle. When Helen wanders into this room, against the maid's warning, she perceived it as evidence of Molly's sin: "So this is the explanation of your exile to this little town, _Miss_ Grey!"[*] In response, the still-grieving Molly lashes out, accusing Helen of being the baby's killer, collapsing her husband's neglect and the death of her child into one grievance.

Motherhood and pregnancy were almost as prohibited on screen, as they were for actresses such as Gloria Swanson and Mollie King. There is no moment in the film where Molly explains about the baby to James – the film was perhaps already too frank for 1919, or even 1921, on the subject of pregnancy and childbirth. For example, Stahl's 1921 film _The Child Thou Gavest Me_, about a young bride revealing she is already a mother, was described by one magazine as "springing from an unsavory dramatic seedbed … it leaves things to the imagination which does nobody's imagination good to have there." (_Screenland_, "Little hints for play-goers", December 1921, 44).

However, the suffering represented by Molly's sad nursery, a suffering that cannot be explicitly named, brings about the crisis that leads to the lovers' reunion. For one thing, there is a suggestion that Molly has finally matured from the party girl of the film's opening scenes, with two boyfriends in attendance. However, Stahl uses the portrait throughout the reconciliation. When James is convinced of Molly's infidelity with Bob, he stands in front of the mother-and-child portrait (the audience can see it, but he can't), ironically saying that he would rather have remained blind than see the evidence of her guilt. When James and Bob (now older and wiser themselves) face off against each other in the foyer of the grey house, a small wall-mirror between them reflects the portrait from the nursery across the hall. They don't see it either, but this is the moment when Bob convinces James of Molly's innocence, and it is also the moment when she swoons, leading to the near-death experience that dissolves all her suspicions. We will eventually see husband and wife embracing happily in front of the portrait, as James explains who Helen is.

[*] Helen herself is not illegitimate, but has been rejected by her father's family, so might be expected to be more sympathetic.

The portrait and the mirror allow the nursery, and by extension the grave, to intrude on the domestic space of the grey house, in the same way that the gun behind the curtain intrudes on the wedding breakfast, rupturing the barriers that have kept the Warren disgrace and Molly's baby out of the film. Helen's story is kept at a distance from the main plot by editing; Molly's grief is separated by just a few feet from the doorway of her home. Neither of these subjects are suitable for elaboration in an American film at the turn of the 1920s, but they are both manifestations of the "perverse and malicious demon of chance" that powers the plot. Again, although the film is necessarily more dramatic than real life, there's a parallel with Mollie King's life and the baby that kept her from the studio.◆

Pamela Hutchinson

The Song of Life

2 January 1922. 6,920 ft. Held in Library of Congress.
D: John M. Stahl. **P**: Stahl, Louis B. Mayer. **Sc**: Bess Meredyth, from a story by Frances Irene Reels. **Ph**: Ernest G. Palmer.
PC: Louis B. Mayer Productions. **Dist**: Associated First National Pictures.

Cast: Gaston Glass (David Tilden), Grace Darmond (Aline Tilden), Georgia Woodthorpe (Mary Tilden), Richard Headrick (Neighbour's Boy), Arthur Stuart Hull (District Attorney), Wedgewood Nowell (Richard Henderson), Edward Peil (Amos Tilden), Fred Kelsey (Police Inspector), Claude Paton (Central Office Man).

This was Stahl's fourth film for Mayer, a project he said he had nurtured until he had his own production unit (*MPN*, 11 June 1922); he was probably cautious about the reception of the film's downbeat social realism, much mitigated though this was by its heightened melodrama and "mother-love" thematic. Since it was strikingly advertised as a "Drama of Dishes and Discontent", play on the dirty dishes motif was inevitable: "Drama of Dirty Dishes Cleans Up", and so forth. The text of one advertisement was written on a plate, while another displayed stills inside oval-shaped dishes (*MPW*, 8 April 1922, 601–602). Another major publicity strand centred on the unusualness of a narrative with an elderly woman (Georgia Woodthorpe as Mary) at its centre.

Though it was referred to as a film with four stars, its leading players – Grace Darmond, Gaston Glass, Georgia Woodthorpe and Wedgewood Nowell, all excellent performers who gained appreciation in the reviews – are little known today. Grace Darmond never quite broke through from supporting roles to consistent leads, and left films in 1928. Her lesbianism now tends to be more discussed than her films. She also had one late role, uncredited, in Stahl's *Our Wife* (1941). The French-born Gaston Glass, like Darmond, never quite became a consistent star actor, but can be watched on YouTube starring with Alma Rubens in Frank Borzage's *Humoresque* (1920), probably his greatest role. A violinist there, and a writer here, he was said by the *Portland Telegraph* to be "enough of the artist type to please the ladies and at the same time not enough of one to turn the men against him". Georgia Woodthorpe, after a West Coast stage career in which, according to *Exhibitors Trade Review* (1 April 1922, XII-XIII), she played in Shakespeare opposite Edwin Booth, was in films only from 1918, when she was nearly sixty. Wedgewood Nowell was a stage and screen character actor with a large number of film credits.

Negative reviews like *Variety*'s (4 August 1922, 35) disliked the film's perceived sentimentality and conventionality, seeing it as "but one of many sob stories on the screen today". *Film Daily*

(19 February 1922, 13), under the heading "Domestic Drudgery and Mother Love in Uncon-vincing Story", found moments in the film to be over-familiar, implicitly accusing Stahl either of plagiarism or of lack of originality.

Positive reviews praised the film's "slice of life" lower-depths verisimilitude, *Exhibitors Herald* (28 January 1922, 67) extending this to the "mother-love" aspect and seeing it as:

> an entirely different version of the, at present, popular mother pictures. [Stahl] has avoided the exaggerated wishy-washy mother-love angle and drawn with broad strokes of his directorial brush vivid graphic pictures of the hum-drum routine existence of hundred of thousands of mothers who long for the more attractive things of life.

The *Ottawa Journal* (2 December 1922, 21) took the opportunity presented by the film to discuss Stahl as a film maker under the headline "John Stahl Declares Old Ideas Must Go – New Pioneers Wanted" and celebrated him as "a precedent maker", not a "follower", "with the foresight and courage to leave the beaten track".

Six years before Victor Seastrom's *The Wind* (1928), Stahl's *The Song of Life* opens with a woman in a desolate shack in the desert, being driven mad by the howling wind and by a life summed up in a title card as "sand, isolation, and dirty dishes". Though its plot relies on preposter-ous coincidences and builds to a shamelessly saccharine mother-love finish, *The Song of Life* is notable for a degree of grittiness and a focus on poverty that are unusual in Stahl's career. He was quoted as saying that the film had "a theme which he has been saving for several years with the intention of using it when he had his own production unit", suggesting that this realistic treatment was important to him (*MPN*, 11 June 1922, 3577). The story is credited to Stahl's wife Frances Irene Reels, and the scenario adaptation is by Bess Meredyth, an admired screenwriter of the 1920s who later married director Michael Curtiz. Sharply written titles and crisp direction keep the film from sinking too deeply into the maudlin.

Many of Stahl's films address women's discontents with marriage (and its alterna-tives), but rarely did he consider the domestic drudgery of wives who are too poor to keep servants. This lot is presented with vivid horror in the prologue, which introduces Mary Tilden, a city girl who followed a "trail of romance" out west, only to wind up in a shack scoured by blowing dust, with a brutish "clod" of a husband and a bottomless tub of greasy dishes to wash. Gazing out of the grimy window, she sees a private railroad car pausing on the tracks outside with stylish women framed in the windows, like a hallucination of the easy, luxurious life she yearns for. (The train as a rolling, cinematic vision of the good life reappears in Clarence Brown's *Possessed* [1931], dazzling factory girl Joan Crawford.) In a moment of despair, Mary breaks down and flees the cabin, jumping on a passing train – and leaving behind her baby boy. In the first of the film's wildly contrived turns, this very train kills Mary's husband as he travels to work on a handcar. The sequence is played for maximum drama, with the locomotive barrelling directly toward the camera, and a sharp cut from the father being flung from a trestle bridge to the forgotten baby happily playing with his toes.

Much later, we learn that Mary went back to find her husband dead and no trace of her son, but in the meantime, despite her lapse, we are clearly meant to see her

Preparing to
shoot the railway
accident that kills
the young Mary's
husband.

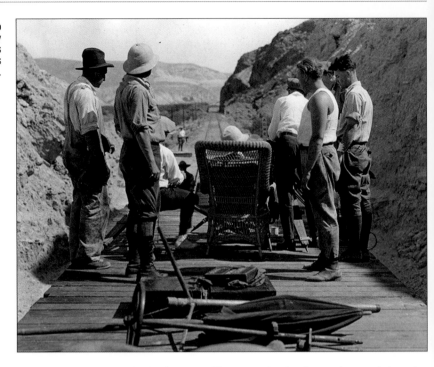

as a tragic and sympathetic character. The story shuttles forward several decades to find Mary a worn-out old woman (now played by stage star Georgia Woodthorpe, the grandmother of director George Stevens), being fired from a job washing dishes in a restaurant. Threatened with eviction, she decides to end it all by drinking poison, leading to a plot twist that plays out like a Rube Goldberg contraption, charming in its implausibility. Startled by a cat, she drops the bottle, and the spilled liquid drips through the floor of her tenement room onto the head of the Struggling Young Writer who lives below, bringing him upstairs to complain and then, when he realises the situation, to kindly invite her into his apartment. As both Mary and the audience soon realise, he is her son, David (Gaston Glass), who is engaged in writing an autobiographical novel expressing his bitter contempt for the mother who abandoned him. To complete the set-up, David has a pretty young wife, Aline (Grace Darmond), who hates housework, chafes at poverty, and is tempted by the attentions of a wealthy publisher. Wouldn't you know, he turns out to be the same publisher who takes an interest in David's manuscript!

Fortunately, some very appealing elements distract from the absurdity of this plot. The setting of New York's Lower East Side is presented with almost neorealist pungency. Street scenes show tenements festooned with laundry, crowds milling around pushcarts and colourful vendors, children playing in gutters and stairwells. Cinematographer Ernest Palmer, making his second film with Stahl, would go on to lens Borzage's *Seventh Heaven* and *Street Angel* and Murnau's *City Girl*; here his work is both concise and atmospheric. During a heat wave, cheap paper fans flutter in people's hands; crowds sprawl on rooftops; neighbours sleep on fire escapes, collect free ice from trucks, and sample homebrew beer. Running comic relief is provided by an organ grinder's monkey that wreaks anarchic mischief via open windows.

Gaston Glass,
Georgia
Woodthorpe,
Grace Darmond.

Aline hates this sweaty, noisy, smelly environment, but her unhappiness is treated more ambivalently than Mary's was in the stark prologue. In her first scene, Aline complains because her husband won't let her go back to her old job, even though they are broke. "I don't want my wife to work, and that's final", he declares, to which she retorts: "Work! You call playing piano in a music store work. Scrubbing floors and washing dishes, I suppose, is a pleasure!" This exchange is remarkably blunt and efficient in simultaneously laying bare the vanity of men's desire to be sole breadwinners and the degree to which they take for granted women's unpaid and unglamorous domestic labour. But the film quickly muddies this clarity. Aline comes up with a scheme whereby she will go back to her job and Mary will take over the housework in exchange for room and board. Though she once recoiled from drudgery herself, Mary is now thrilled by the idea, cheerfully explaining that while all young wives hate dishes, to an old woman like herself they mean home. Both women speak of the longing for "pretty things", which reduces their aspirations to something apparently superficial and materialistic. In the music store where she works, Aline slips off her wedding ring and flirts with customers (when one man holds up the sheet music for "I Love You", she responds with the sheet music for "Hokum"), and she accepts first a ride home in the rain, and then dinner in a stylish beachfront restaurant from the publisher Richard Henderson.

The latter part of the film veers into deepest melodrama, with David shooting Henderson in a jealous rage and Mary confessing to the crime in an effort to save him. The anguished scenes in a police station and jail are heavy-handed and overplayed in contrast to the largely restrained and natural acting in the rest of the film. A certain self-awareness about its genre is injected into the story by the discussion of David's novel, which introduces a life-imitates-art theme. He describes it as "a slice of life", a cliché that was also applied to the movie in reviews

and promotional materials. Henderson summons the author to tell him that he will publish the book only if he changes the character of the mother – presumably written as the heartless monster that David imagines his mother to be – since she is "not real", and "the public won't accept her". In a funny and telling line, the penniless writer immediately acquiesces: "I'll make her into an angel. I need the money". In the end, of course, he proclaims that his mother *is* an angel – but the discussion of pandering to the public's taste gives, perhaps, a slightly tongue-in-cheek quality to the ecstatic reunion of mother and son. In the end, the publisher survives the shooting and declines to press charges, making way for a happy ending.

The Song of Life foreshadows other Stahl films like *A Lady Surrenders* in building a succinct case for women's dissatisfaction with marriage and then backing away from it: the final scene here is particularly dispiriting, with Aline smiling as she shoos her mother-in-law away from the sink, ties on an apron and starts in on the dishes. (David, for his part, is never seen so much as drying, much less washing, a dish.) The movie does too good a job of portraying the soul-crushing grind of household chores to be convincing in this reconciliation. Mixed reviews reveal that some contemporary critics found the story hackneyed and unconvincing, while admiring the directorial skill and realism. The *LA Times* reviewer's assessment (13 February 1922) is well balanced and broadly applicable to this director's work: "the plot is such a crude one, and has been so admirably refined in the process of transforming it to the silver sheet. Mr. Stahl has, I believe, a faculty for taking the trite and commonplace and making them seem like something". ◆

Imogen Sara Smith

One Clear Call

May 1922. 7317 feet. Held in Library of Congress.
D: John M.Stahl. **P:** Stahl, Louis B Mayer. **Sc:** Bess Meredyth from the novel [1914] by Frances Nimmo Greene. **Ph:** Ernest G. Palmer. **Ed:** Madge Tyrone.
PC: Louis B. Mayer Productions. **Dist:** Associated First National Pictures.

Cast: Milton Sills (Dr. Alan Hamilton), Claire Windsor (Faith), Henry B. Walthall (Henry Garnett), Irene Rich (Maggie Thornton), Stanley Goethals (Sonny Thornton), William Marion (Tom Thornton), Joseph Dowling (Colonel Garnett), Edith Yorke (Mother Garnett), Doris Pawn (Phyllis Howard), Donald MacDonald (Dr. Bailey), Shannon Day (Jim Ware's daughter), Annette De Foe (Yetta), Fred Kelsey (Starnes), Albert MacQuarrie (Jim Holbrook), Nick Cogley (Toby).

By the time of this third special-unit production, Stahl's films were treated as big, newsworthy enterprises, with regular trade coverage of *One Clear Call* during its long production period of five months from the start of shooting to final editing (*MPW*, 18 March 1922, 269). Mayer, who often complained of Stahl's profligacy with time and film stock, here used his perceived extravagance to boost the film: "More than 200,000 feet of film were shot" (*MPW*, 18 March 1922, 269). An impressive double-page advertisement (*MPW*, 27 May 1922, 372–373), playing on Stahl's reputation for "all-star" productions, boasted "a cast to conjure with", cameoing sixteen of the players. Though the Ku Klux Klan had only a small and unsympathetic role in the narrative, it created an ambivalent stir, leading to exploitation stunts centred on the "night riders" even in places like Des Moines. With *One Clear Call*, Stahl's 1920s reputation was at its peak, though today the praise lavished on the film might seem excessive, with the terms "genius" and "masterpiece" being used by the *Los Angeles Times* (23 July 1922, 58). Arthur James's editorial in *MPW* (15 July 1922), lavishly praising the film, was reprinted by *MPN* ("We'll Let The Other Fellow Say It For Us", 29 July 1922, 497). The *New York Times* (19 June, 1922) significantly dissented, as Lea Jacobs demonstrates in the essay that follows.

O ne Clear Call was released in May 1922, the fifth of the Mayer-Stahl collaborations. It was evidently a high-budget production, being adapted from Frances Nimmo Greene's novel published by Charles Scribner's Sons in 1914 and starring several well-known actors from the 1910s. Henry Walthall, a distinguished member of D.W. Griffith's stock company, played the role of the dissipated rake in a performance that was widely praised in the trade press: "Too much cannot be said for the wonderful acting of Henry Walthall as the black sheep. He gets more depth of meaning, more appeal, more arresting vibrancy into one glance of his eye, one

Claire Windsor,
Milton Sills.

gnawing of his lip, even the clinch of his hand, than a score of other actors put together. When is he going to have his great chance?"[*] Milton Sills, who played the male lead, had starred as a handsome, rugged and honest type in dozens of films, many by major directors of the period: Maurice Tourneur, Emil Chautard, Raoul Walsh, Reginald Barker, Herbert Blaché, Fred Niblo, Henry King and William de Mille. Claire Windsor, who played the female lead, was relatively new to features but had experience with Lois Weber's stock company. Irene Rich, in a supporting role, was at the beginning of a career that would last through to John Ford's *Fort Apache* in 1948, but even in 1922 she was a veteran of about thirty major feature films.

While praising the cast and production, some influential reviewers found fault with the film's plot. The *New York Times* complained: "But the photoplay lacks unity. It is diffuse. Instead of holding to the one clear path ahead of it, it wanders into numerous byways and spreads itself over irrelevant territory, with a consequent loss of directness and momentum. Action that should be merely incidental to the main plot is stretched out and emphasized until at times the main plot is lost in the maze of it." The *Los Angeles Times* concurred: "Stahl has a magic power of getting marvelous acting out of his people; he has a tremendous, driving sense of drama; he is human and he is deft and skillful. It is only that his sense of drama runs away with him, I think, and he wants to make 'Hamlet' and 'Romeo and Juliet' into one play". *Film Daily* thought the plot was overly complex: having "enough material, in the way of climaxes and situations, to fill several feature productions" (25 June 1922, 2). *Variety* put a more positive spin on it: "The picture is a combination of everything that goes to make a successful screen production. It has a society

[*] Grace Kingsley,"Walthall Triumphs", *LA Times*, 24 July 1922, 1113; see also "The Screen", *NYT*, 19 June 1922, 15.

element, some dive stuff [e.g., low-down nightclub], a measure of mystery, lots of love interest, a wandering boy and blind mother, comedy and a touch of Ku-Klux Klan that serves as a thrill" (23 June 1922, 34).

The press did not complain only about narrative construction. There was also a complaint about the overly emphatic mode of representation. Like *Sowing the Wind* (see above), *One Clear Call* has recourse to highly didactic subtitles over its symbolic imagery, which the reviewer of the *New York Times*, at least, objected to:

> Henry Garnett, knowing that he must die soon, sits listening to an inexorable clock. It ticks and ticks, counting off the seconds of his life. Finally, in futile desperation, he seizes the pendulum and stops it, but as he holds on the metal bar, a phantom pendulum [a second, superimposed image] swings on. Here's cinematography. Here's complete expressiveness within a picture....The spectator with any imagination at all, with a mind that functions even moderately well, gets the point of the picture immediately, and enjoys doing so. But is he permitted to enjoy himself for more than a fraction of a second?...By no means. That would violate all movie traditions. Some moron in the house might wonder why the man stopped the pendulum and why the shadowy one kept swinging. So, almost before Mr. Walthall has completed his unmistakably significant action, the scene is cut and a ponderous subtitle comes on to tell you all about it. And other subtitles follow, until it seems as if someone had been determined to destroy the effectiveness of the scene or use up the dictionary in the attempt.

The film's adapter, Bess Meredyth, seems to have struggled to condense the multiple subplots of the original novel. The narrative is further complicated by new material that seems to have been added by Stahl and/or Meredyth. The first act is largely devoted to the exposition of the relationships among the many characters. At the hospital, nurses try to learn about the origins of Faith (Windsor), a mysterious patient, while her maid refuses to provide information either to them or to Dr. Hamilton (Sills). The nurses gossip about the doctor's attraction to his patient. Later, on the porch of the Garnetts' ancestral home, the Colonel and his blind wife greet Hamilton and his sister Maggie (Rich) who are passing by. Henry Garnett approaches the house, takes off his hat, hesitates. The mother is convinced she hears her son's footsteps, but the old man tells her that is impossible, her boy is dead, and the man whose footsteps she heard was a stranger to her and to him. Out on the street, Hamilton gladly shakes Henry's hand, but Maggie later complains to her brother about Henry's gambling establishment, The Owl, and its notorious hotel, opened "without regard for womanhood". Cut to the hospital where the maid informs her mistress, now conscious, that she was brought to the hospital after fainting at the sight of Henry Garnett. She reassures her mistress that he did not see her.* At Hamilton's office, the doctor examines Garnett and tells him he has a fatal heart disease and only a few months to live. At the Garnett residence, Henry

* Yetta, Faith's mixed-race maid, is a less important character in the film than in the original novel. The novel is particularly troubling in the way that it handles this character, whom Dr. Hamilton insists must "respect the nurses" and "learn her place" even as he approves her attempts to protect the privacy of her mistress. Characters in the film refer to Yetta as a "coloured" maid (she is played by Annette DeFoe in black face) and she assumes a vaguely threatening attitude to Hamilton, presumably out of loyalty to Garnett.

The Ku Klux Klan
gathers outside
The Owl – and
becomes the
focus of publicity
at a cinema in
San Antonio,
Texas.

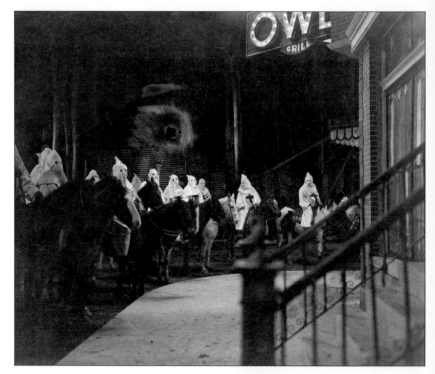

approaches his mother and attempts to
speak, but is silenced by the appear-
ance of his father and runs off.

In the second act, Hamilton determines
to help the despised and dying Garnett
while courting Faith. At the Owl, Henry
reckons with his guilty past and, after a
night of regret, confesses to Hamilton
that Jim Ware, on his deathbed, had

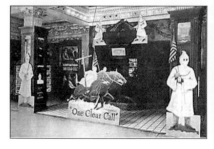

entrusted him with the care of his young daughter and his estate. Garnett had
abandoned the girl in an orphan asylum and used the estate for his own purposes.
He asks Hamilton to help him find the girl so that she can inherit his money after
his death. Later that night, Hamilton proposes to Faith who tells him she is not free.
Meanwhile, at a party at Maggie's, the women gossip about Faith and Hamilton.
Downtown, a group of upper-class men become angry over the demoralising effect
of the Owl on the young women of the town. While the malicious gossip about
Hamilton and Faith is an important theme in the novel, the disparagement of the
Owl by the men is an invention of the film-makers. It is introduced at this point to
motivate the ensuing sequence of the Klu Klux Klan's night raid on the club which
forms the climax of the act. (A particularly troubling aspect of the film is the comic
use of black characters quaking in terror as the Klansmen ride through the
countryside in the build up to the raid.) After the attack commences, Hamilton steps
forward to protect Garnett and disperses the Klansmen by promising that the Owl
will be closed in thirty days, anticipating Garnett's death which is unknown to others
in the town.

In the third act, Garnett appeals to Hamilton to help him find his wife. Later, in conversation with Faith, Hamilton complains about the disloyal woman who has abandoned her husband when he needs her most. Faith reveals that she is Garnett's wife. Hamilton reverses himself, embraces her and stops her from returning to her husband. Meanwhile, Garnett discovers that Jim Ware's daughter is in fact working in the brothel in his own gambling establishment. When he tells her she can have his fortune but she must start life anew, she attempts to flirt with him, prompting a heart attack. Hamilton patches Garnett up, and the dying man again appeals to the doctor to help him find his wife. Coincidentally, at this moment, the nurse brings Hamilton a letter from Faith saying she can not go back to Henry but she owes it to her husband to leave town and end their relationship.

In the fourth act, Hamilton, demoralised by his own betrayal of Garnett's trust, becomes a drunk. This degradation of the hero is another invention of the film-makers. In the novel, Hamilton is falsely rumoured to drink – this forms part of the negative gossip inspired by his association with Garnett and his clandestine romance with Faith. In both film and novel, however, Hamilton's reputation is rehabilitated when Maggie's son is injured and he operates and saves the boy's life. Faith's maid, Yetta, then reveals to Garnett that Hamilton has been making love to his wife (this action is not well motivated in the film; the novel sets up her supposed "rebelliousness" and duplicity). Garnett confronts Hamilton who confesses that he is in love with Faith. Garnett's reaction is opaque: he turns away from Hamilton and does not speak. Later, Hamilton is surprised to discover Faith at his sister's: she has returned and is planning to do her duty by her husband. However, she emerges from the Owl after seeing Henry to tell Hamilton that he would not accept her sacrifice. We see Garnett put some pills in a glass of water, although the word "suicide" is not mentioned directly. Later, Faith and Hamilton visit Mother Garnett and join in her praise for her late son.

It does seem as if "too much" happens in this plot – *Hamlet* and *Romeo and Juliet* in the same play. Some of the major climaxes of the novel, such as Faith's revelation that she is Garnett's wife, fall flat in the film because they are not sufficiently developed or prolonged. In addition, far from amplifying the most important situations, the emendations made by the film-makers merely add to the number of big dramatic scenes, diluting their impact. Thus, there is almost no motivation of the raid by the Klu Klux Klan in the second act, and it has no consequences for the action which follows. In the fourth act, Hamilton becomes a drunk and then redeems himself in the space of half a reel, a progression which moves too rapidly to be fully satisfying and which detracts from the most consequential action of the denouement – Faith's change of heart vis-à-vis Henry. I suspect that in spite of its many positive reviews, the glaring deficiencies of *One Clear Call*, as well as some of the criticisms made in more discerning reviews, helped spur Stahl's experimentation with other genres and other forms of narrative construction in the middle 1920s. ◆

Lea Jacobs

The Dangerous Age

26 November 1922. 7,145 ft. Presumed Lost.
D: John M. Stahl. **P**: Stahl, Louis B. Mayer. **Sc**: J.G.Hawks, Bess Meredyth, from a story by Frances Irene Reels. **Ph**: Jackson J. Rose, Al Siegler. **Asst D**: Sidney Algier.
PC: Louis B. Mayer Productions. **Dist**: Associated First National Pictures.

Cast: Lewis Stone (John Emerson), Cleo Madison (Mary Emerson), Edith Roberts (Ruth Emerson), Ruth Clifford (Gloria Sanderson), Myrtle Stedman (Mrs Sanderson), James Morrison (Bob), Helen Lynch (Bebe Nash), Lincoln Stedman (Ted), Edward Burns (Tom), Richard Tucker (Robert Chanslor).

Married 22 years, Mary Emerson treats her husband, John, more like a son than a husband. He is stung by her rebuffs, and therefore succumbs to the youthful charms of Gloria Sanderson, whom he meets on a business trip. But just after he mails a letter to Mary, telling her he will not return, John finds Gloria in the arms of her fiancé. Realising his foolishness, he races to the train in an effort to retrieve the letter. He fails, and Mary receives and reads the letter; but she too has seen her error, conceals her knowledge of the letter's contents, and accepts John's professions of love.

Based on an original story by Stahl's wife, Frances Irene Reels, the screenplay was written by the distinguished and industrious Bess Meredyth, whose career is outlined in detail in her entry in the online Columbia University "Women Film Pioneers Project".[*] In this, her third film for Stahl, she worked with J.G. Hawks, an experienced film writer who also would contribute to *The Wanters*. This film was advertised with an "all star" cast, headed by Lewis Stone, who would become one of Stahl's favourite actors, working with him six times. Cleo Madison, who plays his wife, was herself an interesting figure, an actress and briefly a director (1915–1916): see her entry in that online Columbia project. Another important woman participant was Ruth Clifford, long-time associate in later life of John Ford: Stahl would cast her again in the Tiffany-Stahl film *The Devil's Apple Tree* (Elmer Clifton, 1929), and later in a small role in *Only Yesterday* (1933).[**]

Early publicity for the film stressed its unusualness, "a daring departure from the average release of the day" (*MPN*, 3 June 1922, 3028), referring mainly to its concentration on middle-aged rather than youthful players. Other reports and

[*] https://wfpp.cdrs.columbia.edu/
[**] see the obituary of Ruth Clifford by Kevin Brownlow (*The Independent*, 5 January 1999).

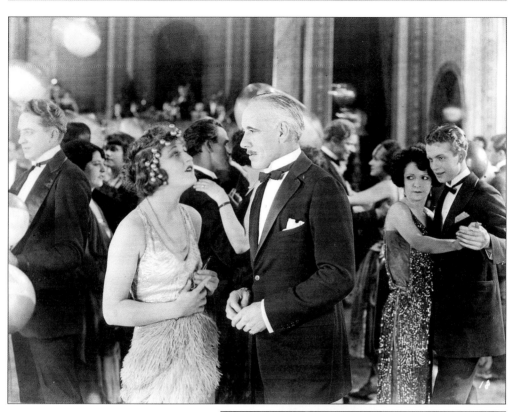

publicity during and after filming con-
centrated on its "all-star aggregation"
e.g. *MPN* (19 August 1922, 864); by this
time Stahl was well known for the quality
of his all-star casts. A big two-page First
National advertisement (*MPN*, 3 March
1923, 1020–1021) has, in addition to
excerpts from many highly positive re-
views, cameo portraits of ten of the cast.
There were also publicity pieces, re-
ports and reviews that commented on
the size and spectacular nature of the
production, a reminder that Stahl was
known at this time as an action director
as much as for his other specialisms:

> The scenes in New York are the
> last word in lavish scenic
> investiture.The racetrack views
> are realistic and thrilling. The race
> between the auto and the train

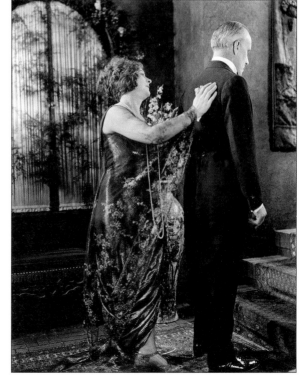

Lewis Stone with Ruth Clifford (above), and with
Cleo Madison (right).

and the wrecking of the auto in front of the flyer is sure to bring the audience to the edge of their seats. (*MPN*, 9 December 1922, 2940).

The *Fort Wayne Journal-Gazette* listed as well "some action on a New York street set said to be the largest ever constructed on a stage"; "an extravagant cafe scene"; "an exciting race track scene staged especially for the director"; and, along with several other notable stagings, "a section of the Grand Central Terminal in New York faithfully reproduced on the immense outdoor stage at the Mayer Studios" (28 January 1923, 9B).

With the film's title a gift to the publicity machine, the forcefulness and extent of its advertising were notable, most obviously the saturation campaign for its premiere in Paterson, New Jersey, which became a byword in the industry. (See the twelve-page spread on this in *MPN* (18 December 1922, 3053–3062). *EH* (30 December 1922, 1333–1344) has a double-page spread stressing to exhibitors the film's "Ideal Title Built For Teaser Purposes And Box Office Results" and showing seven posters for the film. Many publicity stunts were recorded in the trades, and much exploitation based on the titillating question "What is the most Dangerous Age?" The publicity sign shown below was part of the famous saturation advertising for the film on the outskirts of Paterson (*EH*, 2 December 1922, 34).

Reviews: The film was was very positively reviewed. A First National advertisement for its 1923–1924 season in *MPN* (26 May 1923, 2461) could ask without too much exaggeration, "Did ever another picture create such discussion as 'The Dangerous Age'? Or play so consistently to capacity and so many extended runs?"An article in *MPW* (10 February 1923, 591) – "The Dangerous Age is Lauded By New York Newspaper Critics" – surveyed newspapers not only in New York but also in Los Angeles and Chicago, as well as the trades, all agreeing, if more decorously, with the *New York World* that it was "of the type which cinema kings refer to as a - - - - - - good audience picture". Grace Kingsley in the *LA Times* wrote that it was "A real masterpiece, a genuine reflection of life on the screen at last". A reviewer from outside the big cities in the *Fort Wayne Journal-Gazette* (Fort Wayne, Indiana, 28 January 1923, 9B-C) was clearly familiar with Stahl's films, or had assiduously digested publicity material, writing that "Stahl's forte has been the delineation of the dramatic side of American family life." The review emphasised the quality of the cast – "Never in our estimate has such an aggregation of actors of stellar ability been gathered together in one cast" – and praised the film's spectacle: "Monster sets in 'The Dangerous Age'", the train and automobile race, the reconstruction of

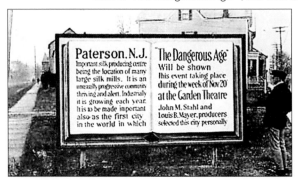

part of a New York street, a café set with hundreds of occupants, an elaborate wedding scene and the reproduction of part of Grand Central Terminal". The *Philadelphia Enquirer* (31 December 1922, 40), asserted that Stahl "generally starts his stories where other directors leave off" (i.e. with married life as a beginning rather than the narrative's end). Three other reviews agreed that Stahl's direction made the film

notable.""He has taken a simple, somewhat hackneyed story and has made of it one of the pictures of the year" (*Film Daily*, 4 February 1923, 2). "Numerous touches sufficient to lift it above and beyond the average" (*Variety*, 8 January 1923, 42). "Pretty old stuff, isn't it? But it's new in *The Dangerous Age* because of the way it's told. This same story told as nine directors out of ten would tell it would be tame, dull stuff [but Stahl] has vitalized his scenes with illuminating little touches of life. His people do things that you can imagine real people doing, and in doing them they reveal themselves" (*New York Times*, 29 January 1923). The reviewers who later linked the film to the comedies *Why Men Leave Home* and *Husbands and Lovers* drew attention to the pervasively comic aspect of these "little touches".

In short, Stahl can be seen now to have established his status as a distinctive and important director who cultivated comedy as well as melodrama.◆

The Wanters

20 November 1923. 7,145 ft. One reel only, the fifth of seven, tinted, is held in The Academy Film Archive, awaiting (we hope) restoration.
D: John M. Stahl. **P**: Stahl, Louis B. Mayer. **Sc**: J.G.Hawks, Paul Bern, from a story by Leila Burton Wells. **Ph**: Ernest G. Palmer.
PC: Louis B. Mayer Productions. **Dist**: Associated First National Pictures.

Cast: Marie Prevost (Myra Hastings), Robert Ellis (Elliot Worthington), Norma Shearer (Marjorie), Gertrude Astor (Mrs Van Pelt), Huntley Gordon (Theodore Van Pelt), Lincoln Stedman (Bobby), Lillian Langdon (Mrs Worthington), Louise Fazenda (Mary).

Elliot Worthington falls in love with Myra, the maid in his sister's household, but Myra is dismissed when found trying on her employer's gown and cloak. Elliot finds her, proposes marriage, and returns home with his new bride. She is snubbed by his relatives and shocked by their and their friends' hypocrisy, e.g. a brother-in law who makes love to her and the affair that her husband's married sister is having. The film finds a metaphor for their treatment of her in a moment where they watch a rabbit torn to pieces by hounds. Disillusioned, she runs away: Elliot follows and saves her being hit by a train when her foot gets caught in a switch.

Leila Burton Wells, author of the story, was known mainly as a writer for *Harper's Magazine*; of the adapters, Hawks had already worked on *The Dangerous Age*, and this was Bern's fourth film for Stahl and Mayer; his reputation as a screenwriter has been overshadowed by the notorious circumstances of his death when married to Jean Harlow, but his record beyond Stahl's films was impressive, with Lubitsch's *The Marriage Circle* to follow soon.

Another Lubitsch link comes through the female lead, Marie Prevost, who had begun as a Mack Sennett Bathing Beauty and who moved on to more substantial roles: most famously, in the period just after *The Wanters,* in three Lubitsch films, *The Marriage Circle, Three Women* and the lost *Kiss Me Again.* Norma Shearer, early in her career, was apparently earmarked for the female lead, but Stahl is said to have refused her the part on the grounds that she was not "photogenic" enough! However, recalling the film in a memoir, Shearer, who played a smaller role, related a story complimentary to Stahl, which, if overblown in its ending, fits in with other reports of his grasp of acting technique:

> In one scene I had to walk down the great winding staircase in a palatial home, dressed from head to toe in a stiff metallic cloth without looking down. This

A characteristic deep-space composition: in the foreground, Robert Ellis and Marie Prevost.

which wasn't easy to do without falling on my face. John Stahl the director came to my rescue. 'My dear,' he said in a caressing whisper, 'when you walk down a staircase never look down. You should instinctively know where the step is. Look where you're going, the person you are to meet, which in this case is the camera. This gives you elegance, assurance.' Mr Stahl was teaching me more than I realized. In one simple scene I learned not only to walk downstairs without being afraid but also to walk through life without being afraid, not looking down but always ahead.[*]

Motion Picture Magazine (October 1924, 63ff.) contained a novelisation of *The Wanters*, a film-to-print version which testified to popular interest in the film's satirically inflected High Society setting.

Reviews. Film Daily (19 December 1923, 5) had a collection of excerpts from reviews in Cincinnati and Indianapolis which showed a range of clashing responses, especially to Marie Prevost. The *Indianapolis Star* praised "a performance that is both delightful and disarming", but the critic of the *Cincinnati Enquirer* found the film unoriginal, writing that "the Cinderella theme, while intrinsically appealing, is beginning to be rather tedious. It again appears in 'The Wanters', thinly and not at all clearly disguised." – much the same point is made in *Variety*, 12 March 1924. The *Indianapolis Star* and *Times* both singled out Stahl's direction, the *Star* referring to "the ever-intelligent supervision of John M. Stahl". C.S.Sewell in *Moving Picture World* (8 December 1923, 367) predicted box office success for a film based on "a live-wire theme of everyday life": like some other reviews, this one noted a familiar enough plot, but qualified any criticism by saying that "the admirable manner in which it has been handled and the fine work of a well-selected cast makes you overlook little inconsistencies". The writer ended by relating his experience of

[*] From the Norma Shearer website, normashearer.com

Shooting *The Wanters*. Stahl at left, in straw hat.

viewing the film at a site already associated with highly publicised runs of Stahl's films: "In Paterson NJ at the Garden Theatre, when the writer saw this picture at the supper show on the last day of a week's run, the house was filled and the lobby was jammed, the crowd extending out into the street at the beginning of the night show." ◆

Shooting *The Wanters*: three cameras trained upon the High Society setting.

Why Men Leave Home

3 March 1924. 8,002 ft. Held in Library of Congress and George Eastman House.
D: John M. Stahl. **P**: Stahl, Louis B. Mayer. **Sc**: A.P. Younger, from the play [1922] by Avery Hopwood. **Ph**: Sol Polito. **Ed**: Margaret Booth, Robert Kern. **AD**: Jack Holden. **Asst D**: Sidney Algier. **PC**: Louis B. Mayer. **Dist**: Associated First National Pictures.

Cast: Lewis Stone (John Emerson), Helene Chadwick (Irene Emerson), Mary Carr (Grandma Sutton), William V. Mong (Grandpa Sutton), Alma Bennett (Jean Ralston), Hedda Hopper (Nina Neilson), Sidney Bracey (Sam Neilson), Lila Leslie (Betty Phillips), E.H. Calvert (Arthur Phillips), Howard Truesdell (Dr Bailey).

The Dangerous Age had mixed melodrama and comedy, but this version by Stahl of Avery Hopwood's recent play was his first film wholly dominated by comedy. Off-screen contributors were A.P. Younger, who adapted the play, editors Margaret Booth and Robert Kern, and cinematographer Sol Polito, later celebrated for his work with Warners. *American Cinematographer* (July 1924, 12) noted that Polito "is being praised for his work in *Why Men Leave Home*". Publicity for Stahl's move to comedy linked it with the director's known proclivities for marital melodrama – he was described (*FD,* 18 March 1924, 6) as "Master at all times of the depiction of the ups and downs of married life" – and with his appeal to female audiences: "Oh! Boy! Women will leave home to see 'Why Men Leave Home'" (*EH*, 29 March 1924, 54). Various reviews attempted definitions of Stahlian comedy, part of an already developed tradition headed by Lubitsch. The *New York Times* (12 May 1924) called the film "an entertainment photoplay for adults, a serio-comedy", while *EH* (29 March 1924, 54) categorised it as "modern domestic drama" and "problem drama": "No more delightful problem drama has been produced in years". *Variety* asserted that Younger's handling of the text "ruthlessly" improved on Hopwood's source play (14 May 1924, 72). Stahl's reputation for bypassing censorship prompted the *New York Times* reviewer to say that "the censor has been rather lenient". *The Times* (Shreveport, Louisiana) notably remarked on Stahl's status: his "personal following is the envy of many established stars of the motion picture firmament" (17 August 1924).

Divorce in haste, repent at leisure: this is the warning of countless films of the 1920s and 1930s, from DeMille's *Don't Change Your Husband* (1919) and *Why Change Your Wife?* (1920) through the classic screwball comedies of remarriage *The Awful Truth* (1937) and *The Philadelphia Story* (1940). Stahl contributed a number of films to this genre, and *Why Men Leave Home* is a typical entry, a light comedy of manners suggesting that there's nothing like divorce to spice up a marriage and bring a couple closer together.

Lewis Stone and
Helene Chadwick
in *Why Men
Leave Home*.

The source was a 1922 play by Avery Hopwood, an extremely successful playwright
of the teens and twenties, known for his risqué comedies and playboy persona. (A
sometime lover of cultural critic Carl Van Vechten, Hopwood tried to keep his
homosexuality a secret; he died under somewhat mysterious circumstances,
drowning on the French Riviera at the age of 46.) As adapted by A.P. Younger, the
film is quite tame, though it nonetheless encountered some problems with censors.
It also seems to have shifted the sensibility of the play, which producer Irving
Thalberg criticised for building its comedy "at the expense of women". A First
National advertisement gives a sense of what he meant, and seriously mischarac-
terises the film, touting "Avery Hopwood's play of wasteful wives...Wives unthink-
ingly wasting youth, happiness, love...." Thalberg, a close friend of Younger, who
for a time headed the writing department at MGM, believed that it was imperative
that films appeal to women, whom he saw as the dominant movie audience.
(Interestingly, he argued that "A picture that will please women will please men, but
the reverse cannot be counted upon", the exact opposite of Hollywood's latter-day
philosophy, which puts a premium on attracting a young male audience). It is no
surprise that Stahl's treatment of the story largely adheres sympathetically to the
wife's perspective.

She is Irene Emerson (Helene Chadwick), whose husband John (Lewis Stone, in
the third of six films for Stahl) has become dull and neglectful. (Emerson seems to
have been Stahl's favourite surname, gracing the leads in at least three of his other
silent films as well as the outstanding *Only Yesterday* [1933].) He forgets their
anniversary, never wants to go out, and devotes his evenings to lying on the sofa
reading the newspaper. An amusing scene follows her persistent attempts to
distract his attention as he churlishly ignores her, eyeing the headline: "Husband

Hits Wife with Pick Handle – Claims She Annoyed Him." Helene Chadwick has a natural and playful warmth, and the skilful Stone is able to portray a rather stiff and clueless man without becoming wholly unlikeable. There is a very funny bit where he sees a bootee in his wife's knitting basket and jumps to the conclusion that she is pregnant, becoming exultant and suddenly protective – stopping her from shifting an armchair, whisking away a monkey statue based on some superstition ("You mustn't look at monkeys!") – to his wife's bafflement and great mirth when she gets the joke. The bootee is actually being knitted by their maid for her sister.[*]

This misunderstanding illuminates their basic conflict: John is a homebody who wants children, while Irene wants to see something of life first. "You had your little fling, you saw the world before you married – that's a man's privilege. But how about me?" she protests, to which he retorts, "You should have married a traveling salesman." Irene begins gadding about with several other wives, one played by future gossip columnist Hedda Hopper; their excursions are perfectly innocent, but while they believe their boring husbands are hard at work or snoring at home, they are actually out carousing with party girls. When two of the husbands are caught in a speakeasy raid, Irene realises her own danger and hurries home, but too late. John, bored and lonely, has taken out his attractive young secretary, Jean (Alma Bennett), and comes home with her perfume on his lapel. Though he's guilty of no more than a kiss, Irene decamps for Europe and demands a divorce, and John is "bewildered" to find himself swiftly remarried to the conniving Jean. In the farcical denouement, Irene's grandmother, unaware of this new wife, tries to get the couple back together by feigning illness and getting a doctor to quarantine the house, resulting in all the major players being trapped under one roof.

The grandparents are a charming old couple whose happy, affectionate marriage clearly presents a model for the young people who are too quick to give up at the first hint of marital strife. The film's values are conveyed with a subtle touch through a pair of scenes in which first Mary and later Jean struggle with dresser drawers that won't open. Mary calmly solves the problem by opening the drawer below and jiggling the stuck drawer from the bottom – at this point you wonder what this seemingly pointless bit of business is doing in an otherwise tightly scripted movie. But when Jean encounters a similar problem, becomes frustrated, and drags John in to fix the problem, it becomes clear that this tiny detail sums up the difference between the two women. Such details help to elevate a small-scale, interior-bound, and somewhat formulaic story, which is entirely dependent on the interest of the characters and the credibility of their interactions.

Jean is plainly mercenary, but she gets off very lightly. The savvy grandmother, abandoning her feigned illness, appeals directly to the bride, who has realised to her annoyance that her husband is still in love with his first wife, advising her to get an annulment and collect alimony. "Old-timer, you said a mouthful!" she responds, to which Grandma adds conspiratorially, "You know, we girls must stick together." Later, we see the resourceful Jean with another male victim, repeating the same tearful ploy she used on John: "I wonder what you must be thinking of me, after last night?"

[*] We may note that Stahl uses this same comedy situation as late as 1949, in his penultimate film *Father Was a Fullback*: see Bruce Babington's essay, page 253.

John and Irene, meanwhile, set off on a second honeymoon trip and are seen sharing breakfast in a train compartment. (Could this be the scene described as "perhaps the most intimate honeymoon scene ever screened" by Michigan's *Battle Creek Enquirer*?) Despite a publicity campaign suggesting that the film would provide a lesson to wives in how to keep their husbands at home, the script places responsibility on men, closing with the winking "MORAL: Husbands, talk to your wives – and take them out of an evening. Send them flowers now – don't wait until they're dead." Stahl continued offering advice to couples in his next film, *Husbands and Lovers* (1924), but seems to have worried that he was returning too often to the same themes, and announced to the press that he would move away from marital subjects, prompting the *Philadelphia Inquirer* to run the headline "Resolves To Stop Breaking Up Homes: John M. Stahl Has Wrecked His Last Home!" (16 November 1924, 65). Like the many husbands and wives in his films who toy with divorce only to reunite, Stahl would change his mind, return to his roots, and continue to mine the dramatic possibilities of troubled marriages for many more years to come. ◆

Imogen Sara Smith

Husbands and Lovers

2 November 1924. 7822 ft. Held in Library of Congress.
D: John M. Stahl. **P:** Stahl, Louis B. Mayer. **Sc:** A.P. Younger, from a story by Frances Irene Reels and John M. Stahl. **Ph**: Antonio Gaudio. **Ed**: Robert Kern, Margaret Booth. **AD**: Jack Holden. **Titles**: Madge Tyrone. **Asst D**: Sidney Algier.
PC: Louis B. Mayer Productions. **Dist**: First National Pictures.

Cast: Lewis Stone (James Livingston), Florence Vidor (Grace Livingston), Dale Fuller (Marie), Winter Hall (Robert Stanton), Edith Yorke (Mrs Stanton), Lew Cody (Rex Philips), Dick Brandon (Little Boy), Betsy Ann Hisle (Little Girl).

This was first of three films for Mayer made by Stahl after the company was amalgamated into MGM in April 1924. Though Stahl's move there was delayed till December 1925, these films were effectively MGM productions, but released for contractual reasons by First National. Another marital comedy, *Husbands and Lovers* was Stahl's wife's last credit. Her story was scripted by the previous comedy's scenarist, A.P. Younger, Madge Tyrone wrote the titles, Antonio (Tony) Gaudio, later famous at Warners, was the cinematographer, the editors again were Kern and Booth, and the on-screen lovers were the notable trio of Florence Vidor, Lewis Stone, and that most charming of lounge lizards, Lew Cody. By the mid-1920s marital comedy was seen as a significant part of Stahl's output. Edwin Schallert in the *Los Angeles Times* saw *Husbands and Lovers* as a "sort of corollary for" *Why Men Leave Home*, with the husband this time rather than the wife "gaining the audience's best favor" (5 November 1924, 49–50). The *Reading Times* (18 May 1925, 6) compared Stahl's mixing of drama and comedy to O.Henry and Belasco, and *Pictures and Picturegoers* (April 1925, 56) noted the film's excellence as "comedy-drama of modern marriage", even though "obviously indebted to [Lubitsch's] *The Marriage Circle*". Stahl himself, in a syndicated piece in the *Battle Creek Inquirer* (Michigan, 31 January 1925, 3) appeared as a marital philosopher, standing knowingly above his unstable characters: "In reality marriage is just the beginning of romance. The puppy love violets-and-candy period is merely a pleasant preliminary." With *Why Men* and *Husbands* only recently discovered in archives, *Memory Lane* languishing unseen, and *The Dangerous Age* still lost, along with the later *Fine Clothes* and *The Gay Deceiver,* this major part of Stahl's work has been largely forgotten.

Stahl's second film in a row on the theme of divorce and remarriage, *Husbands and Lovers* shows both a high degree of polish and a slightly sour tone that might indicate weariness with the formula. Lewis Stone returns as the once and future husband, but where in *Why Men Leave Home* (1924) his character was something of a fuddy-duddy, here his role is such a lavish caricature of masculine selfishness and insensitivity that there is little chance for him to earn any sympathy. Male solipsism and the

John M. Stahl
(centre) directs
Florence Vidor,
with Antonio
(later Tony)
Gaudio operating
the camera.

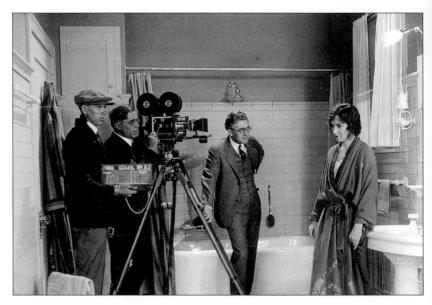

suffering it inflicts on women is a theme Stahl would explore keenly and feelingly in films such as *Seed* (1931) and *Only Yesterday* (1933); here, it is mostly played for laughs, and brushed away with an unconvincing happy ending. Nonetheless, *Husbands and Lovers* displays Stahl's deftness at capturing subtle details of behaviour, and includes some striking cinematic grace notes.

The film opens with a long scene illustrating a typical morning in the lives of a well-heeled married couple, James and Grace Livingston (Lewis Stone and Florence Vidor). Their routine involves Grace waiting on James hand and foot: preparing his bath, laying out his clothes, and cleaning up the mess he leaves in the bathroom. All this is shown in minute detail, as the wife checks her husband's socks for holes, empties his pockets, picks up wet towels and puts them in the hamper. He waves her out of the room when he is in his bath – coming on top of the twin beds they sleep in, this suggests a marriage without a speck of intimacy, and indeed, the couple has almost no physical contact throughout the film. As for the thanks Grace gets for her ministrations – it is James turning smugly from his dressing table to survey her in a kimono with her long hair hanging in a braid, and chiding her for untidiness, saying her hair looks like a rat's nest and that she should dress up in the morning, like he does. While she weeps over this insult he calmly eats his breakfast, ignoring the doorbell because answering it is, presumably, women's work.

That night, Grace returns with her hair neatly bobbed, and what is evidently an entire new wardrobe in the latest fashion. After yelling for her to hurry up because he's starving, James takes in her new look and announces, "Why, you look like a Hottentot!" Before she can dissolve into tears again, she is buoyed by a very different response from their bachelor friend Rex (Lew Cody), who immediately begins to flatter and flirt with her. Annoyed by these compliments, James nastily tells his wife that Rex "would tell a one-legged woman her crutch was becoming". (The film's snappy, occasionally acid titles are by Madge Tyrone.) However, James is alert enough to be dismayed when his wife sits down to talk with Rex, crossing

her legs and displaying a modest amount of silk-stockinged ankle; he hovers behind his friend, frantically and futilely gesturing at Grace to lower her skirts.

James's obtuseness is hard to penetrate. He does not get the point when Grace unveils a new tactic: he wakes the next morning to find that she has allowed him to oversleep, used the bathroom first and left a mess, failed to lay out his clothes, and is absorbed in doing exercises, ignoring his bumbling efforts to get ready. There is almost as much focus on laundry and clothing in *Husbands and Lovers* as there is on dish-washing in *The Song of Life* (1922): on top of this comedy of a man who cannot find a dry towel or a clean shirt in his own bedroom, there is a later scene in which Rex slyly sneaks James's dress trousers into the laundry bag so that he won't be able to go to the theatre. Grace's new wardrobe clearly gives her fresh confidence, and there is much attention to her wraps, her frocks, and, ultimately, her donning and then doffing a bridal gown and veil. (Stahl's next film would be *Fine Clothes*, an adaptation of Ferenc Molnár's play *Fashions for Men*, set in a clothing store.)

Florence Vidor is a perfect interpreter of Stahl's restrained, elegant, yet dryly amused style, though this was the only time he directed her. Vidor was a well-respected leading lady in the late teens and twenties, but has been forgotten since she retired with the coming of sound, and of her silent films only a few are still watched today – one being Ernst Lubitsch's *The Marriage Circle* (1924), to which *Husbands and Lovers* was compared by several reviewers on its release. Her two husbands are much better known: she was married to director King Vidor from 1915 to 1924, and went on to marry violinist Jascha Heifetz. Vidor is exquisitely beautiful without having a strongly distinctive look, and her style is low-key, natural, and self-contained, the other end of the spectrum from the mugging, gesticulating style that many still associate with silent film acting. In frequent but economical close-ups, she displays subtle but crisply legible expressions, like the wry disgust that passes over her face when James insincerely agrees with Rex's praise for her new hair-do, or her look of nervous apprehension as she pretends to read a book ("A Woman's Dangerous Age") while Rex amorously creeps up behind her. Vidor's loveliness and her air of poise and maturity make it even harder to forgive, or even comprehend, James's insulting treatment of Grace.

Lewis Stone had similar qualities of reserve, easy expressiveness, and humour, which made him a favourite of Stahl's. He is able, in a few extended close-ups, to show James sobered and saddened by the realisation that his wife has fallen for another man – but the script provides no suggestion that he ever understands why he has been, as he puts it, "a failure as a husband". The casting of Lew Cody seems like a deliberate attempt to ensure that Rex will gain no sympathy. Cody specialised in playing smooth cads and lounge lizards; his face is a reptilian mask that betrays no feeling. He has "other man" embroidered on him like a monogram, though his character does nothing more caddish here than woo his friend's neglected wife. The players in the love triangle are the film's sole focus; other characters, like the Livingston's maid and Grace's mother, are so minimally sketched in that they barely register.

The centrepiece of the film is a scene in which Grace, in a darkened room at a party, mistakes her husband for Rex and admits that she loves him, but insists that

she cannot betray her marriage. There is something Shakespearean about this mix-up, but Stahl gets away with the contrivance by cloaking it in beautifully cinematic style. Grace sits by a window, with bars of light falling through shutter-slats and slanting across her, a lovely half-lit image that distils her ambivalence. James stands almost completely concealed by darkness, with just a crescent of light tracing one side of his face; he advances into the light and then retreats back into the shadow, like the moon waxing and waning, as he listens silently to his wife's confession. Cinematographer Tony Gaudio, who masters the extremely low lighting in this scene, would go on to an illustrious career at Warner Brothers, shooting classics such as *Little Caesar, High Sierra, The Letter*, and *The Adventures of Robin Hood*.

James is the kind of husband who, on learning that his wife loves another man, says, "I'd better live at the Club while the lawyers arrange matters", and then has a civilised drink with his rival. He becomes slightly less civilised when he spends an evening alone with a quart of Scotch and his soon-to-be-ex-wife's picture ("I love you more'n you'll ever know – only I forgot to tell you", he apostrophises the portrait). He solemnly dons his hat and coat and, after attempting to exit through the closet, makes his way to his home in the snow, where he waits for Rex to come out and drunkenly punches him. However, he makes no attempt to reconcile with his wife until he turns up outside the house where she is set to marry Rex. The film concludes with an elaborate cross-cut sequence as Grace is forced to choose between the festive crowd assembled for the wedding, and her ex-husband, who emerges from the shadows of the yard and persuades her to run away with him. This climax is evidently meant to be at once romantic and comic, but it is, at least for this modern viewer, grossly misjudged. We are forced to watch, at excruciating length, as poor Rex stands at the altar, looking more and more foolish, with women guests snickering at him, then two male guests presenting him with a lily and falling into hysterics, as the little ring-bearer goes to sleep on his cushion. As played by Lew Cody, Rex may not be terribly appealing, but this is a humiliation one wouldn't wish on one's worst enemy. Meanwhile, in the joy of their reunion the former couple apparently doesn't give a thought to the jilted bridegroom, sneaking out the window together and driving off into the night. Nor is there anything to give us confidence that their marriage will be different than before. In waiting until her wedding night to come and snatch his ex-wife, James shows himself to be just as tactless as ever. The final title card avers, "When a woman is willing to marry the same man twice she is either in love with him – or just plain crazy." The second option seems all too plausible.

Perhaps it did not look this way to the film's original audiences. At any rate, reviewer Edwin Schallert wrote in the *Los Angeles Times* (5 November 1924, 49–50) that the final scene was "absolutely indescribable in its comedy. It is one of the funniest scenes that has gone on the screen lately in a serious feature." He also felt that "the husband stands out as the more sympathetic character, while in the earlier picture [*Why Men Leave Home*] the wife gained all the audience's best favor." Gaining popularity at a time when divorce was only just becoming more socially acceptable, remarriage dramas seem driven by conflicting desires to critique and affirm marriage, to flirt with being "modern" about adultery and women's autonomy, and yet to ensure a final retreat back into the romantic conventions of happily-ever-

after. These films made comedy out of the battle of the sexes and at the same time tried to smooth over the very divisions they illustrated, resulting in ambiguities that no doubt looked very different to viewers depending on their own attitudes. Another review in the *Reading Times* (18 May 1925, 6) provided an assessment that still holds true: "The picture is not a big spectacle. Neither does it present thrills, gorgeous sets nor countless mobs of extras. It is reliant chiefly on its ability to 'get under the skin' and it does do that in a decisive way." ◆

Imogen Sara Smith

Husbands and Lovers #2

We have noted earlier how hard it has been to gain unrestricted access to DVDs of the silent films, to enable the taking of frame stills. The one exception has been a condensed version of *Husbands and Lovers*, held and made available by the Netherlands Film Archive, EYE. To judge from its running time (29 minutes of DVD) and the number of inter-titles, it must constitute around one-third of the original. For a long time, until the Library of Congress yielded a full print, it seemed that this might be all that survived of *Husbands and Lovers*, and its abbreviated narrative in fact hangs together quite neatly: it starts with the romantic triangle already in place, and moves quickly on to the protracted set-piece of the new marriage and its disruption. Without all the early details of James's boorishness, anatomised in Imogen Sara Smith's essay, it is easy to be indulgent to him and to the comedy of his reclaiming of his wife; an account of the film based on this abridged EYE version would have been very misleading. Nevertheless, this version remains valuable for the scope it gives for illustration of Stahl's visual strategies at this mature stage of his silent careeer, with fourteen credited features behind him, five still to come.

In this condensed version we are quickly shown two eloquent images of Grace, caught between two men each with his own limitations: first alone and then observing them both coolly from afar.

Both images are characteristic of Stahl: first a long-held meditative close shot of Grace that enforces her role, like so many women before and after, as dramatic

Fig 1: Grace.

and moral pivot of the narrative, and then a wide shot that captures visually the situation in which she is caught: a precisely composed triangle with the men playing a symbolically weighty chess game in the foreground (Fis. 1 and 2). As often in these silents, going back to *Her Code of Honor*, the deep space of the wide image is now physically measured out, as Grace advances to join them within an unchanging set-up.

This formal strategy is sustained. The camera never once moves; the combination

Fig 2: (left to right) Rex, Grace, James.

Figs. 3 and 4: our view of James will be repeated as Grace's view See page 103

of deep/wide composition with judicious editing makes the footage that follows into a small masterclass of expressive staging.

After a long gap – a jump from 71 to 131 in the numbered intertitles, evidently spanning the mechanics of the divorce and its aftermath – the print resumes on the day of the new marriage: held not in church but in the woman's home, in the manner of so many American films, the classic sound-film example being the final scene of *The Best Years of our Lives* (1946) – and we may note that William Wyler's

Figs 5 and 6:
Grace's two
options, James
and the
ceremony.

long-take deep-staging style in that film, famously analysed and celebrated by
André Bazin, has clear affinities with that of Stahl.[*] The first image after the gap
shows Grace waiting while women bustle around preparing her wedding dress: this
time she is in the foreground, separate and pensive until one of them crosses the

[*] For Wyler's in-depth staging, see for instance Bazin's essay 'L'Evolution du langage cinématographique' in *Qu'est-ce
 que le cinéma? I: ontologie et langage* (Paris, Editions du cerf, 1958), with a still of the domestic wedding scene.
 Subsequently translated by Peter Graham as 'The Evolution of Film Language' for his edited collection *The New Wave:
 Critical Landmarks* (London: Secker and Warburg, 1968)

Fig 7: Beyond the
doorway:
bridegroom and
clergyman await.

space to join her. We thus know that Grace has reservations about what she is getting into. As if in response to our thoughts and hers, James is now shown to us in long shot, lingering in the darkness outside, his face illuminated by the headlights of a passing car. Now in her wedding dress, still pensive, Grace turns towards the balcony and sees him, illuminated by another car: the image of him (identical set-up) has become a POV shot (Figs. 3 and 4 – page 101).

From this point Grace's dilemma, to go through with the marriage or not, is played out entirely in visual and spatial terms. In one direction is James, in the other is the site of marriage: the barrier in one direction is the balcony railing, in the other the door beyond which the countdown to the ceremony has begun. James advances to the balcony and they meet wistfully, in the light of a full moon: despite the characters' age and experience, the Romeo and Juliet associations are hard to miss (Fig. 5). The countdown continues: a trio of beautifully composed shots – again, same set-up each time (Fig 6) – shows us Grace turned towards the door beyond which bridesmaids and others move to take their place, culminating in the walk-past of her youthful attendant, leaving her again on her own.

Grace is about to cross her barrier: once she goes through the door she will be absorbed into another deep space, that of the marriage ceremony (Fig 7).

But as she reaches the threshhold, James calls to her (Figs. 8 and 9, over page).

She stops ahead of her barrier, he crosses his, climbing over the railing: soon she has changed out of her wedding dress, and drives away with James.

There is more to the final section than this: cross-cutting not only between Grace's two directions, door and balcony, but between her space and the build-up to the ceremony, shown in lavish detail and widely praised at the time by commentators (though less so by Imogen, above): the repeated playing of the Wedding March,

Figs 8 and 9: The decision which barrier to cross.

the growing impatience of Rex, the growing amusement of others at his expense. The skilled integration of these two levels of cross-cutting makes this final section – almost devoid of intertitles – a fine demonstration of Stahl's methods, and altogether a classic illustration of the power of the mature silent medium.

Charles Barr

Fine Clothes

9 August 1925. 6,971 ft. Presumed Lost.
D: John M. Stahl. **P**: Stahl, Louis B. Mayer. **Sc**: Benjamin Glazer, from a play by Ferenc Molnár.
Ph: Ernest G.Palmer. **Ed**: Margaret Booth, Robert Kern. **AD**: Cedric Gibbons. **Color consultant**:
James Basevi [probably for tinting].
PC: Louis B. Mayer Productions. **Dist**: First National Pictures.

Cast: Lewis Stone (Earl of Denham), Percy Marmont (Peter Hungerford), Alma Rubens (Paula),
Raymond Griffith (Oscar), Eileen Percy (Adele), William V. Mong (Philip), Wilmuth Merkyl
(Receiver), Otis Harland (Alfred).

*Peter Hungerford, the kind-hearted proprietor of a London clothing store, on Christ-
mas Day loses both his wife and his business when she takes all of his savings and
runs off with Oscar, the clerk. Forced into bankruptcy, Peter becomes the manager
of a cheese business owned by his patron the Earl of Denham. The Earl also hires
Paula, Peter's former cashier; aware of the Earl's amorous intentions, Peter keeps
strict watch over the girl, leading to comic sequences where, with Paula seeking the
material benefits of a liaison with the Earl, they are trying to be alone together, but
Peter keeps interrupting them. The Earl, finally driven to distraction, fires Peter, but,
overtaken by remorse, he soon rehires him. The creditors who had put Peter's store
into receivership request that he return as manager, and he leaves the estate,
upbraiding Paula for her announced intention of staying on as the Earl's companion.
Paula then realises that she loves Peter and follows him back to the shop, where
she takes charge of him and his affairs on a permanent basis.*

This film was based on *Fashions For Men* (1917) by the Hungarian
playwright Ferenc Molnár, whose translated dramas had many Broad-
way productions, including eight between 1923 and 1925. *Fashions For
Men* ran on Broadway from December 1922 to February 1923. The play
was translated and directed by Benjamin Glazer, who then wrote the film
script. Glazer was a distinguished scenarist who credits include *The
Merry Widow* (von Stroheim, 1925), *Flesh and the Devil* (Clarence Brown, 1926) and
Seventh Heaven (Borzage, 1927). *Fine Clothes* was the first of three consecutive
films written for Stahl – the first two for Mayer Productions, the third, *The Gay
Deceiver,* for MGM – all three having as editor Margaret Booth (here with Robert
Kern), and as supervising art director Cedric Gibbons, though with different
directors of photography, in this case a familiar Stahl colleague, Ernest Palmer. The
film's setting was changed from Budapest to London, making the characters
English.

Left and right pages: Eileen Percy, Raymond Griffith, Percy Marmont; Lewis Stone, Alma Rubens

The typically strong Stahl cast, much remarked on in reviews, had the English actor Percy Marmont (known for many major roles both silent and sound, including three in England for Hitchcock), in the leading role of Peter. Lewis Stone played the Earl, in the fifth of six roles for Stahl. At the time of the film, Stahl was quoted as saying of Stone that "I like him personally, and I like him on the screen because he is so natural, confident and sincere… He can be a composite of strength and weakness on the screen, and his varying moods can make him either, according to the demands of the role." (*Oakland Tribune,* California, 4 September 1925). Raymond Griffith, best known as a silent comedian, played Oscar, the duplicitous clerk who runs off with Peter's wife, an unconventional casting remarked on at the time. Alma Rubens, a major star before drug addiction ended her career, played Paula, Peter's former cashier and eventual partner.

Publicity included a major tie-in in *Exhibitors Trade Review.* A full-page advertisement (12 September 1925, 33) urged readers to watch for First National's announcement of tie-ups on *Fine Clothes*, described as "the greatest picture John M. Stahl, the most consistent director of big money makers, has ever directed". This was followed (19 September 1925, 21–37) by a very large tie-in section, part advertising the film, part advertising luxury clothing. *Motion Picture News* (19 September 1925, 1386) has an advertisement for the film aimed very much at exhibitors, featuring nine different smaller newspaper advertisements posted by cinemas, which give an idea of the lavish publicity coverage.

Reviews: MPN (7 November 1925, 2194), in its "Newspaper Opinions on New Pictures", printed excerpts from the New York papers' reviews, which were generally, if unexcitedly, affirmative, the *Times* finding it "an agreeable diversion having the great advantage of a distinguished cast". The *Herald* noted that "The fact that that invaluable director, John Stahl, directed the picture helped a lot", and added

whimsically: "Best of all we liked Lewis Stone as the pleasing Earl of Denham. And how Paula ever withstood him is more than we could understand." *Motion Picture News* began its review with "Once again John M. Stahl comes forward with a picture which has all the earmarks of a ready-made box office success", noting too that "He has as usual given the feature an artistic background".

Some criticisms echoed those made of certain early Stahl films, of slowness and excessive length. *Moving Picture World* (15 August 1925, 734), in an otherwise positive review, argued that "The film as shown to reviewers has one big fault – it is far too long", with too many details and incidents, needing the excision of more than a reel. *Variety* in a very negative review complained that the adaptation of Molnár's play is "nothing more than a story told entirely by subtitles and illustrated by more or less motion pictures of its characters" (21 October 1925, 35). In contrast, *Photoplay* (September 1925, 8) judged it to be "produced with a dash of spice and touch of humor as only John Stahl could do it", while *ETR* named it "One of the year's finest pictures… a perfect creation".

Of most interest is the way *ETR*'s advertising and reviews reduce the narrative's multi-focussing into concentration on the single character of Paula, referring to "this delightful story that surrounds a girl's search for happiness" (29 August 1925, 7), and "A Chapter from the Life of a Poor Girl Who Craved Luxury More Than Love" (19 September 1925, 24). This seems to suggest an attempt to simplify for audiences what seems – pending rediscovery – to have been a thematically and tonally complex film by prioritising one strand of it. ◆

Memory Lane

17 January 1926. 6,825 ft. Held by Time-Warner (approx. 6,000 ft.)
D: John M. Stahl. **P**: Stahl, Louis B. Mayer. **Sc**: Benjamin Glazer, from a story by Glazer and Stahl. **Ph**: Percy Hilburn. **Ed**: Margaret Booth. **AD**: Cedric Gibbons, Arnold Gillespie. **Asst D**: Sidney Algier.

PC: Louis B. Mayer Productions. **Dist**: First National Pictures.
Cast: Eleanor Boardman (Mary), Conrad Nagel (Jim Holt), William Haines (Joe Field), John Steppling (Mary's Father), Eugenie Forde (Mary's Mother), Frankie Darrow (Urchin), Dot Farley (Maid), Joan Standing (Maid), Kate Price (Phone Booth Woman).

This was the third of the films that Stahl made at MGM even before his move there was announced. Irving Kaufman's 1924 version of the song the film is named after is on YouTube. The three actors in the lovers' triangle were all major stars: Eleanor Boardman, Conrad Nagel and William Haines. Stahl eulogised Boardman: "Apart from being one of the most sensitive actresses I have ever directed, Eleanor Boardman seems to understand better than any other star the psychology of the average American woman. This is the type she knows how to mirror perfectly on the screen" (*Hartford Courant*, 10 January 1926, 44). Haines was also a considerable star with his good-naturedly bumptious "Harvard Boy" persona, which Joe's impersonation of flashy vulgarity allows him to parody. Conrad Nagel is defined for many today by his elderly appearance as the dull suitor in Sirk's *All That Heaven Allows* (1954), but the *Los Angeles Times* article "Popular Duo Play in Stahl Picture" (2 July 1925, 29) reminds us how tastes change: "It looks as if there is to be a new Pyramus and Thisbe team in picturedom. Eleanor Boardman and Conrad Nagel have been playing lovers on the screen for some time." It suggests, wrongly, that Nagel will have the more romantic part, and the film's posters feature Boardman and Nagel, not Haines.

> "In the old days of the movies ('way back in 1923) a director was known by his ability to build colossal settings, to crowd the screen with enormous mobs of people and to tell a complicated story with the maximum effort. Nowadays, in this enlightened age, a director is known by his ability to avoid colossal settings, to employ the fewest possible characters and to tell a simple story in the most casual manner. The latter feat is the more difficult, as it necessitates a considerable display of restraint by the director. John M. Stahl has done just this in his last two pictures, "Fine Clothes" and "Memory Lane," and I can see no reason why he should not qualify as a member of that small group of progressive directors who constitute the hope of the silent drama."
> (Robert Sherwood, writing in *Life* magazine in 1926).[*]

[*] Robert Sherwood, "The Silent Drama", *Life*, 25 February 1926, 24. Thanks to Ned Comstock for calling my attention to this informative review.

A sentimental comedy, *Memory Lane* can be seen as one of Stahl's mid-1920s experiments with a new sort of plot and a new way of creating emotionally affecting scenes. On the evening of her wedding to Jim (Conrad Nagel), Mary (Eleanor Boardman) is confronted by Joe (William Haines), a former beau who has been out of town for a year. Mistakenly dragooned to drive the car for the newly married couple, Joe quarrels with the groom and speeds off with the bride. They spend the night miserably in the car after running out of gas, and the next morning Mary returns to the groom. Some years later, Joe visits the couple and their baby. Mary is repulsed by his coarse, vulgar demeanour and decides she made the right choice, but her husband realises that Joe has put on an act to ensure the happiness of the woman he still loves. The film was criticised by *Variety* (3 February 1926, 20) for the slightness of the plot but it was praised for these same qualities by others. The *New York Times* described it as "an amusing, smoothly running small town comedy", in which the plot unfolded, "with a gentle appreciation for subtlety" (2 February 1920, 20). *Film Daily* noted: "'Memory Lane' is as subtle and pleasing a bit of entertainment as anyone would want. It has a simple little story that probably wouldn't get very far without the unusually fine treatment given it by director Stahl" (31 January 1926, 5). The simplicity of the plot for which Stahl is both blamed and praised in the case of *Memory Lane* stands in sharp contrast to the complex plots and histrionics of the early melodramas such as *One Clear Call*, replete with what *Film Daily* called "enough material, in the way of climaxes and situations, to fill several feature productions".

Memory Lane is thus an important film, in my view one of the clearest early indications of the shift in treatment and approach that gave rise to the great melodramas Stahl would make at Universal in the 1930s. In "John Stahl: Melodrama, Modernism and the Problem of Naïve Taste", I have argued that this shift

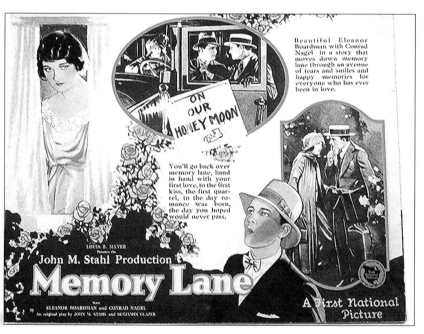

was inspired by the understated style and indirect mode of narration typical of the sophisticated comedies which burgeoned in the 1920s following the release of Chaplin's *A Woman of Paris* in 1923.[*] Ernst Lubitsch is the director who is most commonly associated with the elaboration of sophisticated comedy as a genre, but other directors such as Harry d'Abbadie D'Arrast, Monta Bell, Malcolm St. Clair and Hobart Henley also made important examples of the form. In an article on Stahl written in 1924, Whitney Williams of the *Los Angeles Times* asserted a similarity between Stahl and Lubitsch, classifying them both as exemplars of a "Viennese school" of direction: "Whenever it is possible a light situation is utilized, albeit the lightness may be far more subtle than a heavy dramatic situation" (14 December 1924, C29).

The influence of sophisticated comedy on Stahl may be traced in his comedies of marital infidelity made in the middle 1920s: *The Dangerous Age*, *Why Men Leave Home* and *Husbands and Lovers*. The lost film *The Dangerous Age* is classified by the *American Film Institute Feature Film Catalog* as a drama, but a continuity held at USC indicates that it dealt humorously and sympathetically with a forty-year-old man's dissatisfaction with his marriage and attraction to a much younger woman. *Husbands and Lovers* deals with the reverse situation: Grace Livingston (Florence Vidor) modernises her appearance to the dismay of her husband (Lewis Stone) and the admiration of Rex (Lew Cody). Grace's attraction to Rex leads to a divorce, but her former husband takes matters in hand and carries her off before she can marry the other man.

Eleanor Boardman, Conrad Nagel.

Further evidence of the influence of sophisticated comedy on Stahl is the three films he made with screenwriter Benjamin Glazer. *Fine Clothes*, released in August 1925, was adapted from Ferenc Molnár's comedy *Fashions for Men* which Glazer had translated and directed on Broadway. *The Gay Deceiver*, released through MGM in October 1926, was based on the comedy *Patachon* by Maurice Hennequin and Félix Duquesnel as adapted by Achmed Abdullah under the title *Toto* for the New York stage (1921). *Memory Lane*, the final Stahl/Mayer production released through First National in January 1926, was from an original script credited to Glazer and Stahl. Glazer may also have influenced the casting of *Memory Lane*. He had provided the story for Hobart Henley's flapper comedy *Sinners in Silk*

[*] *Modernism/Modernity*, v.19 n.2 (2012), 303–320; see also *The Decline of Sentiment: American Film in the 1920s* (Berkeley: University of California Press, 2008), 79–126.

(MGM, September 1924) which had Eleanor Boardman and Conrad Nagel in major roles, and thus presumably would have known their work.

Memory Lane may be divided into four acts. In the first act, Mary sneaks out of the house and meets Joe on the night before her wedding to Jim. The tone is nostalgic and sad rather than comic. As they pass the old schoolhouse they reminisce about their first meeting and about growing up together. Their conversation is interspersed with cutaways to a group of boys singing on the village green (fragments of the song lyrics are quoted in the intertitles). The first is "When You Were Sweet Sixteen", James Thornton's 1898 hit and a barbershop quartet standard, and the second is the eponymous ballad by Buddy De Sylva (lyrics) and Larry Spier and Con Conrad (music). The chorus is worth quoting in full:

> I am with you, wandering through memory lane.
> Living the years, laughter and tears, over again.
> I am dreaming yet, of the night we met, when life was a lovely refrain.
> You were so shy, saying goodbye, there in the dawn.
> Only a glance, full of romance, and you were gone.
> Though my dreams are in vain, my love will remain.
> Strolling again, memory lane with you.

Mary tells Joe she would have waited forever for him, but he did not ask, and now it is too late: she feels obliged to carry through with her promise to marry Jim. She embraces him and they part.

The second act is beautifully shot, making use of aperture framings of the wedding through a front window of the house, and later, varied framings through the windshield, windows and door of the car that contains Joe, Jim and Mary. Stahl also organises terrific compositions in depth in the relatively confined space of the car. For example, the windshield frames Joe driving in the foreground, cordoned off from Jim and Mary in the back seat. Cut in to the back seat as Jim turns to Mary. A face appears in the rear window, one of the wedding guests who is hanging onto the car. Jim gestures to Joe to go faster. Cut back to the original framing through the front windshield to show the guest visible through the back window, Jim and Mary in the middle-ground, and Joe in foreground.

The wedding which begins the act is given largely from the perspective of Joe and a small boy who watch it from outside. This scenario is similar to the wedding viewed from the point of view of the waiting children in *The Child Thou Gavest Me* but is developed here with more point of view editing. Over the course of the ceremony, Joe's tears in the exterior are echoed by Mary's within, stressing a regret which is not evident to other wedding onlookers and participants.

The film shifts into a light comic register with the device of having Jim mistake Joe for the driver of the wedding car. When the young husband finally realises his mistake, a quarrel develops between the men. It inspires Joe impulsively to drive off with Mary, leaving Jim to walk back to town in the rain. When Jim arrives back at Mary's house, gossip spreads through the town initially from house to house and then via telephone, the latter process indicated through the comic device of animated telephone wires lighting up as the number of callers increases.

The handling of the night that Joe and Mary spend together is clearly indebted to the indirect narration and non-moralised attitude of sophisticated comedy. Joe, outside the stopped car, tries to signal to Mary within that they are out of gas. They gesticulate and try to speak to each other without words (a recap of the situation of the silent film actor). He re-enters the car and confirms that they are out of gas and miles from anywhere. A side view of the car shows Joe in the front seat and Mary in the back, framed through separate windows. She puts her head down and begins to cry. Cut to the interior of the Bradley living room where Jim sits waiting with Mary's parents. Her father, distraught, refuses a cup of tea proffered by Mary's mother. She puts her head down and begins to cry. Cut to the car, a view through the rear window showing that they are now both in the back seat. Mary continues to cry and leans her head on Joe's shoulder. Cut to a town gossip on the phone, and then to a shot of exterior telephone wires alight with multiple calls. Cut to the car, where we see Mary and Joe asleep in the back seat. Fade to black.

This elliptical and amusing evocation of an innocent but potentially scandalous night is typical of the "lightness" associated with Lubitsch and what the *Los Angeles Times* reviewer referred to above saw as the "Viennese school" of direction. The aftermath of the contretemps is similarly treated in a light-hearted and anti-climactic mode. Joe and Mary wake up to find themselves in a field, surrounded by farm animals, and viewed with some amusement by two farmers passing by in a hay cart. A cut away to the Bradley establishment, where Jim, who has been put to sleep upstairs, awakes, covers an ellipsis to the next scene, in which Joe and Mary pull up in front of the family house in the car. Joe wants to go inside with her and proclaim his love to her family, but she gently tells him goodbye. Inside, Mary's father blusters to his wife about his daughter "spending the night with that ne'er-do-well –God knows where!" Mary enters just after he finishes this line. Her father begins to make a scene but her mother calmly tells her that Jim is upstairs. When Mary finds Jim upstairs, he is delighted to see her and they resume their relationship without any questions on his part.

The third act is largely preparation for the fourth. Jim presents Mary with a bungalow for a wedding present. Sometime later, the couple play with their baby on his first birthday. As in the case of *The Child Thou Gavest Me,* the antics of the baby are prolonged and received much favourable commentary in the trade press (*plus ça change, plus c'est la même chose*). Joe's return to town is noted by the town gossips, one of whom somewhat maliciously passes on the news to Jim and Mary during the birthday celebration. The fourth act is constituted by Joe's visit. Mary eagerly dresses up and anxiously awaits his arrival, only to be disappointed by Joe's vulgar overdress and loud and boorish behavior.

Joe: Mary, do you remember the night before your wedding?
Mary looks away from him, smiles and nods.
Joe: And do you remember how we cried when we said goodbye?
Mary nods gently. Joe continues talking, leaning over toward Mary. Then he leans back in his chair and laughs very loudly. Mary looks right in his direction, surprised.
Joe: Weren't we a couple of saps?

Joe continues laughing and rocks back in his chair. Mary looks shocked. Jim joins them at the table.

Joe: Mary and I were talking about the fool mix-up we had on your wedding night.

Joe laughs. Jim looks stricken. Mary looks down, embarrassed.

Joe: Oh, boy, how near I came to breaking up this happy home!

Joe continues laughing, and claps his hands to his belly in glee. He puts a lot of salt on his celery and eats, chewing with his mouth open and talking at the same time.

After dinner, Jim takes Joe to the train, the two of them framed through the front windshield. As they pass the old schoolhouse, Joe asks Jim to stop and they hear some boys singing "Memory Lane." Tears come to his eyes. This is what enables Jim to see through Joe's act and discover that his deception was motivated by a desire to see Mary without hurting her.[*]

There was quite a bit of discussion of the final act in the trade and general press. The reviewer for *Life* plausibly assumed that given Glazer's familiarity with Molnár, he was borrowing from the latter's comedy *The Phantom Rival* which opened in an adaptation by Leo Ditrichstein (who also played the title role) at the Belasco Theatre in 1914 (Sherwood, *Life,* op.cit.). According to a highly laudatory review of this production in the *New York Times* ("Ditrichstein Plays a Triple Triumph", 7 October 1914, 9), Mrs. Marshall quarrels with her husband over an old love letter from one Sasha Taticheff whom she had known eight years before and whose promised return she fantasises about in various heroic guises which make up the second act.

> It is the suggestion of the comedy that every woman carries in the veiled recesses of her a mind a vision of her first love who holds a place in her secret thoughts so secure that no successor, be he suitor or husband, can ever really dislodge him [...] he is dislodged finally not by her ardent husband but by himself in the flesh [...] The contrast between the heroic figure of her own fancy and the extremely prosaic Russian Attaché who is most deeply interested in her husband's brandy is calamitous.

The *Los Angeles Evening Express* (19 April 1926) cites a different precedent, the film *Private Affairs* (Producers Distributing Corp., 1925) based on the short story "The Ledger of Life" by Georges Patullo which appeared in the *Saturday Evening Post*. In that film, one of several plot lines concerns a married woman who "thinks she loves an old sweetheart until she sees him come home a cheap dandy, and then realizes she has married the man she loves". The reviewer goes on to point out that in Stahl and Glazer's version the status of the wife's disillusionment has been altered since the idealised rival merely *assumes* the pose of a "cheap dandy", and that he is is in fact more attractively sentimental than he appears.

If, as the references to *The Phantom Rival* and *Private Affairs* suggest, we take the wife's disillusionment with her former lover as the basic comic topos, then the twist

[*] This analysis of Stahl's editing is based upon the Silent Cutting Continuity (no date), marked "Film Editor: Margaret Booth", Memory Lane, *John Stahl Collection*, Cinematic Arts Library, Doheny Library, USC, Los Angeles (with thanks again to Ned Comstock). The print I viewed from Time-Warner had displaced footage in the first and second double reels so that while all of this footage survives, it is not all – at least as of 2017 – in the correct order.

that Stahl and Glazer give to the ending of *Memory Lane* presents a significant variation of the plot. Their ending re-inscribes the romantic melancholy of the opening (and of the title song) for Joe, for Jim, and for the spectator, but not for Mary herself. In doing so, it introduces some question as to what Mary would feel if she had a full understanding of the motivation for Joe's actions. In its irony and bittersweet tone, the film's final act clearly points to the film's origin in the best farcical or comic traditions of the 1920s, as well as to the director's continued investment in melodrama and the affairs of the heart.[*] ◆

Lea Jacobs

[*] The Cutting Continuity indicates there is footage missing, at least as of 2017, from the end of the print viewed which clearly tried to mitigate this problem. The script records two missing intertitles spoken by Mary to Jim at the very end of the film: "Jim, you don't think I'm still in love with him", and "Three years of married life – a baby and you – have left no room for anyone else in my heart".

The Gay Deceiver

29 September 1926. 6,624 ft. Presumed lost.
D: John M. Stahl. **P**: Stahl, Louis B. Mayer. **Sc**: Benjamin Glazer, from the play *Patachon* by Maurice Hennequin and Félix Duquesnel, adapted by Achmed Abdullah as *Toto* [1921].
Ph: Antonio Gaudio, Maximilian Fabian. **Ed**: Margaret Booth. **AD**: Cedric Gibbons, Merrill Pye.
Titles: Douglas Furber. **Wardrobe**: Kathleen Kay, Maude Marsh, André-ani. **Asst D**: Sidney Algier.
PC: MGM. **Dist**: MGM.

Cast: Lew Cody (Antoine de Tillois/Toto), Malcolm McGregor (Robert Le Rivarol), Marceline Day (Louise de Tillois), Carmel Myers (Countess de Sano), Roy D'Arcy (Count de Sano), Dorothy Phillips (Claire), Edward Connelly (Lawyer Merinville), Antonio D'Algy (Merinville's nephew).

Antoine De Tillois leaves his puritanical wife and in Paris becomes known as King Toto, leader of the Bohemian set. Their daughter, Louise, spends eight months of each year with her mother in Blois and four in Paris with her father, her sole concern being to see them reunited. Although Louise has fallen in love with Robert Le Riverol, a young friend of her father's, she vows not to marry until she accomplishes her aim of bringing her estranged parents together; consequently, Toto pretends to reform and announces he is giving up his Paris life to return to his wife. Merinville, her accountant, and his nephew – both after Louise's money – discover that Toto has been corresponding with the Countess De Sano, his latest mistress; they try to blackmail him and scheme to get an annulment of Louise's marriage, but Toto thwarts their plot. When the Countess absconds with her husband's secretary, Toto and his wife are reconciled.

This was Stahl's first film credited to, and released by, MGM after the end of the distribution contract between Mayer Productions and First National. The script, another adaptation by Benjamin Glazer, his third writing credit for Stahl, is from the play *Patachon* (1907) by the prolific French comedy writer Maurice Hennequin, in collaboration with Felix Duquesnel. (The meaning of the French title is hard to define, but it certainly has connotations of dissipation and sexual excess). Hennequin had sixteen comedies, or musical comedies, staged on Broadway between 1897 and 1926, including the film's source, *Toto*, a version of *Patachon* performed in March-June 1921. Even if Stahl was too busy to see it, he would have been aware of it. *Toto* (the protagonist's nickname) was Stahl's working title for the film.

The play within the film in *The Gay Deceiver* attests to Stahl's abiding interest in the theatre.

As an MGM production, the film has fuller credits than Stahl's previous films, even more than for the later Mayer productions. This was the fifth editing credit Margaret Booth had for Stahl. Lew Cody starred for the second time in a Stahl film, as the ageing roué, Toto, a variation on the "he-vamp" seducer parts he specialised in; *Film Daily* noted that "Cody, for repeated performances of the same trend, won for himself the enviable position of the screen's worst home wrecker." (19 September 1926, 9). Three significant actresses, Dorothy Phillips (the wife), Marceline Day (the daughter), and Carmel Myers (the mistress) played alongside him. The risqué nature of the play was toned down by Stahl, who defended the softening of the hero's near-pathological sexuality."He had to be reformed enough to screen restrictions without destroying the sophisticated nature of the play" (*Daily Republican*, Rushville, Indiana, 14 October 1926, 9).

Reviews: The scarcity of reviews is a probable indicator of the film's box-office failure. *Variety* noted that, despite his popularity, Lew Cody is "not popular enough to put this over as a blue ribbon proposition.... Photographically there is little fault to find with this one, but it seems stretched to almost the bursting point with little to commend it as a sterling standard b.o. presentation" (8 October 1926, 52). *Film Daily* (19 September 1925, 9) described it as a "fairly interesting vehicle, but picture runs a trifle long for the story material". As with the *Variety* review, little about this lost film can be reconstructed from the comments, though Stahl is praised for providing "a first rate production". The *Film Daily* critic does, however, give some important narrative details missed by the American Film Institute synopsis. The

miniscule entry among "Brief Reviews of Current Pictures" (*Photoplay Magazine*, January 1927, 8) runs: "Plenty of glitter of the Paris variety in this entertaining piece" – more positive, but equally unspecific. Falling, like the earlier *Fine Clothes,* into the category of sophisticated comedy, it seems to have been too sophisticated for the wider audience.◆

Lew Cody, Marceline Day.

Lovers (aka Lovers?)

9 April 1927.* 5,291 ft. Presumed lost.
D: John M. Stahl. **P**: Stahl. **Sc**: Douglas Furber, Sylvia Thalberg, from the play
El Gran Galeoto by José Echegaray. **Ph**: Max Fabian. **Ed**: Margaret Booth. **AD**: Cedric Gibbons,
Merrill Pye. **Titles**: Marian Ainslee, Ruth Cummings. **Wardrobe**: André-ani. **Asst D**: Sidney
Algier.
PC: MGM **Dist**: MGM.

Cast: Ramon Novarro (José), Alice Terry (Felicia), Edward Martindel (Don Julian), Edward
Connelly (Don Severo), George K. Arthur (Pepito), Lillian Leighton (Dona Mercedes), Holmes
Herbert (Milton), John Milian (Alvarez), Roy D'Arcy (Señor Galdos).

*Young José lives with his guardian, Don Julian, a middle-aged diplomat recently
married to young Felicia. Society gossips in Madrid find the situation increasingly
scandalous. José resents a slur overheard in a club and challenges the perpetrator
to a duel. Don Julian preempts him, but is killed fighting the duel. José revenges
his death and is then banished for the killing. Later, José and Felicia are reunited on
a ship bound for Argentina.*

Stahl's penultimate film at MGM, before his move to Tiffany-Stahl, was
adapted from a play by Charles Frederic Nirdlinger, produced on
Broadway in 1908, based in turn on a Spanish play, *El Gran Galeoto*
(1881), by Jose Echegaray Y Eizaguirre. An earlier American film
version, now lost like this one, was released in 1920, and is likely to have
been seen by Stahl: *The World and His Wife*, directed by Robert
G. Vignola.

Stahl's working title, *The Great Galeoto*, would have signified little to American
audiences, and was changed ahead of the release date; the first release title seems
to have been *Lovers?*, complete with a question mark which mimics the question
around which the gossip that dominates the narrative circulates; but this was soon
simplified to *Lovers*.

Of the film's two script writers, Douglas Furber was an English writer who had
supplied the titles for *The Gay Deceiver*; Sylvia Thalberg, sister of Irving Thalberg,
had a short career as an MGM writer, her best-known work being for two Joan
Crawford films and the 1930 version of *New Moon*. The cinematographer, Max

* The footage count indicates a running time that is short by the standards of MGM features with major stars and a
distinguished director, suggesting problems of an undetermined nature with the production.

This page and the following: Images of the two stars.

EDWARD CONNELLY-RAMON NOVARRO-ALICE TERRY-LILLIAN LEIGHTON in"LOVERS"

Fabian, worked on all three Stahl MGM films. The stars, even by MGM standards, were a glittering pair. Alice Terry, wife of Rex Ingram, became famous through his *Four Horsemen of the Apocalypse* (1921), and starred in a number of his other films, including opposite Ramon Novarro in *Scaramouche* (1923), in *Where the Pavement Ends* (1923) and in *The Arab* (1924). Novarro was at the height of his early career, with his part in *Lovers* situated between two of his greatest roles, the titular hero in both *Ben-Hur* (1925) and *The Student Prince in Old Heidelberg* (1927). Though relations between Stahl and Mayer may have begun to decline, this pairing of Novarro and Terry was exceedingly glamorous and suggests Stahl was still a prestige director in the studio's eyes.

Reviews: *MPN* (20 May 1927, 1954) has a collection of excerpts from Los Angeles newspaper reviews that are highly commendatory. "Novarro's clear-cut characterization one that only he could give so adequately" (*LA Express*), "Novarro gaining in popularity in every picture. Has personality and real ability" (*LA Record*). Stahl's direction and the film's technical excellence were much praised. "Photography has the mark of distinction; direction has polish and effectiveness" (*LA Herald*), "Director Stahl did his work well. Production that for smoothness and directness is not often equalled in program features" (*LA Express*).

However, a prevalent opinion was that despite the film's technical mastery and pictorial beauty, it was slow and static. This is most fully encapsulated in the *Variety* review (20 April 1927, 21):

> A screenplay of stunning pictorial beauty, photographic excellence and fine acting, but lacking in the prime essential – sustained dramatic interest. On the speaking stage it may have had a grip, but in screen form it is weak in action, meager in development, and tepid in character interest. It takes an enormous footage of titles to make the exposition clear. Much of the film

merely shows people talking to each other in pairs, trios or in groups with the titles to explain what they said. There is no real drama in this. Only spirited scene in the six or so reels is a duel with swords between hero and heavy. The director seems to have realized that he had to spread out his little conflict pretty thin to make it last for the scene is drawn out, even if the denouement is pretty easy to forecast... The picture more depends upon the strong attraction of its principal players and upon the unquestionable beauty of its production; also its 'sweet' title. In technical treatment of backgrounds, settings and composition of the groupings the production is a marvel of artistry.◆

In Old Kentucky

October 1927. 6,646 ft. Held in Library of Congress.
D: John M. Stahl. **P**: Stahl.[*] **Sc**: A.P. Younger, Lew Lipton, from the play [1893] by Charles T. Dazey. **Ph**: Maximilian Fabian. **Ed**: Margaret Booth, Basil Wrangell. **Art D**: Cedric Gibbons, Ernest Fegte. **Titles**: Marian Ainslee, Ruth Cummings. **Wardrobe**: Gilbert Clark.
PC: MGM. **Dist**: MGM.

Cast: James Murray (Jimmy Brierly), Helene Costello (Nancy Holden), Wesley Barry ("Skippy" Lowry), Dorothy Cumming (Mrs Brierly), Edward Martindel (Mr Brierly), Harvey Clark (Dan Lowry), Stepin Fetchit (Highpockets), Carolynne Snowden (Lily May), Nick Cogley (Uncle Bible).

This was the last of Stahl's MGM films; before its release he had already left MGM for Tiffany, and he did not work there again until his one-off direction of *Parnell* in 1937. Given the imminence of his split with Mayer, it is uncertain whether *In Old Kentucky*, a favourite subject of Mayer's – an earlier version had been produced by him in 1919, starring Anita Stewart – was chosen by Stahl or imposed on him. Though it seems odd to see him advertised as a "noted action director" (*MPN*, 27 May 1927, MGM advertising section), that description can be related to a subsidiary aspect of his silents: the Stahl of car and locomotive accidents and chases, shootings, the spectacular aspects of *The Dangerous Age* and the storm scenes off the Californian Coast in *The Woman in His House* (to be echoed in 1939, in the New York storm scenes of *When Tomorrow Comes*). Perhaps surprisingly, the reworking of Charles T. Dazey's stage melodrama by A.P. Younger and Lew Lipton did not repeat the 1919 version's ending in which the female jockey heroine triumphs, in a premonition of *National Velvet*. Their immaculately crafted, if occasionally regressive, scenario still survives to be compared with its filmic realisation. As noted in the essay that follows, reviews were interested in the cinematic possibilities of the horse-racing sequences, the *Los Angeles Times* (4 September 1927, 57) noting that "Director Stahl is now using a battery of the most up to date cameras capable of showing every move made by the horses [...]". Amongst some very unfavourable responses, the genial "Mae Tinee" review in the *Chicago Tribune* in pastiche southern argot found the film immensely likeable.

n 1927, Stahl left Metro-Goldwyn-Mayer to become an executive of the independent Tiffany Pictures, renamed Tiffany-Stahl Productions, and while acting as a producer there took a three-year hiatus from directing. His last film for MGM, *In Old Kentucky*, thus also became the last silent film he directed. It seems an unusual project for him, a departure from the female-centred melodramas and light comedies for which he was known. The source was an 1893 stage melodrama by Charles T. Dazey, which it is impossible to resist calling a warhorse, both for its equestrian subject matter and the frequency

[*] IMDb lists Stahl as producer, AFI has no producer credit.

with which it returned over the decades, both on stage and screen. (Louis B. Mayer had already produced an adaptation, directed by Marshall Neilan, in 1919, and a later version in 1935 would star Will Rogers.) These various films diverge widely, and each took great liberties with the play: Stahl's version, adapted by A.P. Younger, focuses on the aftermath of World War I, and culminates in a Kentucky Derby race that manages to simultaneously heal the fortunes of a ruined horse-breeding family and the psyche of the war-damaged son and heir, played by the tragically troubled actor James Murray.

The Bronx-born Murray was allegedly an unknown extra when director King Vidor discovered and cast him as the lead in *The Crowd* (1928), a performance that brought him immortality but which is invariably linked to the observation that his own sad fate echoed the film's downbeat arc. Though his widely admired work in *The Crowd* led to other starring roles, a drinking problem seemingly tied to deep insecurity soon derailed his career; alcoholic and destitute, Murray drowned in 1936, whether accidentally or as a suicide. (In a sad coincidence, screenwriter A.P. Younger committed suicide in 1931.) If the account of Murray's discovery is true, this would suggest that *In Old Kentucky* was made after, though released before, Vidor's film. Jimmy Brierly, though a far less thoroughly developed character than *The Crowd*'s John Sims, also draws on Murray's raw emotional intensity and foreshadows his personal self-destructiveness. Before going off to war, Jimmy is a carefree, golden youth, enjoying his family's triumphs at the racetrack and romancing the lovely Nancy (Helene Costello). When he returns, he is a drunken, dissolute gambler who shuns or quarrels with all his loved ones.

The two versions, 1919 and 1927, both produced for Louis B. Mayer.

That his transformation is the result of combat trauma ("shell-shock", in World War I parlance) is never made explicit, but comes across strongly in Murray's performance, redolent of self-loathing buried under a self-medicated haze. It is reinforced by the narrative link between Jimmy and Queen Bess, prize race-horse contributed to the war effort by the Brierly patriarch. Amid the rain, mud, and murk of the trenches, Jimmy is reunited with Queen Bess when he's asked to undertake a dangerous ride

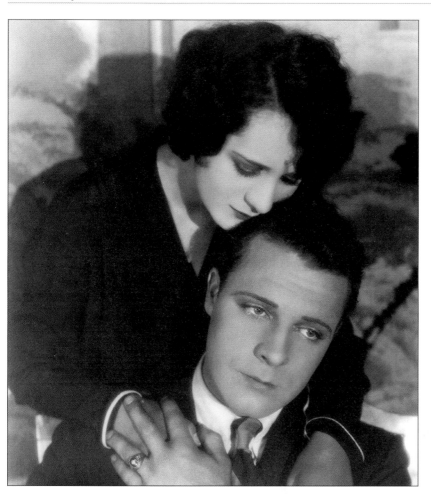

Helene Costello,
James Murray.

across the battlefield to deliver a message. He succeeds, but a shell explodes and apparently kills the horse. Much later, at an auction of war surplus horses, the now impoverished Mr. Brierly recognises the scarred and battered Queen Bess and buys her from a farmer. She winds up winning the Kentucky Derby, after a sudden downpour produces a muddy track, recreating the conditions of her heroic wartime ride. Jimmy secretly pays the fee so that she can enter, having snapped out of his prodigal-son phase when he sees his family's horse-racing trophies in a pawn shop and realises their desperate straits.

Not surprisingly, this plot was met with considerable derision when the film came out: *Variety*'s review was so hostile ("inconceivably asinine in story and with kindergarten technique") that MGM pressured them into a second review, with only slightly more favourable results (14 December 1927, 23). Even warmer reviews generally took for granted that the plot was ludicrous and the film's success was in spite of it. Several reviewers commented on the filming of the final race, with the *LA Times* critic noting that the scene evoked "the origin of motion pictures and, incidentally, proves the strides made in film photography" (4 September 1927, 57). Indeed, the images of the horses galloping across the screen are remarkably reminiscent of Eadweard Muybridge's revolutionary stop-motion photographs of

running horses, but the most striking moments come just before the start of the race, with jostling close-ups of horses' hooves churning and splashing the mud, bringing an unusual degree of physicality and excitement.

The other element of the film that drew attention at the time and remains of interest is the substantial amount of time devoted to African-American actors Lincoln Perry, better known as Stepin Fetchit, as the ne'er-do-well Highpockets, and Carolynne Snowden as his long-suffering fiancée, Lily May, who works as a maid for the Brierlys. These black characters are mainly treated as comic relief, much of it offensive to modern viewers, but – by the extremely poor standards of such roles – they are presented sympathetically and given space for performances that, at least occasionally, feel natural and affecting. Scenes of Highpockets being menaced by a nightstick-swinging white policeman are especially hard to watch now, and the depiction of the Brierlys' servants as devoted to their masters (Lily May even gives the money she has saved up for her marriage to her employer to pay off his creditors) is nearly as distasteful as the pratfalls, chicken-stealing, and messy pie-eating intended as humour. But Snowden's close-ups are so peculiarly touching that her recurring role as the butt of white laughter feels cruel (a familiar face, she would go on to play small roles, often as a singer or dancer, in well-known films like *A Day at the Races, Murder at the Vanities*, and *Roman Scandals*), and Perry's performance is more sly and rascally, less exaggeratedly slow-witted, than the later style that would become notorious. There is a curious extended scene in which Highpockets plays his harmonica to a rapt crowd at one of the Brierlys' parties, prompting a sequence of flashback inserts. An elderly white woman apparently recalls bidding farewell to her sweetheart as he left to fight for the Confederacy; the black servants recall picking cotton in the fields as children. Perhaps the whole scene was intended to be merely a nostalgic, romanticised vision of the old South, but it's hard not to see it as an ironic representation of how very different that past would look to blacks and whites.

In Old Kentucky was the breakthrough film for the eternally controversial Lincoln Perry – who, coincidentally, claimed to have adopted his stage name "Stepin Fetchit" from a racehorse. Stahl seems to have liked him, and cast him in three films he produced at Tiffany-Stahl; there was even a story in *Variety* (30 November 1927, 10) reporting that Stahl might direct a film with Perry/Fetchit, Snowden, and a black cast. This never happened, though the director's interest in racial themes would return in *Imitation of Life* (1934), co-starring Louise Beavers and Fredi Washington. *In Old Kentucky* is finally less than the sum of its parts, but it confirms Stahl's gift for finding the honest emotion within preposterously overwrought situations, which would later salvage films like *Magnificent Obsession* (1935). Like Queen Bess, he ran well on a soupy track.◆

Imogen Sara Smith

The Tiffany-Stahl Period, 1927–1929

Bruce Babington

Why Stahl, still riding high on the stream of highly successful films made for Mayer and First National between 1921 and 1926, should in late 1927 have cut short his tenure at MGM to work for Tiffany, a minor "independent" studio, is an enigma to which there is no indubitable answer. His only recorded statement on a choice which turned out unhappily, hardly closed the matter. "Now I have only my own troubles. Then I had everybody's" (*Los Angeles Times*, 3 May 1931, 44).

A Knight Errant image for Stahl's move to Tiffany.

The move was preceded by a dramatic trade advertisement, urging readers to watch for an important announcement from Tiffany (e.g. *Film Daily*, 18 October 1927, 3). A fortnight later the news broke that "one of the most capable and successful producers of motion pictures" had become "Vice-President supervising productions for Tiffany-Stahl Productions, Inc." The importance placed on the move by both parties was signalled by the name change to Tiffany-Stahl and the announcement that "A change of comprehensive proportions in the cost and quality of Tiffany-Stahl pictures is now in the course of preparation" (*Film Daily*, 31 October 1927, 3). Stahl's move was accompanied by the studio's buying of the Fine Arts (formerly Reliance-Majestic) studio and a $250,000 refurbishing of it (*LA Times*, 3 November 1927, 29).

Tiffany Productions

Tiffany Productions existed at the top end of "Poverty Row". Uncharacteristically for a lower-echelon producer, it specialised in society dramas, melodramas and comedies. However, like other small studios, it lacked the theatres with which the big studios consolidated their control of the industry, leaving it as a producer-distributor, but without access (except for rare hit films) to metropolitan first-run

houses. Stahl, commercially astute, must have decided he could overcome this endemic problem.

Stahl went to Tiffany as Vice-President and General Supervisor of Production, rather than as director-producer of his own films; but in addition to producing 43 features there as well as, it seems, overseeing the colour shorts, there was the tantalising promise of a series of "John M. Stahl Special Productions", working closely with directors on chosen projects, and for 1928–29 four "personally directed specials", including the racy-sounding *The Loves of Sappho* and *The Yellow Passport* – a pass for travelling prostitutes (*Film Daily*, 7 June 1928, 3: an advertisement demanding "Why in Hell Don't You Book Tiffany-Stahl Productions for 1928–29 and Head for Prosperity!").

Circumstances at MGM seem to have undermined Stahl's longstanding partnership with Mayer, and he probably felt that, in order to be supervising rather than oppressively supervised, it was worth risking less secure finances, fewer resources and more stressful industrial conditions. But, as a producer-director himself, notorious for extreme care, multiple takes and overshooting, it is difficult not to think that Stahl underestimated future difficulties. The *Film Spectator,* a publication generally friendly to Tiffany-Stahl, used the studio's overworking of its actors to criticise industry malpractice generally ("Screen Actors are an Exceedingly Dumb Bunch", 29 April 1928, 105). Clearly conditions at Tiffany-Stahl were far from ideal. So, the question why Stahl went there remains a teasing one. Was it a longing for independence? At two significant moments in his career, when studio contracts lapsed (1929–1930 and 1939–1940), he announced that he was going independent and searched for distribution deals, but in both cases eventually moved back to a major studio. An "independent" studio like Tiffany with its unceasing work schedules offered conditions very different from those enjoyed by the "independent" producer working on just a few personal projects.

So why break the pattern in 1927? Did he feel burnt out as a director? Frances Irene Reels, his second wife, and writer on at least five of his films, died suddenly in November 1926. Possibly the trauma of her death affected his desire to direct, so that production may have attracted him. Accustomed as we are to thinking of him solely as a director, we should not underestimate his contemporaries' view of him as a producer. Articles he published in *The Hollywood Reporter* between 1937 and 1949 show great interest in questions of exhibition and commerce, e.g., "Roadshows and Duals" (30 June 1937), where he wrote "Any director who considers his job completed when his picture is filmed and edited shirks his full responsibility".

As regards his period at MGM, where he made three films before leaving for Tiffany, he left with years to run on his contract, which suggests conflict with Mayer, despite their long relationship. *Apropos* of this, Welford Beaton claimed in his *Film Spectator* (12 November 1927, 5–6) that Stahl, who had shown great loyalty to Mayer, had been disillusioned to find, after he moved with Mayer to MGM, that "his treatment by the Mayer organisation has been such that he has been anxious to leave the lot. His pictures were ruined by ignorant editing and titling and his protests went unheeded." Beaton also added details of the unjustified financial penalties Mayer imposed on Stahl as a precondition of leaving. If one can trust Beaton's account (which, however, involves allowing for his bias against Mayer, and explaining how

inferior editing happened with Margaret Booth, the distinguished editor whom we know to have admired Stahl, in charge), it does give a further rationale for Stahl's leaving MGM. But with two of the three MGM films lost, and the third (*In Old Kentucky*) restored only months ago, the case must remain open.

Lacking further evidence, we are in a realm of speculation, though there must have been dissatisfactions to cause Stahl to leave MGM, most likely among them a combination of supervisory pressures and the change from being Mayer's most prestigious director to being one of many, in a studio where the stars were given paramount publicity. Of course there would also have been personal financial motivations for a director who died a wealthy man. Stahl, when he left Tiffany-Stahl, owned 15 per cent of its shares, and his salary must have been substantial. Whatever else may be speculated about his reasons, perhaps overconfident in his box office reputation, he must have felt that he could lead the studio into compe- tition with the majors by producing, in addition to the typical Tiffany "programmer", films that could storm the barriers placed in the way of independents, some of them produced and directed by himself. But his hopes were mistaken. In November 1929, after only two years, he moved out – or was pushed out – of the failing company, which his colleague M.H. Hoffman had already left in April.

It is easy with hindsight to see failure as inevitable, but things may have looked different in late 1927. Tiffany was the only independent with its own studio space, a considerable positive. Various trade papers, e.g. *Film Daily* (18 July 1927, 5–20), had an impressive fourteen-page catalogue advertising 1927–1928 releases made by "Tiffany, the youngest but most progressive National Organization in the busi- ness", promising 20 features ("Twenty Gems from Tiffany"), "24 Color Classics (one reel gems)", and claiming that no alterations to projection or screens will be required for its "Third Dimension Pictures" to come. The colour shorts were popular, and added to Tiffany's aura of progressiveness, forgotten in the association of the studio with its nadir of "talking chimps" shorts as it neared closure in 1932. It was announced that "a feature-length picture in Technicolor is to be made" (*Film Daily*, 23 May 1927, 3). This did not eventuate, though the post-Stahl remake of *Peacock Alley* (1930) did have one two-strip Technicolor sequence.

"Third Dimension Pictures" was Tiffany's attempt to rival bigger studios in devel- oping a 3D process for feature films. The *Spokane Daily Chronicle* (15 September 1927) said that Tiffany had made a picture in its exclusive process, "which it is said will revolutionize the motion picture industry [...]". This system's advantage was that it would require no alteration to exhibitors' theatres and no installation costs. (See also the Tiffany-Stahl advertisement in *Film Daily Yearbook*, 1928, 396). Like other studios' attempts at 3D features, it came to nothing. It could be that "Third Dimension" was one of the factors that attracted Stahl to Tiffany. Or if not, it must have seemed either viable enough or unimportant enough not to put him off joining the ambitious company, whose catalogue covered a range of genres: melodrama, divorce comedy, backstage comedy, divorce drama, and various women-centred titles, which would have appealed to Stahl's interest in female-centred films. A further reason for moving to Tiffany was the executive presence there of M.H. Hoffman, the producer/distributor of Stahl's *Suspicion* (1918). Stahl probably persuaded his fellow-director Reginald Barker to follow him from MGM, and is

The Tiffany-Stahl studio on Sunset Boulevard.

recorded to have unsuccessfully asked the editor Margaret Booth to move with him. Tiffany-Stahl's lack of theatres, especially metropolitan first-run theatres, though, was to prove an enduring weakness.

Tiffany-Stahl

A "Program of Special Productions and Star Series for 1928" was announced after Stahl had been at Tiffany-Stahl for eight months (*Film Daily*, 5 June 1928, 3–10). It followed the big studios in promoting a "Star Series": three Belle Bennett productions, two George Jessel productions, three Dorothy Sebastian productions, two Ricardo Cortez productions, three Eve Southern productions. While not negligible, these players were of a middling rank compared to the majors' stars. Tiffany-Stahl's directors and writers, like the stars, had their portraits in the catalogue, adding to the impression of Tiffany-Stahl having a large pool of first-rank talent. But like the stars, the directors – e.g. Tom Terriss, George Archainbaud, James Flood, Reginald Barker – and writers were of a lesser rank than those of the bigger studios, Also advertised were "Ten Special Productions Suitable for Extended Runs", by two producers, Stahl himself and Barker.

Stahl produced 43 features at Tiffany-Stahl, ranging from dramas, romances and comedies to Jack London sea stories, an unhappy proportion of which are probably lost. Despite the four films promised for 1928–1929, he directed nothing himself. Supervising so much to the tightest budgets and schedules must have meant no time for directing, and only one "John M. Stahl Special Production", *Marriage by Contract* (directed by James Flood – see the essay that follows), was ever realised. After Hoffman resigned and Stahl became General Manager, his workload increased. Tiffany-Stahl's crowded 1928–29 production schedule was dominated by the transition to sound, requiring films in multiple modes (silents with synchronised music, part-talkies and full talkies using the RCA Photophone system, as well as sound on disc for theatres wired for discs only, and silents for theatres without wiring). These demands must have been more difficult for a small studio than for bigger ones.

An unforeseen problem was that in 1928 the renowned jewelry firm Tiffany & Co began demanding that the studio cease using its name. Tiffany & Co's action against Tiffany Pictures began in June 1930, resulting in a 1932 judgment "enjoining the defendant from the use of the name 'Tiffany' or any similar name or names as part of defendant's corporate name or as a label, designation or mark or otherwise in connection with defendant's business in any manner whatsoever".[*]

[*] Tiffany Co v Tiffany Productions Inc, Supreme Court, New York County, i47 Misc.679, NY Misc.1932.

Stahl's time at Tiffany-Stahl must have been shadowed by this looming action with its obviously serious ramifications. It cannot but have been a factor in the disruptions that precipitated his leaving with nearly four years of his contract to run.

Amidst all this, did Stahl achieve anything substantial at Tiffany-Stahl? Presumably he was partly responsible (with A.L.Selig, in charge of advertising) for the eyecatching full-page and double-page advertisements in the 1928 trade journals for both single films and groups of films, though they were often implausible in their predictions of huge box-office success, and were cut back as the studio's situation worsened. He probably deserved some credit for the US-UK co-production Gainsborough deal which, after his departure, produced Tiffany's most celebrated film, *Journey's End* (James Whale, 1930). He certainly kept Tiffany-Stahl in the news. And he maintained a busy and varied rate of production, at least a few of which films, according to some reviews, might have attained greater success had they come from bigger studios, though clearly there was a quotient of dross. In late 1928 a reader of *Motion Picture News* would have seen impressive full and double-page black and white and coloured ads for the latest output, and read that *The Toilers* was playing at the Brooklyn Strand, *The Cavalier* at the Embassy on Broadway, and *Marriage By Contract* and *Lucky Boy* coming soon. But this was as good as it got. In a year it would all be over, and, alas, Hoffman's praise poem to him in the *1929 Motion Picture News Booking* Guide, p.167, proved in the end more advertiser's copy than unbiased judgment.

> Tiffany-Stahl made the biggest, most rash, most daring promises. Bigger pictures with dynamic drawing power, packed with personalities, loaded with honest box office value – real John M. Stahl pictures –
>
> NOW YOU KNOW JOHN M. STAHL MORE THAN MADE GOOD ALL OUR PROMISES.

Stahl Leaves Tiffany-Stahl

On 12 October 1929 the *Los Angeles Times* reported "Stahl Leaves Film Concern of His Name" (p.19). The same day's *Los Angeles Examiner* supposed that this news wasn't "red-hot", since "it was assumed that Mr. Stahl would send in his resignation" because of a "complete reorganization of the studio". Earlier, an article in *Hollywood Filmograph*, "Just Where Does John M. Stahl Stand Today?" (31 August 1929, 18) pointed to serious boardroom clashes. Now the General Manager, Stahl had been, the article said, "the main spoke in the wheels of the company's destinies". It reported rumours that the coming to the company of Grant L. Cook "who represents the moneyed interests of the Tiffany-Stahl organization,

which controls the company", will cause a "general shakeup" affecting Stahl's position. It protested that:

> If it wasn't for Mr. Stahl there wouldn't be any Tiffany-Stahl Corporation ... It is his name and standing in this profession these many years that made the whole deal possible, and remove the man who built up this great institution, and you might as well close the doors of the Sunset Studios, for it is the life of this man, his ability to make box office pictures for a price that no other company can compete with that has placed them by leaps and bounds in the first ranks and permitted the pact between the Allied States Exhibitors to be closed.

These last words give credit to Stahl as the force behind Tiffany-Stahl's launching of a large-scale franchise deal in which, in conjunction with RCA, independent exhibitors would be guaranteed 52 films a year, 26 from Tiffany, for a five-year period. Advertised as the exhibitors' "Lifesaver" with a striking lifebelt icon, and quickly gaining an impressive take up, the deal was intended to be as much a lifesaver for Tiffany-Stahl as for the exhibitors. But the company would prove to be beyond saving.

Tiffany-Stahl's exhibitors' franchise: a lifebelt thrown into stormy commercial seas.

What, finally, of Stahl as film-maker in this period in which he directed nothing, and where traces of him must be sought in films directed by others under his general supervision? Which of them had Stahl's closer attention is a matter of speculation, made more difficult by the number lost and the difficulty of seeing most of the

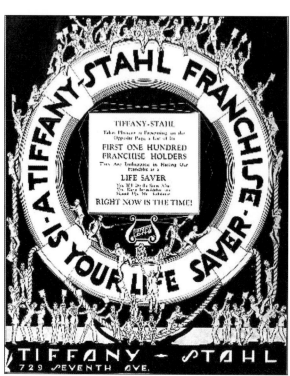

survivors. One might intuit that they would be those thought more likely to be popular – a clear instance being George Jessel's post-*Jazz Singer* vehicle, *Lucky Boy* (Norman Taurog, 1928), viewable on DVD and YouTube, which has a minor charm – and films presupposing a strong female audience such as *Whispering Winds* (James Flood, 1929), and *Beautiful But Dumb* (Elmer Clifton, 1928), a comedy of early DeMillean transformation from frump to flapper.

Other titles of interest include *Clothes Make the Woman* (Tom Terriss, 1928), in which the Princess Anastasia (played by Eve Southern), having escaped the massacre of the Czar's family, is discovered, by the Russian immigrant film director who rescued her, working as an extra on the Tiffany-Stahl lot, and given the starring role in the film as herself – a fascinating piece of self-referentiality.[*]
The Lost Zeppelin (Edward Sloman,

[*] There were favourable reviews of this film, in particular in *Screenland* (August 1928, 51), and in the *Film Spectator* (23 June 1928, 11–12); the latter wrote that it "would have attracted great attention if it had been turned out by one of the big studios, to the products of which the doors of the big houses swing open automatically".

1929), an early all-talkie, conflating science fiction and marital triangle, is, like *Lucky Boy,* available on YouTube; technically crude, it retains only historical interest. Similarly viewable on YouTube is *Painted Faces* (Albert Rogell, 1929), with comedian Joe E. Brown in a serious role: its jury drama looks back to Stahl's own *The Woman Under Oath* (1919), and indeed ahead to *12 Angry Men* (Sidney Lumet, 1957). Likewise, *Midstream* (James Flood, 1929), happily extant, sounds like a fascinating precursor of Frankenheimer's *Seconds* (1966). *The Toilers* (Reginald Barker, 1928), also extant, received good reviews.

A sheet music spinoff of Stahl's policy of theme songs for Tiffany-Stahl films.

The one film from this period where Stahl's role as hands-on producer is undoubtedly verified is *Marriage By Contract*, unfortunately incomplete, but discussed below.◆

Stahl as Feature Film Producer at Tiffany-Stahl

The majority of the 47 films released during Stahl's time at Tiffany-Stahl are believed to have been made and shown as silents; exceptions to this, in the second half of the list, are noted. Around half are presumed lost, wholly or in part; survivors are given in bold type, with a note of archival location. Stahl is credited alone as producer on all of these films, apart from – as indicated – three early ones, and the two Gainsborough collaborations towards the end. On the initial two, *Wild Geese* and *The Haunted Ship*, IMDb (unlike the AFI catalog) names him alongside L. L. Ostrow and Roy Fitzroy respectively; although they were released, after his arrival, as Tiffany-Stahl films, it is unlikely that Stahl had much to do with their production. On *The Devil's Skipper*, the AFI likewise credits Fitzroy alone, while IMDb credits Stahl as well.

Wild Geese (Belle Bennett, Eve Southern, Donald Keith, Jason Robards Sr., Anita Stewart, Wesley Barry). **D:** Phil Goldstone. **P:** L.L. Ostrow. November 1927. Melodrama.

The Haunted Ship (Dorothy Sebastian, Montagu Love, Tom Santschi). **D**: Forrest K Sheldon. **P**: Roy Fitzroy. December 1927. Jack London sea drama.

Streets of Shanghai (Anna May Wong, Pauline Starke, Kenneth Harlan, Jason Robards Sr., Margaret Livingstone, Eddie Gribbon). **D**: Louis J. Gasnier. December 1927. Oriental drama. **IMDb says one reel survives in a private collection in UK.**

A Woman Against the World (Harrison Ford, Georgia Hale, Lee Moran). **D**: George Archainbaud. January 1928. Melodrama.

The Tragedy of Youth (Patsy Ruth Miller, Warner Baxter, William Collier Jr., Claire MacDowell, Stepin Fetchit). **D**: George Archainbaud. March 1928. Drama.

The Devil's Skipper (Belle Bennett, Montagu Love, Gino Corrado, Stepin Fetchit, Carolynne Snowden). **D**. John G. Adolfi. **P:** Roy Fitzroy. February 1928. Jack London Sea Drama. **Library of Congress.**

Nameless Men (Claire Windsor, Antonio Moreno, Eddie Gribbon, Charles Clary, Sally Rand, Stepin Fetchit, Carolynne Snowden). **D**: Christy Cabanne. February 1928. Crime Drama.

The Man in Hobbles (John Harron, Lila Lee,). **D**: George Archainbaud. March 1928. Comedy. **Library of Congress.**

Their Hour (John Harron, Dorothy Sebastian, June Marlowe, Huntley Gordon, Myrtle Stedman, Holmes Herbert). **D**: Alfred Raboch. March 1928. Comedy.

Bachelor's Paradise (Sally O'Neill, Ralph Graves, Eddie Gribbon, James Finlayson). **D**: George Archainbaud. March 1928. Drama.

The House of Scandal (Pat O'Malley, Dorothy Sebastian, Gino Corrado). **D**: King Baggot. April 1928. Melodrama.

The Scarlet Dove (Lowell Sherman, Robert Frazer, Josephine Borio). **D**: Arthur Gregor. April 1928. Romance.

Clothes Make the Woman (Eve Southern, Walter Pidgeon, Charles Byer). **D**: Tom Terriss. June 1928. **BFI Archive.**

Ladies of the Night Club (Ricardo Cortez, Barbara Leonard, Lee Moran). **D**: George Archainbaud. May 1928. Comedy-Drama.

Stormy Waters (Eve Southern, Malcolm McGregor, Shirley Palmer). **D**: Edgar Lewis. June 1928. Jack London Sea Drama.

Green Grass Widows (Walter Hagen, John Harron, Gertrude Olmstead, Hedda Hopper). **D**: Alfred Raboch. June 1928. Sports Comedy-Drama. **BFI Archive.**

Prowlers of the Sea (Carmel Myers, Ricardo Cortez, George Fawcett, Gino Corrado). **D**: John G. Adolfi. June 1928. Jack London Sea Drama. **Cinémathèque Française.**

Lingerie (Alice White, Malcolm McGregor, Mildred Harris). **D**: George Melford. July 1928 Melodrama. **BFI Archive (one reel missing).**

The Grain of Dust (Claire Windsor, Ricardo Cortez, Alma Bennett). **D**: George Archainbaud. July 1928. Melodrama.

The Albany Night Boat (Olive Borden, Ralph Emerson, Duke Martin). **D**: Alfred Raboch. July 1928. Melodrama.

Beautiful But Dumb (Patsy Ruth Miller, Charles Byer, George E. Stone). **D**: Elmer Clifton. August 1928. Romantic Comedy.

Domestic Meddlers (Claire Windsor, Lawrence Gray, Roy D'Arcy). **D**: James Flood. August 1928. Comedy-Drama.

The Toilers (Douglas Fairbanks Jr., Jobyna Ralston, Harvey Clark). **D**. Reginald Barker. October 1928. Drama. Silent with some synchronised music and sound effects; also all-silent version. **Library of Congress, George Eastman House, BFI Archive, New Zealand Archive.**

The Naughty Duchess (Eve Southern, H.B.Warner, Gertrude Astor). **D**: Tom Terriss. October 1928. Drama.

The Power of Silence (Belle Bennett, John Westwood), **D**: Wallace Worsley. October 1928. Mystery. **Cinémathèque Française**

The Cavalier (Richard Talmadge, Barbara Bedford). **D**: Irvin Willat. November 1928. Western. **Filmoteca de Catalunya.**

The Floating College (Sally O'Neill, William Collier, Jr., Georgia Hale). **D**: George J. Crone. November 1928. Comedy.

The Gun Runner (Ricardo Cortez, Nora Lane, Gino Corrado). **D**: Edgar Lewis. November 1928. Melodrama.

Marriage By Contract (Patsy Ruth Miller, Lawrence Grey, Robert Edeson, Ralph Emerson, Duke Martin, Raymond Keane). **D**: James Flood. December 1928. Silent and sound versions. **First reel of silent version held by the Australian Archive** *See essay below by Tom Ryan.*

Tropical Nights (Patsy Ruth Miller, Malcolm McGregor). **D**: Elmer Clifton. December 1928. Drama. **Cinémathèque Suisse, Cinémathèque Française.**

George Washington Cohen (George Jessel, Robert Edeson, Corliss Palmer, Lawford Davidson, Florence Allen). **D**: George Archainbaud. December 1928. Comedy. **Cinémathèque Française.**

Broadway Fever (Sally O'Neill, Roland Dew, Corliss Palmer). **D**: Edward F. Cline. January 1929. Comedy. **BFI Archive (incomplete).**

The Rainbow (Dorothy Sebastian, Lawrence Gray). **D**: Reginald Barker. February 1929. Western. Silent, with synchronised sound and music.

Lucky Boy (George Jessel, William Strauss, Rosa Rosanova, Margaret Quimby). **D**: Norman Taurog + Charles C. Wilson, Rudolph Flothow (sound sequences). February 1929. Silent, with synchronised music and dialogue sequences. **Library of Congress; also available on commercial video**. (*The Ghetto*, which features erroneously in some Tiffany-Stahl filmographies, was an unreleased Tiffany-Stahl film featuring Jessel; after the arrival of *The Jazz Singer*, it was quickly transformed into *Lucky Boy*.)

The Spirit of Youth (Dorothy Sebastian, Larry Kent, Betty Francisco). **D**: Walter Lang. February 1929. Comedy-drama. **UCLA Archive.**

The Devil's Apple Tree (Dorothy Sebastian, Larry Kent, Edward Martindel, Ruth Clifford). **D**: Elmer Clifton. February 1929. Melodrama.

Molly and Me (Belle Bennett, Joe E. Brown, Alberta Vaughan, Charles Byer. **D**: Albert Ray. March 1929). Comedy. Silent, with dialogue sequences and musical soundtrack; also silent version. **Library of Congress (one reel missing).**

Whispering Winds (Patsy Ruth Miller, Malcolm McGregor, Eve Southern). **D**: James Flood. September 1929. Drama-Romance. Sound on Film, Sound on Disc, and Silent versions.

My Lady's Past (Belle Bennett, Joe E. Brown, Alma Bennett). **D**: Albert Ray. April 1929. Melodrama. Sound on Film, Sound on Disc and Silent versions. **BFI Archive.**

Midstream (Ricardo Cortez, Claire Windsor, Montagu Love, Larry Kent). **D**: James Flood. June/July 1929. Drama. Sound on Film, Sound on Disc, and Silent versions. **Cinémathèque Française.**

New Orleans (Ricardo Cortez, William Collier, Jr., Alma Bennett). **D**: Reginald Barker. June 1929. Melodrama. Silent with synchronised sound sequences. Also all-silent version.

Two Men and a Maid (William Collier, Jr., Alma Bennett, Margaret Quimby, Eddie Gribbon). **D:** George Archainbaud. June 1929. Drama-Romance. Silent, sound and part-sound versions.

The Wrecker (Carlyle Blackwell, Benita Hume, Joseph Striker, Winter Hall, Gordon Harker). **D**: Gezá von Bolváry. **P:** Hermann Fellner, Arnold Pressburger, Josef Somlo. August 1929. Drama. Silent with synchronised music score. This Gainsborough film, shot in England, was a product of the Tiffany-Stahl /Gainsborough agreement, with sound synchronised in New York. **Available on commercial video; also on YouTube.**

Mister Antonio (Leo Carillo, Virginia Valli, Gareth Hughes). **D**: James Flood, Frank Reicher. October 1929. Comedy. Sound. **Library of Congress. Also online at Archive.org.**

Woman to Woman (Betty Compson, George Barraud, Juliette Compton). **D**: Victor Saville. **P**: Michael Balcon, Victor Saville. November 1929. Melodrama. Sound. A co-production between Gainsborough Pictures, Burlington Films and Tiffany-Stahl: shot in Hollywood, taking advantage of superior sound technology, and released in British and American versions. There was also a silent version, as well as an earlier film of the story, now lost, shot in England in 1923, scripted by the youthful Alfred Hitchcock. **BFI Archive.**

Painted Faces (Joe E. Brown, Helen Foster, Dorothy Gulliver, Richard Tucker). **D**: Albert Rogell. November 1929. Mystery. Sound. **Released on commercial video**; **also on You Tube**.

The Lost Zeppelin (Conway Tearle, Ricardo Cortez, Duke Martin, Kathryn McGuire, Winter Hall). **D**: Edward Sloman. December 1929. Sound and silent versions. **Library of Congress. Released on commercial video; also on YouTube.**

Tiffany-Stahl Personnel.

Actors:

These actors played recurrent lead roles in Tiffany-Stahl films: Ricardo Cortez (7), Dorothy Sebastian (6), Eve Southern (5), Patsy Ruth Miller (5), Belle Bennett (5), Alma Bennett (4), Claire Windsor (4), William Collier Jr. (4), Malcolm McGregor (4), Montagu Love (3), John Harron (3), Larry Kent (3), Joe E. Brown (3), Stepin Fetchit (3).

Others of note appearing once or twice included: Harrison Ford, Anna May Wong, Anita Stewart, Walter Pidgeon, Jason Robards Sr., Wesley Barry, Douglas Fairbanks Jr., Carmel Myers, Sally Rand, Mildred Harris, Warner Baxter, George Jessel, H.B. Warner, Winter Hall, Conway Tearle, Carolynne Snowden, Virginia Valli.

Directors:

Those with multiple credits are George Archainbaud (8), James Flood (5), Reginald Barker (3), Elmer Clifton (3), Alfred Raboch (3), Tom Terriss (2), Edgar Lewis (2), John G. Adolfi (2), Albert Ray (2).

Writers:

The busiest of the Tiffany-Stahl writers was the prolific Jack Natteford, who has 151 credits in all on IMDb, most of them for B Westerns, but running across other genres. He wrote for twelve of these films. The next most used was Frances Hyland, who wrote for eight of the films – spanning various genres, as she did throughout her career. Many of the films were worked on, usually titled, by Frederic Hatton (15) and his wife Fanny Hatton (19), almost always together.

Cinematographers:

The major Tiffany-Stahl cinematographers were Ernest Miller (14), Harry Jackson (10), Jackson Rose (5) and Chester Lyons (5). Jackson Rose went on to work on films such as *The Band Wagon*, *The Halls of Montezuma*, and *Mother Wore Tights*. He was cinematographer on Stahl's musical *Oh, You Beautiful Doll* in 1949. Ernest Miller, though without stellar films on his cv, was clearly never out of work, with 351 IMDb credits. Chester Lyons had major work with Frank Borzage on three films, and with John Ford on *Mother Machree,* and paired with Gregg Toland on *Mad Love*. Rose went on to work on three early Stahl sound films, *Seed, A Lady Surrenders,* and, uncredited, *Strictly Dishonorable*.

Editors:

Among various lesser-known names the standout exception is that of the distinguished Robert Kern: after editing three of Stahl's own silent films – *Why Men Leave Home*, *Husbands and Lovers* and *Fine Clothes* – he edited eight Tiffany-Stahl productions, before resuming a career full of major films at MGM such as *David Copperfield* and *The Women*.

Music:

The dominant music credit among the few films with special scores is that of Hugo Riesenfeld, a major cinematic composer/arranger of the silent and early sound eras, responsible for such outstanding scores as DeMille's *King of Kings* and *Carmen*; he has the music credit on five Tiffany-Stahl films, including *Midstream* and *The Toilers*.

Colour Plates

John M. Stahl directed only two features in colour, but a lot of the publicity was – typically of the industry – in vivid colour, and here we present, in chronological order, a cross-section: lobby cards, advertisements and posters. First for his silent films as director, to 1927 (pages C2–C4); then for his work as producer for Tiffany-Stahl, 1927–1929 (C5); then for his sound films as director, 1930–1949 (C6–C7). Then images from his two Technicolor features, *Leave Her to Heaven* (1945) (C8–C10), and finally *Oh, You Beautiful Doll* (1949) (C11–C12).

C2: 1917. Episodes 2 and 4 of the ten-part release version of *The Lincoln Cycle*, under its alternative title; see the list of episodes on page 29. Charlie Jackson as the young Abraham Lincoln, with (left) Benjamin Chapin as his father Tom.

1921. *The Child Thou Gavest Me*: Lewis Stone, Barbara Castleton, and child star Dickie Headrick.

1922. *The Song of Life*: Georgia Woodthorpe.

C3: 1922. *One Clear Call*: Milton Sills, Claire Windsor.

1923. *The Dangerous Age*: Lewis Stone with Cleo Madison and (inset) Ruth Clifford.

1923. *The Wanters*: prominent credits for writing and photography.

1924. *Why Men Leave Home*: Lewis Stone, Helen Chadwick and (below) Alma Bennett.

1924. *Husbands and Lovers*: Lew Cody, Florence Vidor.

C4: 1926. *Memory Lane*: Eleanor Boardman; and, above, with Conrad Nagel (right) and William Haines.

1927. Lew Cody as *The Gay Deceiver*.

1927. *In Old Kentucky*, Stahl's last silent film.

C5: Above: 1928 and 1929. Two prominent Tiffany-Stahl productions.

Below: an advertisement for "Color Classics", short fiction programme fillers with a travelogue aspect, a minor part of the Tiffany-Stahl production line; and an advertisement for "Color Symphony" shorts combined, here, with publicity for four "Star Series" features – all of them included in the book's Tiffany-Stahl section, pp. 133–134, October–November 1928.

C6: 1930. Publicity for *A Lady Surrenders*, showing, at left, the scene between Rose Hobart and Conrad Nagel that is illustrated more fully on p.147.

1931. *Seed*: visible in the top half of the letters E are ZaSu Pitts and Bette Davis.

1935. *Magnificent Obsession*: the intricate montage below the title includes, high up, a version of the moment that is illustrated more fully on pp. 140–141.

1937. *Parnell*: Stahl's name is prominent, on his one-off return to MGM and Mayer.

C7: 1938. *Letter of Introduction*: Charlie McCarthy dominant, above the father-daughter couple.

1939. *When Tomorrow Comes*: the couple rising above a compressed evocation of the historic New York floods of 1938.

1941. *Our Wife*: flaunting the spanking motif discussed on p. 206.

1949. *Oh, You Beautiful Doll*: a sheet-music tie-in with the release of Stahl's only musical.

C8-10: 1945. *Leave Her to Heaven*, the first of Stahl's two Technicolor films, for whose photography Leon Shamroy won an Oscar (see p.231). The first image is a production still, showing Jeanne Crain and Cornel Wilde; the rest are frame stills, featuring Crain, Wilde, Gene Tierney and the drowning Darryl Hickman, as contextualised and discussed in Michael Walker's essay, pp. 229–241.

C11-12: 1949. *Oh, You Beautiful Doll*: four frame stills featuring June Haver and Mark Stevens, performing "Come, Josephine, in My Flying Machine", and one of S.Z. Sakall at the piano.

Silent films to 1927

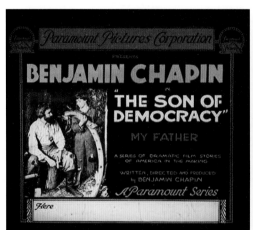

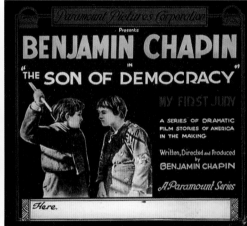

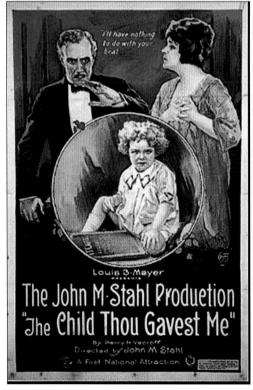

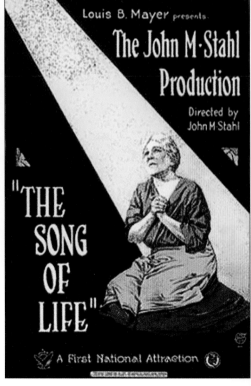

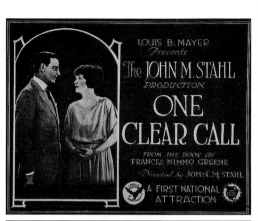

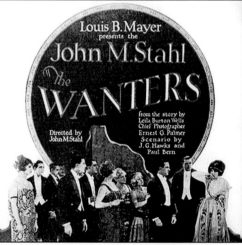

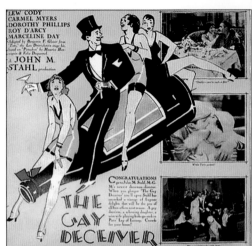

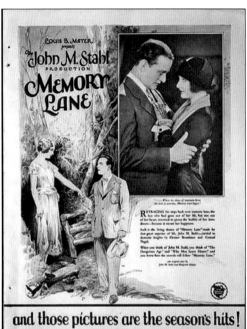

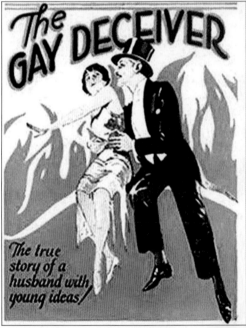

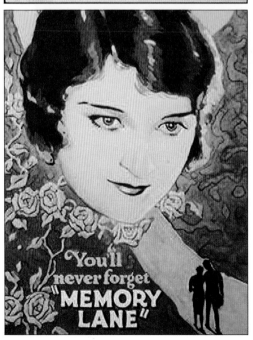

Tiffany-Stahl 1927–1929

Sound films 1930–1949

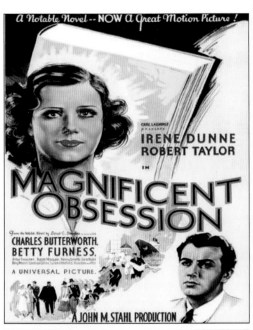

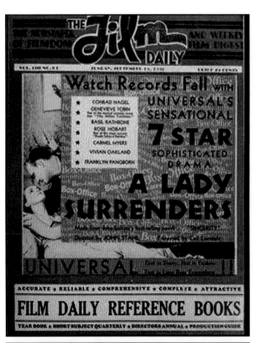

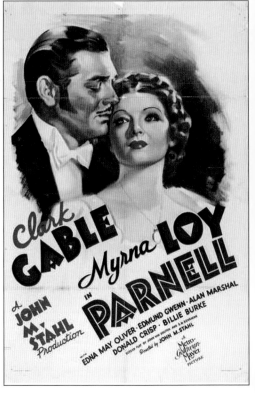

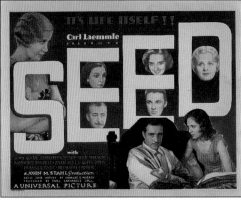

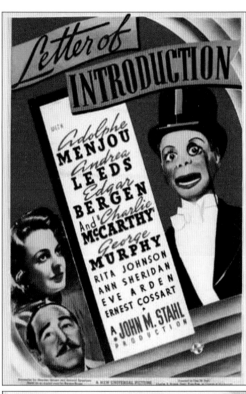

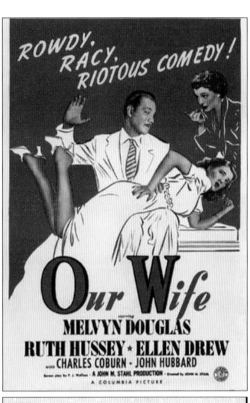

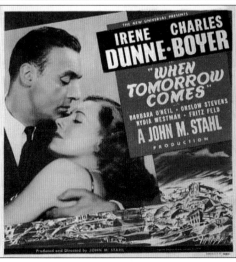

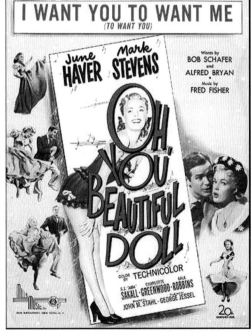

Leave Her to Heaven (1945)

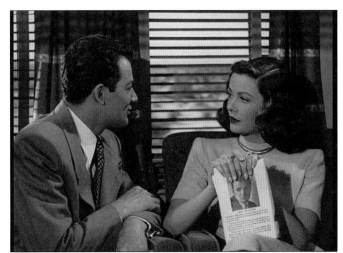

Oh, You Beautiful Doll (1949)

Marriage by Contract

Tiffany-Stahl Productions. 9 November 1928. 70 mins (full version, with sound).
D: James Flood. **P:** John M. Stahl. **Story:** Edward Clark. **Continuity:** Frances Hyland. **Titles**:
Paul Perez. **Ph:** Ernest Miller. **Ed:** L.R. Brown. **M:** Manny Baer.

Cast: Patsy Ruth Miller (Margaret), Lawrence Gray (Don), John St. Polis (father), Claire
McDowell (mother), Duke Martin (Dirke), Raymond Keane (Drury), Shirley Palmer (Molly).

As far as can be ascertained, there are no surviving complete prints of this "John M. Stahl
Special" from Tiffany-Stahl Productions, although the National Film and Sound Archive of
Australia does hold a single 35mm reel (also in 16mm) amounting to around 25 minutes.[*]

Shot in the old Reliance-Majestic Studios in Hollywood, *Marriage by
Contract* was both produced and distributed by Tiffany-Stahl, who
made it available in both silent and sound versions. It was the sixteenth
feature directed by James Flood. Apparently the sound version incor-
porated both incidental (non-diegetic) music composed by veteran
Manny Baer, who subsequently signed with Max Fleischer's animation
studios, and two songs. While there was no sound at all on the partial print I viewed,
Mordaunt Hall's contemporaneous review in the *New York Times* takes note of the
songs, which the AFI Catalog lists as "Come Back to Me", written by Dave Goldberg
(lyrics) and A.E. Joffe (music), and "When the Right One Comes Along" by L. Wolfe
Gilbert (lyrics) and Mabel Wayne (music).[**]

The opening scroll provides a light-hearted context for what is to follow: "Since the
first man – armed with a club – went out and chose a wife, marriage has been a
sacred institution. And later, when that same man desired his neighbour's wife, he
tried to hand her a substitute for that institution." The man is designated as the key
player here, although the patriarchal trajectory is promptly subverted when it
becomes clear that the protagonist of our story is to be a woman: Margaret, played
by Patsy Ruth Miller.

The setting for the first scene is a high-society party, the camera primarily surveying
the characters' interactions in wide shot. Margaret is a flirtatious young woman for
whom, it appears, there is no shortage of marriage proposals. It's also evident that
she's not yet ready to make a commitment. At the same time, a jovial group of

[*] The NFSA acquired what it has of the film in 1984 from a private collector. No information is available about what
 happened to the missing reels, and there are strong indications that they were never received in the first place.
[**] *NYT*, 13 November 1928, 37.

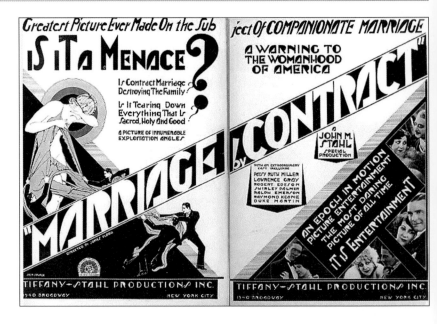

onlookers has gathered to listen to the predictions on offer in a book entitled "The Marriage of Tomorrow". Margaret is attracted by the possibilities of a new way, and decides to test the water with the debonair Don (Lawrence Gray). "No wedding bells!" she exclaims with an air of relief. "Just a contract. And, if it doesn't work, divorce."

When she takes him home to meet the folks and to tell them of her plans for "a contract marriage", they don't approve. She calls them "sweet, old-fashioned darlings", and a cut to a newspaper headline – "Back From Honeymoon" – indicates that she's gone her own way on this matter. Exactly how the unorthodox marriage she has undertaken might differ from a civil union, aside from the openly-acknow-ledged opt-out clause, remains unclear.

In the post-headline sequence, Margaret and Don are being visited by friends bearing gifts to celebrate their union. Gradually the men and the women move into separate groups, transforming the occasion into an almost tribal encounter where division according to gender is the rule. Margaret's struggles to make the new kind of marriage work take place, evocatively, against a background of this kind of tension – and in the face of the disapproval of conservative forces, which are here embodied in the hostility of the elderly maid, who is signified as working-class by the titles' erasure of her final -g's, and who quits her job in protest at her employers' scandalous behaviour.

Margaret tries to be reasonable: "of course" Don can go to the fights with his friends, she tells him, just as she can go with hers to a dance. We're not quite in the realm of the "open marriage" here, but we're in the same vicinity. After becoming the centre of attention at the fights, where he is acclaimed as "the bachelor husband", he runs into an old girlfriend and then doesn't arrive home until 3pm. For her part, Margaret meets a man at the dance and invites him home. Whatever infidelities the pair might have engaged in occur offscreen, but there is little doubt that chaos is

about to descend on their relationship. It comes as no surprise when she packs her things and heads home to her parents.

To this point, the story has surveyed its characters largely through the filter of a series of social interactions – the party at the start, the visit to Margaret's parents, the friends' post-wedding visit, the boxing arena, the dance – with only a couple of more intimate scenes with the pair, and with Margaret alone. The film's focus is not just on Margaret's marital experiment but on its place within a broadly defined social order.

Alas, what happens next and how the film goes about dealing with its consequences remains a mystery, because this is where the surviving reel ends. The plot synopsis from the AFI catalog provides some data on what ensues:

> Margaret and Don, an average American girl and boy, enter into a companionate marriage, and Don goes philandering the first night after their honeymoon, so Margaret leaves him. She finds that no decent man of her own class will marry her and finally enters into another companionate marriage with Dirke, a self-made man much beneath her social station. Margaret has children and is content, but Dirke leaves her at the end of the marriage contract. She then marries a rich old man, quickly divorcing him to marry Drury, a suave young fellow who soon runs through all her alimony. Margaret kills Drury and is dragged away by the police. It all turns out to be a dream, however, and Margaret marries Don the next day in a church ceremony.

There are inaccuracies here: for example, given the social world they inhabit, Margaret and Don are hardly "average American(s)", and while Don's "philandering" is strongly suggested, the implication is that he hasn't been the only one to stray. But what the AFI's plot outline points to – at least in print – is a cop-out ending, one that dismayingly steps away from issues raised in the early part of the film (and perhaps beyond) about the social beliefs, expectations and pressures that constrain individual behaviour.

Certainly Mordaunt Hall's review – concluding condescendingly with the observation that "those who like this sort of thing will be delighted to hear that Margaret agrees that contract marriage is 'a mess of applesauce'" – confirms such a fear, and suggests that this is the route the film finally settles on.◆

Tom Ryan

The Sound Films

Shooting
*Magnificent
Obsession*
(1935). Stahl, at
left, between the
wheels; Irene
Dunne in the
arms of Robert
Taylor.

Stahl in the Sound Era
1929–1949: Introduction

Bruce Babington

Stahl left Tiffany-Stahl on the cusp of the sound era, entering the second half of his career under contract to Universal, with his first talkie, *A Lady Surrenders* (1930, *aka Blind Wives*). In the pages that follow we again present Stahl's sound films chronologically, tracking his movement to, and activity at, Universal (1930–1939) and Twentieth Century-Fox (1941–1949), with one film at MGM (*Parnell*, 1937) and one at Columbia (*Our Wife,* 1940). With his long tenures at Universal (eight films) and at Fox (nine films) the story looks very stable. However, it is, in fact, rather complex.

After resigning from Tiffany-Stahl, and later when he left Universal in 1939, Stahl seriously contemplated pursuing a route apart from the studios as an independent producer-director. As Head of Production at Tiffany-Stahl, a less well-appointed simulacrum of the big studios, he had been unable to direct, and his overseeing duties were so onerous that he produced only one film in the promised category of "special" on which he was able to work closely with director and film. Presumably what he now had in mind, after the chastening Tiffany-Stahl experience of "independence", was – both in 1929–30 and in 1939–40 – a much smaller and more personalised operation, making perhaps two films a year produced and directed by himself, to be distributed through agreements with the major studios (see *Variety*, 13 November 1929, 9).

In the immediate post-Tiffany-Stahl period, despite reports of a return to MGM, Stahl's ambition to "complete plans for the formation of his own producing organization" (*Exhibitors World*, 14 December 1929) was the dominant story, with *Variety* reporting, in the story quoted above, that "he has opened offices in the Hollywood Bank Building" to that end. However, *Variety,* still running the return to MGM story, further reported (24 March 1930, 4) that Stahl's "plans for independent production did not materialize because of inadequate release channels", something that would be as true in 1940 as in 1930. The upshot was Stahl's move to Universal, in what proved to be, under the patronage of Carl Laemmle Jr., as felicitous a decision as his signing with Mayer in 1920 – though both studio connections were to end less happily than they began.

After signing for Universal, Stahl made his earliest sound films: the sophisticated comedy dramas *A Lady Surrenders* (1930) and *Seed* (1931), and an adaptation of Preston Sturges's Broadway comedy hit, *Strictly Dishonorable* (1931). Following this, he made the five melodramas, *Back Street* (1932), *Only Yesterday* (1933), *Imitation of Life* (1934), *Magnificent Obsession* (1935) and *When Tomorrow Comes* (1939). Supported by Carl Laemmle Junior, the head of production until 1936, Stahl enjoyed a golden period, working with great female stars, Irene Dunne (three times), Margaret Sullavan, who made her film debut with Stahl, and Claudette Colbert, and with the male stars John Boles, Robert Taylor, and Charles Boyer. Though Stahl could straddle fences as well as most, the racial problematics of *Imitation of Life* and the socio-sexual interests of *Back Street,* as well as the subtly low-keyed style of melodrama he developed, to name the most obvious instances, were genuinely ground-breaking.

The Universal studio files of this time (available in the University of Southern California's collection) give a great deal of information about Stahl's working methods at his peak, and the large sums he earned. (In his last years at Universal,

Stahl off set, with ZaSu Pitts, during the production of *Back Street* (1932).

because of the contract Laemmle Junior rewarded him with before he was forced out, his salary was around $200,000). The reports of executives intensely suspicious of Stahl's perceived slowness, over-shooting, and incorrigible insistence on working with incomplete continuities so that parts of the script arrived throughout production, reveal a growingly inflexible system impatient with his methods, but also a director adept at getting his way. By the time of Universal's financial crisis, which led to the Laemmles being forced out, Stahl, though holding the studio's most expensive contract, found himself in an increasingly difficult position: viewed, despite his reputation and box-office successes, as an expensive dinosaur by the incoming economic rationalisers. The years between *Magnificent Obsession* and *When Tomorrow Comes* show evidence of this, with only one film made at the studio, the comedy-melodrama hybrid *Letter of Introduction* (1938), Stahl's only other work being the one-off loan-out return to MGM to produce and direct *Parnell* (1937) in order to pay off the film that he still owed them when he left in 1927 for Tiffany-Stahl.

Stahl departed from Universal in late 1939, leaving unmade an interesting project, *Bull By the Horns*. There followed activity mirroring his immediate pre-Universal time

Stahl on set, directing Myrna Loy and Clark Gable in *Parnell* (1937).

when, after leaving Tiffany-Stahl, he announced plans for independent production. Trade papers such as *Independent Exhibitors Film Bulletin, Motion Picture Daily, Motion Picture Herald, Film Daily,* and *Boxoffice,* now reported negotiations for distribution deals, predominantly with United Artists, and a one-picture deal with James Roosevelt's Globe Productions that never eventuated. There were also reports of Stahl buying rights to novels, and viewing dramas in New York, but, after further rumours of a return to MGM, he went to Columbia on the one-film deal that resulted in the comedy *Our Wife* (1941). This period of indecision ended in June 1941 when Stahl signed with Twentieth Century-Fox what the *Motion Picture Herald* (21 June 1941, 40) said was a "producer-director deal for two years".

This signing, with further extensions, culminating in a seven-year contract in February 1946 (*Motion Picture Daily*, 7 February 1946, 5), began his career's last phase, in which he worked uninterruptedly at Fox up to his death in 1950. Here, as director, but not as producer – if *MPH* was correct about the contract's terms, Stahl must have been disappointed to find himself constantly assigned overseers – he made nine studio-assigned films in a wider variety of genres than before: *Immortal Sergeant* (1943, war), *Holy Matrimony* (1943, comedy), *The Eve of St Mark* (1944, war), *The Keys of the Kingdom* (1944, drama), *Leave Her to Heaven* (1945, noirish version of the woman's film), *The Foxes of Harrow* (1947, historical melodrama), *The Walls of Jericho* (1948, early twentieth-century melodrama), *Father Was a Fullback* (1949, family comedy), and *Oh, You Beautiful Doll* (1949, musical). *Leave Her to Heaven* is perhaps the only one that has a secure place in the critical canon, but, as the essays that follow argue, Stahl's last phase produced films that demand critical reappraisal.

Now seen as a veteran director, Stahl was subject to executive vicissitudes, being given and then taken away from various projects, most famously *Forever Amber*: a hugely publicised and controversially titillating Technicolor subject that he was awarded after the considerable box-office and critical successes of *The Keys of the Kingdom* and *Leave Her to Heaven*. Stahl began shooting this with Zanuck's protegée, Peggy Cummins, in the title role, a project that faltered when Cummins proved too inexperienced for the role, leading to her replacement by Linda Darnell and Stahl's by Otto Preminger, though Stahl, despite being taken off the film, seems not to have been blamed for the production difficulties.[*]

He was clearly valued and financially well rewarded at the studio, his salary rising from $80,500 in 1944 to $172,250 in 1946 and $195,000 (more than Henry King, Henry Hathaway and Otto Preminger) in 1948. His films were generally good box-office, and strongly advertised, with their director promoted as being particularly skilled in bringing popular novels to the screen. Though much occupied with studio assignments, Stahl – probably in an attempt to push the studio into adding production to his direction – developed some interesting projects that unfortunately never progressed. He developed material for a biopic of the early-18th century English actress Anne Oldfield, which emphasised his continuing interest both in theatre, and more generally – like the earlier project dropped at Columbia, *The First Woman Doctor*, a biopic of Elizabeth Blackwell MD – in the lives of women. There were also unfulfilled personal developments of a domestic comedy, called *$25,000 A Year,* and what would appear to be a very unconventional musical, temporarily referred to as "Cavalcade of American Music from the Times of the Pilgrim Fathers up to Modern Song". Edwin Schallert described the former as illustrating Stahl's old penchant for "leaping in on the heels of the news" by creating a presumably satiric comedy about rich people trying to adapt to a speculation attributed to F.D. Roosevelt that in the future the moneyed class's incomes might be limited to the $25,000 of the proposed title (*Los Angeles Times,* 1 May 1942, 39). Also early on at Fox, Stahl researched a biopic of Samuel Gompers, the founder of the American Federation of Labour who, it should be noted, before we attribute radical views to Stahl, while fighting for workers' rights, vigorously opposed socialism and the radical Industrial Workers of the World.

This emphasis on Stahl's unofficial projects, which underlines aspects of his ambitions that did not fit the Fox frame, should not divert attention from the various successes, by no means confined to the best known of his films, of his final years. ◆

Bruce Babington

[*] This protracted episode of conflict over *Forever Amber* is discussed and documented in detail by Chris Fujiwara in his book on Otto Preminger, *The World and its Double* (Faber, 2009) – obviously with more of a focus on the incoming Preminger than the departing Stahl. Peggy Cummins was an inexperienced actress brought over from Britain for this film, very different from the experienced stage and screen actresses with whom Stahl had mostly worked hitherto; but she did later give some memorable film performances both in Hollywood (*Gun Crazy*, 1949) and back in Britain (*Hell Drivers*, 1957). It is notable that both her co-star, Cornel Wilde, and her replacement, Linda Darnell, worked later for Stahl on *The Walls of Jericho*.

A Lady Surrenders

Universal Pictures. 6 October 1930. 94 minutes.
D: John M. Stahl. **P:** Carl Laemmle jr., E.M. Asher. **Sc:** Gladys Lehman, from the novel *Sincerity: A Story of Our Time* [1929] by John Erskine. **Dial:** Arthur Richman. **Ph:** Jackson Rose. **Sets:** Walter Kessler. **Ed:** Maurice Pivar, William L. Cahn. **Sound**: Joseph R. Lapis, C. Roy Hunter.

Cast: Genevieve Tobin (Mary), Rose Hobart (Isabel), Conrad Nagel (Winthrop), Basil Rathbone (Carl Vaudry), Carmel Myers (Sonia), Franklin Pangborn (Lawton), Vivian Oakland (Mrs Lynchfield), Edgar Norton (butler), Grace Cunard (maid).

The romantically suggestive title A Lady Surrenders *was later changed to the more judgmental* Blind Wives, *though the original title is the one that has survived. The Library of Congress holds a 35mm print, which appears to be the only surviving copy.*

A Lady Surrenders (1930) is a pivotal film in Stahl's career: it was his first talkie, and his first project at Universal Pictures, where he returned to directing after two years acting solely as a producer at Tiffany-Stahl. Though handsomely and fluently crafted, it plays as a rough draft or warm-up for the trio of rich, troubling melodramas that would follow: *Seed* (1931), *Back Street* (1932), and *Only Yesterday* (1933). In these three variations on a theme, women are caught between old-fashioned ideals of devotion and self-sacrifice and modern promises of independence and moral latitude, gallantly facing up to the disappointments and limitations of their lot. *A Lady Surrenders* hints at the ambivalence towards marriage and romance that would develop in Stahl's next project, but retreats into more conventional plot mechanics; it is one of those films whose most interesting moments seem either unintended or unfulfilled.

Like so many of Stahl's films of the period, when he was anointed as one of Universal's prestige directors during the ambitious tenure of Carl Laemmle, *A Lady Surrenders* announces its literary pedigree up front. The source was John Erskine's 1929 novel *Sincerity: A Story of Our Times*. Erskine was a remarkably distinguished and prolific man: a humanities professor at Columbia College (now Columbia University, in New York), where he founded the influential "Great Books" programme; a musician, composer, and president of the Juilliard School of Music; and an author of around a hundred books, ranging from the popular *Private Life of Helen of Troy* – which was promptly snapped up by Hollywood in 1927 – to the philosophical essay "The Moral Obligation to be Intelligent". *Sincerity* centres on a married couple, Winthrop and Isabel Beauvel, and the complications that ensue

Conrad Nagel and Rose Hobart, rehearsing for director John M. Stahl.

when Isabel anonymously publishes an essay titled "Sincerity", attacking the secretly stifling conditions of outwardly happy marriages. Confusing matters further, when she receives a letter in response from her own husband, she asks her friend Mary to meet him in her place, posing as the author of the article.

The film, adapted by Gladys Lehman with dialogue by Arthur Richman, discards the theme of sincerity, but otherwise hews to this premise. Here, the irritated novelist wife Isabel (Rose Hobart) fires off an essay called "The Marriage Trap", in which she argues: "Marriage is just a trap for women, baited with protection chiefly, companionship and affection...Why can't a woman have these things, these necessities, without losing her freedom?"

This is strong stuff, but it is a spark that fails to catch and simply fizzles out. By the time Isabel furiously types her manifesto, she has already been well established as selfish, self-absorbed, and oblivious to the needs of her husband. Played by Conrad Nagel – an actor whose presence is as stimulating as a glass of tepid milk – Winthrop Beauvel is a nice fellow, if an incorrigible bore on the subject of shooting ducks, an activity he repeatedly rhapsodises about as his idea of heaven. The script places all blame for the Beauvels' marital difficulties on the wife who neglects him for her fashionable, shallow, cocktail-swilling friends (including one played by beloved character actor Franklin Pangborn). Isabel writes her assault on marriage after her husband interrupts her work on a novel with clumsily amorous attempts to coax her into bed – and evidently she does not shy away from discussing her annoyance with such conjugal duties: when her friend Mary (Genevieve Tobin) reads the essay, she blushingly declares it "so brutally frank it's indecent".

Tobin was one of the New York stage actors imported to Hollywood at the start of the talkie era (she had appeared in a few silent films as a child), and her poised urbanity and polished mid-Atlantic accent fit the swanky sets and air of sophistication in this basically stage-bound film. She would star again in Stahl's next movie, *Seed*, and in both she plays a likeable homewrecker – a type she revived in Lubitsch's *One Hour with You* (1932), where she tries to poach Maurice Chevalier from her friend Jeanette MacDonald. Mary, who comes to visit her friend Isabel, immediately sets her sights on Winthrop; given the opportunity (when Isabel asks her to meet him, posing as the essay's author), she lures him with a sympathetic ear, a home-made cake, and even – her trump card – by pretending to be an avid duck-hunter. "I'm only modern on the outside", she tells him when they visit her smart New York apartment, and he responds predictably, "You'd make a marvelous wife for some man".

A fairly standard love triangle is established – except that curiously the two women seem to share more chemistry than either has with the wan Winthrop. Mary and Isabel are always embracing and kissing each other on the lips; while Mary reads the manifesto over breakfast in bed, Isabel lounges at the foot of the mattress, seductively smoking. They read the stack of mail she receives after the piece is published sitting side by side on a sofa, bantering, believable as close if somewhat warily competitive friends. Sadly, this interesting, prickly rapport vanishes once Isabel, believing her husband has spent the night with Mary, walks out on him and sets sail for Europe. While Mary enjoys a wholesome love scene in a duck blind, Isabel takes up with a suave European playboy – played by a young Basil Rathbone, looking as sleekly art deco as the suite where the couple stays.

When the playboy takes a powder, Isabel decides to return to her husband, setting in motion a melodramatic third act – since Winthrop, believing his wife was divorcing him, has married Mary. (This portion of the plot would be recycled in Stahl's 1941 film *Our Wife*.) The accidental bigamy situation is not played for comedy, as in Garson Kanin's *My Favorite Wife* (1940), but used to draw the starkest contrast between the two women, with Isabel descending into hissable villainy and Mary elevated to self-sacrificing martyrdom as she walks in front of a car. The film that opened with a lightly comic, urbane tone winds up as a nearly Victorian morality tale. (At the beginning, there are some very mildly risqué jokes about Winthrop's

Genevieve Tobin, Rose Hobart

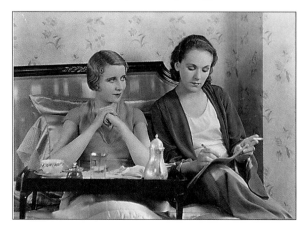

job as executive of a bed manufacturer; his slogan, emblazoned in streamline moderne lettering, is "Beauvel stands back of every bed he sells," but Mary suggests an alternative: "You can't go wrong on Beauvel beds.") This ambivalence about modern sexual mores and women's roles is typical of the period, when films often seem to be going full speed ahead and furiously back-pedaling at the same time, leading to a kind of narrative whiplash. If the film seems divided against itself, this is chiefly evident in its treatment of Isabel. Rose Ho-

bart, an angular actress with a style so contained as to be nearly opaque, does little to resolve the contradictions of the character, who vacillates between being a typical Hollywood movie bitch and something far more rare, a complex and intelligent woman who declines to play by the rules of feminine likeability, and whose deepest feelings are complicated and obscure – perhaps even to herself.

Stahl's greatest gifts as a director were the restraint and unforced sympathy he brought to melodramas, the tact and sincerity that allow nuance to emerge from formulaic or contrived plot twists. You can start to see this at work at moments in *A Lady Surrenders*, especially in the ending, with the germ of rueful self-knowledge Isabel shows in her exit, leaving her husband with the recovered Mary. There are also glimpses of the subtle beauty that marks his films, which eschew showy camera movements but contain moments of stirring loveliness. Here, there are effects of morning sunlight or heavy rain done with a naturalism and delicacy that freshen the settings, and long close-ups that are powerful precisely because they seem disinterested, not manipulative. There is something in Stahl's straightforward-ness that deepens even flimsy characters and plots, an eye always patiently on the lookout for what is real.◆

Imogen Sara Smith

Seed

Universal Pictures. 17 May 1931. 96 minutes.
D: John M. Stahl. **P:** Stahl, Carl Laemmle jr., E.M. Asher. **Sc:** Gladys Lehman, from the novel *Seed: A Novel of Birth Control* [1930] by Charles G. Norris. **Ph:** Jackson Rose. **Ed:** Maurice Pivar. **Sound:** C. Roy Hunter.

Cast: John Boles (Bart Carter), Genevieve Tobin (Mildred Bronson), Lois Wilson (Peggy Carter), ZaSu Pitts (Jennie), Richard Tucker (Bliss), Jed Prouty (Bob), Kenneth Seiling (Junior Carter), Don Cox (Dicky Carter), Terry Cox (Danny Carter), Helen Parrish (Margaret Carter), Dickie Moore (Johnny Carter), Raymond Hackett (Junior Carter ten years later), Jack Willis (Dicky Carter ten years later), Bill Willis (Danny Carter ten years later), Bette Davis (Margaret Carter ten years later), Dick Winslow (Johnny Carter ten years later), Frances Dade (Nancy).

The Library of Congress holds a 35mm print of Seed, as well as a nitrate print of a silent version of the film, which it has not been possible to view.

"I just bumped into my past", a woman remarks in the opening scene of *Seed* (1931), the second film Stahl made at Universal and his first as both director and producer. Like his subsequent films *Back Street* (1932) and *Only Yesterday* (1933), *Seed* pivots on a successful, independent career woman bumping into a man she once loved and can't forget. Each time, the man is played by John Boles, a bland mannequin with the generic good looks of a collar ad and eerily inexpressive eyes. The men he plays are not villains, at worst they are cads, but they are patterns of male selfishness and entitlement, incapable of comprehending the far more passionate and difficult inner lives of the women who love them. This is the paradox, perhaps the bargain, of the woman's picture, the genre with which Stahl is most closely associated. The plots insist that women's lives revolve around men, and that their destiny is suffering and sacrifice, but there is a kind of revenge inherent in the detailed, sympathetic attention to female experience and the contrasting reduction of men to flat ciphers.

With *Seed*, Stahl launched a run of extraordinary melodramas that represent his finest work. In these films he treats the theme of female devotion with unusual subtlety and ambivalence, at once accepting the great loves – whether romantic or maternal – to which the heroines give their lives, and looking with a cold, clear eye at how little they get in return.

Seed quickly sets up a contrast between two types of womanhood, one embodied by a chic, modern female executive and the other by an old-fashioned housewife

and mother. At first, our sympathy and the film's are with Mildred (Genevieve Tobin), the manager of a publishing house's Paris branch, who on a visit to the New York office stumbles on Bart Carter (Boles), her "first, last and only" love. She lost him five years earlier, she explains, to "a brown-eyed homebody, the clinging-vine type". Mildred, a porcelain blonde with poise, style, an elegant wardrobe and a dryly mocking wit, recalls Bart as an aspiring writer. Now he is the father of five unruly children, toiling as a clerk to support a financially and emotionally draining family. His

Genevieve Tobin, John Boles

wife, Peggy (Lois Wilson), seems smug in her domesticity, living solely for her domineering brood. The kids have a habit of speaking all at once, their voices blending into a shrill cacophony.

"Don't you think your maternal instinct is a trifle overdeveloped, Peggy?" Mildred inquires wryly, earning a sure laugh. She proves there is a quicker way to a man's heart than giving him meals and too many offspring: she convinces her publishing house to pay Bart a salary to finish his novel, and invites him to write in her glamorous art deco duplex apartment. ("It's a writer's dream of heaven!" he cries.) She lavishes him with praise and confidence, while his home offers only children who distract and interfere, and a wife who falls asleep when he reads from his magnum opus. The film's source was *Seed: A Novel of Birth Control*, published in 1930 by Charles G. Norris (brother of Frank Norris, the author of the novel *McTeague*, which Erich von Stroheim adapted as *Greed*). Both men were realists who wrote about contemporary social problems, but the film version of *Seed* treads cautiously around the controversial topic of family planning. Peggy's idea of birth control is to shoo her husband out of her bed, saying they don't want *six* kids, do they? You can hardly blame him for preferring Mildred, whose door is always open.

But then something interesting happens to the audience's sympathies, a sort of underground tectonic shift. Stahl begins to devote long, long close-ups to Peggy: the camera simply holds motionless on her face as she starts to cry after her sulky, exasperated husband makes a mean crack about the kids. It remains patiently fixed on her as she breaks down in her car, stranded in the rain with all the kids in the back seat as she tries to set off across the country. Meanwhile Bart, far from showing any concern when he learns his wife has left him and taken the children, goes straight to Mildred's for the night. He plans to "make some arrangement" for the family after he decamps to Paris, of course. But when the movie jumps ahead ten years, we learn that Peggy hasn't taken a cent from Bart; instead she has raised the kids on her own by opening a dress shop. And the crowd of brats has grown into a crowd of attractive young men and women who do her credit. The one girl is now played by Bette Davis, in only her second film role. Davis later dismissed this as a blink-and-you'll-miss-it part, but in fact she's on the screen quite a bit and is appealingly natural and engaging.

Lois Wilson, who plays Peggy, has a face as ordinary as her name, and her plain acting contrasts with Tobin's more mannered, soignée style. Peggy reveals herself slowly, first earning pity, then sympathy, then admiration. The long, quietly forceful close-ups of her continue in the film's last act, for instance as she watches – with deeply mixed feelings – Bart hugging their daughter, whom he hasn't seen in ten years. He has returned a rich and famous author, though his literary genius is never for a moment convincing. The children are excited and proud, harbouring not the slightest grudge against the father who abandoned them, and Peggy must watch him swoop into their lives with expensive presents and promises. There is a striking shot of her watching through the shop window as they cluster around his car, and an even more poignant one of her looking out from an upstairs window, through lace curtains shimmering in the darkness, as they return from an evening out with him. She looks desolate yet resigned. Peggy has one big angry outburst, telling Bart he can't take the children away from her, but in the end of course she lets them go, to benefit from the chances he can give them. And he remains as obtuse, as insensitive as ever, declaring, "I think you're the most wonderful woman in the world!"

This is the final slap in the face, and Peggy takes it that way, absorbing the full bitter measure of how men sentimentalise female self-sacrifice even as they take advantage of it. The long scene in which she says goodbye to the children is all the more heartbreaking for being unadorned and pedestrian; it is followed by an even longer scene of the mother alone in her empty nest, eating the cinnamon buns her kids have left. This should be where the movie ends, rather than with a disappointing coda in which Mildred returns to tell Peggy that she has "won" and that she herself would give anything if the children were hers. This speech feels tacked on and inauthentic, but what the scene of rueful female bonding leaves you with is not the glory of motherhood, it is the sense that women cannot win no matter what route they choose – while men, rewarded for their selfishness, cannot lose.

Coming out of a screening of *Seed* at New York's Museum of Modern Art, my friend said of Stahl's direction: "You feel like he's not doing anything, but then you find you're crying." The virtues of Stahl's films – the clarity, nuance, and emotional honesty of their story-telling, and the powerful empathy for women – are never showy; his direction in *Seed* is almost self-effacing, allowing deep feeling to develop naturally, rather than striving to create it. These qualities are all the more remarkable given his reputation as a harsh, temperamental director with whom few actors enjoyed working. (Irene Dunne, star of *Back Street*, told James Harvey that Stahl was "rough on his actors", and described him throwing things around the set.) Stahl's understatement and simplicity have not always been appreciated. *New York Times* reviewer Mordaunt Hall

Boles and Tobin with (left) Lois Wilson.

panned *Seed* on its release, calling it a "lethargic and often dull production", and condemning Stahl's "unimaginative" direction.

Stahl remains under-appreciated for several reasons, including the difficulty of pinning down what he is "doing" to make you cry. Some of his best films, such as *Seed*, have been hard to see, while his most celebrated film, *Leave Her to Heaven* (1945), is uncharacteristic, drawing power from the unsettling contrast between its lusciously pretty surface and its icy, ugly heart. It is, not coincidentally, Stahl's one foray into the ever-popular film noir cycle, while most of his movies are consigned to the cinematic ghetto of women's pictures. Stahl himself spoke cynically of the "commercial instinct" behind his "feminine approach" to directing, based on the fact that matinee audiences were heavily female, and women could "drag in" the men at evening shows.

Ironically, Stahl's name is forever linked to the melodrama – a term often used pejoratively to imply implausibility, excess, and heavy-handedness – yet his best films have none of these qualities. Plot twists are anchored by the naturalism and credibility of his characters, and there is a bracing dryness that contains but never denies emotion. The tone is neither overheated, nor baroquely stylised and obliquely ironic, like Douglas Sirk's Universal melodramas of the 1950s, several of which were remakes of Stahl films. Though they are usually about romances, Stahl's films are rarely romantic. Their signature moments are not soaring emotional outbursts but quiet acceptance of disappointment, as when Peggy and Mildred gloomily bond over cinnamon buns, facing the neglect and invisibility that are their fate as middle-aged women. Such moments are, in their reserved and quiet way, radical.◆

Imogen Sara Smith

Strictly Dishonorable

Universal Pictures. 26 December 1931. 94 minutes.
D: John M. Stahl. **P:** Carl Laemmle jr. **Sc:** Gladys Lehman, from the play [1929] by Preston Sturges. **Ph:** Karl Freund, Jackson Rose. **AD:** Herman Rosse. **Ed:** Arthur Tavares, Maurice Pivar. **Sound**: C. Roy Hunter.

Cast: Paul Lukas ('Gus' DiRuvo, *aka* Tino Caraffa), Sidney Fox (Isabelle Parry), Lewis Stone (Judge Dempsey), George Meeker (Henry Greene), William Ricciardi (Tommaso Antiovi), Sidney Toler (Mulligan), Carlo Schipa, Samuel Bonello (Waiters), Natalia Moorhead (Lilli).

Strictly Dishonorable is interesting chiefly as a faithful reproduction of Preston Sturges's smash Broadway hit, which opened in 1929, ran for 557 performances, and launched his career as a writer. When the film version came out, Sturges wrote a tongue-in-cheek letter to producer Carl Laemmle, complaining that he had gone expecting to see a Hollywood treatment filled with columned mansions, car chases, and champagne orgies, but "instead I saw only my play". He went on, "Granted you did it beautifully; granted your cast is magnificent; granted you used taste and discretion; and granted little Sidney Fox can charm the birds out of the trees and back again."

It could be that this letter was an ingratiating ploy by Sturges, who was struggling to establish himself in Hollywood (he had been thwarted in his hope to write the screenplay for *Strictly Dishonorable* himself; it is credited to Gladys Lehman, also the screenwriter for Stahl's *A Lady Surrenders, Seed*, and *Back Street*), but there is no reason to think he was insincere. The movie does hew very closely to the play, for better or worse. Stahl's direction feels largely impersonal, and he shows little rapport with Sturges's vibrant, verbally acrobatic comedy. There is no attempt to disguise the material's stage origins; apart from a brief opening shot from a car driving along a streetcar track in the nocturnal glitter of midtown Manhattan, the film consists of four major characters trading lines in three different rooms – a speakeasy and two apartments. Stahl uses subtle camera movements within the sets to track the shifting relationships and attitudes among the characters, but the film still feels staid and static, with a pace that sometimes dips from unhurried to listless.

Even the stage production's rave reviews noted Sturges's astonishing trick in pulling, like a rabbit from a hat, a sparkling comedy from a slight and formulaic premise. The characters are, at first and even second glance, stock types: a sweet,

Henry (George Meeker), Judge Dempsey (Lewis Stone), Tommaso (William Ricciardi), Isabelle (Sidney Fox).

innocent Southern belle; her domineering, uptight fiancé from the New Jersey suburb of West Orange; a suave, philandering Italian opera singer; a bibulous but wise and kindly judge; and for garnish a thick-witted, tippling Irish cop and a hysterically voluble Italian speakeasy-owner. Sturges's genius for creating stock figures who dazzle us with sudden transformations, like exotic butterflies breaking from drab cocoons, is present only in embryonic form here, as are the speeches that climb into the air in arabesques and curlicues and bursts of unexpected color. Here, the dialogue is smart and sometimes amusing, but still earthbound.

The play's greatest strength is its evocation of a warm, impromptu community discovered by Isabelle (Sidney Fox), when she and her fiancé Henry (George Meeker) wander into a nearly empty speakeasy that is home base for opera singer Gus (Paul Lukas) and the Judge (Lewis Stone). Isabelle, who despite her innocence proves not only naturally kind but open-minded and immune to conventions, awakens to the misery in store for her with the controlling, small-minded Henry. The story's basic twist is that she accepts Gus's offer to put her up for the night with every intention of acceding to his "strictly dishonorable" intentions, and she later asserts that her virginity is no one's concern but hers. It is Gus, instead, who proves too conventional to go through with it; faced with the realisation of her inexperience and vulnerability, and his dawning love for her, he lashes out – in a deeply unpleasant scene – calling her "a baby" and shoving a teddy bear at her as he storms out to spend the night elsewhere.

Since the whole nub of the matter is whether the practised seducer will deflower the ingénue, the story was approached by censors as though it were a ticking bomb in need of extremely delicate handling and defusing. The correspondence about the film between the Hays Office and the studio is often funnier than the script itself, with the parties continually reassuring each other that this is basically a "charming, inoffensive picture", in fact "not a sexy picture at all", and that its "exceedingly

Isabelle with Gus
(Paul Lukas).

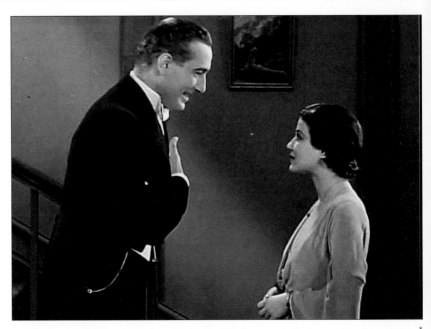

dangerous" subject matter "could be handled properly if done with discretion". [*]
In addition to insisting that the heroine's willingness to be seduced be made "much
less pointed", the censors forced the filmmakers to make the judge an ex-judge,
in order to avoid the appearance of irreverence toward the law, and to cut the line
when Officer Mulligan toasts "Prohibition, a noble law", and the (ex-)judge corrects
him: "Noble experiment." They also worried about the cop drinking on duty and
seeming too willing to bend rules.

Stahl and Junior Laemmle agreed to cut the line about Prohibition, and trim some
of the risky scene in Gus's apartment where he opens a closet to reveal a wide
assortment of women's negligees, and where Isabelle changes into pyjamas.
However, they were able to keep Mulligan's acceptance of a drink, and even
Isabelle's retort to Henry's moralising ("By the way, are *you* pure?"), as well as her
key line to Gus, "If you loved me you wouldn't have left me last night", which
shockingly suggests that she does not appreciate his decision to preserve her
virtue. More shocking to contemporary ears is the way Henry flings the terms
"dagoes", "greasers", and "white trash", as he storms out of the speakeasy. The
censors did fret over "dago", citing the fact that "under Mussolini the Italians have
become patriotic to the nth degree", but it slipped in anyway. No one seems to
have worried about "white trash", or about Isabelle's cringe-making speech recall-
ing happy "darkies" singing on the family plantation. The censors and studio heads
congratulated themselves that the whole thing was "done in extremely good taste
considering the story".

An outlier in Stahl's career – though he apparently loved comedy, it was not his
forte, and the film interrupted a string of intelligent, deeply felt melodramas – *Strictly*

[*] This correspondence, chiefly between Col. Jason S. Joy, Fred W. Beetson, John V. Wilson, Lamar Trotti, and Carl
 Laemmle, Jr. (who signs himself "Junior"), is held by the Margaret Herrick Library of the Academy of Motion Picture
 Arts and Sciences, which makes digital copies available online.

Dishonorable remains a significant curiosity. Lewis Stone, who would become best known for his role as the perennially wise and patient father Judge Hardy in the Andy Hardy movies, gives a subtle performance as the perennially soused Judge, even if his slurred delivery in the first half grows tiresome. His fatherliness and moral insight are blended with sly irreverence and resigned passivity; he is someone who has, quite happily, abdicated the role of authority. Hungarian-born Paul Lukas is charming but not really able to convey an air of seductive danger, though his consciousness of being too old for such a young girl is touchingly conveyed.

The film represents probably the finest hour for Sidney Fox, a tragic actress who was discovered and promoted by Carl Laemmle, Jr., only to suffer from Hollywood gossip about their relationship, and to die at thirty-four, apparently a suicide. Tiny and adorably pretty, she lamented: "My greatest cross is that my face and body don't match my mind and soul. People expect me to be an ingénue, a baby doll, and they're terribly disappointed when they find I'm not. At parties, I've seen men ask to be introduced to me, and I knew they thought I was attractive, but after talking to me a few minutes they'd turn away in dismay. Men, in Hollywood especially, don't like intelligent women." Based on his movies, at least, this was not an accusation that could be made to stick against John M. Stahl. He allows Fox to shine as the "baby doll" who surprises all the men around her by having a mind of her own. Though her character is made to do far too much crying, she also gets some of the script's wittiest lines, as when she explains the downfall of her plantation-owning family: "Just when cotton was getting high, women stopped wearing underwear."

During the pre-Code era (when the Production Code had been written, but was only loosely enforced, between the coming of sound and the crackdown of 1934), nearly all of Stahl's films involved sympathetic treatments of extra-marital relation-ships and frank expressions of female desire. During this period, despite the efforts of (male) censors far more nervous and moralising than any silver-screen biddy committee, Hollywood toyed with presenting some semblance of life as adults actually know it to be. It was, to quote the Judge, a noble experiment.◆

Imogen Sara Smith

Back Street

Universal Pictures. 1 September 1932. 86 minutes.
D: John M. Stahl. **P**: "A John M. Stahl production, produced by Carl Laemmle jr." **Sc**: Gladys Lehman, from the novel [1931] by Fannie Hurst. **Dial**: Lynn Starling. **Ph**: Karl Freund. **AD**: Charles D. Hall. **Ed**: Milton Carruth, Maurice Pivar. **Sound**: Roy C. Hunter, Joe Lapis.

Cast: Irene Dunne (Ray Schmidt), John Boles (Walter Saxel), George Meeker (Kurt Schendler), ZaSu Pitts (Mrs Dole), June Clyde (Freda Schmidt), William Bakewell (Richard Saxel), Arletta Duncan (Beth Saxel), Doris Lloyd (Corinne Saxel), Paul Wegel (Adolphe Schmidt), Jane Darwell (Mrs Schmidt), Shirley Grey (Francine), James Donlan (Phothero), Walter Cattlett (Bakeless), Robert McWade (Uncle Felix) + Maude Turner (Mrs Saxel Sr).

The film lists 14 actors and their roles at the start, and again at the end, but other on-screen credits are sparse, giving only director, producer, writer and source. Others are supplied from the AFI catalog.

When Stahl began directing at Universal after his tenure at Tiffany, he essayed several different genres. His first talker was a society drama, *A Lady Surrenders* (1930). This was followed by *Seed* (1931), a heavily revised adaptation of Charles Norris's novel advocating birth control. Next came a comedy, *Strictly Dishonorable* (1931), a faithful rendition of Preston Sturges's hit play. A dainty southern girl drops her priggish fiancé from West Orange, New Jersey after meeting a philandering opera singer in a New York speakeasy. She spends the evening in the singer's flat despite his assurances that his intentions are "strictly dishonorable". The film was described by *Film Daily* as "ultra-modern and highly sophisticated". The *New York Times* critic commented that "the director, has sagaciously steered clear in all but a few instances of anything that savors of exaggeration". *Strictly Dishonorable* was followed by *Back Street* which, like the comedy which preceded it, can be considered a melodrama that eschews "exaggeration", and is "ultra-modern and highly sophisticated".

As I suggest in my essay on *Memory Lane* in this volume, Stahl's treatment of the domestic drama evolved over the course of the 1920s and 1930s under the influence of the understated style of sophisticated comedy. In many ways, *Back Street* is the culmination of his experimentation with this light, reduced style as applied to melodramatic plot types. It was extremely influential, and was followed by other films from the director which have had a definitive influence on subsequent American cinema thanks to a series of remakes: *Back Street* (1932, remade by

First encounter, then settling into the back-street role.

Robert Stevenson in 1941 and by David Miller in 1961); *Only Yesterday* (1933, remade by Max Ophüls as *Letter from an Unknown Woman* in 1948); *Imitation of Life* (1934, remade by Douglas Sirk in 1959), *Magnificent Obsession* (1935, remade by Douglas Sirk in 1954) and *When Tomorrow Comes* (1939, remade by Douglas Sirk as *Interlude* in 1957).

Back Street also marks Stahl's first collaboration with the great Irene Dunne, who would also go on to star in his versions of *Magnificent Obsession* and *When Tomorrow Comes*. Trained as a singer and successful in musical theatre, Dunne had played in only six films prior to working with Stahl for the first time. Her most important film role had been in RKO's *Cimarron* (1931), which earned her a nomination for an Academy Award as Best Actress in 1932. The director may have been impressed by her generic range, which included musicals (*Leathernecking*, *The Great Lover*), melodramas (*Consolation Marriage*, *Symphony of Six Million*) and sophisticated comedy (opposite Lowell Sherman in *Bachelor Apartment*). John Boles, who had been acting in films since 1924, seems to have been Stahl's choice for a handsome and likable but ultimately unreliable husband/lover, the kind of part he held in *Back Street*, in *Seed* (opposite Lois Wilson), and in *Only Yesterday* (opposite Margaret Sullavan), as well as in Alfred Santell's remake of the *Back Street* plot for RKO, *The Life of Vergie Winters* (1934, opposite Ann Harding).

Back Street is tightly organised in three temporally and spatially unified acts. Indeed, the review in *Variety* praised the way that Stahl and scriptwriter Gladys Lehman condensed the long time span of Fannie Hurst's original novel. The basic structuring device which allows the condensation of the novel is the systematic use of marked ellipses which separate and define the acts.

The first act, which takes place in Cincinnati, ends when Ray misses a chance to meet Walter and his mother, and thereby any chance to gain permission for them to marry, because she has to deal with an emergency posed by her younger sister, unmarried, pregnant and threatening suicide. The second act, in New York city, follows a lapse of five years. A chance meeting on the street between Ray and Walter, who is now married, leads to dinner and to Walter's admission that he still cares for her. She becomes his mistress.

It seems probable that the use of ellipsis between the first and second acts is modelled on a similar one that occurs at the end of the first act of *A Woman of Paris*. Chaplin's 1923 film cuts from Marie at a rural railroad station after Jean has missed their rendezvous to a Paris restaurant, one year later, where Marie, already Pierre's mistress, appears in his company. This transition was much praised in the 1920s

(for example, it is mentioned by Eisenstein).[*] Stahl not only utilises this device to cover the time between the missed meeting and the initiation of the love affair in *Back Street*, he utilises it again in the transition between the second and third acts.

In despair at the boredom and loneliness of her life as the other woman in Walter's life, Ray returns to Cincinnati and to a former suitor, Kurt, who has proposed marriage. Walter follows her there and urges her to stay with him, to which she responds with a question "If I do go back, where will it end?" The film cuts to a view of train tracks as seen from a moving train and the title "1932" which grows in size as if approaching the camera. Twenty-five years have elapsed, and Walter is travelling to Paris with his wife and grown children while Ray, who takes the same boat, discreetly maintains her distance. In Paris, Walter's son confronts Ray and condemns her, but Walter defends their relationship. The next day, stricken by a stroke, he pleads with his son to place a call to Ray and he is connected to her via telephone when he dies. After the funeral, Ray has a fantasy of herself as a young girl, meeting Walter and his mother in the appointed place, and getting permission to marry. She dies.

While the film takes many of its incidents from Hurst's novel, it is much more economical. The novel covers a longer span of Ray's life (for example, she lives on after Walter's death, in poverty and isolation) and there are no marked temporal gaps of the sort which define the act structure of the film. Even within the acts, Stahl favours a condensed representation of events. For example, take the sequence of four short scenes in Act 2 which convey Ray's decision to become Walter's mistress. After the meeting on the street, they are shown at a restaurant: there is a brief exchange of glances but no dialogue. Inside a cab, Walter pays Ray compliments and asks if she has any special friends in New York and she says no. Outside the same cab, they stand in front of her rooming house in the snow, and she explains that men and dogs are not permitted by the landlady. Walter confesses that he still loves her. They try to kiss, but are interrupted when lit up by the headlights of a passing car. He departs, making a date for Saturday. The film cuts to Walter waiting for Ray in the shelter of a doorway; presumably it is Saturday. Her cab pulls up and, as she greets him, he invites her inside, to her evident surprise. They enter an apartment upstairs and there is a brief conversation:

> Walter: It's for you Ray.
>
> Ray: For me?
>
> Walter: We couldn't go on meeting on street corners, hiding in doorways. You don't mind do you?
>
> Ray: No Walter, I don't mind.

The film fades to black.

This representation of Ray's decision to become Walter's mistress is remarkable for its simplicity and matter of factness. There is no scenario of temptation and doubt, Walter is no villain, and Ray no wilting or self-sacrificing heroine. In addition, one does not have a sense that either character is overwhelmed by passion in these

[*] S.M.Eisenstein, "The New Language of Cinematography", in *Close Up*, IV/5, May 1929,10–13.

 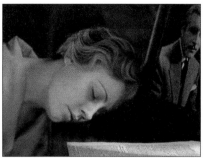

The call of the heart: Ray hears of her lover's death, and soon after, in the film's final shot, dies herself.

scenes, although their mutual attraction is evident. Walter's declaration of love is not heightened by the elements of film style: there is no music, no close-ups. In its place we have simply the presence of the characters on the street at night, the awkwardness of the car lights, the rule of no dogs and no gentlemen. They need a place to meet. This way of representing Walter's invitation and Ray's acceptance of it seems to me unthinkable for a melodrama like *Sowing the Wind* (see my discussion of that film in this volume): in that tradition Ray's choice would be represented as a spectacular "fall", and both erotically and morally charged. Given the censorship difficulties posed by this film in general, and the scenes described above in particular, it might be argued that the elliptical narration of events was a way of avoiding cuts by state censor boards or industry censors (in this period, the Studio Relations Committee). But the brevity and matter-of-fact presentation also obviates the kind of moral didacticism that the SRC typically recommended as a way of dealing with such potentially offensive material.[*]

In addition to its narrative economy and lack of moralising, *Back Street* differs from a film like *Sowing the Wind* in its style. From his very earliest films, Stahl had experimented with deep staging and relatively long takes but, by the time of *Back Street*, these tendencies had become integrated within a coherent and distinctive approach to melodrama: a preference for extremely remote and understated representations of characters' emotional states. Stahl eschews close ups and even medium shots in *Back Street*. Shot-reverse-shot is rarely used in the film, reserved for moments of intense drama, such as Kurt's second proposal when he seems to offer an escape from Ray's life with Walter, and Walter's death bed, when, barely able to speak, he looks pleadingly at his son to get him to call Ray on the phone.

A good example of the film's dedramatised mode of narration is the scene of the missed meeting at the close of the first act. Ray arrives late at the bandstand and wanders through the crowd as it disperses. In the final shot, she is left alone as the sound dies away and the camera tracks back – there are no close ups, and no dialogue calls attention to her chagrin at the unfortunate coincidence. In the following scene in New York, she and Walter make light of the missed meeting

* In pre-production *Back Street* occasioned much correspondence between Universal and the Studio Relations Committee; after release, it was condemned by the Catholic Legion of Decency in 1934; Joseph Breen refused its re-release in the late 1930s, leading to Universal's 1941 remake. I discuss moral didacticism as a basic strategy advocated by industry censors in *The Wages of Sin: Censorship and the Fallen Woman Film*, 1928–1942 (Madison, University of Wisconsin Press, 1991).

when he playfully accuses her of standing him up. It is not until the film's final scene, when Ray, dying, imagines herself meeting Walter and his mother, that the scene takes on its full weight of pathos.

Every dramatic climax in the film is similarly treated in a reduced manner. Take, for example, the climactic scene in the second act, in which Ray decides she cannot continue to live as Walter's mistress. Walter has been sent to Europe on a business trip. Under orders from his knowing boss (his wife's uncle) he has taken his wife along. Ray is left alone in the flat in New York, enduring a hot and lonely summer. Walter returns just at the moment when is Ray advising a young neighbor, Francine, that she should give up her married boyfriend and opt for a life of respectability. Once he enters, she rushes to embrace him despite her words. Over the scene that follows, however, it becomes clear that her position is intolerable – a fact which becomes evident through an accumulation of oversights mentioned in passing and hardly stressed by the actors or the film's style. Walter sits with his head in Ray's lap framed in a medium long shot unbroken for over three minutes while evidence accumulates of his unthinking selfishness. He brags that unlike New York, which has been hot all summer, Europe was pleasantly cool. When he finished conducting his business negotiations he spontaneously decided to take a four-week tour with his wife through Switzerland (deliciously cool), France and Italy. Ray mentions that she has only had three postcards, and describes her own summer of solitaire, sewing and selling pottery she made herself. He objects to this enterprise on her part, but then realises that he forgot to make provision for her during his improvised four-week European tour. She says the lack of money was not "inconvenient" but that she is lonely without occupation or friends and finally asks him to give her a child. Walter is shocked and rises up from the couch, initiating a cut to a long shot of the couple with Ray seated and Walter near the door background right. He explains that a baby would mean scandal and ruin for him: "After all, Ray, you are not my wife." He reverses himself enough to kneel down beside her and apologise, but then walks to the rear, to put on his coat in preparation for leaving. There is a cut-in to medium shot of Ray sitting silently on the couch – as close as the scene ever gets to a close up. Throughout this shot and the next she hardly moves or changes expression. Cut back to the long shot as Walter kisses her, goes off frame right to get his hat and exits. The camera holds on Ray sitting motionless, then tracks in. Cut to Walter, seen from behind in the hall. He pauses, but since we do not see his face it is hard to hypothesise about his feelings at this moment. Cut back to Ray in medium shot. She slowly rises, the camera tilting up to follow her as she moans softly. Cut as she approaches the window opposite the couch, raises the blind and the window. She stops and turns at the sound of a knock at the door, and the film cuts to Kurt entering the flat (he is about to leave town after renewing his acquaintance with Ray following a business trip).

While the accumulation of insults to Ray makes Walter look boorish, especially in contrast to the considerate Kurt, he is in no way a melodramatic villain: his vanity and self-absorption are petty and commonplace in a way that a character like Petworth in *Sowing the Wind* is not. Moreover, the interrupted suicide attempt is remarkably underplayed by director and actress – to the point that audiences might not pick up on it (although the idea is underscored by the parallel between Ray and her younger sister Frieda who threatened suicide by jumping from a window earlier

in the film). The casual and unmarked staging of the incipient suicide, and its lack of consequent narrative development, seems astonishing for any classical Hollywood film, and much more for a melodrama that one would expect to build to such a climactic moment and to prolong it.

Back Street's deliberately flat and uninflected style was received with a mixture of praise and trepidation. *Variety* dubbed the film a winner and, while the reviewer classified the film as a "tear-jerker", he went on to note: "At no time is it sleazily sentimental. The sentimentality of Ray Schmidt and Walter Saxel's pseudo-unconventional association is a natural, humanly progressive [sic] which is built up without ostentation and is all the more gripping by its very ease and naturalness" (30 August 1932, 9). The review in *Motion Picture Herald* was more concerned about the film's lack of punch:

> Maybe that portion of your audience that looks for a lot of hip-hip-hoorah in its entertainment will not find it appealing, but to those who are more intellectual, who can be entertained and at the same time do a little thinking, "Back Street" should be a treat...Sell this picture as a high-priced attraction. You don't have to specialize. There is plenty of meat for both sexes from the adolescents to the oldest. By the same token, "Back Street" is not a children's picture. It probably will be over the heads of lots of grownups and it certainly is too deep for any child. (23 July 1932, 42)

In general, then, *Back Street* was judged a quality production, elegantly structured and likely to please "thinking" audiences but possibly over the heads of the general run of audiences. As *Variety* noted, it was an unsentimental tear-jerker, a melodrama without hokum.◆

Lea Jacobs

Only Yesterday

Universal Pictures. 6 November 1933. 105 minutes.
D: John M. Stahl. **P:** Carl Laemmle Jr. **Sc:** William Hurlbut, Arthur Richman, George O'Neill, from the novel [*sic* –see below] by Frederick Lewis Allen. **Ph:** Merritt Gerstad. **AD:** Charles D. Hall. **Ed:** Milton Carruth. **M:** Constantine Bakaleinikoff. **Sound:** Gilbert Kurland, Joseph Lapis.

Cast: Margaret Sullavan (Mary Lane), John Boles (Jim Emerson), Edna Mae Oliver (Leona), Billie Burke (Aunt Julia), Benita Hume (Phyllis Emerson), Reginald Denny (Bob), George Meeker (Dave Reynolds), Jimmie Butler (Jimmy), Noel Francis (Letitia), Bramwell Fletcher (Scott Hughes), June Clyde (Deborah), Jane Darwell (Mrs Lane), Oscar Apfel (Mr Lane), Robert McWade (Harvey Miles), Onslow Stevens (Party guest), Huntley Gordon (Wall Street Investor), Edmund Breese (Wall Street suicide).

As in *Back Street*, which listed no technicians, the on-screen credits in *Only Yesterday* are problematic. Seventeen actors are listed, as above; in publicity material, certain other cast members, and even their faces, are foregrounded, for instance that of Franklin Pangborn, already a popular character actor, who was billed sixth in *A Lady Surrenders* and has a strong early role in *Only Yesterday*. In the pressbook, Pangborn is listed eighth among the cast, and is unmistakable in the visual display, while other familiar figures like Berton Churchill and Marie Prevost are prominent there as well, but none of the trio are credited on screen.

In a way this confusion is understandable. Publicity boasted that there were 93 featured players, sometimes dubiously rephrased as 93 speaking parts; either way, these gave an embarrassment of riches to choose from. The AFI catalog lists 96 cast members, providing character names for 30. IMDb lists no fewer than 110, supplying names – or generic roles such as party guest – for 71 of them. These supporting-cast details may be of marginal scholarly interest now, but they attest to the sheer scale and ambition of the film's extraordinary project.

A more noteworthy confusion concerns the screen credit for source material: the screenplay is "based on the novel by Frederick Lewis Allen". The pressbook puts it more tentatively and accurately: it has been "suggested by the book by Frederick Lewis Allen". Far from being a novel, Allen's book is a work of popular history, subtitled "an informal history of the 1920s", first published in 1931 and seldom, if ever, out of print since. It starts by looking back, in a "Prelude" chapter, to the eve of that decade:

Let us refresh our memories by following a moderately well-to-do young couple of Cleveland or Boston or Seattle or Baltimore – it hardly matters which – through the routine of an ordinary day in May, 1919....[*]

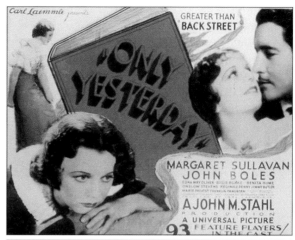

The couple, Mr and Mrs Smith, never become characters: as their names suggest, they are token representative figures. After this introductory chapter evoking their dress and their lifestyle, they are virtually forgotten, as the book traces the public events of the 1920s that impinged upon citizens like them, culminating in the Wall Street Crash.

The book's success gave it value as a film property, and Universal bought the rights. But how to convert its essentially documentary mode into a work of popular cinema? Surviving documents from Universal show Stahl and others, in the summer of 1932, playing with a variety of ideas and characters that could bulk out the "Mr and Mrs Smith" concept, embodying and bringing to life elements of the history in the form of multiple strands, but without getting very far.[**]

Two influences then came together at precisely the right time. One was Noel Coward's *Cavalcade*, a spectacular dramatic pageant of recent English history. Staged in London in October 1931, filmed in 1932 by Fox in Hollywood and premiered early in 1933, it was a commercial hit and won several Oscars. Looking back in 1941, Coward noted that " I was fortunate to be able to administer a little artificial respiration to the word: – 'Cavalcade'. Before I wrote the play of that name the word had fallen into disuse. Now there are... Cavalcades of fashion, Hollywood Cavalcades... Cavalcades of practically anything that can be cavalcaded."[†] Universal and Stahl were undoubtedly very aware of this film as they continued with their adaptation of Allen. The advertising campaign would directly exploit the predecessor film and the newly popular noun, calling *Only Yesterday* variously "a cavalcade of American life", and "a cavalcade of American life and love"; one of Stahl's later projects, as reported in 1942 and discussed by Bruce Babington

[*] Frederick Lewis Allen, *Only Yesterday: an Informal History of the 1920s* (reissue of 1931 publication: John Wiley and Sons, 1997), 1.

[**] Documents from the Universal collection at the University of Southern California, kindly supplied by Ned Comstock.

[†] Noel Coward, *Australia Visited 1940* (Heinemann, 1941), iv. 25 – cited in the Oxford English Dictionary entry on *Cavalcade*.

elsewhere in this book (see pages 145 and 257), was for a "Cavalcade of American Music from the Times of the Pilgrim Fathers up to Modern Song".

Cavalcade itself covers three decades, picking out, as Allen does over his shorter American time-span, key historical moments. Both play and film open on the last day of 1899; the play ends on the last day of 1929, the film on the last day of 1932; the film of *Only Yesterday* will stage its own big New Year scene at the end of 1928. The *Cavalcade* film opens with these written words: "This is the story of a home and a family – history seen through the eyes of a wife and a mother", and moves in linear fashion through the years, keeping the mother of the Marryot family (Diana Wynyard) as a focus. The film of *Only Yesterday* will likewise place a woman (Margaret Sullavan) at its centre, and tell the history through her: from the latter stages of the Great War via Prohibition to the Wall Street Crash. But she, though a mother, is never a wife, and her story is told in flashback, adopting a new framework from the other big influence that fell into Universal's lap at this time, the translation of the novella by the Austrian Stefan Zweig, *Letter from an Unknown Woman*.

The letter of that title is written by a dying woman to the man whom she has loved for many years, who fathered her son, but who doesn't know this, and who doesn't even remember her, nor will she remind him until the sending of the deathbed letter which narrates the whole story through the woman's memories. The novella provides a new template for working through the historical time-span of Allen's work of history: in flashback from the woman's viewpoint, starting with the Wall Street Crash of October 1929, the moment at which the Allen book ends.

Zweig's story had been published a decade earlier, in Germany, and then in translation in 1932. Universal hurriedly bought the rights, but there is no acknow-ledgment of Zweig on screen or in publicity, nor do any contemporary reviews of *Only Yesterday* that I have seen pick up the connection. Even after translation, the novella seems to have remained relatively obscure until the official adaptation of it, under its own title, in its original Viennese setting, by Max Ophuls, again for Universal, fifteen years later.

The Ophuls film is rightly celebrated, much written about, and given scholarly DVD packaging; in contrast, *Only Yesterday* seems never to have been issued on VHS or DVD, and has seldom been revived. Just as the two films with which Stahl and Universal followed it, *Imitation of Life* and *Magnificent Obsession*, came to be seen as minor predecessors to the more glamorous colour remakes of the 1950s by Douglas Sirk, so was *Only Yesterday*, if noted at all, seen as an eccentric prelude to the Ophuls film, vulnerable on twin counts: compromising the rigour of Allen's history book by reducing it in "typical Hollywood" fashion to a melodrama, and using Zweig's novella not respectfully on its own terms, but opportunistically.

This film's long neglect makes it all the more stunning a revelation when it is brought out of the archives and shown. No other film of the 1930s, by Stahl or anyone else – least of all the ponderously dutiful *Cavalcade* – seems fresher or more modern, with more of a meaning for today.

It echoes many of Stahl's previous films in its intense focus on a woman and her suffering as she obeys "the call of the heart", however unworthy the object of her love may seem to be. As in *Back Street*, John Boles plays the love object, again a

successful banker, a complacent "Master of the Universe", to adopt Tom Wolfe's phrase from his 1987 novel, also set in New York, *The Bonfire of the Vanities*. George Meeker again plays the faithful suitor, his long loyalty counting for nothing against the first-love hold of his rival.

Only Yesterday takes seventeen minutes to reach its letter, and its star. A close-up of the calendar date, 29 October 1929, is followed by three minutes of frantic stock market activity, then a protracted scene of panicky reactions at a crowded cocktail party hosted by stockbroker Jim Emerson and his wife. Ruined like so many others, Jim retires to his study, gets out a handgun, and writes a suicide note. At this point he notices the envelope on his desk, and opens it. The first lines of the letter, unspoken, fill the screen:

> My dear
>
> Does the name Mary Lane mean anything to you?
>
> And have you forgotten completely a night in Virginia during the war? To me it seems only yesterday...

Dissolve to that night in Virginia: the camera picks out Mary, centre-frame, within a formal dance scene, and moves forward with her towards her meeting with Jim.

The first section has been devoid of music: we hear Stock Exchange bustle, and incessant nervous talk, followed by a long silence as Jim prepares to shoot himself. The camera has moved restlessly in reporter style from person to person, privileging no-one for long; we can identify nearly 30 speaking parts in this section alone. This initial busy world is overwhelmingly masculine, created and driven by men like Jim: the women depend entirely upon them, and fear being ruined by and with them.

Then we go abruptly into dance music, and into a different kind of camera movement; from objective to subjective, from a world of men and money into the woman's memory. And it is from this perspective that the film now works through the events of Allen's decade, from the late stages of the war through to the Crash: it will only catch up with the letter-reading in its last few minutes.

As this flashback unfolds, Mary herself drives the action. She accosts the young officer, Jim, whom she has loved from afar; they go walking in the moonlight, and don't return until the dance is over. While their love-making is covered in an ellipse, the implications are made clear enough by the long lapse of time, and by her body-language and nervous adjustment of her clothing as they emerge from the woods. When she subsequently finds herself pregnant, she will be entirely unashamed.

As Tom Milne noted in the *Monthly Film Bulletin* in 1981 – a review linked to the Stahl Retrospective of that year in London – this episode could not have been presented so frankly after the more rigid enforcement of censorship codes that came a few months later.[*] The same can be said of two elements in the pre-flashback section. The party guests include a gay male (Franklin Pangborn) and his young partner, presented in a less oblique way than would become the enforced norm. Likewise,

[*] Tom Milne, *Monthly Film Bulletin*, November 1981, 231. The "Retrospective" section of that issue contains reviews of some other Stahl films from the 1930s, as well as a short essay by Tim Pulleine, "Stahl into Sirk".

the suicide theme is presented very directly: scene 1 (Wall Street) ends with one, scene 2 (the Emersons' cocktail party) leads up to the reporting of another, and scene 3 (Jim at his desk) prepares us for a third. This multiple frankness enhances both the historical interest of the film in relation to censorship issues, and its vividness as an account of the decade.

Such elements, of course, added to the film's long-term obscurity by making it unshowable for many years; *Back Street* had similar problems. In September 1936 and again in May 1937, Joseph Breen of the PCA refused Universal's request for a limited reissue of the film. Responding in 1945 to an inquiry about a possible remake, Breen wrote that

> the 1933 picture was approved before the organization of the Production Code and was a "thoroughly unacceptable screenplay, viewed in the light of the Production Code" because it was the story of "illicit sex and adultery, without sufficient compensating moral values." …. a remake of the film would not be allowed without "considerable revamping of both its basic structure and its details."*

One of the many sticking points was the *condoning* of Mary's behaviour by her sophisticated Aunt Julia in New York, where she had been sent – in Jim's absence serving in Europe – to have her baby. Various themes from the Allen book (notably chapter 5: the Revolution in Manners and Morals) are brought pointedly together in their first conversation. Welcoming Mary to her apartment, Julia tells her "I just can't wait to see your hair bobbed" and, when she protests, launches into a set-piece speech which is saved from excessive didacticism by the skill and wit of the actress, Billie Burke:

> Women have cut more than their hair. That's just a symbol. We've cut a lot of the whole silly nonsense. We can get good jobs now and hold them. We're not dependent any longer. And what's more, we've kicked the bottom out of that old bucket known as the Double Standard…. [and in reference to Mary's pregnancy] It's just another of those biological events. Listen, little southern daughter of an age of chivalry: today a woman can face life as honestly as a man can. I mean by that, this sort of thing isn't a tragedy, it isn't even good melodrama. It's just something that happens.

But of course good melodrama is exactly what it is shaping up to be.

After Mary's night with Jim, they had planned more meetings, but his regiment is at once called to Europe at short notice, and her dash to the railway station is too late even for an emotional goodbye: instead, we get the equally intense emotion of the *missed meeting* so common in melodrama, as in the bandstand scene of *Back Street*. The months pass, she gives birth to their son in New York, the war ends, the heroes return to a carnivalesque victory parade (cf Allen chapter 1: Prelude, May 1919). She spots Jim marching at the head of his men and, when he dismisses them, goes eagerly to meet him, but others are already surrounding him. When she accosts him he is polite enough, but doesn't seem to know her – another woman, Benita Hume, whom we recognise from the 1929 opening as his future wife, takes him off with her. It is a devastating emotional moment, playing the festive

* Quoted from the entry on the film in the AFI catalog.

crowds and the military music against a series of four desolate close-ups of Sullavan, magnificent in her first film role.

1918: the war hero has forgotten her. Margaret Sullavan, John Boles.

By the time she considers making herself, and the boy, known to him, he has gone back to Europe on honeymoon. From this point, based still at Julia's, she dedicates herself to her son, to a small business, and to cherishing the memory of Jim. As in the Zweig story, she sends him an annual anonymous New Year's greeting ("from one who does not forget"). As in the story and in the Ophuls film, she meets him again by chance, and attracts him afresh, years later (New Year's Eve, 1928). The Ophuls film could not, for censorship reasons, have her sleep with him this second time, but Stahl's film is here able to stay closer to Zweig, creating a scene of great delicacy and poignancy set in the functional "bachelor pad" which he has, we infer, been using for a series of mechanical seductions. He is touched more deeply by her, feels he may even have met her before, but she is, half-teasingly, saying nothing unless and until he can show himself worthy of her commitment by remembering, which he cannot…

… until, that is, he is enabled to by reading the letter, ten months later. Mary has sent it because she is now dying; when he receives it he has been, as we know, ruined financially, with his own childless marriage effectively finished as well.

Having read it, he rushes to see her, but this time, reversing the movement of the 1917 scene of the troop-train's departure, it is he who is too late. Instead, he is received by the son he he had not known he had, a grave 12-year-old in uniform, Jimmy junior, summoned home from his military-style boarding school. The two sit down for a getting-acquainted talk, taken mainly in a static two-shot. Jim gets the boy to talk about the medals he is wearing, gained for manly pursuits. Would he like to come out sometime with him on expeditions, say for a bit of hunting? This is exciting enough to take Jimmy's mind off his mother's very recent death. But "Why not? I'm your father". On Jimmy's stunned response, "My father!", the film fades out.

I don't think I have ever seen or shown *Only Yesterday* without hearing a certain amount of shocked, nervous laughter at this ending. How wonderfully easy and convenient it is for the man to move in and take over. There is extra outrage in the fact that Jimmy is dressed in his military-style uniform and seems to be embracing the pursuits and values associated with it. It is impossible not to think back to the wartime scene in which Mary reacted against the departure of Jim and his contemporaries to fight in Europe. Around the family dining-table, her father saw only the glory of war, while her mother deprecated it, and Mary sided passionately with her: "If I ever have a son, he'll never go to war". Yet it must

1929: father and son getting acquainted. John Boles, Jimmie Butler.

be she who later takes the decision, which we never see made or discussed, to send her son away at so young an age to the military school.

The shocking irony of this, and of the ending, is like that of the final scene of *Fort Apache* (John Ford, 1948). In his dealings with the Apache and their chief Cochise, Captain York (John Wayne) has consistently, and with some success, opposed the hardline racist strategies of his commanding officer, Colonel Thursday (Henry Fonda). Thursday's arrogance then leads him and his men into a disastrous defeat: unlike him, York survives, and inherits his command. And he seems, too, to have inherited his policy: the film ends as he leads out his men in a vigorous new military campaign against Cochise. Some critics have taken this as confusion or bad faith, showing Ford slipping back into a default mode of Manifest Destiny triumphalism, but others, and they are surely more persuasive, see him and the film as being fully aware of the tragic irony of what it presents. This is the momentum of history, and of America's inexorable territorial expansion: liberals, if they stay within the system, cannot but be caught up in it. The very dissonance of the ending, its startling inconsistency with all that Wayne's character has stood for, makes this point all the more powerfully.

It is wrong, likewise, to take the ending of *Only Yesterday* as a shallow re-imposition and endorsement of patriarchal values, though some audiences at the time and since may have chosen to dismiss it – or indeed to welcome it – as such. The ironies are too extreme. The film has used the freedoms of the melodramatic mode to dramatise conflicts and anomalies at a profounder level than a straighter version of the Frederick Lewis Allen book could have achieved.

Many of its episodes are far-fetched by normal standards. Not only the fact that Jim should fail to show any glimmer of recognition of Mary on his return, but that she should have taken it for granted that he will know and embrace her, after a year without any letters. Not only the abrupt onset of her fatal heart disease, for which nothing has prepared us, but the fact that this, and the arrival of the letter that it causes to be written, are so perfectly synchronised with Jim's equally abrupt slide into suicidal despair. But this is consistent with what Ben Singer, in his useful taxonomy of melodrama devices, refers to as a characteristic "tolerance, or indeed preference, for outrageous coincidence, implausibility, convoluted plotting, *deus ex machina* resolutions".[*] Christian Viviani expands on this notion:

> Melo must be moving, and thus it has recourse – not to the grotesque, as many believe – but to situations, feelings and emotions which everyone has experienced at one time or another. These elements are juxtaposed, telescoped, multiplied, in order to maintain the pathos at an intense level, simultaneously creating both an outer layer, which seems unreal by virtue of its excessiveness, and an inner core, which calls upon a collective experience of real life. Successful melo maintains the difficult equilibrium between its narrative form – often of a baroque complexity – and its emotional content of disarming simplicity.[**]

[*] Ben Singer, *Melodrama and Modernity* (Columbia University Press, 2001), 46.
[**] Christian Viviani, 'Who is Without Sin? The American Maternal Melodrama 1930–1939', in Christine Gledhill (ed), *Home is Where the Heart Is: Studies in Melodrama and the Woman's Film*, (BFI, 1997), 83. Essay originally published in French in 1979.

The "emotional content" here is the painfully asymmetric man-woman relationship. But beyond this, the "baroque complexity" of the form conveys meanings about public life. Jim's macho private behaviour is writ large in his professional behaviour, and by extension that of Wall Street. What is the lesson of the 1929 Crash, and of all the crashes that have succeeded it? Financiers *forget*, in their pursuit of profits – forget honest principles, and forget, repeatedly, the lessons of what has happened before (cf Allen chapters 12 and 13, The Big Bull Market and Crash!). It makes perfect sense that Jim should go through the 1920s living a life of double unreality, double obliviousness, in public and personal life alike, and that the two should converge so dramatically on this day in October. The letter from the unknown woman in effect functions partly as a rebuke for the tunnel-vision forgetfulness of the Wall Street community that he represents.

Could any 85-year old film be more relevant today? One of the consistent laments, in the context of all the recent bank bailouts, was that the greed-is-good banking culture was too macho, that women should be more involved – as if that in itself would transform the culture, any more than Margaret Thatcher or, more recently, Theresa May have done as British Prime Ministers. The idea of alternative *values* being taken on board, or on Boards, is a different matter, and we might be tempted to give those values a shorthand label of "feminine". The values of "one who does not forget". At the end of the film, Mary has died and Jim slips easily into his paternal role, ready to train up the son to follow him. Insofar as he has finally *remembered*, and has belatedly honoured the fact, and the offspring, of Mary's love, we might see him as being therapeutically transformed; but, equally, he has survived, like so many recent delinquent bankers, and the tone of the ending, as well as the lessons of history, suggest that he may prosper anew in a system as resistant to radical reform as that of *Fort Apache*.

Only Yesterday seems to me to be fully alert to the complex implications of its ending. It stands as one of the great films of its decade.◆

Charles Barr

Imitation of Life

Universal Pictures. 26 November 1934. 116 minutes.
D: John M. Stahl. **P**: Carl Laemmle, Jr., Henry Henigson. **Sc**: William Hurlbut [+ 11 uncredited, including Preston Sturges], from the novel [1933] by Fannie Hurst. **Ph**: Merritt Gerstad. **Ed**: Philip Cahn, Maurice Wright. **AD**: Charles D. Hall. **M**: Heinz Roemheld. **Sound**: Theodore Soderberg. **Costumes**: Travis Banton.

Cast: Claudette Colbert (Beatrice Pullman), Warren William (Stephen Archer), Rochelle Hudson (Jessie Pullman), Fredi Washington (Peola Johnson), Louise Beavers (Delilah Johnson), Ned Sparks (Elmer Smith), "Baby Jane" (Baby Jessie), Marilyn Knowlden (Jessie aged 8), Sebie Hendricks (Peola aged 4), Dorothy Black (Peola aged 10), Alan Hale (Martin, the furniture man), Henry Armetta (the painter), Wyndham Standing (the butler).

"The stentorian sobbing of the ladies in the Roxy mezzanine yesterday seemed to suggest that *Imitation of Life* held a vast appeal for the matinee trade as well as for Miss Hurst's large and commercially attractive public. On the whole the audience seemed to find it a gripping and powerful if slightly diffuse drama which discussed the mother love question, the race question, the business woman question, the mother and daughter question and the love renunciation question." (from the *New York Times* review of *Imitation of Life*, by Andre Sennwald, 24 November 1934).

A bestseller when first published, Fannie Hurst's 1933 novel, *Imitation of Life*, has had two American screen adaptations.* The first was released the following year, directed by John M. Stahl, the second in 1959, directed by Douglas Sirk, his last production in Hollywood before he returned to Europe.

The plots of all three have much in common: they deal with broken families and follow the developing relationship between two mothers, both widows: Bea is white, Delilah black. In each case, Delilah not only serves as a nanny and live-in house-keeper for businesswoman Bea but also becomes a personal intimate and a professional colleague. And, despite their obvious differences, the two mothers are

* Hurst's shamefully undervalued novel first appeared in serial form in the women's magazine, *Pictorial Review*, in November 1932. Against her wishes, it was retitled *Sugar House*, although she fought successfully to have the original title restored when the book was published the following year by P. F. Collier & Son. It is currently available through a Duke University Press edition (2004), edited by Daniel Itzkovitz, who also contributes an excellent introduction.

further linked by their struggle – often a contentious one – to do right by their offspring, daughters who live in the shadow of their mothers' fears and flaws as they venture out into the world around them. Jessie is Bea's daughter, Peola is Delilah's.

At the same time, the three tellings of the tale are melodramas about race relations, echoing or anticipating the structure and the thematic concerns of fictions as various as Mark Twain's classic *The Adventures of Huckleberry Finn*, first published in 1884 and adapted to the screen more than 20 times, Stanley Kramer's *The Defiant Ones* (1958, remade as a telemovie in 1986), Kathryn Stockett's *The Help* (2009, adapted to the screen in 2011) and Jeff Nichols's *Loving* (2016). In each of these stories, a Caucasian and an African-American are emotionally, or even literally, handcuffed together and forced both to confront outside challenges to their relationship and to deal with their personal differences.

Despite condescending reviews like the *New York Times* one cited above, Stahl's adaptation was a box-office hit, although it might never have been made if the Production Code Administration (PCA), set up by the Motion Picture Producers and Distributors of America (MPPDA), had got its way. Early in 1934, Joseph Breen, the PCA's recently appointed chief, refused to register the project because Peola was of mixed race: as a mulatto, she signified the occurrence of miscegenation somewhere in her family tree and, since her genetic make-up "is founded upon the results of sex association between the white and black race, [the submitted screenplay] not only violates the Production Code but is very dangerous from the standpoint both of industry and public policy".[*] Apparently, Breen was not only concerned to protect audiences from the harmful contemplation of taboo sexual activity but also wished to save Universal Pictures from alienating potential paying customers.

Furthermore, the focus on Delilah and Peola's circumstances and the sympathy evoked for them, Breen's enforcers suggested, might be mistaken for a criticism of the policies of segregation operating in the south. The censors were also worried that Bea's appropriation of Delilah's recipes for her pancake enterprise might be perceived as an implicit criticism of the ways in which whites went about exploiting blacks in the US.[**] According to Bernard F. Dick's biography of Claudette Colbert, producer Carl Laemmle, Jr., by way of response, even went so far as to proffer the solution that, if it would ease the censor's concerns, Peola's skin condition could be attributed to a genetic disorder.[†]

This kind of pressure perhaps goes some way towards explaining the number of people who ended up working on the screenplay. Official credit goes to William Hurlbut, who had worked with Stahl on *Only Yesterday*, and would do so again, uncredited, on *Letter of Introduction* (his other credits include *The Bride of Franken-stein* for James Whale, 1935), but, according to official production information, there were also eight other writers involved, collectively classified under the heading

* Cited in Judith Weisenfeld, *Hollywood Be Thy Name: African American Religion in American Film, 1929–1949* (University of California Press, 2007), 217.
** See Matthew H. Bernstein, Dana F. White, "*Imitation of Life* in a segregated Atlanta: its promotion, distribution and reception", *Film History*, vol 19, 2007.
† Bernard F. Dick, *She Walked in Beauty* (University Press of Mississippi, 2008), 95.

"Continuity".[*] Among them were Preston Sturges (still six years away from directing his first film), Samuel Ornitz, who was later to become one of the "Hollywood Ten", and playwright Arthur Richman, whose work includes the 1922 play on which Leo McCarey's *The Awful Truth* (1937) is based, as well as *Only Yesterday*.[**]

Four months of negotiations between the studio and the PCA and at least three revisions of the screenplay saw no change in the PCA authorities' view of the project. Even after the film had been shooting for two weeks, Universal was still awaiting official approval of the script. The reasons for the eventual assent remain unclear and can only be inferred from the finished film.

Made for $665,000 – of which Colbert received $90,277.75 for her role as Bea, Stahl $60,000, Hurst $25,000 for the rights, male lead Warren William $25,000, supporting actor Ned Sparks $10,000, and Louise Beavers a paltry $2,900 for playing Delilah[†] – *Imitation of Life* earned three Oscar nominations, including one for Best Picture. But its place in history is assured for its bold introduction of a commentary about race relations into a realm of popular American cinema which, as the reaction of the PCA indicates, was unaccustomed to dealing with such matters. It's one thing to look back at the film past the comforting barricades of contemporary sensibilities; it's quite another to see it as a product of the time in which it was made and to reflect on the constraints under which its makers had to operate.

The process of adapting Hurst's novel to the screen included a rigorous streamlining of the plot and reduction of its scope, as well as some revision of the characters. As the film begins, it is early morning. Bea is living in Atlantic City with three-year-old Jessie, and dealing with the frustrations of being a working mother. "Mama's so late and she's got so much to do", she tries to explain to her daughter, who's vehemently protesting from the bathtub about having to go to day nursery. In the midst of the chaos, there's a knock at the door, announcing the arrival of Delilah, who is to watch over Bea and Jessie for the next 15 years or so.

Declining payment, she says that all she wants is accommodation for her and her four-year-old, Peola, whose white skin belies her racial heritage. "Her pappy was a very light-coloured man", Delilah explains matter-of-factly. In the novel, Bea meets Delilah "across the railway yards [in] the shanty district", an encounter which takes place a quarter of the way into the book. She's gone there in desperation to search for a house-keeper to watch over her daughter while she's out working.[‡] The film's juxtaposition of the stresses Bea is enduring and Delilah's entrance lends an air of magic to the visitor's appearance on her doorstep, effectively a *deus ex machina* that casts Delilah as something of a fairy godmother or guardian angel whom destiny has assigned to help Bea and take care of Jessie.

Details from the novel about Bea's past are compressed into her conversations with Delilah, who (as in the novel) instinctively identifies what's missing from her

* Universal Pictures Corporation production documents, 9 August 1934.
** The others included three who went on to work with Stahl on *Magnificent Obsession*: Sarah Y. Mason, Victor Heerman (director of the Marx Brothers in *Animal Crackers*, 1930), and (again uncredited) journalist Finley Peter Dunne.
† Universal Pictures Corporation production documents, 9 August 1934.
‡ In the novel, Delilah is also assigned to take care of Bea's ailing father – a significant presence in Hurst's work who is entirely absent from the film.

employer's life. "Y'oughta have a man takin' care of you, yes'm", she declares as she assumes her role as maidservant and foot-masseuse.[*] With the pancakes she prepares for her charges' breakfast, Delilah also inadvertently provides Bea with the key to an expansion of the maple syrup business she has taken over from her late husband.

Riding roughshod over any rights Delilah might have to the fruits of her labour, Bea goes about setting up a pancake business without ever consulting her employee. On the same day on which she comes up with the idea, part of her pitch to the landlord of a boardwalk shopfront is the claim that "*I* have a marvellous recipe for pancakes" (my emphasis). That evening, she announces to Delilah, "We're going into business . . .", at least acknowledging a collaboration, but also leaving no room for doubt about who's going to be in charge.

Whether we're meant to take this as an appropriate course of action for Bea or as a critique of her behaviour remains unclear. My inclination is towards the latter, largely because, throughout the film, attention appears to be drawn to her generally supportive but sometimes thoughtless treatment of Delilah. Stahl and his team of screenwriters appear well aware of Bea's oversights here, while the novel seems to slide past them. Nonetheless, any initial uncertainty the viewer may feel is likely to be reinforced by the subsequent scene in which Bea tells Delilah to assume an Aunt Jemima pose by way of modelling for her sign painter, the extended medium close-up seeming to invite laughter.^{**} And, soon afterwards, the film opens itself to the charge of racism in the scene where Bea and her recently appointed business manager, Elmer Smith (Ned Sparks), try to persuade Delilah to lend her signature to the registration of the Aunt Delilah Corporation and thus to establish her right to a share of the profits.

"After all, it's from your pancake flour", Bea points out, offering her a 20 per cent share in the business and the chance for a home of her own. Delilah declines. "I'll give it to ya, honey", she says. "Makes yo' a present of it. Yo's welcome." She goes on to say that all she wants is for her life to stay the same. "Don't send me away How'm I goin' to look after yo' and Miss Jessie?" To which, Elmer wise-cracks, "Once a pancake, always a pancake." The comment serves as a horrid punch-line to the sequence and seems to be, unequivocally, a deeply offensive racist putdown.

In her *Glossary of Harlem Slang*,[†] Fannie Hurst's former secretary, African-American Zora Neale Hurston, lists "pancake" as an idiomatic term for "a humble type of negro" – and, incidentally, "Pe-ola" as "a very white Negro girl". The fact that the glossary wasn't compiled until 1942 hints that the terms might not have been slang at the time that the film was made, but only became so afterwards, quite possibly as a result of their usage in the film (the "pancake" insult doesn't appear in the novel, where Delilah's specialties are waffles). And there seems to be little doubt that Elmer's epithet is meant to signal his contempt for Delilah.

* The phonetic renderings of Delilah's speech patterns and rhythms are also an aspect of how Hurst characterises her. They point to her personal history – a mammy who speaks in a Southern dialect – while what happens to and around her also makes her a tragic figure rather than the Southern mammy of cliché.

** Aunt Jemima, an iconic 19th-century minstrel show figure, was adopted as the face of a celebrated real-life pancake mix and, in her subservience, became the female equivalent of the Uncle Tom archetype.

† http://aalbc.com/authors/harlemslang.htm

The crucial question, however, is the perspective *Imitation of Life* invites us to take on Elmer's line. Are we to take it as endorsing him here or, as, arguably, was the case earlier with Bea, inviting us to see what he says as a sign of *his* limitations as a human being?

His chief function in the film appears to be to provide comic relief, although he remains distinctly unfunny throughout. Sullen of demeanour and scathing in his observations about the world in general, he's a curious presence, a refugee from the Great Depression who becomes helpful to Bea in her business dealings, but is hopeless at anything else. Whereas Delilah advises Bea to lighten up and enjoy life more, he doesn't seem to understand anything beyond what needs to be done to make the business work smoothly, which is one of the reasons why he can't make sense of Delilah, or anyone else, for whom making money doesn't matter.[*]

There's no equivalent for Elmer in the novel. The role there of Bea's empathetic business manager, Frank Flake, whom she comes to fancy, here appears to have been split between Elmer and Stephen Archer (Warren William). Stephen is an old friend of Elmer's (inexplicably!) with whom Bea falls in love the moment she lays eyes on him (equally inexplicably!). By the time he appears on the scene, she has become a successful businesswoman, her home a New York mansion looking out over the Hudson River and the 59th St. Bridge. The film bestows on him the profession of an ichthyologist (no, really!), but his appearance and demeanour identify him as the kind of playboy who regularly turns up in 1930s screwball comedies.[**] "She's got no time for romance", sourpuss Elmer warns him when he shows an interest in her, although Stephen knows better.

Their affair moves the film in a very different direction from the one taken by the novel. By the time that Jessie returns home from boarding school in Switzerland, Bea and Stephen are talking marriage. Their affair has run very smoothly to this point, although the problems are not far away. On Bea's instructions, he doesn't mention their plans to Jessie. She has to be given time to get to know him first, Bea has decreed. But then Jessie proclaims her love for him, inadvertently driving a wedge between her and her mother. He sympathetically declines her advances, but the damage has been done.

The novel ends with Bea left alone and desolate, watching Jessie and Frank move towards their future: "They were so young, standing there . . . so right . . .". The film ends poised somewhere between *Stella Dallas* (1925, 1937, 1990) and *Now, Voyager* (1942), as Bea turns down Stephen's proposal of marriage in order to avoid the perceived disruption which it would represent in her daughter's life. "To me, she's the beginning

The problematic role of Elmer: Claudette Colbert, Ned Sparks

[*] In "*Imitation of Life* (1934 and 1959): Style and the Domestic Melodrama", an article originally published in *Jump Cut*, No. 32, and reprinted in Lucy Fischer (ed), *Imitation of Life* (Rutgers, 1991), Jeremy G. Butler presumes otherwise, proposing that "... the film ridicules Delilah's inability to grasp financial matters".

[**] In the book, Frank is eight years younger than Bea. Here Stephen is 37, roughly the same age as Bea (Colbert was 30 at the time of shooting and William, in a part originally slated for Paul Lukas, was 40, although he looks old enough to be her father).

and the end of everything," she tells him. Over his very sensible objection that Jessie simply has a girlhood crush on him and will quickly forget about it, she insists that she's right: "You must see how impossible it is."

While the novel begins with Bea feeling lost and alone after her mother's death and ends by returning her to a state of isolation in the wake of her surrogate mother's passing, Stahl's film deploys Bea's relationship with Jessie as a narrative frame for Delilah's with Peola. It begins with Bea giving little Jessie her morning bath and ends – in a classic "lost paradise" moment – with her reminiscing over the routine they used to share with the toddler's rubber ducky. But in both cases (and in the Sirk version), it's Delilah and Peola's relationship which lies at the emotional heart of the story, even when its attention is officially elsewhere. Their situation is the stuff of a modern tragedy: a mother's laudable wish for her child to be true to herself – in this case, to accept her racial identity – clashes with the child's perfectly understandable wish to be free to make her own choices about how she's going to live her life.

The depiction of the relationship between Delilah and Peola, played as a 19-year-old by Fredi Washington, is unambiguously heart-wrenching.[*] While the plot structure might foreground Bea's rags-to-riches story and the bittersweet ending that separates her from Stephen but unites her with Jessie, what one takes away from the film is Delilah's heartbreak and Peola's existential crisis.

So, whatever the ambiguities pervading particular sequences, there is no question about where the film's overall sympathies lie, politically and emotionally. Music is often a key indicator, and Stahl's use of it here is unusually sparing for a melodrama of this kind,[**] which makes the orchestrated snippets from "Nobody Knows the Trouble I've Seen" accompanying the opening credits, and then more fully elaborated as Delilah lies on her deathbed, especially telling.

Even as they react differently to the situation, both Delilah and Peola are presented as victims of history, trapped by the ideology of their times. Through them, the film charts its irresistible social critique. As John Flaus points out in his commentary on Stahl's *Back Street* (1932), based on Hurst's 1931 novel:

> The characters of melodrama are signifiers of social forces; these latter are the proper subject of the audience's deduction and hypothesising. In melodrama the characters are templates for the tracing of society's invisible or ideologically dissembled ministers of power, while the narrative unwinds the psychological machinery of their enforcement. Personality becomes the crucible of the culture's contradictions.[†]

[*] Fredi Washington (1903–1994) was a light-skinned African-American who explained her view of being a mulatto to journalist Earl Conrad in 1945: "I can't for the life of me find any valid reason why anyone should lie about their origin . . . Frankly, I do not ascribe to the stupid theory of white supremacy and to try to hide the fact that I am a Negro for economic or any other reasons would make me inferior and [indicate] that I have swallowed whole hog all of the propaganda dished out by fascist-minded white citizens." (*Chicago Defender*, 16 June 1945) After her short-lived screen career, she became a writer and a civil rights activist. When *Imitation of Life* was made, she was 31, while Louise Beavers, who plays her screen mother, was 32.

[**] The same is true for a number of Stahl's other romantic melodramas, including *Back Street* (1932), *Magnificent Obsession* (1935) and *When Tomorrow Comes* (1939). Elsewhere in his work, though, the scores tend to be deployed more conventionally.

[†] John Flaus, "*Back Street* (John. M. Stahl, 1932)", in the online journal *Senses of Cinema*, No. 20, May 2002.

After the traumatic visit by her mother to Peola's school: Dorothy Black, Colbert, Louise Beavers.

Delilah's acceptance of the subservient role for which she believes she has been born and her insistence that Peola should live according to the same assumptions about the workings of the world expose the devastating impact racism has on the individual consciousness and place this mother and daughter on a collision course from which – within the world the film has created – there is no escape.

Twice Delilah attempts to impose her will on her daughter by publicly "outing" her, repeat viewings making both scenes increasingly painful to watch. The first takes place in Peola's all-white classroom at school, the second when Delilah and Bea track her down after she has run away from an all-black boarding school and taken a job as a cashier at a café in Virginia. The first scene appears in the novel, the second is the film's invention.

"I just can't be separated from Peola, no matter what happens", Delilah tells Bea during the film's opening sequence, but her embrace of her daughter in all that follows is as claustrophobic as it is loving. As Laurent Berlant points out, Delilah's attempt to make sense of her daughter's situation has her uttering "the film's most political sentences": "It ain't her fault, Miss Bea. It ain't yourn, and it ain't mine. I don't know rightly where the blame lies. It can't be our Lord's. Got me puzzled."[*] These lines also point to Delilah's lack of awareness, to her inability to see beyond the personal to the political, something which the film ensures that we come to understand.

At the same time as Delilah's pursuit of her perceived responsibilities as a mother fractures her relationship with her daughter, it also serves as an example against which Bea measures her own mothering activities. She is a regular witness to the drama unfolding in her own home, always empathising with Delilah, sometimes silently watching from the sidelines, sometimes intruding with advice for Peola.

A crucial factor in laying the foundations for her decision to separate from Stephen at the end is that she is present at the earlier scene where Peola comes home to tell her mother that she's leaving, never to return. Immediately afterwards, Bea encounters Jessie coming downstairs, greets her with an urgent embrace and tells her, "Oh, darling. If anything should ever come between us, it would kill me."

There's a harrowing inevitability to the final exchange between Delilah and Peola. In the novel, agonisingly, Peola never returns. In the film, she does, but only after Delilah's death, for which she holds herself responsible. "I killed my own mother", she wails. In their depictions of Peola's plight, both the novel and the film create a situation for which no happy outcome is possible, short of the civil rights uprising that was still decades away.

* Lauren Berlant, "National Brands/National Body: *Imitation of Life*", in Bruce Robbins, ed., *The Phantom Public Sphere* (University of Minnesota Press, 1993), p. 192.

The ending poses a resolution of sorts for its characters, with Bea noting Peola's agreement to return to the college she'd earlier fled. But whether this represents a sign of Peola's surrender to the oppressive order of race relations or a triumphant reassertion of her identity is left as a question for another day, and another film.

The film's general critique of racism, however, is clear: the force which drives it towards tragedy is nothing less than a national ideology that asserts that those whose skin is black are automatically inferior to those who are white. It should come as no surprise to find the PCA raising objections to a work whose emotional power stems primarily from a critique of this.◆

Tom Ryan

Magnificent Obsession

Universal Pictures. 30 December 1935. 112 minutes.
D: John M. Stahl. **P**: Stahl, Carl Laemmle, Fred S. Meyer, E.M. Asher. **Sc**: Sarah Y. Mason, Victor Heerman, George O'Neil, from the novel [1929] by Lloyd C. Douglas. **Ph**: John J. Mescall. **Ed**: Milton Carruth. **AD**: Charles D. Hall. **M**: Franz Waxman. **Sound**: Gilbert Kurland.

Cast: Irene Dunne (Helen Hudson), Robert Taylor (Robert Merrick), Charles Butterworth (Charles Masterson), Betty Furness (Joyce Hudson), Sara Haden (Mrs Nancy Ashford), Ralph Morgan (Randolph), Henry Armetta (Tony), Gilbert Emery (Doctor Ramsay), Arthur Treacher (Horace), Beryl Mercer (Mrs Eden), Alice Ardell (French maid), Theodore von Eltz (Doctor), Sidney Bracey (Keller), Arthur Hoyt (Perry), Cora Sue Collins (Ruth).

n the beginning there was the word, embodied in the Lloyd C. Douglas novel, published in the immediate wake of the 1929 stock market crash, when the author was 52. It was the then-Protestant minister's first foray into fiction. In 1935, the word became a film, directed by John M. Stahl and starring Irene Dunne and Robert Taylor, which, in turn, begat Douglas Sirk's remake (1954) with Rock Hudson and Jane Wyman.[*]

All tell more or less the same story. Resuscitated after a boat accident on a lake, self-centred playboy Bobby Merrick learns that the medical team which came to his aid had been unable to reach the widely-respected Dr. Wayne Hudson, who'd died as a result after suffering a heart attack at around the same time on the other side of the lake. Merrick's guilt at what occurred and his quest for redemption lead both to his assumption of the late doctor's role in the community and to his discovery of a formula for how to lead a constructive life. The keys to this kingdom are provided by a man of wisdom: in the novel, it's Hudson, via the mysterious diary that is his legacy and which Merrick is required to decode;[**] in the Stahl film, it's a famous sculptor; in the Sirk, a painter. Along the way, Merrick falls in love with the

[*] A further six of Douglas's stories found their way on to the big screen, three directed by Frank Borzage – *Green Light* (1937), *Disputed Passage* (1939) and *The Big Fisherman* (1959) – as well as *White Banners* (1938), *The Robe* (1953) and its sequel, *Demetrius and the Gladiators* (1954), in which writer Philip Dunne and director Delmer Daves extend the adventures of the former slave played by Victor Mature. *Dr. Hudson's Secret Journal*, published in 1937 and a prequel to *Magnificent Obsession*, led both to an hour-long dramatisation in *The Philco-Goodyear Television Playhouse* on American television in 1951 and to a TV series in 1955.

[**] In providing a kind of magic wand for Merrick to use in the world, the lesson provided by Hudson's diary serves as an approximate dramatic equivalent to the discovery of the green light in Douglas's *Green Light* (1935) and to the power attached to Christ's robe in *The Robe* (1942).

doctor's widow, her initial resistance finally giving way as various obstacles are overcome and he proves his moral worth.

Douglas's best-seller is a bit of a mess, but it's also reasonably engaging pulp storytelling, fuelled by its author's committed belief in the rewards on offer from a Higher Power, and occasionally leavened by a dry humour.[*]

Universal originally wanted Frank Borzage to direct the film adaptation, but he was forced to turn down the project when Warner Bros. refused to release him.[**] It's fascinating to reflect on what Borzage, who had a potent reputation and two Best Director Oscars to his credit at the time – for the sublime *7th Heaven* (1927) and *Bad Girl* (1931) – might have done with the material. Given the transcendent romanticism that drives his work, it's much more likely that he would have played it straight rather than reshaping it in the way that Stahl does.

Certainly that was how Borzage went about adapting Douglas's 1935 novel, *Green Light*, to the screen the following year. And the similarities between it and *Magnificent Obsession* are irresistible. Set in England, and starring Errol Flynn as a doctor "without too many scruples and not very much courage" (the character's own assessment of himself), it traces the course of his redemption under the spiritual guidance of a patient (Spring Byington) and her Randolph-like minister (Cedric Hardwicke). Also in the mix is a budding romance between the doctor and the patient's daughter (Anita Louise), although, since she (wrongly) holds him responsible for the botched operation in which her mother dies, he keeps his identity secret from her for a time. In the end, though, his redemption is the result of a noble sacrifice he makes in the interests of medical practice.

Borzage doesn't take a backward step from his material, unambiguously celebrating the capacity for individuals to rise above their limitations and to reach out for something beyond themselves. When Flynn's doctor puts his life on the line in the film's final passages, it's for a higher purpose, and Borzage lends his sacrificial endeavours a moving, Christ-like force.

By contrast, Stahl's adaptation of *Magnificent Obsession* is much more measured. It's as if he has set out to drain the material of as much of its melodrama as possible (while Sirk's goal, in his adaptation, appears to have been to put it all back in, and then some). Comic bits of business are frequently deployed to provide a counterpoint to the emotional intensity of unfolding events; composer Franz Waxman has designed a soundtrack that is largely devoid of the emotive force that was *de rigueur* for dramas of the 1930s; and Stahl's visual style rigorously eschews the big, glowing close-ups that are characteristic of the melodramas of the time.

[*] According to veteran neurosurgeon Gary V. Vander Ark, it has long been understood by those "in the know" that Douglas drew on a real-life model for his depiction of Dr. Hudson: "[Between 1916 and 1921] Douglas was the minister at the Congregation Church in Ann Arbor, Michigan, which is only a few blocks from the University Hospital... And it has always been a poorly kept secret in Michigan that Edgar A. Kahn, MD, was the neurosurgical inspiration for *Magnificent Obsession*... Dr. Kahn was my hero, and it has always been my goal to emulate Dr. Kahn in my practice of neurosurgery. He certainly passed on his magnificent obsession to all of his residents.... He spent his entire career at the University Hospital in Ann Arbor and always worked for $1 per year." *American Association of Neurological Surgeons Media Bulletin*, v.10 n.4, 2001.

[**] www.tcm.com/tcmdb/title/82394/Magnificent-Obsession/articles.html. The website also notes that, before up-and-coming new star Robert Taylor was borrowed from MGM for his first big leading role, unsuccessful overtures had been made to Douglas Fairbanks, Jr., to play Merrick.

Instead, working with cinematographer John J. Mescall (who collaborated with him again on *When Tomorrow Comes*), he relies heavily on master shots, with exchanges between the characters repeatedly filmed as unbroken two-shots and three-shots. The effect is to draw our attention to the flow of an interaction rather than to the individuals' particular contributions to it – to make it not about one or another, but both or all – a visual approach which is subtly distancing and, arguably, at odds with any melodramatic impulse. And it is also at odds with Andrew Sarris's notion that a defining feature of Stahl's work was his "naïve sincerity".[*] There's nothing "naïve" about Stahl's approach here, or its effect, and it revitalises the material.

The screenplay was officially written by the husband-and-wife team of Sarah Y. Mason and Victor Heerman (who also collaborated on the 1930s versions of *Stella Dallas* and *Little Women*) and George O'Neil (who also worked with Stahl in 1933 on *Only Yesterday*), as well as an uncredited committee of nine others.[**] And, while the presentation of the almost vignette-styled plot – made up of relatively brief "chapters" separated by fades to black – is readily recognisable as an adaptation of the approach taken by Douglas's novel (the Sirk film also deploys the same strategy), numerous details have been changed that also make it a very different kind of story.

Gone are numerous establishing elements and secondary characters, as the film-makers trim back the plot detail and create a different tone for the telling of the tale. Whereas the novel opens with 20 pages dealing with Dr. Hudson's life and his work running Westchester's Brightwood Hospital, Stahl's film begins as Hudson's wife, Helen, picks up his daughter, Joyce, from the New York pier at around the time of his offscreen death. Only on their return to Westchester do they (and we) hear about the accident. And all that we come to know of the doctor emerges through what the other characters in the film have to say about him.

Randolph, the famous sculptor who was Hudson's spiritual mentor in the novel, is dead before the novel's story begins. Here, however, played by Ralph Morgan, he's alive and well and, in fact, indebted to Hudson for the access he's gained to the secret power, rather than the other way around. As a result, there's no need for any diary to be decoded in order for Merrick to discover how "to make contact with a source of infinite power". It's a simple solution to the film-makers' problem of having to find something visually interesting in a man poring over a book for lengthy stretches of time and launching into extended philosophical dissertations about its contents.

While the novel builds a back story regarding the automobile empire that has provided the foundations for the Merrick family's riches, the film changes the source of their wealth to an electrical power company and notes it only in passing. The grandfather who founded it is only referred to in a throwaway line: near the end of

* Andrew Sarris, "The American Cinema", *Film Culture*, Spring 1963 (cited in Stephen Handzo, "Intimations of Lifelessness: Sirk's Ironic Tearjerker", *Bright Lights*, No. 6, Winter 1977–78, 20).
** Universal Pictures Corporation production documents. For the record, collectively listed as "Continuity", they were David Hertz, Alden Nash, Eugene Walter, Elizabeth Meehan, Philip Dunne and (his brother) Finley P. Dunne, Lynn Starling, Aben Kandel and Rena Yale. The same documents reveal that the film's budget was $763,500, from which Dunne was paid $116,666, Taylor a paltry $3000 and Stahl $87,500.

Merrick's first visit to Randolph's studio, he says that his grandfather owns stock in a nearby powerhouse. His aside comes as Randolph compares how Hudson taught him "to make contact with a source of infinite power" with the turning on of a switch to make a stove work, a much more concise analogy than the one Douglas had come up with in the novel.

The adaptation also cuts any reference to there being an earlier romantic attachment between Merrick and Helen's stepdaughter, Joyce, the film-makers clearly regarding it as an unnecessary complication. And it removes any reference to the unconsummated yearnings hospital superintendent Nancy Ashford has for Hudson in the novel.

Furthermore, it changes the character of Tommy, Joyce's boyfriend. In the novel, he's an old friend of Merrick's with a drinking problem that threatens his relationship with Joyce, and he needs help to get his act together. Cue another Merrick intervention. In the film, however, he's simply depicted as a good-humoured lap-dog, nicknamed "Poopsy" and tagging along behind her in the opening sequence like a transplant from a screwball comedy. He appears primarily in the interests of light relief, only briefly crosses paths with Merrick, and doesn't have a drinking problem. Along the same lines, the film's Merrick is given a comic manservant, Horace (Arthur Treacher, in a role that could have equally been played by Eric Blore, Edward Everett Horton or Franklin Pangborn).

As in the novel, Helen's financial affairs and those of the hospital are in a mess as a result of her late husband's deployment of its funds for his charitable acts, and Merrick again works secretly to set them in order. But there's no duplicitous broker cousin around in the film to take advantage of Helen's financial gullibility.

There are further changes between novel and film in their depictions of Helen and what happens to her, some of them minor, some crucial. Most significantly, the accident that blinds her and puts her life at risk occurs late in the book (only 16 pages before the end), but takes place before the half-way mark of the film (49 minutes in; the total running time is 112 minutes). There it's presented as a direct result of her attempt to escape Merrick's advances, making it seem as if there's nothing he can do right as far as the Hudson family is concerned. In the novel, it occurs while Helen is away overseas.

Just before the accident that blinds her: Irene Dunne, Robert Taylor..

At the same time, however, its placement in the film has far-reaching effects on what follows. One is that, supported by some citing of *Hamlet* that isn't in the book, the Oedipal implications of Merrick's mission and his pursuit of Helen come more clearly into focus. Put simply, the reshaping of the plot leads to them spending more time together, her adjusting to her blindness, him ingratiating his way into her trust incognito (she's blind and doesn't recognise his voice). Furthermore, what happens

between them is no longer thrust into the background by his extended musings about Hudson's diary or by his discussions about religion late in the book with a minister friend on whom he's operated (and who doesn't figure in the film).

Dunne, who was 35 at the time while Taylor was 24, delivers a performance that lends her character an assurance that Helen seems to lack in the novel. There, her vulnerability is initially underlined by how long it takes for her to realise the identity of the man she's falling for (about half-way into the book), whereas he becomes aware of who she is almost immediately after fate draws them together for the first time when her car breaks down on a country road (only a quarter-way into the book).

In the film, *both* discover who the other is immediately after that meeting (about 10 minutes in), when they're introduced in the hospital. Their scenes together, both before and after this, create the strong impression that she's the one in control. Her manner is very much that of a mother dealing with a precocious child.[*] This, combined with how the late Hudson functions plot-wise as a father figure for Merrick, even though the two never meet, makes the Oedipal reading virtually irresistible.

In both novel and film, Helen travels to Europe, but for very different reasons. In the book, it's strongly suggested that her trip is a flight from her feelings for Merrick. Rather than dealing head-on with them and her problems at home, including Joyce's unhappiness, she chooses to try to escape. Further disillusionment sets in when she realises that Merrick is manipulating her life from afar – with the best of intentions, of course – helped by a friend whose husband he's assisted with his medical studies back home (neither the woman nor her husband appear in the film, although, in it, Merrick is still pulling the strings). It's only the news of her accident that brings Helen and the now famous Dr. Merrick together again, with him performing the operation that saves her life and her sight.

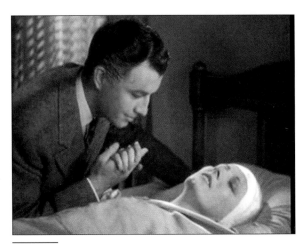

The Sleeping Beauty about to wake: the film's final shot.

In the film, however, her trip to Europe occurs *after* her accident when, unbeknownst to her, Merrick arranges for a consultation with the world's leading eye specialists in Paris. Beforehand, bizarrely unrecognised and despite Joyce's disapproval, he'd inveigled his way into her company and given her hope when there appeared to be none.

However, when the specialists tell her that nothing can be done, the film's tone darkens considerably. Facing the rest of her life without her sight – "Joyce, you don't know how lonely it is in the dark", she tells her travelling companion (who doesn't accompany her in the book) – she contemplates leaping from her apartment window in Paris to her death.

[*] This could at least partially be a consequence of Taylor's awkward playing during the first half of the film. When he's supposed to be young and irresponsible, he's much less convincing (especially when simulating drunkenness) than when he ages and discovers a new direction in life.

Only Merrick's unexpected arrival from America prevents her from doing so. He then takes her out for the evening, a romantic escapade in a glittering city cast in the mould of an Ernst Lubitsch set. However, she mistakes his subsequent proposal to her for pity and disappears from the city.

The film's rearrangement of the narrative not only pushes the relationship between Merrick and Helen more fully into the foreground, but also bases his efforts to step into Hudson's shoes in his feelings for her and his wish to do something to help her condition rather than in his belief in some higher power.

After her accident, Helen vanishes and six years pass before he receives news of her (it's only a few minutes of screen time). In the interim, he's acquired some grey around the temples, become a brilliant surgeon, funded clinics, donated to medical research and been rewarded for his efforts with a Nobel Prize. He's now a fully-fledged and officially-accredited hero. Furthermore, as he explains to Randolph, his good deeds haven't been "to better myself in any way" but to assist Helen, "hoping she might be one of those helped without my knowledge".

The film thus replaces the novel's insistence on the material benefits available for benefactors – its Merrick likens them to "earn[ing] compound interest" – with an emphasis on its protagonist's altruism. And it raises a knowing eyebrow at the happy ending which it confers on the lovers with its reference to the Sleeping Beauty fairytale in its closing sequence, Merrick's operation on Helen serving as the equivalent of a waking kiss. Raises an eyebrow at, but doesn't undermine.

The Stahl film's reshaping of the material has resulted in the telling of a very different kind of story from the one told by the novel. The results are sometimes to the film's detriment: the screwball elements, for example, at times seem awkward, as if out of touch with the serious events unfolding around them. But the general rearrangement of Douglas's plot, the distinctively different viewpoint the film brings to its characters and their motives, and the marked shift in tone make it clear that Stahl and his collaborators' work is a creative step away from the limitations of its source.◆

Tom Ryan

Parnell

MGM. 4 June 1937. 118 minutes.
D: John M. Stahl. **P**: Stahl. **Sc**: John Van Druten, S.N. Behrman, from the play [1935] by Elsie T. Schauffler. **Ph**: Karl Freund. **Ed**: Frederick Y. Smith. **AD**: Cedric Gibbons, William A. Harning, Edwin B. Willis. **M**: William Axt. **Sound**: Douglas Shearer, Jimmy Burbridge. **Costumes**: Adrian.

Cast: Clark Gable (Parnell), Myrna Loy (Katie [O'Shea]), Edna May Oliver (Aunt Ben), Edmund Gwenn (Campbell), Alan Marshall (Willie [O'Shea]), Donald Crisp (Davitt), Billie Burke (Clara), Berton Churchill (the O'Gorman Mahon), Donald Meek (Murphy), Montagu Love (Gladstone), Byron Russell (Healy), Brandon Tynan (Redmond), Phillis Coghlan (Ellen), Neil Fitzgerald (Pigott), George Zucco (Sir Charles Russell).

F ew, if any, of John M. Stahl's 1930s films have fared as poorly as *Parnell*. Produced with top MGM talent and a budget of $1.5 million, it barely recouped half of that at the box office, failed to impress the critics, and damaged the reputation of its director after a string of successes at Universal. Eclipsed by Gable's career-defining performance in *Gone With the Wind* two years later (a role he was initially reluctant to take, on account of his unfavourable experience here with period drama), it has largely disappeared from discussions of star, director or studio, and is widely dismissed as an outlier in Stahl's otherwise defining decade. The *New York Times* described it as a "singularly pallid, tedious and unconvincing drama", while the *New York World-Telegram* judged it "an astonishingly diffuse and insignificant entertainment. Under the circumstances this is rather bewildering, for everyone involved with the production has done a good job ..."[*] In the discussion that follows, I develop the tensions within this judgment, recognising that while *Parnell* combined MGM's strengths in high production values with contemporary genre trends, its dramatisation of the life of a celebrated historical figure was fundamentally compromised by demands of censorship, casting and, crucial to the concerns of this book, the impulses of Stahlian melodrama.

Parnell as historical figure

No figure galvanised and subsequently divided Irish politics as intensely as Charles Stewart Parnell (1846–1891), the defining politician of 19th-century Irish nationalism, and the one who came closest to securing self-government for Ireland. Although he remained largely unknown in the years immediately following his election in 1875, Parnell found his calling and purpose in Westminster with the

so-called "New Departure" – a coalition of disparate factions of Irish and Irish-American nationalists to which he brought leadership, purpose and method through a single-minded pursuit of Home Rule. Over the course of the next decade, Parnell's exceptional parliamentary skills and rise in political authority led Prime Minister William Gladstone to introduce the Home Rule Bill of 1886: a historic shift in British policy towards Ireland which ultimately, however, failed to pass due to opposition both from Unionists and from members of the governing Liberal party. In the aftermath of this failure – not before, as Stahl's narrative presents it – Parnell experienced two dramatic charges that divided public opinion and led to the collapse of his reputation and his cause. First, forged letters claiming that he supported the murder of British officials in Ireland were published by *The Times,* leading to an enquiry headed by three British judges (The Parnell Commission of 1888); second, and far more damaging, a petition for divorce was filed in 1889 by minor Irish politician Captain William O'Shea from his wife Katharine, naming Parnell as co-respondent. The "Kitty O'Shea" scandal split the Irish Parliamentary Party; although he continued to campaign, the "uncrowned King of Ireland" fell into bad health and died in October 1891, aged just 45. Stahl's film covers the final decade of his life, beginning with a visit to the United States in 1880 and his meeting with Katharine O'Shea in 1881. The majority of its action, however, is concentrated on the scandals that dogged his final three years.

Parnell as dramatic figure

In the decades following his death, Parnell became an immediate and a frequent subject for biographers and historians. The events and personalities of the 1916 Rising and Irish War of Independence, however, overtook both his methods and his legacy, and his story remained ignored by dramatists until Elsie T. Schauffler's play *Parnell* opened at the Ethel Barrymore Theatre in New York in November 1935. It ran until February 1936, with a brief revival in May, and was subsequently performed in London.[*] While popular enough to sustain a three-month run, the play drew biting criticism from some quarters for its treatment of Irish history. James T. Farrell, Irish-American author of *Studs Lonigan*, dismissed it entirely, saying that although Parnell's life story offered "material for a real drama… the author, director and producers are all political illiterates" who had accentuated "the setting of the English drawing room to produce a love story borrowing the prestige of history".[**] While the enormous resources of MGM would seek to remedy – or at least disguise – such shortcomings in the screen adaptation, it could be argued that the film never fully escaped the limitations of the source material identified by Farrell. Nevertheless, MGM had seen off keen competition from several studios to secure the screen rights to the as yet un-staged production, described in their reader's report as "A splendid play that offers excellent possibilities for the screen … RECOMMENDED".[†]

[*] The famed Margaret Rawlings – as Katharine – was the only actor to play in all productions. James Mason played Capt. O'Shea in the first London performances at the Gate (sometimes mistaken for the Gate Theatre Dublin, where Mason did work for several years). This was only accessible to members and their guests, because the English theatre censor had refused to pass it on account of protests from Captain O'Shea's family. After the rewriting of some scenes, it subsequently had a short public run. Parnell was played on Broadway by George Curzon, and in London by Wyndham Goldie.

[**] James T. Farrell, 'A Spoonful of History', in the Marxist journal *New Masses*, 17 December 1936, 44.

[†] Henry Klinger, 8 November 1935: from "Reader's report on Manuscript of Play by Elsie T. Schauffler to be produced at Ethel Barrymore Theatre – to open 11 November 1935". *Parnell* MPAA File, Margaret Herrick Library.

Why Parnell?

Although *Parnell* may seem at first glance an unlikely property for a bidding war in 1930s Hollywood, a number of production contexts inform its commercial appeal as well as its treatment. In the first instance, it emerged at the height of the classic biopic film cycle which included titles such as *The Story of Louis Pasteur* (1936), *The Life of Emile Zola* (1937), *Juarez* (1939), and *Young Mr Lincoln* (1939). Alongside their place within the tradition of Hollywood prestige projects (literary and dramatic adaptations, historical and period subjects etc.), such films have frequently been read in relation to the socio-political context of the period, and their protagonists compared to the New Deal presidency of Franklin D. Roosevelt.

Early in the film, Parnell defends a dispossessed Irish family.

This works, up to a point, for Gable's Parnell: the insecurities of the Irish tenants he defends are comparable with the disenfranchised dustbowl farmers, and resonate with FDR's reference to the "ill-housed, ill-clad, and ill-nourished" in his 1937 inauguration speech, while the Irish politician's tactic of filibustering (obstructing parliamentary business by refusing to cede the floor to political opponents) finds an echo in Frank Capra's populist *Mr Smith Goes to Washington* (1939). Within such contexts, it is also worth noting that John Ford had recently directed two films on the Irish struggle for political independence: *The Informer* (1935) – for which he won a Best Picture Oscar – and *The Plough and the Stars* (1936), an adaptation of Sean O'Casey's celebrated and controversial drama on the 1916 Rising. Finally, *Parnell* offered MGM a vehicle to consolidate Gable's star status as leading man and to pair him once again with Myrna Loy in what would be the fourth of six films they made together. In his analysis of studio finances from the period, Mark Glancy states that:

> *Mutiny on the Bounty* (1935) with a gross of $4,460,000 confirmed Clark Gable's status as MGM's top star. His next film *San Francisco* (1936) … earned the best gross ($5,273,000) of the decade. The success of *Mutiny* and *San Francisco* led to further and more expensive prestige productions.*

* H. Mark Glancy, "MGM film grosses, 1924–1948: The Eddie Mannix Ledger", *Historical Journal of Film, Radio and Television* v.12 n.2, 1992, 127–144.

However, as he goes on to ruefully note, "most were costly failures". *Parnell* was chief among these, with a recorded loss of $637,000.

Producing *Parnell*

When Standard Capital Company called in a loan that Universal Studios couldn't repay in 1936, Stahl – as the most highly paid director at the near-bankrupt studio, earning up $90,000 per film – was loaned to MGM. Universal's predicament represented an opportu-

First meeting, at Westminster: Clark Gable, Myrna Loy.

nity for Louis B. Mayer to rekindle a highly successful professional relationship that went back to 1920 when he first hired Stahl at Metro Pictures, and *Parnell* seemed an ideal fit for his talents as producer and director. Charles E. Whittaker, an experienced Irish-born screenwriter who specialised in adapting literary sources, was tasked with researching and drafting a screenplay, though the final version from August 1936 bears the name of the well-respected English playwright John Van Druten. (Sam Behrman, a leading Broadway writer of comedy, subsequently provided 25 pages of re-writes.) Beginning with Whittaker, these writers sought to "open up" the physical and temporal limits of Schauffler's drama, which was limited to "Katharine O'Shea's drawing room" for Acts One and Two, and, for Act Three, "Gladstone's study", and "Committee Room No 15, Westminster". This opening up is most apparent in the film's early phases, which endeavour to provide both cinematic spectacle and additional detail in representing Parnell's career and his developing relationship with Katharine O'Shea.

Following the opening scenes where he is seen addressing large crowds on the New York waterfront at the conclusion of a US speaking tour, Charles Parnell receives a rapturous reception on his return to Kingstown (the port now known as Dun Laoghaire, close to Dublin). As he goes back to his estate in County Wicklow, he encounters the eviction of a poor Irish family and tries to assist them, but is arrested and imprisoned in Kilmainham gaol. He is shown again speaking, from his cell window, to crowds of supporters who wait outside. In the House of Commons he leads the Irish parliamentary cause and gives an impassioned speech on the moral and political justification for Home Rule. The speech is witnessed by Mrs. O'Shea; she has come to invite him to dinner at the prompting of her estranged husband Willy, who is seeking Parnell's patronage to commence a career in politics. Thereafter the story follows his developing relationship with Katie against the backdrop of forces that conspire to bring him down.

Filmed on 74 sets designed by Cedric Gibbons (including a full Irish village, and New York and Dublin harbours), with costumes by Adrian and cinematography by Karl Freund, *Parnell* envisions nineteenth century Anglo-Irish history on a grand scale.[*] Notwithstanding the extravagantly staged early scenes, however, Stahl's

[*] "*Parnell* was Made the Hard Way", *Life* magazine, 14 June 1937, 43–45

overwhelming impulse is to return to the "drawing room" settings of its source material and locate its drama in primarily domestic terms. Although Charles Parnell is established as a hugely popular and effective public figure, Stahl quickly positions him as a man for whom Home Rule has a double sense, both political and private, with the latter ultimately more important than the former. The O'Shea house at Eltham provides his true fulfilment, and retrospectively illuminates his pity towards the evicted Irish family as gesture rooted more in in emotion than ideology. In the public sphere, Katie is consistently placed in spaces of exclusion and concealment: behind the grille in the ladies' gallery at Westminster; hidden in Parnell's office; refused access to the Parnell Commission. By contrast her home is her castle, a feminine counterpoint to the masculine House of Commons which she shares with her formidable Aunt Ben (Edna May Oliver) and flighty cousin Clara (Billie Burke). During Charles's first visit, the Irish politician O'Gorman comments on this atmosphere: "What a fine house you have here, Mrs. O'Shea. And you've given it a soul too, filled it with that subtle warmth that makes houses live." This sets up Parnell's subsequent moving in after his collapse from a cardiac condition and Katie's pained discovery of the un-homely condition of his bachelor apartment. As a still married (though separated) woman, the potential for scandal is clear, but emboldened by Charles's belief that they are destined for one another ("Have you never felt there might be someone, somewhere who, if you could meet them, was the person that you'd been always meant to meet?") they cast aside caution. As Stahl tells it, home is where the (weak) heart is, with domestic fulfilment of greater importance than public opinion or political cause. Within the conventions of melodrama, such priorities lead inevitably to tragedy. What is unusual in *Parnell* is that the traditional feminised "victim" is also its masculine hero.

While the film's privileging of what Farrell disparagingly called the "love story" had its basis in both Schauffler's play and Stahl's instincts, it took additional impetus from comments made by Joseph Breen, the proudly Irish-American and devoutly Catholic head of the Production Code Administration (PCA). In the weeks leading up to the Broadway preview, several major studio producers including Irving Thalberg and Mayer (MGM), Walter Wanger (Columbia), and Col. Jason Joy (Fox) contacted Breen to seek his views on purchasing the screen rights to the property. In his letter to Mayer, Breen warned that:

> The whole subject of Parnell is a very delicate question . . . The Irish, in this country and in Ireland, are likely to resent any aspersion cast on the memory of a man who is generally believed to be one of the greatest of Irish Statesmen and patriots. The English are certain to take umbrage at the portraiture of Gladstone. It is our recommendation that you continue to think a little more about the purchase of this play for screen presentation.[*]

Mayer went ahead, but Breen's cautioning presence can be felt through the film's treatment of its subject. While aspects of Parnell's life are presented with admirable attention to historical and visual detail, the film carefully avoids any overtly politicised debate or confrontation between the politicians – notably Gladstone – that MGM had taken such effort to research. In place of ideological conflict, the film's antagonists are the blackmailing journalist Pigott (who kills himself) and the

[*] Letter from Breen to Mayer, 20 November 1935, Parnell MPAA File, Margaret Herrick Library.

scheming Captain O'Shea. Breen's office also issued warnings regarding the on-screen representation of the unconventional relationship between Parnell and Katherine: "scenes showing physical contact between P and Katie [must] be reduced to an absolutely necessary minimum", "omit embraces in 3 scenes", and so on. Under the influence of the 1934 Production Code, the screenplay entirely omitted any mention of Katherine O'Shea's six children – three by her husband and the three born out of wedlock to Parnell (one of whom was stillborn). The overall – and desired – effect was to render their relationship as simultaneously passionate and chaste.

Linda Williams describes romantic melodrama as "a peculiarly democratic and American form that seeks dramatic revelation of moral and emotional truths through a dialectic of pathos and action".[*] In *Parnell* this dialectic is expressed in terms of a tension between its title character's tireless political campaigning and a love affair cut tragically short by his early death. Within this structure, Gable's character is rapidly transformed from charismatic leader and defender of the Irish agrarian poor to a smitten and then helpless figure, let down by poor health and disloyal colleagues. While the film's climactic staging of his death within the surrounds of idealised Victorian domesticity (snow outside, blazing fire, comfortable armchair, surrounded by loved ones) seeks to evoke a sense of pathos, the effect is to eclipse his political career and achievements and render him impotent in both private and public terms. It was this feminisation of its subject that led many contemporary critics to complain that the film's central problem was the casting of Gable. Louella Parsons spoke for many when she wrote: "Personally I prefer the rough and ready Gable . . . You get the impression he is being constantly repressed".[**] *Parnell* represented a significant setback for the actor, but not the disaster that is often reported. Just months later, he and Loy would be crowned King and Queen of the Movies in a nation-wide poll.[†]

Parnell represented an unexpected opportunity for John M. Stahl at a time of professional crises, a scrupulously researched big-budget biopic that attempts to explain the complexities of Irish history within the conventions of Victorian melodrama. Although it never reconciles these tensions, it remains aware of them to the end. Omitting the historical fact that Parnell and O'Shea married in the months previous to his death, the film's final scene is between Charles and his men as he dies in Kitty's arms – thus leaving us with a hero who dies for Ireland in the well furnished but unconsummated bedroom of his suburban home. It remains the only attempt ever made to put Parnell's story on screen. ◆

The film's final shot.

Tony Tracy

* Linda Williams, "Melodrama Revised", in Nick Browne (ed), *Refiguring American Film Genres: History and Theory* (University of California Press 1998), 42.
** Louella Parsons, "*Parnell*: Slow But Beautiful Drama of Erin", *Los Angeles Examiner*, 6 October 1937.
† The results of the Ed Sullivan poll were published in *NY Daily News*, 9 December 1937.

Letter of Introduction

Universal Pictures. 29 July 1938. 104 minutes.
D: John M. Stahl. **P:** Stahl, Charles R. Rogers. **Sc**: Sheridan Gibney, Leonard Spigelgass, from original story by Bernice Boone. **Dialogue**: Bernice Boone. **Ph**: Karl Freund. **Ed**: Ted Kent, Charles Maynard. **AD**: James Otterson. **M**: Charles Previn. **Sound**: Bernard R. Brown.

Cast: Adolphe Menjou (John Mannering), Andrea Leeds (Kay Martin), George Murphy (Barry Paige), Edgar Bergen (himself), Charlie McCarthy ('himself' – ventriloquist's dummy), Mortimer Snerd ('himself' – ventriloquist's dummy), Rita Johnson (Honey), Ann Sheridan (Lydia Hoyt), Ernest Cossart (Andrews), Frank Jenks (Joe), Eve Arden (Cora Phelps), Jonathan Hale (Woodstock).

In his well-known book *The Genius of the System*, Thomas Schatz examined the situation at Universal Studios from 1934–5 to 1939,[*] a period coinciding with the second half of Stahl's time there, after three of his best remembered films, *Back Street*, *Only Yesterday* and *Imitation of Life*. Though given a long-term contract, just before Junior Laemmle was ousted in the studio's 1936 financial crisis, Stahl made only three more Universal films – *Magnificent Obsession* (1935), already under way during the transition, *Letter of Introduction* (1938), and *When Tomorrow Comes* (1939). In Schatz's narrative, dominated by the viewpoint of the post-Laemmle cost rationalisers, Stahl appears as a relic of the old system retained reluctantly as the studio's highest-paid director because of his contract. Under the new regime, his expensive directorial methods were no longer easily tolerated, and it became difficult for director and studio to agree new projects. These were the uneasy circumstances in which *Letter of Introduction* came about.

Schatz's studio backstory is revealing, but he unfortunately lacks any insight at all into Stahl's films. His account is, to burlesque André Bazin's famous phrase "the genius of the system", all system and no genius. His careless talk of Stahl's "overblown melodramas" and "bloated and excessive style"[**] suggests, to put it mildly, no intimate acquaintance with works notable for shunning such qualities. If this critique seems harsh, it is of a distortion of Stahl's work which has contributed to its neglect. It's true that *Letter of Introduction* is unlikely to be thought the equal of Stahl's other Universal melodramas, but it has, though less concentratedly, many of their virtues, and, through the starring of the ventriloquist comedian Edgar Bergen and his famous dummy/alter ego Charlie McCarthy, it is, at the least, interesting for

[*] Thomas Schatz, *The Genius of the System: Hollywood Filmmaking in the Studio Era* (London, Simon & Schuster, 1988).
[**] Schatz, 245.

a juxtaposition of melodramatic and comic modes more extreme than is found in *Imitation of Life* and, in particular, *Magnificent Obsession*.

Letter of Introduction, with its cross-generic mixing, is hardly Schatz's Frankensteinian "monstrous assemblage". Backstage drama – melodrama – comedy – play on George Murphy's musical roles when he and Andrea Leeds dance in the street – various intertextual and real-life allusions, e.g. Adolphe Menjou doing John Barrymore, Edgar Bergen re-enacting his real life breakthrough on Rudy Vallee's radio show – Stahlian self-reference, with a poster of Mannering in a film called *The Lady Surrenders,* echoing Stahl's own *A Lady Surrenders* from 1930…. This mix is far from neoclassical, but hardly outlandish.

The presence of Bergen and Charlie McCarthy's vastly popular ventriloquist act is the sticking point for modern-day critics, and perhaps viewers, but earlier audiences and reviewers approached the film's mixed attractions more relaxedly. Louella Parsons, crediting "John M.Stahl's witchery", wrote that "I don't know when I have seen a picture that holds better entertainment, and that doesn't mean only for a Hollywood audience but for people all over the country" (*Los Angeles Examiner*, 20 August 1938, 27). Frank S. Nugent, soon to become a distinguished screenwriter for John Ford, praised it similarly – "all the while, with deft bits of business – satirical, tragic, comic and sentimental – the tale keeps spinning and never lets you realize how frail it is" – and summed it up as "a surprisingly fresh, uncommon, diverting, remarkably well-directed film". He was notably undistressed by the presence of "the little hero of the occasion", Charlie McCarthy. "By the strictest narrative standards, Charlie's frequent interruptions of the story's course are inexcusable; by amusement standards they were all for the best" (*New York Times*, 1 September 1938). Nugent also, with a scriptwriter's equanimity about intertextual borrowings, noted that the narrative was a kind of "sequel to 'Stage Door'". Stahl's film, like Gregory La Cava's from 1937, mixed melodrama and comedy in its story of struggling Broadway actors. Though *Stage Door* is starrier – Katharine Hepburn, Ginger Rogers, Lucille Ball, Gail Patrick and Ann Miller, against Eve Arden, Ann Sheridan, Rita Johnson and George Murphy – Adolphe Menjou is in both, along with Andrea Leeds (called Kay in each, which can't but link them), the two playing not dissimilar roles.

Central among *Letter of Introduction*'s intersecting plotlines, following the characters' quests for work and love, is the letter with which Kay gains access to the celebrated stage turned movie star, John Mannering (Menjou), a synecdoche for all the characters' dreams of fulfilment, "a passport to fame and fortune and happiness". Though we are led to think that it recommends her as an actress, it is revealed to have been written by her mother, the earliest of Mannering's wives, before her death, introducing his abandoned daughter. The scene where she gives him the letter mixes affect with irony. Though he is touched by their reunion, Mannering's vanity means he cannot bring himself to disclose that a woman no younger than his newest fiancée is his daughter. To protect his image, he claims she is his protegée, first to his fiancée, then to everyone. Kay willingly agrees to sustain this fiction, despite the inevitable interpretation that protegée means mistress, which leads to Mannering's fiancée, Lydia, leaving him, and to the relationship between Barry (George Murphy) and Kay nearly failing.

Kay's motives for agreeing, it might be felt, are as mixed as her father's, partly genuine feeling for him, but also the calculation that he will aid her career if humoured. And indeed Mannering does return to the stage to expedite his daughter's career by playing alongside her; but his drunken collapse onstage leads to the play's closing, and with it Kay's chance of stardom. It is typical of Stahl's discreet handling of relationships that the heroine's ambivalence is implied rather than plainly stated, until the moment when she walks out coldly on her father after his collapse, an action which is the final catalyst for his suicide. Clearly, though, in the hospital death encounter her guilt-stricken grief is genuine. This scene, though overtly emotional in a way Stahl usually avoids, nevertheless concludes ironically as Mannering, who has failed to fulfil his promise to announce, at what would have been Kay's triumphant curtain call, their real relationship, now, in an attempt to belatedly carry it out, asks for the gathered reporters to be brought to his room – but dies before they arrive. After this, relationships are wrapped up: witty tough girl Cora (Eve Arden) takes on lonely Bergen (and Charlie), and Kay leaves the stage to marry Barry, though with the possibility of a future return to acting. A minor instance of Stahl's characteristic playing down of potentially hyper-dramatic moments comes at the end when Kay gives the recurrently significant letter of introduction to Barry, and we see him begin to read, but not for long enough to grasp its significance and respond – before a cut to Cora and Bergen catching a taxi leaves implicit the predictable moments about to follow.

Much of the film's press coverage focussed on Bergen and Charlie McCarthy, e.g *Photoplay*'s story of Charlie's unruly encounter with Stahl – see the cartoon opposite, "Not even John Stahl, Hollywood's most dignified director, escaped Charlie's heckling" (December 1938, 20–21). Certainly in the general view Charlie was the main attraction. Whatever Stahl thought of this, he took pains to bind the pair into the narrative, beginning it with Bergen and Kay rescuing their respective futures (his Charlie, hers the letter) from the fire, and ending it with Bergen and Cora (Eve Arden) together, with a jealous Charlie commenting sardonically "She'll take you like Grant took Richmond". Mannering is responsible for their appearance on Rudy Vallee's radio show, and it is when Bergen announces Mannering's "accident" over the radio that Kay and Cora learn he is near death in hospital.

Daughter (Andrea Leeds) and father (Adolphe Menjou) meet through her "letter of introduction".

Why was the act so massively popular that Universal grabbed it, teaming the pair with W.C. Fields the year after Stahl's film? Technically, as Charlie waspishly reminds Bergen, with his too-evident lip movements he is not the most accomplished of ventriloquists. But such is the comic intensity of their interplay that this can seem a minor issue. With his fractiousness, smarmy opportunism, lechery and insulting audience putdowns, Charlie under-mines the sentiments and illusions of those around him, not least the film's Bergen, with his unspoken passion for

Kay. What is most extraordinary in the pair's performance is their apparent symbiosis, their verbal interchanges not episodes of distinct stychomythia, but seemingly overlapping, intertwining, best exemplified when Bergen and Mannering's butler wraps the vocally and physically resisting Charlie in newspapers, the duo's interchanges continuing through all the impediments in their way. Watching this sequence, directed by Stahl to augment the almost uncanny impression of Charlie's vivacity, one is hardly surprised by the strange revelation that Bergen bequeathed money in his will to Charlie "who has been my constant companion and who has taken on the character of a real person and from whom I have never been separated for even a day".[*]

In his *American Cinema* essay on Stahl, Andrew Sarris, naming "Who Can Forget?" moments in the films, includes, alongside scenes from *Leave Her To Heaven*, *Only Yesterday*, and *When Tomorrow Comes*, the letter of introduction meeting between Kay and Mannering – impressed, one imagines, by the cool, complex restraint with which the scene's daughter-restored-to-father melodrama is handled.[**] He could equally well have cited the sequence culminating in Mannering's suicide. A comparison with Andrea Leeds's killing herself in La Cava's *Stage Door* is revealing. There, having lost the role she obsessively coveted, she climbs the staircase, the camera retreating before her, her shadow accompanying her on the wall expressionistically, her progress also accompanied by subjective sound, the greatly distorted singing of a girl below at the piano, an unidentifiable male voice, and the swelling applause she craves. Highly effective in its own terms, the scene also underlines the radically different nature of Stahl's restrictions on camera and sound

A cartoonist's view of Stahl's meeting with the incorrigible Charlie McCarthy.

rhetoric in treating a similar situation. La Cava may well have learned from Stahl's earlier 1930s melodramas the possible potencies of the refusal of non-diegetic music. His suicide sequence, like Stahl's, uses only diegetic sound, but its play with subjectivity creates a sonorous envelope as complete as any immersion in unsourced symphonic music. By contrast Stahl's objective treatment of the situation is without either diegetic music (realistically unlikely anyway in the crowded street) or subjective sound distortion. As Mannering/Menjou joins the crowd of theatre leavers streaming towards the taxi rank, the soundtrack is naturalistic, the buzz of conversations, the cacophony of taxis arriving and departing to piercing police whistles, all unrandomly organised for emotive effect, obviously, but undeniably realistic.

* http://www.womansday.com/life/real-women/news/a50235/candice-bergen-reveals-twisted-details-about-relationship-with-her-father/
** Andrew Sarris, *The American Cinema: Directors and Directions 1929–1968*, (New York, E.P. Dutton, 1968), 139–140.

Mannering stands at the front of the shifting crowd, contrastingly immobile, seemingly diminished in size by the heavy dark overcoat and hat he wears, hands in pockets, eyes downcast, expression impassive. In the scene's single closer shot of him with members of the crowd behind him, Menjou's usually supercilious features seem sunken and aged, making no reaction of any kind to the clearly audible conversation about himself going on near him – "it would have been funny if it wasn't so tragic". Cut back to the wider view of the scene. Rather than hurling himself in "a suicidal leap" (in Schatz's description), Mannering steps quickly forward – nothing at all like a leap – into the taxi's path, the actual collision blocked to the audience, only seen, as it were, in the crowd's reaction, their shock and screams. A cut to reporters phoning in the news, and a figure in authority demanding someone gets Kay on the phone, as the business of the world carries on.◆

Bruce Babington

When Tomorrow Comes

Universal Pictures. 11 August 1939. 90 minutes.
D: John M. Stahl. **P**: Stahl. **Sc**: Dwight Taylor, "based on story by James M. Cain". **Ph**: John J. Mescall. **AD**: Jack Otterson. **Ed**: Milton Carruth. **MD**: Charles Previn.

Cast: Irene Dunne (Helen), Charles Boyer (Philip André Chagal), Barbara O'Neil (Madeleine), Onslow Stevens (Holden), Nydia Westman (Lulu), Nella Walker (Mrs Dumont), Fritz Feld (Butler).

When Tomorrow Comes brings together elements that had been tried out before. It was the final film that Stahl was to make with Irene Dunne, coming after Back Street (1932) and Magnificent Obsession (1935), and it was the second film to cast Dunne and Charles Boyer as its star couple, following on from Leo McCarey's Love Affair, which had been released earlier in 1939. The credits tell us that it was "Based on story by James M. Cain"; this slightly cryptic formulation refers to an unpublished work, "The Modern Cinderella". The only access we have to Cain's contribution is in the use he made of the material in The Root of his Evil (1951). This novel uses the opening situation of the film: the central figure is a waitress in a big restaurant and there is an impending strike, but after this it takes a different direction from the film.[*]

The studio's weekly status reports, recording the progress of the production, make it clear that the script was largely written as the film was being made.[**] The first report (6 May 1939) comments that there is only enough written script for a week's work, and subsequent reports refer to the difficulty of projecting production costs in the absence of a script. A crisis appears to have been averted when Boyer and Dunne waived their salaries for 3 July in order that Stahl could consult his writers, and the picture was completed by the end of July.[†] So in the absence of a script, Stahl had some freedom to follow prompts such as the stars' work together – and Dunne's earlier films.

[*] A few details from the opening chapters were adopted by Stahl and his writers, such as the sailing episode and the squall, but the hero has no wife and marries the waitress early in Cain's text. The book is the story of this marriage.

[**] Documents from the Universal collection at the University of Southern California, kindly supplied by Ned Comstock.

[†] Part of the relevant memo (8 July 1939) reads: "Stahl took good advantage of the day, remaining at the studio with the writers until after 6 P.M. and accomplished sufficient to place us in the position of being able to proceed without further story interruptions".

First encounter:
Charles Boyer,
Irene Dunne.

The populated world

Stahl often seems to choose to open with a crowd: the 'Over the Rhine' restaurant in *Back Street*, the Stock Exchange followed by the cocktail party in *Only Yesterday*, the masses aboard ship and on the dockside in *Magnificent Obsession*. When *Tomorrow Comes* opens with an establishing shot of a packed New York restaurant. As in *Back Street*, this world is both appeasing hunger and is a site of sexual assignation. The food is served only by waitresses: identically dressed, and as elaborately dressed as the work will allow. With their puff sleeves and bows, they might be costumed for a fantasy about waitressing, say a Hollywood musical. They are being poorly treated by the (male) management, and are meeting that evening to consider strike action. That they are mostly pretty and chosen for this reason is underlined by the heroine's friend Lulu, who is worried about getting the sack and not finding similar work as "I ain't a looker".

Philip Chagal (Boyer) orders lunch from the waitress heroine, Helen Lawrence (Dunne). As part of their verbal fencing, she tells him what a gentleman is: "One who doesn't immediately ask a girl what she does with her evenings". Her stress falls on "immediately"; Helen has no objection to being asked, but defines a gentleman as one who knows how to wait and when, and what, to ask. She tells Philip he is a gentleman; she calls him Prince Charming.

That the restaurant is felt to be a proper context for such exchanges is implicit in Helen's attitude to Philip. The waitresses can weigh up the men who show interest in them; one has commented earlier on the unfairness of being sacked for making dates with the customers.

A bit of plot introduces the idea that Philip might be a management spy. Philip suggests that "in these troubled days, it is quite a serious matter to be taken for a

spy". He tells Helen that in France he would be taken out and shot. He goes on "and in Germany…" and she finishes the line with "…we'd both be shot". So this establishes the significant ominousness of the contemporary moment; the film was released in the inexorable buildup to the war, only a few weeks before Hitler's invasion of Poland. A little later Philip will tell Helen that he is to about to return to France.

After a rousing speech by Helen, the strike meeting concludes. Philip has been quizzing Lulu about Helen, and has learned that this modern Cinderella is an orphan, and a singer. The couple stroll to a waterside, which Philip comments is "a little crowded". The evening ends outside Helen's apartment with a gag about the insistent presence of others. Philip is trying to persuade Helen to spend Sunday with him. Stahl stages interruptions: a girlfriend questions Helen, a woman asks for directions, a neighbour chats to her. Finally a figure noisily puts out a dustbin. Philip comments: "I've been told there are seven million people in this city, and tonight I've met them all". After a brief scene in Helen's and Lulu's apartment, there is a dissolve to a long shot of Philip's sloop; it is now Sunday afternoon.

Privacy and peril

Stahl has introduced a considerable ellipsis here, covering Philip's collection of Helen from her apartment and their picnic aboard the sloop. Its effect is to make a very pointed contrast between the crowded social worlds of the first 27 minutes and this isolated couple. Also elided is Helen's learning to be at ease with Philip; when we first see them, she is asleep. So she has chosen to spend the day in a way which puts her entirely in his hands. (It is made clear that only one of these two – not her – knows anything about sailing and about weather.)

The conditions deteriorate – a squall. Helen and Philip's reaction to this is to laugh together, and they are still laughing when they leave the sloop. They arrive at Philip's home in what is now a fully-fledged storm, and he invites her to sing. He chooses a love song: Schubert's *Serenade*. This recollects the Madeira sequence of *Love Affair*, where Dunne's character had sung for Boyer's, in that case the eighteenth century love song *Plaisir d'amour*, connecting the couple through their shared relation to a dense European culture that is marked as receding into the past. The singing marks the couple's ideal communication with each other; they are literally in harmony.

Helen comments, a little wryly, on the spaciousness of the room, its security and beauty. The storm causes the power to fail, and they kiss. Just before they do so, he grasps her, holding her upper arms, as if to express a need to clutch, to hold onto her, a gesture that we will see varied in later scenes. Helen now announces that she must leave. When Philip refers to the weather, she tells him, stressing the final word, "I'm not afraid of storms".

What is she afraid of? Evidently of the unequal circumstances in which they find themselves: Cinderella and Prince Charming. In these terms she cannot think of eating with Philip, or of sleeping with him. (We shall see her doing both of these things, in unlikely ways, in the next few hours.) What she wants is a kind of equality, something which could make her laugh. And after her passive snooze on the boat, she wishes to be the one who dictates events.

What this initiative turns out to be, is taking them both out into a raging hurricane. By the time Helen gets into Philip's car she is already laughing out loud again. He tells her he has no sympathy for her, while tucking a blanket around her legs.

There is an increasingly apparent presence of danger, even the threat of death, and after their car is wrecked they take shelter in a church. While deserted now, it is a place which implies a social world, and thus the possibility of finding a place in one. Yet in its current state it is both private and neutral. Love can be declared here, but it cannot be otherwise acted on: it is a consecrated place which evokes the sacrament of marriage. That is, it does if you believe in it; we see Helen offer a prayer, again recollecting the Madeira sequence of *Love Affair*. She tells Philip that she is giving thanks, but does not say exactly what for.

The couple take refuge in the organ loft from the rising waters. They talk about the end of the world, but death now feels less like a possibility – Stahl never cuts back to the flood – and more like a way of expressing their happiness at the intimacy and equality conferred by these circumstances. As they lie comfortably together, she can tell him that she loves him, and they fall asleep. Morning comes, and with it reality, in the form of a rescue party. Just before they leave the church, acknowledging that this is the right place for these words to be said, Philip tells Helen, grasping her arms again, that he loves her.

More reality: the appearance of Philip's life in the form of his wife Madeleine. Philip persuades Helen to accept a lift into the city, and the journey is long enough for her to understand something about his – and thus her own – situation: that Madeleine is deranged.

Madeleine

Successive scenes define Madeleine's madness. It is not associated with violence, nor with sexual promiscuity. It is strongly associated with the childlike; she behaves, occasionally thinks of herself, and is routinely treated, as if she were a child. The point is underlined by the constant presence of her mother, Betty Dumont, so that the family relations feel a little like Philip and Betty acting as parents to a problematic infant. (Nella Walker, who plays Betty, was only thirteen years older than Boyer, and is presented by Stahl as someone who could conceivably have been mistaken for his wife.)

Madeleine's story is of failed motherhood; her madness followed the delivery of a stillborn child. In terms of her antecedents in literature, she is less the madwoman in the attic (say, Bertha Mason in *Jane Eyre*) than one of the inefficient child-wives of Victorian fiction (say, Dora Copperfield). Dickens followed an available convention in having Dora fade and die, so that the hero could marry his childhood love, but Madeleine is not suggestively unwell.[*]

The strike is settled in the waitresses' favour, and Helen receives two successive visitors in her apartment. The first is Philip, and Stahl photographs the conversation in two-shot, with the couple facing each other, until the climactic moment of

* The figure of the child wife is helpfully discussed in Claudia Nelson's *Precocious Children and Childish Adults: Age Inversion in Victorian Literature* (Baltimore, Johns Hopkins University Press, 2012).

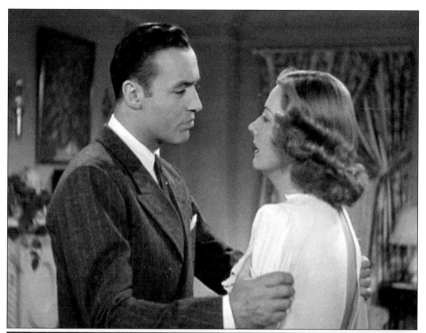

Successive
scenes,
successive
two-shots.
Boyer, Dunne,
Barbara O'Neil

declaration: in close-up, Philip tells Helen, grasping her shoulders again, that "I have my work, my music – and now I have you". He needs to hold her, and to hold on to her.

Helen's second visitor is Madeleine, who has come to attempt to part the lovers. She tells Helen : "I'm not always as mad as people think I am. Cigarette?". The startling jump in register here tells its own story; while believing that she is sometimes sane, she is madder than she thinks. Stahl films the two women in the

same way, facing each other in continuous two-shot with moves into close-up at points of intensity. The conversation is inconclusive; Madeleine extracts no promise, nor does Helen offer one.

The nature of her conversation expresses Madeleine's inadequacy as a wife. Her speeches are mainly focused on herself, emphasising her small, rebellious triumphs against what she interprets as unfair control. She rarely addresses Philip directly, and he is not the subject of their exchanges. In contrast to the lovers, she is fundamentally out of harmony with him. Of course no blame attaches to her condition, but only her death could release her and allow the lovers to marry.[*]

Philip invites Helen to dinner on the evening of his departure for France. An ellipsis takes us to the end of the meal, which is the film's closing sequence. Philip asks Helen to come with him to Paris, but she refuses: "If I came to Paris, I'd be living in the shadows of your life". The moment evokes *Back Street* – what Helen means by "shadows" is what her earlier character had called the "back streets" of a life. That this is impossible is confirmed by Helen suggesting that they would find themselves desiring Madeleine's death. They must settle for something less, while hoping for something more.

So they must part, and Helen proposes a little charade. They must act as a married couple might, sure of the kind of continuity that marriage would offer. "I'd rather you just got up and left, as if you were coming back again. As if you'd just been called away for a minute." He does so, telling her: "I'll be back . . . in a little while". Helen replies: "I'll be waiting", and the film ends with this line.

Love and Hunger

The film has been punctuated by meals, and looking over these we see their consistent connections to its themes.[**] Philip's initial lunch establishes the regulation of desires –- Lulu primly telling Philip that "we only serve what is on the menu" – and the need to challenge that regulation. The dessert is apple pie with cheese. Philip wants only the latter. and when the rattled Lulu refuses he talks about "grabbing" the cheese. We will soon see that he is a man who believes in grabbing, in grasping an opportunity when it is offered.

The picnic meal on the sloop is the opposite, a shift in control to one rich man and his desire. While Helen obviously enjoys the intimacy here, Philip's ordering dinner for two at his house is more problematic. Helen seems complaisant, but the power failure, and Philip's sending away of the candles – his comment is that "we don't need to see the far corners of the room" – associates the imminent food with something ominous.

The next moment is an acknowledgment of different kinds of hunger. Trapped in the organ loft, Philip and Helen joke about food, but in each other's company they

[*] A partly parallel case is the blameless figure of Flip/ Anita Louise in Edmund Goulding's *That Certain Woman* (1937). Flip is the crippled wife of a potentially adulterous husband, and Goulding does engineer a happy ending via her death at the end of the film.

[**] An earlier film which also reflected on the relations between love and hunger was Frank Capra's *It Happened One Night* (1934). Given the Oscar-winning success of that film, it is arguable that Stahl and his writers could have had it in mind.

find that they are not truly that hungry. She tells him that "I'd settle for a nice hot cup of coffee, wouldn't you?", and he replies: "I'll settle for being here, with you". The couple wake to an *ad hoc* breakfast, some ordinary food to munch as you get dressed. The organist, Mr. Henderson, glosses the gift of his forgotten lunch box with this: "some people say music is the food of love, but personally I prefer three meals a day". The comment fits the moment. The couple have to find a way back from love and music, to the world of three meals a day, say the world of New York and 1939.

The film began with the start of a meal, and it ends with the close of another. This is the second time we see the public space of a restaurant, but Stahl stages it as a contrast to the opening. There is no establishing shot, and almost the whole scene is conducted in one set-up, with the couple sitting side by side and facing the camera. The dialogue refers to other diners, but they are not visible. Philip and Helen are neither struggling with an intrusive social world, nor shutting themselves off from others. They have learned to be alone together but in company.

Some of the details here are designed to relate to earlier moments. The nostalgia for French pleasures that prompted the thought of *bouillabaisse* (Philip's first request, in the opening scene) is now answered by the wine which Philip tells Helen is from near his home village. And the candles that he has ordered for the table relate both to the power-cut scene, and more positively, to the comfort of lighting them in the church, and Helen's speech there about why she finds pleasure in them. Both details reach backwards into their pasts, to Philip's village, to Helen's orphanage.

How can we describe the tone of this ending? The story cannot end with an actual marriage, and the shadows cast by Madeleine's condition and by the political moment of 1939 remain, but the film has traced the movement of two figures in the crowd becoming a couple with a place in the world. Stahl's films can show us the starkness of isolation: think of Dunne's scenes as the lonely mistress in *Back Street*, or the blind, stumbling figure alone in the room in *Magnificent Obsession.* Here, faith in the future displaces loneliness. Their final words are acts of mutual promising which will have to stand in for another occasion of exchange of promises (the marriage service) for now. This is reaching not for a happy ending, but a satisfying one.◆

Edward Gallafent

Our Wife

Columbia. 28 August 1941. 95 minutes.
D: John M. Stahl. **P**: Stahl, Irving Starr. **Sc**: P. J.Wolfson, from the play *Our Wife* [1933] by Lillian Day and Lyon Mearson. **Ph**: Franz E. Planer. **Ed**: Gene Havlick. **AD**: Lionel Banks. **M**: Leo Shuken.

Cast: Melvyn Douglas (Jerry Marvin), Ruth Hussey (Susan Drake), Ellen Drew (Babe Marvin), Charles Coburn (Professor Drake), John Hubbard (Tom Drake), Harvey Stephens (Dr Cassell), Theresa Harris (Hattie).

Stahl made *Our Wife* at Columbia between leaving Universal and joining Fox. It was an already troubled project that he took over. Originally to be written by Sidney Buchman and directed by Mitchell Leisen, both experts in Romantic Comedy, its first-choice stars, Loretta Young and Cary Grant, withdrew, followed later by Jean Arthur and Rita Hayworth. It is unclear why Columbia were so committed to Mearson's and Day's play, hardly a Broadway success, lasting only 20 performances in 1933 even with Humphrey Bogart and Rose Hobart. Stahl may have felt that *The First Woman Doctor*, announced as his upcoming film at Columbia, a biopic of Elizabeth Blackwell MD, starring Loretta Young (*Motion Picture Herald*, 8 June 1940, 15), but then dropped, was a better project. The Broadway *Our Wife*'s central situation, never likely to pass the Breen Office, had a husband's *ménage* with his mistress interrupted by his wife's arrival, with the husband, after various complications, including being seduced by his wife while the mistress is away, choosing the mistress, and the wife, having gained a suitor herself, giving him his freedom.

P.J. Wolfson, the film's writer, had some interesting credits, e.g. *Picture Snatcher* (1933), *Shall We Dance* (1937), and two romantic comedies, contemporaneous with *Our Wife*, that starred Melvyn Douglas: *Married But Single* (1940) and *He Stayed For Breakfast* (1940). Here his screenplay translated the play's Americans in Europe back to America, and European morals to American screen ones, cut out the adultery, and downplayed comedy. These factors may begin to explain some of the film's oddities, which began with its title. In *Too Many Husbands* (Wesley Ruggles, 1940) the rival husbands, Fred MacMurray and Melvyn Douglas, refer to Jean Arthur as "our wife", but the situation in Stahl's film is quite different – not two husbands and one wife, but two "wives" and one husband. Can one make sense of Stahl's film's title, the unsuitableness of which was remarked by contemporary reviewers (e.g. the *New York Times*, 18 September 1941, and *Photoplay*, November

1941, 98)? Perhaps it addresses the audience with the implicit question, who would "we" choose as "our wife", Susan or Babe? Failing that, it is hard to dispute that it makes little sense. Could it be that the title, *Our Wife*, of Laurel and Hardy's 1931 film, which makes sense in *its* context, was used simply because it sounded familiar and attractively risqué, as it probably did to the source play's writers?* Another factor possibly making for confusion is *Our Wife*'s partial plot resemblance to Stahl's 1930 film *A Lady Surrenders*, close enough for the later film to be seen as, though not a remake, at least another version of the same triangular situation: husband, returning wife, new love object.

Promoted as a romantic comedy, the film gives premonitions of generic instability in title music suggesting romantic melodrama. Though it has a notable romantic comedy hero in Melvyn Douglas, fresh from three films for Ernst Lubitsch – *Angel* (1937), *Ninotchka* (1939), and, just before *Our Wife*, *That Uncertain Feeling* (1941) – as well as *Too Many Husbands* (1940) and the two other Wolfson comedies mentioned above, he here plays a character less assured than usual, semi-alco-holic, broken by imminent divorce, his jazz-composing career dead-ended. He enters the narrative deliberately (or semi-accidentally) attempting suicide by jump-ing off a ship. Rescued in a rather bleak "meet cute", he invites the fellow-voyagers who try to help, Professor Susan Drake (Ruth Hussey), her father, also a professor, and her brother, to use his Westchester house while he is away. Realising he loves Susan, and recovering his ability to compose, he returns just as his beautiful, grasping wife, Babe (Ellen Drew), arrives to reclaim him, setting up the problematic, shared with *Too Many Husbands* and *My Favorite Wife* (Garson Kanin, 1940), in which a missing spouse – declared dead in those cases, though not here – returns to a partner who has remarried or is about to remarry.

Finding Susan, father and brother in the house, and with Jerry's disillusion with her and desire to marry Susan evident, she stages an accident, convincing everyone except Susan that her legs are paralysed. With Jerry too gentlemanly to expel her, she stays, bedridden, planning a malign "comedy of remarriage" through the working of her sexuality on her husband. Thus Jerry is caught between two women, neither of whom fits romantic comedy easily, one too stern, one too calculating. The heroine, brought up by her father (Charles Coburn , an unlikely feminist) to be a scientist, has the romantic heroine's intelligence in spades, but such wit as she has is dryly moralistic, with none of the wisecracking she delivered as Elizabeth Imrie in *The Philadelphia Story*. Entering this narrative, she is hyperbolically chided by her brother for ignoring the romance of their South Seas cruise, "You're an intellectual zombie. Only your mind is alive, your body is dead". Her father, who openly prefers her to her brother, calls her, not wholly ironically, "my sedate and dignified offspring". Arguably, Ruth Hussey's heroine, given Melvyn Douglas's presence, faintly recalls Ninotchka, and her vocation as scientist and her upfront virtue equally feel like residues from the abandoned medical biopic. Susan's beautiful, materialistic opposite, Babe, only returns to her husband after his Gershwinian jazz concerto has been successful. Luxuriating in objectification, she always refers to herself as Babe, followed by everyone else. Clearly Jerry's marriage

* It should also be noted that the expression "our wife" for my wife is quite common in early 20th century comic-sentimental journalism.

was foolish, but her overt physical attractiveness explains this, remaining a latent danger throughout as she continually primps herself in her bed, the site of her calculating influence in sickness and health.

The film's latter half is dominated by Susan's attempts to expose Babe while hiding her actions from Jerry, who would not believe even Babe capable of such deceit. Her first attempt outmanoeuvered, her second is to get Babe drunk and flatter her into showing off her famous dancer's legs. Her failure, abjectly getting herself rather than Babe drunk, means that Jerry will feel obliged to take his wife to a spa to recuperate, an innocently generous act without ambiguous intent, but one which Babe mockingly tells Susan will end in her seductive repossession of him. With all seemingly lost, an accident intervenes, creating a highly melodramatic scenario as Susan knocks over some chemicals in her makeshift laboratory, causing a fire which threatens to engulf Babe's bedroom. Babe, believing Susan is tricking her again, disregards her warnings to escape. Finally, recognising the danger, she is on the point of betraying herself when Jerry arrives to carry her to safety.

Whether Susan's blunder is a parapraxis from *The Psychopathology of Everyday Life,* or wholly accidental, it too ends with Babe victorious. But another accident, this time mechanical, in no sense attributable to Susan, leads to her exposure. Doused unexpectedly by the sprinklers, Babe forgets herself in her vanity and, leaping up, betrays herself. In the finale, Jerry, like some unrefined heroes, pulls her onto his lap and begins to spank her, [*] despite her comic protest that "You can't blame a girl for trying", until he stops at Susan's admonishment that "a gentleman can't strike a lady". She then adds unexpectedly "But I can", and, with Babe pinned to Jerry's lap, flails at her backside until fadeout.

This rambunctious ending's rationale, separating it from the trope's cruder versions, is that Susan is chastising a woman who has tarnished the female sex, even more than she has hurt the male sex, literally striking blows for unparasitic wives. In an exchange with Babe, Susan judges her predatory view of marriage with typical seriousness, very untypical of romantic comedy. "I've heard of women like you [...] What a dirty place you make this world". Before the spanking, as Jerry inveigles Babe into coming towards him for forgiveness, Susan looks on, a thinly smiling figure of justice.

Though this ending relates to Stahl's woman's film interests, it is still a strange closure, even if Babe, whose only arguable virtue is the cynical woman's clearsightedness about male psychology – "They're all alike, some are a little more housebroken than others. But they weep for no woman" – is felt to deserve it. A heroine appropriating questionable male behaviour, in a closure privileging punishment over union, brings into focus other anomalies. For instance, Susan's plan to trick Babe into betraying herself, taking up most of the narrative's second part, is a protracted failure in which superior intellect fails to defeat the sexually manipulative woman's cunning, with Babe's ultimate exposure purely accidental, however much it punishes her vanity. Further, Susan hiding her plans from Jerry marginalises him for long stretches, meaning that, first, there is no dramatisation of the latent erotic

[*]	See Andrew Heisel's video *The Endless Spankings of Classic Hollywood* on YouTube, and his accompanying article " 'I Don't Know Whether to Kiss You Or Spank You': A Half Century of Fear of an Unspanked Woman".

power that Babe may still have over him, something necessary to narrative tension, and, second, though there are affecting emotional moments between Susan and Jerry, there is almost nothing of the witty companionate interplay of classical romantic comedy.

Stahl instructs Melvyn Douglas how to embrace Ellen Drew, and Douglas obliges

As regards the first point: the two stills reproduced here are of Stahl on set demonstrating to Douglas how he should embrace Drew, and then Douglas doing it. But the scene was strangely cut from the release print.[*] After Susan has brought Jerry into Babe's bedroom on the pretext of bringing her breakfast, but really to expose her, Babe coolly demonstrates how she outmanoeuvred her, and Susan exits humiliated. This, leaving Jerry and Babe alone, is clearly the scene from which the stills were taken. However in the only print available Susan's departure is followed by a wipe to her at work talking to her colleague about nervous paralysis.

Making sense of this, which might stand as representative of the film's problems, is difficult. While studio pressures and script difficulties may be part of the answer (judging by evidence from his Universal period, Stahl often worked with incomplete continuity, insisting on a writer remaining with him), it is perhaps more fundamental to suggest the effects of a problematic with its sources in Stahl's earlier work. Stahl's comic forte from early on was a marital comedy of imbalance, boredom and vicissitudes of desire, culminating in a crisis where one or both parties find new partners, the crisis ultimately averted by a chastened return to a – hopefully – better

[*] The film is very difficult to get hold of, only available on dvd from a few rare-films outlets. The discussion here is based on a dvd from one of these.

version of the original bond by characters educated in their mistakes (the pattern of *The Dangerous Age*, *Why Men Leave Home* and *Husbands and Lovers*). For all of Stahl's somewhat cloyingly uxurious statements about marriage, which may reflect his actual beliefs – e.g. the *Philadelphia Inquirer* report (16 November 1924) where, announcing an end to his marriage problem films, he said "domestic life offers a wonderfully fertile field for picturization provided the treatment does not deprecate the beauty and sweetness of happily married life" – he hardly ever touches on companionate romantic comedy, and in his one go at it, his very literal version of Preston Sturges's play *Strictly Dishonorable,* he added nothing to disambiguate the doubts generated about the permanence of Isabelle and Gus's impending union. *Holy Matrimony*'s late-age cohabitation lies largely outside of this debate: certainly companionate but, with Monty Woolley and Gracie Fields, hardly romantic.

Whatever his beliefs, in the romantic sphere Stahl's comedic strengths tend to reside more in in the exploration of tensions destructive of harmony than supporting it, which may partly explain why in affirming Jerry and Susan's relationship the film is uncomfortable with the conventions of romantic comedy.◆

Bruce Babington

Immortal Sergeant

20th Century-Fox. 28 January 1943. 90 minutes.
D: John M. Stahl. **P**: Lamar Trotti. **Sc**: Lamar Trotti, from the novel [1942] by John Brophy.
Ph: Arthur Miller, Clyde De Vinna. **Ed**: James B. Clark. **AD**: Richard Day, Maurice Ransford.
M: Alfred Newman, David Buttolph. **Sound**: W.D. Flick, Roger Heman.

Cast: Henry Fonda (Corporal Colin Spence), Maureen O'Hara (Valentine), Thomas Mitchell (Sergeant Kelly), Allyn Joslyn (Cassidy), Reginald Gardiner (Benedict), Melville Cooper (Pilcher), Bramwell Fletcher (Symes), Morton Lowry (Cottrell).

mmortal Sergeant was released in early 1943 to strong box office and excellent reviews, many of which praised John M. Stahl for his skilful direction of vivid combat and introspective drama. In recent decades, however, the picture has been seldom revived or discussed – to the point of becoming one of Stahl's most undervalued works. One reason for the dearth of interest may be a screen story clearly designed to help rally the public behind the war effort, making the film a product of a very specific time. A fresh examination 75 years on reveals *Immortal Sergeant* to stand on its own terms as a visually and thematically coherent film, well-paced and engaging, thanks to expert, often subtle, craftsmanship.

On 18 June 1941, the trade paper *Variety* reported that 20th Century-Fox had signed John Stahl to a two-year contract. The director had recently completed *Our Wife*, a Columbia comedy that was still two months away from release, and his debut film at Fox was announced as *Another Spring*, with production set to begin in July. This would turn out to be just the first of many assignments to fall through. In fact, well over a year would pass before Stahl finally directed *Immortal Sergeant* as his first Fox picture, and even then he was not the studio's initial choice. On 10 August 1942, *The Hollywood Reporter* announced that *Immortal Sergeant* was to be personally produced by Fox chief Darryl Zanuck and directed by Archie Mayo. The next day, the paper reported that Henry Hathaway was now directing the film. Two weeks later, *Variety* disclosed that Zanuck was having Hathaway "switch" films with Stahl, who had been assigned to the espionage drama *Tampico*. In the end, Hathaway would be reassigned yet again, to *Home in Indiana*, while Archie Mayo was given *Crash Dive* and Stahl remained on *Immortal Sergeant*, with production starting at last on 10 September.

Immortal Sergeant originated as a bestselling 1942 novel by John Brophy, an Anglo-Irish author who had served in the British infantry during World War I. The script was adapted by Lamar Trotti, who specialised in historical dramas and war

films and was highly respected in the industry. He also wound up producing the picture after Zanuck, who held an army rank of colonel, took an eight-month leave from the studio to oversee the production of army training films.

Trotti's screenplay hewed closely to Brophy's novel, centring on a timid Canadian corporal, Colin Spence (Henry Fonda), serving in a World War II British army unit on patrol in the Libyan desert. When the platoon's beloved, tough Sergeant Kelly (Thomas Mitchell) is killed in a skirmish, Colin finds himself suddenly in command of the remaining men. Lost, on foot, and almost out of supplies in hostile territory, he must somehow lead the group to safety as he wrestles with self-doubt. Meanwhile, in a series of flashbacks, he remembers his life before the war in London, where he loved a girl named Valentine (Maureen O'Hara) but was too shy to say so, and had to watch silently as a smug war correspondent, Tom Benedict (Reginald Gardiner), pursued her aggressively.

In love and war: Colin (Henry Fonda), in London with Valentine (Maureen O'Hara), and in the Libyan desert with the sergeant of the title (Thomas Mitchell).

On the surface, it would seem inevitable that John Stahl, the director of *Back Street* and other notable women's pictures, should end up making a war movie that devotes a large chunk of its running time to home-front romantic melodrama. The

truth is a bit more involved. First, there was a clear trend in combat films of the time to intersperse scenes of civilian life through the narrative: *Stand By for Action*, *Crash Dive* and *Action in the North Atlantic*, all released in the weeks after *Immortal Sergeant*, use devices to periodically withdraw their characters from the battlefront. Film scholar Jeanine Basinger has postulated that this may have been because filmmakers thought audiences were not yet willing "to submit themselves to movies that give no relief from the war" and that "such outlets helped to build [...] important links in the emotional lives of American civilians who needed to feel connected to their friends and relatives who were fighting in combat."[*]

Second, the home front scenes in *Immortal Sergeant* are almost incidental to the spine of the film's real story. They depict a romantic triangle, but are not really "about" that triangle or the melodrama that surrounds it. Instead, they serve the larger point of illustrating Colin's timidity with Valentine, which Colin (like Stahl) equates with a lack of

[*] Jeanine Basinger, *The World War II Combat Film: Anatomy of a Genre* (New York: Columbia University Press, 1986), 38.

physical courage in war. Colin enlists partly in order to prove himself worthy of Valentine, and the story's central issue is thus his character growth: will he find within himself the confidence and the wherewithal to fight and lead? If so, the film declares, he will gain the confidence he needs in love. The propagandistic value of such a tale was why Zanuck saw *Immortal Sergeant* as having the potential to help the war effort: if an ordinary guy like Colin could overcome his fears, then audience members might feel the same.

Third, and of greatest interest to a study of Stahl, there is actually much more of the emotional sensitivity one associates with the director to be found in the military scenes than in the flashbacks. About halfway through the picture, for instance, Colin shares his last cigarette with three fellow-soldiers. Stahl practically brings the film to a halt to follow the cigarette as each man takes a few drags and passes it along. It is a dreamy, wordless, two-minute sequence, with Stahl's camera lingering on the men's faces as they anticipate the cigarette in vivid reaction shots – and then savour it as if it's the last they will ever smoke.

Later, Stahl does it again when the now-parched group shares a tin of pineapple that Colin has secretly been saving. Once more the pace slows considerably, and Stahl uses reaction shots of the famished men to create an almost ethereal effect. The audience luxuriates in this moment, as the men do; one can practically taste the pineapple. In both sequences, Stahl is making visual choices in composition and editing to emphasize the bonding of the group and to show Colin becoming a respected member of it, slowly overcoming his uncertainties.

Even more powerful are the sequences between Colin and Sgt. Kelly. Throughout the first half of the film, they have several scenes together that grow increasingly sensitive and meaningful, shifting from lighthearted banter to more serious discussion of Colin's soldiering abilities. Kelly reassures the corporal that he considers him ready to take command should the need arise, and Thomas Mitchell's excellent performance – in what is after all the title role – does much to instil confidence, respect and affection within Colin. The scenes pay off in the film's most poignant sequence. Sgt. Kelly has been gravely wounded and knows he must be left behind, but Colin refuses to leave him; when Kelly realises he can't change Colin's mind, he tricks him into leaving a rifle nearby, which Kelly soon uses to commit suicide. As visualised by Stahl, the sequence is so sensuous as to be almost a love scene: it's night-time, the characters remain mostly still in the frame, and they look at each other tenderly, almost continuously in two-shots and medium close-ups. In all these scenes – cigarette, pineapple and Colin/Kelly – Stahl conveys extraordinary intimacy between battle-weary comrades that is akin to the romantic, male-female intimacy in his other pictures.

The aforementioned moments are all the more effective for standing in contrast to the quick-paced combat scenes that surround them. *Immortal Sergeant* is built on contrasts: combat/home front, desert/water, blinding sun/black night, exterior action/interior anxiety. Some of the juxtapositions (such as a dissolve from the Libyan desert to a London nightclub complete with Latin dance number) are so delirious that Andrew Sarris characterised them as "the cinema of audacity".[*]

[*] Andrew Sarris, *The American Cinema: Directors and Directions 1929–1968* (New York: E.P. Dutton, 1968), 140.

In truth, they become somewhat less startling as the story moves along, simply because their frequency winds up creating a unity to the film; the audience gets used to them as a way of creating meaning. Ultimately, they pay off with a final visual contrast – from a frenetic combat offensive to a peaceful hospital bed – and then a final character contrast, as Colin fully transforms. "I'm no longer the fellow you knew in London", he tells Tom, the war correspondent. "I'm another man altogether." The most striking aspect of the contrasts is actually the straightforward manner in which they are made. Stahl doesn't embellish the shifts in and out of flashbacks with, for instance, stylised angles, lighting flourishes or musical bursts; rather, he places equal weight – visually and emotionally – on the material before and after, letting the transition itself create the "audacious" effect.

He also applies this matter-of-fact approach to his staging of individual scenes, and even of shots. For example, each of the five flashbacks begins with either a two-shot of Colin and Valentine or an angle that quickly becomes a two-shot. Stahl tends to remain with such an angle for most of the scene rather than emphasising Colin's reactions in close-up. In the nightclub sequence with Colin, Valentine and Tom, Stahl even favors lengthy three-shots, with all three characters figuring equally in the frame. As a result, the audience effectively observes from a distance the characters enacting the scene, rather than participating solely through Colin's perspective. In other words, Stahl crafts an objective point of view: our engagement is less of feeling Colin's reactions – his helplessness and uncertainty – and more of observing that he *has* those reactions.

This is true even though the flashbacks are presented as Colin's own memories as he trudges through the desert – and even though the audience is nonetheless aligned with his overall story situation. The best illustration of this dichotomy is the exceptional sequence in which Colin sneaks into an enemy camp to gather food and water and perform some reconnaissance. The way Stahl stages it, our experience of the scene is not so much one of traditional suspense ("will Colin get caught?") than it is one of evaluating Colin's skill ("will he show the ability to carry out this mission properly and bravely?"). When Colin breaks the radio or steals the food, Stahl does not have German soldiers guarding those things to build tension; instead, he designs the moments to be about Colin's resourcefulness. Even when two Germans do hear Colin make a noise, our satisfaction comes mainly from seeing Colin think quickly to defuse the moment, rather than from simple relief that he has evaded capture. And just to drive home the point, the scene has Colin hearing the voice of the immortal sergeant himself – Kelly – in his head all the while. Kelly advises him on what to *do* as a soldier, not on merely how to avoid detection.

Stahl's objective approach is perfectly in keeping with a story that has concerned itself all along with the issue of ability. From its opening scene at a military base in which the men discuss Kelly and Colin's competence, the film has continually invested the audience in the question of whether Colin can succeed as a leader. That is why more typical emotional suspense not only isn't needed but might actually have disrupted the movie's focus.

Immortal Sergeant filmed for about a week in the desert near El Centro, California, before temperatures of 129 degrees Fahrenheit drove the company back to air-conditioned soundstages on the Fox studio lot. A second unit remained behind

to collect combat footage not involving the principal actors, such as shots of attacking airplanes and a vivid crash of a plane into an armored truck. This unit was headed by James Tinling, a Fox contract director who had been making B movies for fifteen years. Tinling was summoned after the studio sped up production by two weeks so that Henry Fonda could report to naval duty. After shooting wrapped on 8 November 1942, Fox rushed postproduction as well, in order to release the film as quickly as possible; the real-life military campaign in North Africa was heating up, and the studio wanted to take advantage of the attention. Indeed, the topicality was played up in the film's advertising: "The First Great Epic of the African Campaign!"

Fox held pre-release screenings in selected cities on 28 January 1943, with a general release date of 4 February. Reviews were exceptional, from industry trade journals to many major newspapers across the United States. They noted the story's timeliness, raved about the exciting combat sequences and praised the acting and fast pace. Many complimented John Stahl by name, and across the board they lauded Henry Fonda. "One of his finest achievements", said one. "More than any other actor he has the power to suggest the average man and what it means to be one in this war", said another. However, one major outlet gave *Immortal Sergeant* a mediocre review: the *New York Times*. This has no doubt contributed to the picture's underrated reputation, simply because of the paper's prominence and influence. Still, even this review praised Henry Fonda.

Fonda himself felt quite differently. He had been forced by Zanuck to make the picture after trying to enlist in the Navy following production of his previous film, *The Ox-Bow Incident*. Zanuck had used his influence to get Fonda a deferment and pluck him back to Hollywood. Fonda would later recall bitterly: "So there I was back in Imperial Valley, California, in the hottest part of the desert, making a film called *Immortal Sergeant*. It was a silly picture. You want to hear the plot? I won World War II single-handed!"[*]

Zanuck's treatment left a bad taste in Fonda's mouth – for the film, for Zanuck and for 20th Century-Fox. For the rest of his life, Fonda routinely cited *Immortal Sergeant* as his least favorite movie, and surely that is another reason for the film's current underappreciation.

For Stahl, *Immortal Sergeant* was a worthy beginning to his Fox career. It had taken a long time for him to get the assignment, but its success meant a much shorter wait for the next one: just two months after *Immortal Sergeant* opened, Stahl was rolling cameras on *Holy Matrimony*.◆

Jeremy Arnold

[*] Howard Teichmann, *Fonda: My Life* (New York: New American Library, 1981), 138.

Holy Matrimony

20th Century Fox. 27 August 1943. 87 minutes.
D: John M. Stahl. **P:** Nunnally Johnson. **Sc:** Johnson, from the novel *Buried Alive* [1908] by Arnold Bennett. **Ph:** Lucien Ballard. **AD:** James Basevi, Russell Spencer. **Ed:** James B. Clark. **M:** Cyril J. Mockridge.

Cast: Monty Woolley (Priam Farll), Gracie Fields (Alice Chalice), Laird Cregar (Clive Oxford), Una O'Connor (Sarah Leek), Alan Mowbray (Mr Pennington), Melville Cooper (Dr Caswell), Franklin Pangborn (Duncan Farll), Ethel Griffies (Lady Vale), Eric Blore (Henry Leek), George Zucco (Mr Crepitude), Fritz Feld (critic).

Holy Matrimony is adapted from Arnold Bennett's popular novel *Buried Alive* of 1908. The novel had been filmed twice before as *The Great Adventure* in Britain in 1915 and in the USA in 1921, and again in the USA as *His Double Life* in 1933. Stahl's version stars Monty Woolley as Priam Farll, an eminent painter who has spent his entire career in self-imposed exile. It opens with Farll's agent (Laird Cregar) dictating a letter in which he recognises his client's shyness and dread of the celebrity which his status as England's greatest painter has conferred upon him, but nevertheless summons him back to London: Farll is to be knighted. A crisp montage sequence follows the letter to the very edge of Empire – first by ship and rail, and then carried by a native messenger running through the jungle, and by a half-naked colonist rowing a canoe with the letter clasped in his mouth. Finally it arrives at Farll's wooden chalet, where it is presented to him by his valet, Henry Leek. Unlike Farll, Leek admits to being gregarious by nature, and has found his 25 years of service to the recluse something of a trial. Farll agrees that under certain circumstances – "if I were a complete nobody like you, or if all the art lovers of England could be exterminated overnight" – he too wouldn't mind seeing London again. He is about to get his wish of course, for nobody can ignore a summons from the King.

This narrative set up is so precise and economical that it comes as a surprise to discover that it is not a contraction of the source material, but an expansion. Bennett's novel actually opens after they have returned to London, and when Leek, having caught pneumonia on the journey, is close to death. The addition is necessary, though, for it plants with the audience an explanation for Farll's next action, without the need for the wordy exposition of the novel. When the doctor arrives to examine his manservant, Farll opens the door to him, and the doctor assumes he is the servant and Leek the master. No dialogue is needed to convey this misapprehension – the doctor simply hands his coat and hat to Farll with the

unthinking imperiousness of a superior. A close-up shows Farll's confusion at this behaviour, shading into irritation. The camera cuts back briefly to the doctor tending to his patient, and then returns to Farll, registering his acceptance of the situation as he dithers over where to deposit the items. A third shot follows his movement as he finally dumps the clothes on a drying rack in the corner of the sickroom. With just these three shots, Stahl establishes both the misunderstanding, and the shifting social relationship between the two men as Farll, instead of asserting his true status, begins to inhabit the role of the "complete nobody" that the doctor assumes for him.

After Leek's death this role becomes a reality. Farll addresses the doctor as "sir", and behaves with the deference of a manservant. Filling out the death certificate, the doctor identifies the dead man as Farll. "I take it you were Mr Farll's valet?", he asks Farll, and, seizing the opportunity to return to London not as a celebrity but as a "complete nobody", Farll acquiesces in the doctor's mistake, identifying himself as Leek.

Some British reviewers objected to the casting of Monty Woolley – who remains best known for his success as the irascible Sheridan Whiteside in *The Man Who Came To Dinner* (William Keighley, 1942). Woolley's trademark bombast, they suggested, was an unconvincing substitute for the overwhelming shyness of the literary character, making his reticence appear "improbable, if entertaining".[*] That judgment appears harsh today. Under Stahl's direction, Woolley offers a convincing portrait of an eccentric whose shyness is exhibited through both reticence and futile bravado, and who, having lost his social status and his valet, appears somewhat adrift in the world. He finds his perfect foil in Alice Chalice (Gracie Fields), the woman with whom Leek had been corresponding through a marriage agency, and who (mis)recognises Farll as Leek as a result of a mislabelled photograph. Alice is absolutely sensible, capable and down to earth – not in any way cowed by the blustering of the men around her. "I'm just as I am – just as you see me now", she tells Farll/Leek, before making it clear that she wrote to the marriage agency meaning business, and he is the business she means. They marry and settle down to a quiet life in Putney.

Two brief scenes establish the tenor of the relationship they will develop. After Farll has caused a kerfuffle at his own funeral and lost his hat, she takes him to buy a new one. The shop assistant asks him his hat size, but when he brings a hat of that size, it is clearly too small. The shop assistant tries to bully him into the sale, "You *said* 7 ½, Sir…. Of course if you don't know your own hat size…" Rather than back down, Farll reaches for his wallet, but Alice simply cuts through this competition of male egos. Firmly handing the hat back to the assistant, she speaks on behalf of her fiancé, "Mr Leek doesn't like this size. He doesn't like this style… Now will you get out some others please?" Immediately afterwards, in a restaurant which is grander than Alice is used to and has menus in French, she asks the waiter for a translation. He makes a snooty reply, but she is unfazed. Just as Farll is about to order for them both, the waiter goes off to attend to other customers. He ignores Farll's attempts to catch his attention again, until Alice simply catches him by the tailcoat, and pulls him back, "Mr Leek is speaking to you!"

* T.C.K., "Film Show in Birmingham: *Holy Matrimony*", in *Birmingham Post*, 1 January 1944, 1.

Being dead is less trouble-free than Farll had anticipated, though. He is faced with the spectacle of his own induction into the British pantheon of heroes when he tries to attend – and is eventually ejected from – his burial in Westminster Abbey. Being the anonymous Leek also proves to be more complicated than expected when a wife and sons appear out of the past and accuse him of abandonment and bigamy. The final indignity is visited on him by his art agent (Laird Cregar). Farll continues to paint for his own pleasure, and he has no objection to Alice selling his efforts through a local shop in order to make a little extra money. Eventually his old agent discovers this abundant source of "posthumous" works, and begins acquiring the pictures at the value appropriate for the work of an anonymous amateur, then selling them at the fantastic prices which the work of "Britain's Greatest Artist" commands. When his clients discover the deception and threaten to sue, Farll is dragged out of his beloved obscurity and forced to testify to his real identity in court. The quality and technique of his work, though, is not enough to convince the court who he really is. Identity is measured in far more banal ways than that – through the presence of a couple of distinctive moles on his neck.

For British audiences, of course, Gracie Fields's performance as Alice was a key attraction. This was her first film in Hollywood, but she'd been a box-office favourite in the UK throughout the 1930s, and was Britain's highest-paid film star for much of the decade. Her British films had played on her down-to-earth image as an ordinary working-class girl, often the moral compass of her community, keeping Depression audiences going with a song and a joke. *Holy Matrimony* is a departure from her usual star persona in that it is a straight role, offering no opportunity for singing or comedy routines – a fact mentioned in all of the contemporary reviews, sometimes with regret, but more often with condescension (She played the role with "a strict avoidance of all virtuosity", exclaimed *The Times*).[*] The film marks a watershed in her career – a shift away from her British music-hall vehicles, but also the end of a painful period when she had been criticised by British journalists for "deserting" her country by moving to America at the outbreak of the war (following her marriage to film director Monty Banks, an Italian citizen who would have faced internment). Reports of its release and reception in the English papers never fail to mention her extensive tours entertaining the troops in the various theatres of war. Fields's star persona is also subtly alluded to in the film: Alice whistles snatches of folk songs while she bakes, and her appearance onscreen is several times heralded by a few bars of *Genevieve* on the soundtrack. Her solidity, reliability and straightforwardness plays into a central association of Field's star persona and indeed of her Lancashire heritage. Although in the novel Alice is a cockney, Fields plays her with her natural northern accent.

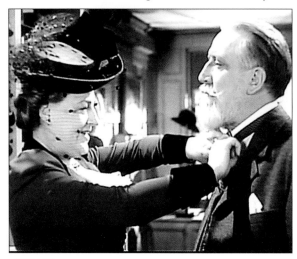

Gracie Fields,
Monty Woolley.

[*] Anon, "Tivoli Cinema: *Holy Matrimony*", in *The Times*, 10 October 1943, 6.

The script was by Nunnally Johnson, whose elegant adaptation was widely acknowledged in the contemporary reviews. More recently, scholars have read the film within the context of Stahl's auteurism, seeing it as a reworking in comic mode of some of the preoccupations of his more famous melodramas. Farll's attempt to pass himself off as someone he isn't has been linked to the attempts of Peola to pass for white in *Imitation of Life* – both characters try to shed the baggage associated with their identity and start afresh. The funeral scene has also drawn comparisons with the famous funeral planned by Delilah in the same film.[*] Such concerns to identify an authorial signature are close to the film's own themes – and can certainly be understood to chime with the pre-occupations of the story's author. Arnold Bennett was famously identified (by Virginia Woolf) as a "tradesman of letters" later in his career – a "competent journeyman" turning out products for a market, rather than the sort of great auteur who deserved a place in Westminster Abbey. The techniques and themes of Farll's own paintings, which to himself and to his agent scream out his identity as the artist in every brushstroke, fail to impress as evidence either the court, or his wife Alice. As Yann Tobin suggests,

> Appearances are all that matter in an ignorant and corrupt world in which the value of a painting is reduced to the placing of a famous name at the bottom of the canvas. Farll's 'anonymous' paintings go for a song, while the signed paintings command vast sums.[**]

Perhaps Alice is the character who most clearly cuts through such posturing. She sees only the man she loves, and remains indifferent throughout to the question of whether he is a nobody or a great painter. The paintings seem to her pleasant but inconsequential – nice enough, but perhaps not as good as the real pictures by "real artists" that you can pick up in the newsagent's for a couple of shillings. A key scene shows the scales falling from her eyes. Having learnt that one of his pictures has sold for as much as five pounds (nothing compared to its eventual value), she looks around his studio with new eyes. Every picture suddenly to her view, transforms into its price tag. This is a joke about class and status. For Alice, the idea that paintings might have value beyond a few shillings is fantastic, but in other respects she is utterly unfazed by worldly concerns. The pretensions of the expensive restaurant Farll takes her to do not blind her to the fact that the fish they served is not fresh, and when Farll tries to convince her that he is indeed England's "greatest painter", she simply humours him as though he were a delusional child. Even when she eventually does come to understand his true status, the news seems to be of little account to her – the couple escape to obscurity again after their courtroom ordeal, ending the film dining on kangaroo in a little house in the Australian outback.

Holy Matrimony was well received on both sides of the Atlantic. Reviewers praised the performances, and singled out Stahl's direction. The *Hollywood Reporter* thought it the "finest work of his career", although others were more modest with their praise – *Variety* characterising Stahl's work on the film as "sensitive" and *The*

[*] Miguel Marias, "The Strange Comedies of John M. Stahl", in *John M. Stahl* (San Sebastián, 1999 – see Bibliography section 7), 198.

[**] Yann Tobin, "John M. Stahl", in *John M. Stahl* (San Sebastian, 1999 – see Bibliography section 7), 225.

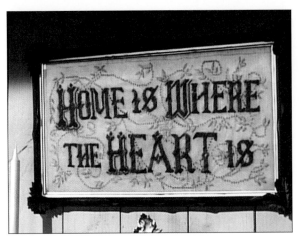

Guardian commenting on its "great resource and address".[*] Watching the film now, one wouldn't perhaps be moved to argue that it displays the egotistical flourish of a great auteur; rather is it subtle, delicate and perfectly judged. The scene in the hat shop discussed above, for instance, works perfectly for the purpose of the narrative, and is handled with a minimum of fuss – the whole incident being covered in just six elegant shots. C.A. Lejeune in *The Observer* emphasised the balance of script and direction as the strongest point in what she considered "the film of the week". "'Home is Where the Heart Is" is the motto over the painter's Putney hearth", she concluded, '"Film is Where the Script Is" remains the moral of this neat, small piece".[**] ◆

Lawrence Napper

[*] "Woolley, Fields and Stahl Win Laurels", in *Hollywood Reporter*, 23 August 1943; "*Holy Matrimony*", in *Daily Variety*, 23 August 1943; A.D., "New Films", in the *Manchester Guardian*, 25 October 1943, 6.

[**] C.A. Lejeune, "The Films", in *The Observer*, 24 October 1943, 2.

The Eve of St Mark

20th Century-Fox. 30 May 1944. 96 minutes.
D: John M. Stahl. **P**: William Perlberg. **Sc**: George Seaton, from the play [1942] by Maxwell Anderson. **Ph**: Joseph LaShelle. **Ed**: Louis Sackin. **AD**: James Basevi, Russell Spencer. **M**: Cyril J. Mockridge, Emil Newman. **Sound**: Eugene Grossman, Harry S. Leonard.

Cast: William Eythe (Private Quizz West), Anne Baxter (Janet Feller), Michael O'Shea (Sergeant Mulveroy), Vincent Price (Private Francis Marion), Ruth Nelson (Nell West), Ray Collins (Deckman West), Stanley Prager (Private Glinka), Henry Morgan (Private Shevlin), Bob Bailey (Corporal Tate), Dickie Moore (Zip West).

After completing the comedy *Holy Matrimony*, John M. Stahl returned to wartime themes with *The Eve of St. Mark*. Like his recent *Immortal Sergeant*, the film intercuts the home front with military settings – first an army training camp and then a Pacific island under attack – and incorporates a romance between a soldier and his girl back home. The similarities end there. With *Immortal Sergeant*, a combat film, Stahl directed a visually coherent and well-balanced story drawn from a novel suited to adaptation. With *The Eve of St. Mark*, an allegorical drama, Stahl tackled a play so heralded that he and 20th Century-Fox perhaps felt compelled to remain *too* faithful to it, unwilling to make the alterations in content and focus needed for it to work coherently on screen. The end result was treated as a prestige release, and drew a generally positive reception for its "important" subject matter, but it has not withstood the test of time. Most of the film feels stagebound, and Stahl's earnest storytelling approach falls short because the story itself lacks a consistent point of view.

On Broadway, Maxwell Anderson's play had been a triumph. "Anderson has restored to the theatre its self-respect", declared the *New York Times* in October 1942. "No other play has brought so much of the truth and anguish of our war into the theatre."[*] As the show began its run of 307 performances, a bidding war ensued in Hollywood, with 20th Century-Fox eventually paying $300,000 for the screen rights. This tied an industry record set just seven months earlier when Fox bought the rights to *The Moon is Down*, a novel and play that also had a war theme – and also came from an esteemed, Pulitzer Prize-winning author, John Steinbeck. Anderson had won his own Pulitzer in 1933, and earned considerable renown in the years since for such plays as *Mary of Scotland* and *Winterset*.

* Brooks Atkinson, theatre review, *NYT*, 8 October 1942.

In fact, while the high price tag indicates that Fox expected *The Eve of St. Mark* to be a sizeable hit, the studio's casting of several unknowns suggests that it was banking heavily on the play's prestige value to sell tickets. Initially, Fox leaned toward established stars Dana Andrews or Brian Donlevy to play Pvt. Quizz West; ultimately the part went to William Eythe, a virtual newcomer. Five supporting players imported from the stage version brought fine acting and Broadway credentials – but not star power. Aside from character actors Ray Collins and Dickie Moore, the best-known cast members were probably Anne Baxter and Vincent Price, and even they were still climbing the ranks.

Eythe and Baxter play Quizz and Janet, farm neighbours since childhood who have fallen in love only now, in 1940, when Quizz is drafted and enters boot camp. After Pearl Harbor, Quizz and his army buddies are deployed to a Pacific Island, where eventually they face a moral choice: stay and fight an important battle, even though they will certainly not survive, or withdraw honourably. In the play, they stay and fight – and die. In the film, they decide to remain, but after sinking a few enemy boats their cannon is destroyed by a bomb, and they withdraw, alive and well.

This ending was criticised for blunting the central idea of Anderson's story as well as the symbolic meaning of the title, which refers to a legend that, on St. Mark's Eve, a maiden standing in a church door may have a vision of those who will die in the coming year. (A faithful ending was filmed, then re-shot when preview audiences complained about its downbeat nature.) A second criticism of the time, despite the respectful reviews, was that the tale was quite dated. A stipulation of the play's sale had prevented Fox from releasing the film until after 1 January 1944 so that the play could complete its run without screen competition; it was finally released in early June, the same week as the D-Day invasion of Normandy, a time when audiences must have felt well beyond debating the morality of a last stand (a device, moreover, they had already seen to powerful effect in other war movies, such as *Bataan*). From today's vantage point, both criticisms are inconsequential. With World War II long over, the subject matter does not feel "dated" in the way it did in 1944 with the war still raging, but rather stands as a parable for all wars, albeit a preachy one. As for the ending, it is the least of the film's flaws.

Ironically, *The Eve of St. Mark*'s own advertising tagline – "The Love Story of a Soldier" – encapsulates why the film loses coherence well before its ending. It *begins* as the love story of a soldier, with Quizz returning home to his farm, on leave from boot camp, with his fiancée Janet. As filmed by Stahl, the sequence is a touching piece of Americana, with seasoned performances from Ray Collins and Ruth Nelson as the parents and a sincere turn from Baxter. Stahl's typical long-take two-shots bind the young lovers to each other visually and to the audience emotionally. The result feels promising: audience investment builds in the couple's romance and prospective screen journey.

When the film shifts to the boot camp, that investment is left behind. Suddenly the story becomes an ensemble piece of the male recruits and their sergeant, concerned with issues of camaraderie, discipline, and Maxwell Anderson's moral message. "How close does a man have to come to being horizontal before he earns the right to remain perpendicular?" asks Pvt. Marion more than once, verbalising a central Anderson theme. If Stahl had tied that question consistently to Quizz's

point of view and presented the army scenes from his perspective – rather than through various other soldiers and the group as a whole – he might have maintained the audience alignment with Quizz created by the opening farm sequence. This would have meant drastically cutting down other characters such as Marion, who is played with relish by Vincent Price but overwhelms Quizz's story; it would also have meant eliminating much of the script's talkiness and altering other elements of the narrative. It's possible that George Seaton's screenplay did account for some of these issues: Seaton later said he was dismayed that Stahl had emphasised different aspects of the script than he himself had intended.[*]

Be that as it may, the film allows other soldier characters to dominate as the story progresses, and Quizz gets lost in the shuffle – as does his love story with Janet. They share just one more sequence together, and by the climax, when they literally communicate with each other through their dreams (a device reminiscent of the 1935 film *Peter Ibbetson*), the movie has diffused audience interest in the duo to such a degree that the sequence feels maudlin and contrived, not touching.

The dream sequence, in fact, illustrates the key difference between *The Eve of St. Mark* and *Immortal Sergeant*, which also contains a sequence of its hero, played by Henry Fonda, "communicating" across dimensions with a beloved character – his deceased sergeant played by Thomas Mitchell. As he infiltrates an enemy camp, Fonda hears Mitchell's voice, and they carry on a dialogue in his mind about Fonda's abilities. There the device was powerful and effective because Stahl had been telling the story all along from a consistent viewpoint: overall objectivity and a general alignment with Fonda's story situation. Stahl's visual presentation has brought the audience along Fonda's journey, but through the constant prism of observing his character growth. *The Eve of St. Mark*, on the other hand, cries out for subjectivity, not objectivity, because that's the way it so firmly establishes itself at the outset. After it shifts away from its compelling and subjective opening, the film treats Quizz and Janet almost as an afterthought and never recovers from the sense of becoming a series of theatrical set pieces, including the dream sequence.

At home, before he goes to war: Anne Baxter, William Eythe.

[*] As a direct result, and with Stahl's encouragement, Seaton became a director himself, starting with *Diamond Horseshoe*. He went on to write and direct, among other films, *Miracle on 34th Street*, *The Country Girl* and *Airport*

Furthermore, *Eve*'s dream communication carries no real thematic meaning because of the change to the story's original ending. The St. Mark legend includes a provision that if the maiden's lover is among those prophesied to die, his voice can reach her from a great distance – hence the dream sequence, intended as a symbolic device. But the film never supplies this explanation because the film doesn't end with Quizz's death, and the result is that the dream seems to pop up out of nowhere and becomes another casualty of a muddled point of view. Stahl would fare much better when he returned to adapting a novel for his next film, *The Keys of the Kingdom*.◆

Jeremy Arnold

The Keys of the Kingdom

20th Century-Fox. 15 December 1944. 137 minutes.
D: John M. Stahl. **P**: Joseph L. Mankiewicz. **Sc**: Mankiewicz, Nunnally Johnson, from the novel [1941] by A.J. Cronin. **Ph**: Arthur Miller. **Ed**: James B. Clark. **AD**: James Basevi, William Darling. **Set design**: Thomas Little, Frank E. Hughes. **M**: Alfred Newman. **Sound**: Eugene Grossman, Roger Heman. **Costumes**: Bonnie Cashin.

Cast: Gregory Peck (Father Francis Chisholm), Thomas Mitchell (Dr Willie Tuck), Vincent Price (Rev. Angus Mealy), Rose Stradner (Mother Maria Veronica), Roddy McDowall (Francis as a boy), Edmund Gwenn (Rev. Hamish MacNabb), Cedric Hardwicke (Monsignor Sleeth), Jane Ball (Nora Bannon), Peggy Ann Garner (Nora as a child), James Gleason (Dr Wilbur Fiske), Ann Revere (Agnes Fiske), Ruth Nelson (Lisbeth Chisholm), Benson Fong (Joseph), Leonard Strong (Mr Chia), H.T. Tsiang (Hosanna Wang), Si-Lan Chen (Philomena Wang).

The Keys of the Kingdom is a film with multiple authorships, each of them forceful enough that Stahl can, at first sight, be felt to be missing. The opening title reads "A.J. Cronin's The Keys of the Kingdom", and the trailer speaks of the book capturing "the hearts of 30 million persons". Archibald Joseph Cronin was a Scottish Catholic who in the 1930s gave up his career as a doctor to become a popular novelist. The Stars Look Down (1935) focused on the coal-mining industry, The Citadel (1937) on the medical profession; both were soon made into high-profile films, the Oscar-nominated The Citadel (1938, King Vidor), and The Stars Look Down (1940, Carol Reed). The two novels – and the films – strongly convey his sympathies for the working poor in contrast to the comfortable class at the top of the pile, sympathies that would surface again in The Keys of the Kingdom, published in 1942 after Cronin had moved to the USA. This was a challenge for him: while the story starts in Scotland and the north of England, areas he knew well, the long portion of the book set in China would have required much research.

The screen rights were acquired by David Selznick, but in 1942 he assigned them to Fox, where Darryl F. Zanuck commissioned a script from the leading scriptwriter Nunnally Johnson. Having approved his treatment, Zanuck then asked Joseph Mankiewicz to produce it. Mankiewicz rewrote Johnson's script to Zanuck's satisfaction by January 1944, and Stahl was assigned to direct what would be – at $3 million – Fox's second most expensive film in that year after Wilson.* That Stahl was

* A fuller account of the production history is given in the notes by John Burlingame that accompany the CD of Alfred Newman's musical score, issued by Screen Archives Entertainment in 2004. Thanks to Ned Comstock of USC for supplying a copy of these notes.

chosen is a measure of the professional esteem in which he was held, although at first sight it was not a natural subject for him.

Besides all these individual contributions, the "Fox film" element is important: the studio may have felt that a prestige film with a Chinese subject should be part of the war effort, and should deploy talent in all departments. Arthur C Miller was a Fox cameraman through the 1930s and 40s, and in 1940 the composer Alfred Newman began a thirty-year career with the studio. His score here can be described as virtually "through-composed" – to take a term from opera – which suggests Fox wanted it to have particular prominence.

The story tells the life of Francis Chisholm. The first thirty minutes cover his early life in Scotland, which ends when he is orphaned as a result of anti-Catholic bigotry. He goes to live with a distant relation and finds himself torn between affection for her daughter and a vocation for the priesthood. The latter wins, but Chisholm finds his curacies difficult, and volunteers at the request of Bishop MacNabb to take on the mission at Paitan in China. It is at this point that Chisholm is truly brought to the test. In the background are poverty, disease and mistrust of Catholic missionaries. In the foreground are Chisholm's relationships: with Joseph, the young Chinese who helps him to get established, with the mandarin Mr Chia, whose son he cures, and with Sister Maria Veronica, the nun who joins the mission. Two childhood friends make a visit: one is Dr Willie Tulloch, Chisholm's atheist soulmate, and the other is Angus Mealy, now a bishop. Success comes eventually for Chisholm's mission, despite the initial hostility, the eruption of war, and a prickly relationship with Maria Veronica.

The film starts with Chisholm in his Scottish parish in 1938, and uses a flashback to tell the story of his life, starting somewhere in the nineteenth century. The novel on the other hand is much more specific: we learn that Francis was born in 1868 and goes to China in 1902. Much is made of World War One taking place on the other side of the globe, and there is unsentimental portrayal of the bandit warfare in which the mission finds itself. However, over thirty years the mission is successfully established, and Francis returns to Scotland in 1937/1938. Although the novel has an epic sweep, the film is a depiction of an interior life, not of exterior realism.

It has a very marked filmic context. Three years earlier, *Citizen Kane*'s version of how to make a biopic had caused a sensation. But *The Keys of the Kingdom* looks as much to *Goodbye Mr Chips* (1939), at how an ordinary life can be understood as an extraordinary one, again using the flashback device to show failure being transmuted into success. John Ford is a presence too: Willie Tulloch is played by Thomas Mitchell as a sober version of the whiskey doctor in *Stagecoach*, and the deathbed scene between Francis and Willie is a soft version of the tragic death of Yank in Ford's *The Long Voyage Home*. A further Fordian echo is of his film of *How Green Was My Valley*, a Fox production that had won the Oscar for best picture in 1941. The two films are linked superficially by the presence of Roddy McDowall as a boy in both, and more significantly by Arthur Miller's camerawork. Just as *How Green Was My Valley* suppressed its Welshness, *The Keys of the Kingdom* suppresses its Scottishness.[*]

[*] Only Edmund Gwenn, the English actor playing MacNabb, and Mitchell as Tulloch, have remotely plausible Scottish accents; Vincent Price as Mealy does not even try. Nor does Gregory Peck.

Among Zanuck's and Mankiewicz's challenges in preparing the film was to steer it past the snares and eddies of a subject likely to infringe the sensibilities both of the Catholic Church and of America's ally in the Far East, China. This task must have required unusual amounts of patience and decisiveness. The sensibilities of the church had been a constant for all the studio heads, especially since the advent of sound and the strengthening of the Production Code Administration in 1934, headed by the card-carrying Irish Catholic, Joseph Breen. To ensure harmony on this front, Fox employed two Jesuits as technical advisers, one of them a former missionary in China, both of whom were involved in script conferences throughout. One particular concern was that the Church was not depicted as "the heavy". This was avoided by the sympathetic representation of Bishop MacNabb, Francis Chisholm's mentor; and at the core of the story is the reconciliation between the good priest Chisholm and the repressed nun, Sister Maria Veronica.

China was something new altogether. The USA and China were allies, and because *The Keys of the Kingdom* was largely set in China the Office of War Information (OWI) took a keen interest: a three-page review of the revised temporary script, dated 19 January 1944, focuses on the "negative" portrayal of the Chinese as outdated medically, politically and culturally, and subject to internal strife. Finally, "Several references which suggest racial antagonism between the White and yellow races are in contradiction to United Nation's war aims." How were Fox to deal with this? The answer is by both ignoring it and in a significant way submitting to it. For example, the OWI objected to the idea of "rice Christians", Chinese who had converted to Christianity solely as a way of getting food, but Fox ignored this point, while they obeyed the OWI in downplaying the historical context. That had started with the Boxer Rebellion against Western colonialism, among the victims of which were Catholic missionaries. Then, after the formation of the Republic of China in 1912, a period of warlordism followed. When Chiang Kai-shek seized control of the Nationalist Party in 1926–7, the struggle with the Communist Party began in earnest, a struggle that intensified in bitterness in the following decade: the Long March, under Mao Zedong, took place in 1934. With China embroiled in Civil War, the Japanese occupied the country after 1931, a bleeding chunk of modern history characterised by the Japanese rape of the Chinese capital, Nanjing, in 1936. When America entered the war in 1941, the China theatre posed the difficult question of how best to support Chiang Kai-shek.

Despite this stark background, Fox pleased the OWI by ensuring that *The Keys of the Kingdom* eliminated almost any reference to politics. One can only regret that the film was partially emasculated as a result, but it is important to judge it by the circumstances of the time, i.e. that the USA and China were engaged in a major war and Fox needed to handle this expensive film responsibly.[*]

What is Stahl's place in this jigsaw of talents and outside interests? He must have discerned possibilities in the story, with its echoes of *Magnificent Obsession*, in which a Theory of Creative Force derived (rather coyly) from the gospels converts a feckless young man into a "hero of goodness", and in which a young woman, Joyce Hudson, confesses to the man that she had misjudged him. In *Keys of the*

[*] I am indebted to Barbara Hall for her work in unearthing much of this script history in the Joseph Mankiewicz papers held in the Margaret Herrick Library in Beverly Hills.

Kingdom the creative force is the Catholic faith, and the psychology of the Joyce Hudson figure is more fully realised in Sister Maria Veronica. The finished film brings to the fore Father Chisholm's relations with women in particular, and Stahl may have had a hand in structuring the film this way. First of all, as a young man, not yet ordained, Francis Chisholm has a childhood and teenage sweetheart in Nora. In the novel Nora's mother Polly is a lively, sympathetic figure who is instrumental in finding a purpose and a career for Francis after the death of his parents. In the film by contrast her liveliness is bossiness, and her steering of Francis into the seminary is oppressive, less to Francis than to her daughter Nora, who clings to Francis, but whose desires are crushed by her mother.

Sister Maria Veronica is one of three nuns to arrive at Francis's mission at Paitan. Relations between them are frosty. The women keep to themselves, although their help with schooling and the medical clinic contributes significantly to the mission's success. Maria Veronica is upper-class and snobbish (a quality more forcefully delineated in the novel than in the film), clearly dismayed by Father Chisholm's identification with the poor. But the dramatic charge of the second half of the film is how she comes to appreciate his priestly qualities. There are two confessional moments, firstly when she finds Father Chisholm sitting alone in his ruined church and confesses she is bitterly sorry for her conduct; then, near the end, when the two are sitting quietly together before Chisholm's return to Scotland, she says, "I shall never forget you" in a way that hints at sublimated desire.

Chisholm himself is played, in only his second film role, by Gregory Peck, who manages successfully enough to go from being around nineteen to old age. His moral stature in the film is matched by his physical bearing, but gaucheness does not come to him naturally, nor the idea that at the outset of his career he is a failed priest. On the other hand, Chisholm's point in the narrative is to be defined by those around him. His father is Catholic, his mother Protestant, a formative influence that produces not fissure but wholeness. His mentor is Bishop Hamish MacNabb, who expresses to Chisholm his faith in what he can do – and then throws him in the deepest of ends by sending him to China. He has two childhood friends. One is Willie Tulloch, a doctor and firm atheist, who admires Chisholm's capacity for taking on a challenge and for his essential goodness towards human beings despite what he sees as the mumbo-jumbo of his Catholicism. The second childhood friend is put memorably centre-stage in the film. In the novel, Angus Mealy has a parallel but contrasting career to Chisholm's, intersecting with him at various points as he rises effortlessly up the ecclesiastical ladder. As Secretary of the Society for the Propagation of the Faith he oversees Chisholm's work in China, and it is Mealy as Bishop of Tynecastle who has power to grant or withhold a Scottish parish at the end of his life.

Mealy's presence turns the film into a triangle of relationships fraught with tensions of the kind that Stahl would exploit so powerfully in his next film, *Leave Her to Heaven*. For Maria Veronica it is Mealy's arrival at Paitan on a supervisory visit that opens her eyes to Chisholm's qualities of tolerance when she concludes, "Angus Mealy tried to humiliate you". It is in these scenes that the film most comes to life, when Cronin's contempt for arrogance and hypocrisy coincides with Stahl's ability to portray the brittleness behind success. He is aided in this by the casting of

Vincent Price as Mealy, in training as it were for his later roles in horror films in which a smoothness of voice and style overlay a deranged quality underneath. In his ten minutes on screen he lectures Chisholm on his disappointment in finding the church is a bombed ruin, he preens himself on being "the youngest Monsignor in the northern diocese", he urges Chisholm to increase the conversion rate by ingratiating himself with "some of the better-class Chinese" – and reveals that his favourite tipple is amontillado sherry, a bottle of which he has brought with him to remotest China.

Gregory Peck, Rose Stradner.

Most creepily, his gathering of material on "God in Darkest China", thwarted by the bombing of the church, is revised in (to him) an inspired way by retitling it as "Dangers and difficulties of the missionary field: God chastiseth his own." This contrast between false outward success and an inner God-directed one is Cronin's way of revealing his shallowness, and Chisholm's depth. In the hands of Stahl and Price, Mealy becomes a monster of unctuousness and vainglory.

This comes as an epiphany to Maria Veronica. When Chisholm is to leave Paitan, he mentions that Mealy has become Bishop of Tynecastle, and that he is happy for him, to which she comments, "I am sure he is too." Such acidity is quite missing from Chisholm's make-up, and for a secular audience risks making him a rather bloodless figure. Yet to appreciate the point of the film, it is necessary to see Chisholm in counterpoint with others. In the film's opening scenes, he has two father figures, his natural father ("the best of men") and, after his death, Bishop Hamish MacNabb, with whom he bonds by a shared love of fly fishing.

He likes verbal sparring with Tulloch, theism versus atheism. When well-funded Methodist missionaries in the person of Wilbur and Agnes Fiske arrive in Paitan, his instinct is to collaborate with them, and in his meeting with Mr Chia, he assures him that the Fiskes do not worship a false God. "It is the same true God that I serve." This sentiment of potential theological complexity must have been a subject of discussion with the two technical advisers, but it survives in the film.

Vincent Price as Mealy, in the second of his three consecutive roles for Stahl.

Chisholm seems at first to be a passive character, but as the story unwinds he becomes an active shaper of the destiny God has in mind for him. *Keys of the Kingdom* wants to portray him as a saint, and the idea in the epigraph for the film – "And I will give to thee the keys of the

kingdom of heaven", Jesus's words to Peter in Matthew 16:19 – is accentuated by appearing at the end. Unlike Mealy, he is "no ecclesiastic mechanic", as MacNabb discerns, and he achieves a transcendent union with Maria Veronica.

In a secular age, the film's uncomplicated commitment to the merits of faith may seem out of date, and its melodramatic potential may feel muted. The war scenes lack the sense of misery one might expect, and the action scene in which Tulloch is fatally wounded by a sniper feels especially flat. On the other hand, the story has its own power from which Stahl succeeds in creating a momentum by a series of strong incidents and scenes.

What is more, the film utilises a potent narrative device in which words spoken in voice-over from Chisholm's journal provide a glue for the film as a whole. These occur eight times, and in six of them, their effect is duplicated by our seeing the words on the page. Six years after *The Keys of the Kingdom*, Robert Bresson was to use this device in his film version of Georges Bernanos' *Journal d'un curé de campagne*, one of the most celebrated priestly dramas of the twentieth century.

Chisholm had arrived in Paitan to meet indifference and hostility; at the end he leaves it with the inhabitants crowding the quays and cheering him, despite the history books and the problematic link between the missionary church and colonialism. In light of the eight decades since then, the film has a curiously innocent air. In one respect, however, it points to the future in an unexpected way. Inland China in the nineteenth century, so physically cut off, so ancient in its civilisation, so alien in its culture to the West, was not necessarily a fruitful mission field. *Keys of the Kingdom* shows how it might be. While calculating the number of Christians in China is notoriously difficult due to the country's size and the hidden nature of unregistered groups, there were an estimated 67 million Christians in 2010.[*] It turns out that the key to the kingdom unlocked a hidden door.◆

Tim Cawkwell

[*] See the Pew Forum on Religion and Public life: "Global Christianity: a report on the size and distribution of the world's Christian population," Appendix C: methodology for China – 19 December 2011. See also Ian Johnson *The Souls of China: the Return of Religion after Mao* (New York: Pantheon, 2017).

Leave Her to Heaven

20th Century-Fox. Technicolor. 25 December 1945. 110 minutes.
D: John M. Stahl. **P**: William A. Bacher. **Sc**: Jo Swerling, from the novel [1944] by Ben Ames
Williams. **Ph**: Leon Shamroy. **Ed**: James B. Clark. **AD**: Lyle Wheeler, Maurice Ransford. **Set
Design**: Thomas Little, Ernest Lansing. **M**: Alfred Newman, Edward B. Powell. **Sound**: E.
Clayton Ward, Roger Heman. **Wardrobe**: Kay Nelson.

Cast: Gene Tierney (Ellen Berent/Harland), Cornel Wilde (Richard Harland), Jeanne Crain (Ruth
Berent), Vincent Price (Russell Quinton), Mary Philips (Mrs Berent), Ray Collins (Glen Robie),
Gene Lockhart (Dr Saunders), Reed Hadley (Dr Mason), Darryl Hickman (Danny Harland), Chill
Wills (Leick Thorne), Paul Everton (Judge).

L*eave Her to Heaven* is probably the most widely discussed Stahl film,
prompting a number of different critical approaches. Jean-Loup Bourget
(1974 & 1985) has written about the film as a melodrama. Yann Tobin
(1977) makes some pertinent observations about it as the story of a
transgressive heroine. Michael Renov (1983) discusses the pathology of
its disturbed heroine, Ellen Berent (Gene Tierney), and relates this in part
to the film's time of production at the end of World War II. Marshall Deutelbaum
(1987) focuses primarily on the implications of the colour-coding of Ellen's and
Ruth (Jeanne Crain)'s costumes.* Nevertheless, there remains a great deal more
to be said about this remarkable film. I shall concentrate on it as a melodrama, but
will also refer to other angles – e.g. its relationship to the source novel – where this
seems appropriate. However, I am unable to position – and therefore to discuss –
Leave Her to Heaven as a Stahl film. It is simply too different from all the other films
I have seen of his. Stahl's direction is exemplary, but primarily as a coordinator and
enabler, serving, with his cast and crew, to bring out the force of the melodrama
implicit in the script.

* Jean-Loup Bourget, "Romantic Dramas of the Forties", in *Film Comment*, January/February 1974. Bourget: *Le mélodrame holywoodien* (Paris: Stock, 1985). Yann Tobin, "John M. Stahl: présentation", in *Positif*, July/August 1977. Michael Renov, "*Leave Her to Heaven*: the Double-Bind of the post-War Woman", in *Journal of the University Film and Video Association*, Winter 1983. Marshall Deutelbaum, "Costuming and the Color System of *Leave Her to Heaven*", in *Film Criticism*, Summer 1987. The Tobin and Deutelbaum essays, along with the Stahl section of Bourget's 1985 book, are reprinted in Spanish and English in Ciompi and Marias (eds), *John M. Stahl* (San Sebastian 1999: see Bibliography section 7); Tobin's is also included in Jean-Pierre Coursodon and Pierre Sauvage (eds.), *American Directors* (New York: McGraw-Hill, 1983). The Renov essay is reprinted in Marcia Landy (ed.) *Imitations of Life* (Detroit: Wayne State University Press, 1991).

Property and adaptation

Ben Ames Williams's best-seller *Leave Her to Heaven*[*] was snapped up by Darryl F. Zanuck for production at 20^{th} Century-Fox; Jo Swerling was assigned as screenwriter. The story of a highly possessive woman (Ellen) "taking over" the life of its novelist hero (Richard Harland), the novel has elements that were ideologically quite daring for the time, but Zanuck encouraged his writers not to dilute the impact of the original works and, taking into account the inevitable compression when a 400-page novel is translated into a script, the film is in fact fairly close to the original. Two points are however worth noting at the outset. The novel is in the third person, but successive chapters are from different characters' points of view: Richard's, Ellen's, Richard's brother Danny's, Richard's, Ruth's etc. This is particularly successful in the early chapters, where the crucial events leading up to Ellen and Richard's wedding are in effect narrated twice, first from Richard's point of view, then Ellen's. Such chronological overlapping accompanied by systematic shifts in the point of view would obviously have been a little radical in a Hollywood movie of the era. But, without this device, the motivations of the characters in the film are inevitably more ambiguous than in the novel.

The other point concerns structure. Like the novel, the film has a prologue in which Richard (Cornel Wilde), just out of jail, is seen making his way home by motor boat and then canoe across Deer Lake, Maine. At this point, the novel simply goes into flashback, but in the film Richard's lawyer, Glen Robie (Ray Collins), settles down with a convenient listener, and it is he who narrates the back story. That the film felt the need for a diegetic narrator merits discussion.

First, the figure of the narrator was simply Hollywood convention, a convention which would later change: by the time of *Written on the Wind* (Douglas Sirk, 1956), which has a similar structure to *Leave Her to Heaven*, a flashback could be shown without a narrator. But, second, the sense that Glen is narrating soon evaporates: there is no voice-over; many of the events are outside his knowledge. (His statement – "I suppose I'm the only one who knew the whole story" – is highly questionable.) That the film is initially narrated this way seems to be no more than a rhetorical device. Third, the particular choice of Glen – both lawyer and father-figure – to tell the story is nevertheless significant. It has led Maureen Turim to write that the film's "vision of a mentally disturbed, seductive murderess [is] filtered through a frame structure of male narrators".[**] I don't agree: once inside the flashback, the film is in effect in the third person, and the balance of sympathies between the characters is determined, as always, by the perspective the film constructs on the events. Turim is right in the sense that the film *sets out* to frame Ellen's story within Glen's narration. But it doesn't work – at least, not at the narrative level. Ellen escapes such control, and the film has to resort to other tactics – notably, a posthumous trial – to recuperate her threat to the patriarchal order.

Genre

In his survey of the American cinema, Martin Scorsese calls *Leave Her to Heaven* "a film noir in colour", and other US critics have followed suit. In fact, as the French

[*] Boston: Houghton Mifflin Company (1944).
[**] Maureen Turim: *Flashbacks in Film* (New York: Routledge, 1989), 155.

critics (Jean-Loup Bourget; Yann Tobin) realised, it makes far more sense as a melodrama.[*] *Leave Her to Heaven* is concerned with sexuality and desire in relation to the family; in film noir, the family is almost entirely absent. The narrative is driven by the heroine's desire; in film noir, more usually, the hero's. Nor can Ellen be reasonably seen as a *femme fatale*. A typical *femme fatale* is motivated by money, power and independence; Ellen is driven by the intensity of her emotions, particularly possessiveness. She is as ruthless as a femme fatale, but she lacks the characteristic cool of the type: she is too tormented, too disturbed. Above all, Ellen's is an excessive desire, driving her to murder, abortion and suicide. The film is also stylistically a melodrama: violent, clashing colours; exaggerated, over-the-top climaxes; a score with strong, dramatic orchestrations. In particular, Leon Shamroy's magnificent colour photography, for which he won a richly deserved Oscar, is absolutely crucial to the impact of the film: it enhances and stylises the excessive passions of the heroine.

The film also possesses the sense of spectacle of melodrama, but in an unusual way. In her big scenes, Ellen self-consciously turns herself into a spectacle: riding to and fro scattering her father's ashes (Ruth, Mrs Berent and Richard are strictly onlookers); bursting out of the swimming-pool in front of Richard (she even says, "How's that for an entrance?"); dressing up and applying makeup before throwing herself downstairs to induce a miscarriage. It's as though these occasions serve to provide her with dramatic settings for her performance as the star, and she plays to this, the centre of everyone's attention.

The melodramatic excess in such scenes anticipates that of some of the most famous "expressionist" melodramas of the 1950s: those directed by such figures as Douglas Sirk, Vincente Minnelli and Nicholas Ray. Indeed, I would maintain that *Leave Her to Heaven* is a crucial precursor of such highly stylised, emotionally violent melodramas. In particular, as I shall argue, it can be seen as the *Written on the Wind* of the 1940s.

The transgressive heroine; the uncertain hero

The flashback begins with Richard meeting Ellen on a train. She is reading his novel *Time Without End*; he is struck by her beauty. But Ellen then stares back at him with such intensity that he becomes flustered, burning his fingers as he lights a cigarette. We assume she's trying to place Richard's face (his photograph is on the back of the book's dust jacket) but her explanation for staring is that he looks like her father. This, to Ellen, is far more significant than Richard's status as author. When he begins to chat her up, pointedly using phrases from the book, she recognises the – distinctly clichéd – phrases, but still doesn't realise he is the author. This is one of the places where Jo Swerling's script has been particularly ingenious. The phrases are in fact from the novel of *Leave Her to Heaven*: they are the stream-of-consciousness thoughts running through Richard's mind as he first looks at Ellen (page 25). By placing them in Richard's *novel*, Swerling in the first instance parodies Richard as an author. But then, as Richard uses the phrases to try and make Ellen realise that he's the novel's author, his cute way of doing this reduces him to the

[*] Martin Scorsese & Michael Henry Wilson, *A Personal Journey with Martin Scorsese through American Movies* (London: Faber & Faber, 1997), 83–86.

cliché level of the novel. He is doubly parodied. Moreover, Ellen doesn't particularly like the novel.

Equally important here is Ellen's gaze. Mary Ann Doane has commented on the "difficulty associated with women who appropriate the gaze", and cites *Leave Her to Heaven*: "the female protagonist's excessive desire and over-possessiveness are signalled from the very beginning of the film by her intense and sustained stare at the major male character [...] the woman is constructed as the site of an excessive and dangerous desire". However, Doane goes on to argue that, "This desire mobilizes extreme efforts of containment and unveils the sadistic aspect of narrative", which is a much more contentious statement.* Ellen is by no means treated "sadistically" by the narrative: the film is much more ambivalent than that.

Richard, Ellen, Ruth and Mrs Berent have been invited to Glen's New Mexican ranch, where Richard discovers that the father Ellen insists he resembles is dead, and the family have come to pay their last respects. Richard also learns that Ellen is engaged, but her father was her first love. In fact, it soon becomes clear that Ellen completely monopolised her father; it is even implied that Mrs Berent adopted Ruth – her husband's niece – as compensation. In the novel, Mrs Berent is an acerbic, hostile figure, and she even exclaims at one point that she's surprised Ellen didn't sleep with her father (page 31). In the film, she's more sympathetic, and she declines at first to blame Ellen. After Richard has married Ellen, he becomes concerned about her possessiveness towards him. Mrs Berent defends her: "There's nothing wrong with Ellen; it's just that she loves too much… She loved her father too much".

Ellen's scattering of her father's ashes in the mountains is the first of the film's heightened melodramatic scenes. Accompanied by Alfred Newman's crashing musical chords, the scene has a powerful, elemental feel, as though Ellen were communing with the Gods. Later she says: "Father used to say it was like riding across the front lawn of Heaven".

I am unaware of any previous Stahl scene which is like this. Since it is Newman's chords ("menacing horns and ominous timpani")** that give the scene such a heightened impact, Newman should also be included amongst those contributing to the melodramatic thrust of the film. The crashing chords are first heard during the credits, where "*Leave Her to Heaven*" is accompanied by a dust-jacket-style painting of a woman in trousers on the horizon, stretching her arms up to the word "Heaven", so that the film's very title is introduced "melodramatically". We are alerted from the beginning to the notion that this is a woman who will transgress boundaries, but we should not judge her: rather, "leave her to Heaven" (a quotation from *Hamlet*).

However, although such scenes of melodramatic excess punctuate the film, they are not as insistent as in, say, *Written on the Wind*. Much of the film has the cool stylishness of Stahl's 1930's films; it is only occasionally that passions erupt. Although the eruptions are so powerful that they tend to dominate the film, equally important are more nuanced details.

* Mary Anne Doane, *Femmes Fatales* (New York: Routledge, 1991), 27–28.
** Mark Evans, *Soundtrack: the Music of the Movies* (New York, Da Capo Press, 1979), 52.

Richard is interrupted at his poolside typing by Ruth pruning the roses. Cornel Wilde, Jeanne Crain.

One example is a little cluster of references to Ellen's superior powers, which shade into suggestions of witchcraft. When Ellen tells Richard she knows his background – Harvard to Paris (as a painter) to journalism to novelist – he comments, "If you lived in Salem a hundred years ago, they'd have burned you". But all Ellen has done is to read the blurb on his novel's dust jacket. Although Richard's comment is a joke, it is an example of his unease, an unease that begins with her stare on the train. In this unease, he gives her witchlike powers.

Ellen and Ruth are contrasted through nature: Ruth is linked to the home and garden, Ellen to the great outdoors, which will eventually extend to lake and sea. As Richard types by the pool-side, each – within her domain – disturbs him: Ruth pruning roses on an arbour, and Ellen appearing out of the swimming pool. Jean-Loup Bourget also notes how Ruth appears from above, and Ellen from below: "Two conceptions of woman are presented here: the Angel and the Fiend or [...] Lilith".[*] A further point about this scene – and the contrast between the two women – is that Ruth says she hopes she didn't interrupt Richard, whereas Ellen says she hopes she did. As becomes explicit later, Ellen cannot bear Richard having any interest but her: she sees even his work as a threat.

In the scene at the pool-side, the matter of Ellen's engagement comes up: Richard says he hates Quinton, the fiancé; Ellen reveals that she no longer wears her engagement ring. But whereas Richard's comment will turn out to be misleading (he just doesn't like the idea of a rival), Ellen is set on securing him as husband. When she races Glen's children in the pool, Richard cheers on Lin, and comments, "Lin's going to win". But he is interrupted by Glen (off): "No – Ellen. Ellen always

* Bourget, *Film Comment* essay, 51.

wins". This is both an explicit statement of Ellen's superior powers and a warning: if Ellen sets her mind on something, she will succeed.

Ellen's skill at getting her own way is shown vividly in the next scene. Out of the rain strides Russell Quinton (Vincent Price), the angry, rejected fiancé. As he enters, he sees Ellen and Richard, hand-in-hand, laughing, looking for all the world like two young lovers. But, if we are to believe Richard's testimony in court towards the end, he had – by this stage – decided *not* to ask Ellen to marry him. In other words, his behaviour here is deceptive: as with his 'I hate Quinton', he's acting to encourage Ellen without thinking how this must seem. Ellen may turn out to be a transgressive heroine, but Richard himself is far from innocent of duplicity – this is an early example.

In fact, Quinton's arrival seals Richard's fate: Ellen promptly introduces him to Quinton in front of everyone as her fiancé. As she then goes off to speak to Quinton, the confused Richard is deluged with congratulations. And when Richard is finally able to tackle Ellen, his masterful "Now look here, Ellen" is trumped by her, "Darling, will you marry me?", and a passionate kiss. At this stage, we assume Richard has simply been rushed into marriage. When we hear his testimony later, we are forced to re-evaluate this: he has allowed himself to be seduced into a marriage he does not really want. We can understand something of Quinton's venom as he belatedly establishes this.

At the end of the proposal scene, Ellen says to Richard: "I'll never let you go; never, never, never". This is the end of the first act. But, at the end of the third act, after Ellen has taken arsenic to frame Ruth for murder, these are also her dying words to Richard. This not only demonstrates the film's highly organised construction, it stresses the power of Ellen's transgressive desire.

At the same time, it becomes apparent that Ellen is so disturbed she really needs professional help. This emerges when Richard, Ellen and the teenage Danny, who is paraplegic, move to Back of the Moon, Richard's lakeside lodge in Maine. On the one hand, Ellen wants Richard exclusively to herself, and resents not only Danny and Leick Thorne, resident woodsman, but also Richard's writing. On the other, Richard is insensitive to her needs. When their early morning embrace is interrupted by Danny banging on the wall, Richard takes this as an excuse to go off with Danny for a swim. Richard then invites Mrs Berent and Ruth to stay with them without even consulting Ellen. His excuse, "We wanted to surprise you", rings hollow: he should have known how she would feel. In fact, his behaviour only really makes sense in retrospect, when we hear his doubts about the marriage. It would seem he behaves as he does because he doesn't want her persistent attentions. But the arrival of Mrs Berent and Ruth makes Ellen feel like an outsider – this is shown in an evening sing-song from which she feels herself excluded.

The film, here, balances its positions. Although Ellen is behaving unreasonably towards the others, she is mentally disturbed, and Richard is unable to handle this. On her knees, she begs his forgiveness for her behaviour: "It's only because I love you so; I love you so I can't bear to share you with anybody". In the crucial scene later which ends with him walking out on her, she uses (virtually) the same words, the same suppliant posture. By then, it's too late – Ellen's pathological possessive-

Watched intently
by Ellen, Danny
(Darryl Hickman)
starts to drown.

ness has led to Danny's murder and a self-induced miscarriage. But the film's re-use of the same "plea "emphasises, too, Richard's failure as a husband. Not once does he suggest that Ellen needs help; not once does he even try and talk to her about her possessiveness.

In an early scene at Back of the Moon, Ellen tells Leick about her nightmare. Whilst she rowed on the lake, Richard was swimming and, when he started to sink, she couldn't help: the lake was like glue; her arms were paralysed. Very soon, albeit with a crucial substitution, she will have put her nightmare into practice. After Mrs Berent and Ruth have left, Ellen tries to encourage Danny to follow them to her family home at Bar Harbor. Danny isn't keen: he'd rather wait until all three of them can go. His refusal to comply with her wishes triggers Ellen's murderousness: as Danny swims in the lake, from a rowing boat Ellen encourages him to continue until he gets cramp, and then watches whilst he drowns.

Yet the nightmare is, almost consciously, her excuse. When Richard later forces her to confess what happened when Danny died, she says: "It was like a night-mare... I began to paddle and the boat didn't seem to move". Exactly the same notion of a partly conscious self-justifying lie can be discerned in her comment, to Danny, about how they'll present his record-breaking swim to Richard: "Just pretend you decided to do it on the spur of the moment". It's like the devil putting thoughts into her head, or, more psychologically, like a schizophrenic's voices. Whilst we know that, from the moment Danny begins to swim and Ellen puts on sunglasses, she intends to let him drown, she can pretend to herself she decided to do it on the spur of the moment. The subtext of the film reveals the psychopathology of the heroine.

Ruth poses for Richard's mural in the playroom, with Mrs Berent (Mary Philips) in the background.

Hidden behind sunglasses, it's as though Ellen's gaze becomes literally murderous, willing Danny to sink and drown. Referring back to her gaze in the first scene, here her look really does seem to grant her a witchlike power.

Ellen's nightmare concerns Richard, not Danny, which opens up a speculative area. Richard's relationship with Danny seems over-close, like Ellen's with her father. Danny's paraplegia may thus also be read symbolically, as a comment on Richard's sexuality. If we see the drowning of Danny as an oneiric attempt to get rid of this symbolisation of Richard's sexlessness, then the dream helps make the connection: it's a certain *feature* of Richard that Ellen unconsciously wants to drown. Her phrase "the lake was like glue" may thus be read as displacement: it really applies to the man in the water, specifically to his inability to swim (i.e. make love).

It is also possible that Ellen genuinely *couldn't* move when Danny started to drown. The novel depicts her feelings at this moment as paralysing her with conflicting impulses (page 159). She also says of her dream, "I had no voice". And, in the next scene in Bar Harbor, when she tries to call to Richard (who is sitting, disconsolately, by the sea) she *has* no voice. It's as though Ellen's dream is her excuse in a more profound way: it indicates, in the language of the unconscious, her mental illness.

In the novel, Richard watches through binoculars as Ellen lets Danny drown (148) and, when he comes racing by boat to the scene, Ellen realises he must have seen what happened (163). To protect herself, she tells him she's pregnant (164–5). But she then has not only to become pregnant, but also to handle the problem that the dates won't fit. This is necessarily simplified in the film, but if the changes make Richard seem less compromised, they also make Ellen seem less manipulative.

Sibling rivalry

In the film, it is Ruth who suggests to Ellen that perhaps a child might help fill the "emptiness" in Richard's life. Ellen responds enthusiastically but, when she becomes pregnant, she resents her condition, convinced it makes her look unattractive. This, in turn, leads her to cut herself off from Richard, who correspondingly spends more time with Ruth, which exacerbates Ellen's anxieties. During this period, Richard, Ruth and Mrs Berent redecorate Mr Berent's old laboratory as a playroom, but when Ellen discovers this, she is horrified, saying she wanted the room left as it was. Again, it would seem she is being unreasonable; equally, however, again the other three have done something without consulting her.

But there is also a telling subtextual detail here. The scene begins with Ruth posing for Richard as he draws a mural, and the smock she is wearing quite clearly evokes – within the Hollywood conventions of the time – maternity wear. Indeed, since this shot occurs immediately after Ruth has suggested to Ellen that a child might help, the effect is quite startling, as though Ruth is the one who has become pregnant. Is the film suggesting that Ruth somehow seeks to share Ellen's pregnancy? We may well already suspect Ruth is in love with Richard; here, the film seems to be suggesting, her love has caused her – however unconsciously – to dress in a way which would be extremely likely to fuel Ellen's fears.

A later scene also hints at Ellen's sinister powers. Richard and Ruth have been shopping and, from a window, Ellen watches their return. A wind is blowing and, as Ellen opens the window, a sudden gust bursts open a box Richard is carrying, scattering baby clothes around the garden. Again, it's as though Ellen's gaze causes this to happen, and again this suggests witchcraft: the gust a translation of the violence of her feelings. But a consequence of the scattering of the clothes is that Richard and Ruth, assisted by Mrs Berent, rush around excitedly gathering them up: we thus have another scene showing everybody else doing something together, whilst Ellen feels excluded. Richard and Ruth then enter the house laughing. And so, another effect of the scene is that Ellen here is also in the same position as Quinton was earlier: seeing the one she loves happy with another.

In these scenes at Bar Harbor, again the film balances its positions: yes, Ellen is behaving jealously and possessively, but equally her feelings are not without foundation. She is not (yet) simply the "monster" she will be called in the trial scene.

In going with Richard to buy baby clothes, and then putting them away, Ruth continues to "share" Ellen's pregnancy. Yet Ellen herself continues to resent her condition. Looking at herself in a mirror, a site of unconscious projection, she says to Ruth: "Look at me! I hate the little beast: I wish it would die". On behalf of the audience, Ruth is suitably shocked: "How can you say such wicked things?" After Ruth has left, again in front of a mirror, Ellen has a moment of realisation. This leads to her second "murder", a self-induced miscarriage – the only type of abortion available to Hollywood at the time. She changes into a flowing night-gown (her excuse this time will be that she was sleepwalking – another "dream state"), puts on perfume and lipstick, and throws herself downstairs. This is one of the occasions – they ripple through the film – when her hair seems to change colour: dark brown in the first close-up of her at the top of the stairs, almost completely black in the second. It's as though her very body were changing in response to her "evil".

Equally, as noted, she turns herself into a spectacle. She does not simply throw herself downstairs, but lies decorously at the bottom, her posture a mute appeal for the attention she so desperately craves. Her theatricality is a feature of melodrama, but it also masks a vulnerability: her need always to be the centre of attention.

After her miscarriage, we next see Ellen as she emerges out of the sea in a bathing suit. The associations multiply. First, she would seem to have extended her power-link with water: the swimming-pool; the lake; the sea. She emerges from the sea instead of the hospital; symbolically, it is as though the sea has taken the foetus, as the lake did Danny. (The foetus was, of course, male.) Second, the Freudian association of water with birth is rendered ironic: indeed, Ellen completely subverts it. Wearing a bathing suit is above all an opportunity to display her trim figure again.

The suppressed emotional tensions between the characters finally erupt. Ellen discovers Richard has dedicated his new novel to Ruth, pointedly going against Mrs Berent's sound advice that he should dedicate all his novels to Ellen. Moreover, anxious to escape the atmosphere in the house, Ruth is going to visit the Mexican setting of the novel. Ellen's jealousy finally provokes Ruth to retaliate: "With your love, you wrecked mother's life; ... pressed father to death; ... made a shadow of Richard ... You're the most pitiful creature I've ever known". At the end of this outburst, she walks out of the room, and Ellen turns to see that Richard is present.

Richard remains accusingly silent, provoking Ellen to talk more and more compulsively, gravitating to the "forbidden" matter of Danny's death. At one point she lies on the sofa, which evokes the psychoanalyst's couch. Ellen is like a patient, gradually revealing more and more of her guilt and anxiety, and Richard is like the analyst, using silence to encourage her to talk. But, of course, his role is far from impartial. As Ellen starts to give herself away, he turns accuser, and wrings a confession from her: yes, she killed the "baby"; yes, she let Danny drown.

It is here that Ellen echoes her earlier words, "I couldn't stand having anyone between us", and goes on her knees before Richard: "I love you so, Richard, I love you so". On the one hand, like Scottie at the climax of *Vertigo* (Alfred Hitchcock, 1958), agonisedly saying, "I loved you so, Madeleine", Ellen is expressing the overwhelming intensity of her feelings. On the other, the nature of her possessiveness is pathological, and the forms it takes invite a psychoanalytical interpretation.

In killing Danny and aborting the foetus, Ellen – I would maintain – is symbolically destroying displaced, partial representations of Richard, as though they threatened her idealised conception of him. Equally, her disgust at her own body when pregnant makes her feel she has lost her sexual attractiveness. Ellen's idealised, exclusive relationship with Richard is thus premised on a fantasy of "perfection", a fantasy which, because of its implicit roots in an unresolved Oedipus complex, is peculiarly tenacious.

Although, once again, this would suggest that Ellen needs clinical help, Richard's response is to walk out on her. Ellen retaliates by arranging her own suicide so that it looks as though Ruth has poisoned her. As part of her plan, she writes to Quinton, now the District Attorney, giving a fictitious account of Richard and Ruth's relationship and their intentions towards her. As she is dying, she asks Richard to cremate

her body and scatter her ashes in the same place as her father's. This completes three separate thematic threads: Ellen will finally be symbolically reunited with her beloved father; like a witch, she will also be finally burnt, but also – it is part of her plan – her body will be disposed of in a manner which in retrospect looks suspicious. It is never explained why a post-mortem and inquest were not automatically ordered. In the novel, we learn that Ellen had attacks of acute gastritis since childhood (235–236), and so Richard has an excuse for assuming a post-mortem was unnecessary. Even so, Quinton still holds the lack of an autopsy against Richard and Ruth (314).

Courtroom trial as melodrama

The courtroom sequence of Ruth's trial is one of the most bizarre in the movies. Initially, Quinton as prosecutor merely establishes the basics of his case (i.e. the basics of Ellen's plot to frame Ruth, although he cannot see this): arsenic in the sugar Ellen took was also found in Ruth's bathroom; the cremation of Ellen's body was contrary to the specifications in her will. But then, with none of the normal legal restraints – the familiar calls of 'objection' – Quinton proceeds to rake over the details of Richard's relationship with Ellen exactly like the jealous ex-lover that he is. Indeed, it's as though Ellen's terrible jealousy has transferred itself to him. He not only makes Richard read out Ellen's incriminating letter, he also forces him into a highly personal account of his feelings during courtship and the early months of the marriage. When he gets to the crux of his argument: "Was she jealous of Ruth?... Are you in love with Ruth?", he becomes quite beside himself, repeatedly hurling the last question at a Richard who declines to answer. When it is Ruth's turn on the stand, he works himself up into a similar frenzy as he accuses her of loving Richard. Ruth, finally, says she is in love with Richard, and promptly faints.

It is quite common for court-room sequences in films to become like theatre, even melodrama: there are heroes, heroines and villains; emotions frequently run high; the diegetic audience responds as though at a performance. But Quinton's extraordinary display is still exceptional. He uses the court-room to enact his own, private vendetta: he sets out to expose what he sees as the wickedness of the conniving couple he berates on the stand. But, in his ignorance of the true facts, and his highly personal tone, he becomes the villain of the piece. At the same time, Ellen – in a strange way – is partly vindicated. The device of using the witness stand, with the witness of course under oath, to dramatise a confession of love that has until now been unspoken (*Mr Deeds Goes To Town*, Frank Capra 1936; *A Woman's Face*, George Cukor 1941) is well known. But *Leave Her to Heaven* is nevertheless a powerful example, because it demonstrates that Ellen's "paranoid" conviction that Ruth and Richard loved each other was in fact the truth. Although Richard declines to admit his love even when recalled to the stand, his silence reveals the truth of the accusation. And so, we are invited to see him as both weak – seduced into a reckless marriage – and duplicitous: turning from the demanding and dangerous Ellen towards the more nurturing Ruth, but unable to admit this.

The film, however, needs to effect closure, which means Richard has finally to tell "the truth" about Ellen – "Yes, she was that sort of monster" – in order for the blame

to be allocated where it belongs and Ruth to be freed. However, when we come out of the flashback for the brief epilogue, and Glen explains why Richard has been to jail (for withholding knowledge of Danny's murder), the film hints that his two-year sentence was at least partly deserved. He ran away from Ellen rather than facing up to her dangerousness. Now, however, he has his happy ending. It is Glen who delivers the final line: "I guess Dick's about home now". The closing sequence – Richard joining Ruth at dusk at Back of the Moon – is silent. Ironically, they will now have the place to themselves: the situation Ellen was never able to achieve.

Generic influence?

It is well known that no fewer than three of Douglas Sirk's films were remakes of Stahl's. But, to my knowledge, no-one has commented on the links between *Leave Her to Heaven* and *Written on the Wind*. Although *Written on the Wind* is an oil-empire film, with Jasper Hadley (Robert Keith) as its tycoon, within this is a family melodrama, and there are many elements that echo those in *Leave Her to Heaven*. First, the characters. Kyle Hadley (Robert Stack), is the equivalent of Ellen, the official family heir, Lucy (Lauren Bacall) the equivalent of Richard, and Mitch (Rock Hudson) the equivalent of Ruth. Like Ruth, Mitch is in effect an adopted child. And although Marylee (Dorothy Malone), Kyle's sister who has loved Mitch since childhood, is without a precise equivalent in the earlier film, her jealousy of Lucy – whom she realises Mitch loves – aligns her with both Ellen and Quinton.

Second, the structure. *Leave Her to Heaven* divides neatly into four acts plus a prologue and epilogue, the end of each act marked by a significant event and a shift of location. Thus the first act ends with Ellen winning Richard as husband; the second begins after their marriage, as they visit Danny at a sanatorium in Palm Springs, Georgia. This act ends with Danny's drowning at Back of the Moon; in the third act the action shifts to Bar Harbor. The pattern of *Written on the Wind* is extremely similar. Its first act shows Kyle's obsessive pursuit of Lucy and ends with their honeymoon. In the second act, the action shifts to Hadley – both the town and the family home – and depicts the tensions that arise as a result of Kyle's neuroses and insecurities. The act ends with Jasper's highly melodramatic death – echoing Danny's. In the third act, Marylee convinces the by now permanently drunk Kyle that Mitch is sleeping with Lucy. Here the parallels are particularly close. Lucy becomes pregnant but, convinced the father is Mitch, Kyle violently attacks her, precipitating a miscarriage. He then sets out to kill Mitch, but in a struggle over the gun with Marylee, is himself fatally shot. The relatively short final act is then the inquest – in *Leave Her to Heaven*, Ruth's trial – in which Mitch, like Ruth, is accused of murder.

And so, in both films, the pathologically jealous sibling – who precipitates the miscarriage – dies a violent death, and the entirely innocent "good" sibling is accused of murdering them. In *Written on the Wind*, Marylee in the courtroom at first blames Mitch for Kyle's death – another link with Quinton – but she recovers her decency and tells another story, bending her testimony in Mitch's favour. And so, to complete the parallels between the two films, Mitch is freed for a happy ending with Lucy.

It seems highly unlikely that there was any conscious borrowing here, and so the links would seem to derive from Hollywood scripting conventions (the patterning in a film's acts) and the similarity of the two stories as complementary family melo-dramas, one with a female heir, one with a male, each of them highly disturbed. Both films trace the problem back to the father, but in different ways. Mr Berent obviously allowed Ellen to monopolise him. Kyle, by contrast, is convinced his father has always seen him as weak, and has favoured Mitch, a surrogate son. Unable to compete with Mitch, Kyle became a hedonistic playboy, but Lucy offers him the chance to "settle down". Whereas Ellen seeks to perpetuate her Oedipal fantasy with a husband who resembles her dead father, Kyle seeks to triumph in his sibling rivalry by presenting his father with a daughter-in-law he knows Jasper will approve of. Yet, despite the different motivations of the central characters, both films reach a point where the unborn child who would have continued the family bloodline is killed by the tormented sibling. This is a remarkable connection, striking at the heart of the family. ◆

Michael Walker

The Foxes of Harrow

20th Century-Fox. 24 September 1947. 118 minutes.
D: John M. Stahl. **P**: William A. Bacher. **Sc**: Wanda Tuchock, from the novel [1946] by Frank Yerby. **Ph**: Joseph LaShelle. **Ed**: James B. Clark. **AD**: Lyle Wheeler, Maurice Ransford. **Set design**: Thomas Little, Paul S. Fox. **M**: Alfred Newman, David Bottolph. **Sound**: George Leverett, Roger Heman. **Costumes**: René Hubert, Charles LeMaire.

Cast: Rex Harrison (Stephen Fox), Maureen O'Hara (Odalie D'Arceneaux), Richard Haydn (André LeBlanc), Victor McLaglen (Captain Mike Farrell), Vanessa Brown (Aurora D'Arceneaux), Patricia Medina (Desirée), Gene Lockhart (the Vicomte), Charles Irwin (Sean Fox), Hugo Haas (Hugo Ludenbach), Roy Roberts (Tom Warren), Denis Hoey (Master of Harrow) + Suzette Harbin (Belle).

The Foxes of Harrow begins with a brief prologue, set in Ireland in 1795. The stern patriarch of the Harrow family, a wealthy landowner whose daughter has given birth to an illegitimate child, is shown arranging for the boy to be taken away by a poor couple, the Foxes, and paying them to raise him as their own. The main action of the film then begins on a Mississippi riverboat in 1827 with the introduction of Stephen Fox (Rex Harrison): the Harrow child is now a reprobate dandy who has been caught cheating at cards. He is evicted from the boat and abandoned on a small sandbar, providing a strikingly incongruous image of an immaculately attired man astride a tiny, barren space. The staging also suggests a rebirth, as Stephen contemplates a new life in the American South. Another passenger, the Creole aristocrat Odalie D'Arceneaux (Maureen O'Hara), is a witness to his disgrace, and, though outwardly disapproving, is clearly intrigued. Her gaze establishes a bond between the couple which will lead to their marriage, and also reinforces the film's early focus on Stephen as a charismatic but transgressive figure.

The film is Stahl's last major melodrama, and one which at times, perhaps inevitably, echoes Gone with the Wind (Victor Fleming, 1939). Most obviously, in place of "Tara", there is Stephen's relentless dedication to "Harrow", the plantation named to honour his lost heritage, which comes to symbolise his desire for status and power. As with Scarlett and Rhett's daughter Bonnie, the central couple's relationship is similarly ruptured by the loss of a young child. However, while there are moments of spectacle befitting an antebellum family drama, the film is not conceived solely in epic terms. Indeed, as Odalie moves more to the emotional centre of the story, and themes of sacrifice and atonement emerge, there is some

First meeting:
Maureen O'Hara,
Rex Harrison.

resonance with the intimacy and restraint of Stahl's melodramas of the 1930s. The absence of colour, surprising given Twentieth Century-Fox's predilection for Technicolor in this period, also de-emphasises spectacle.

The key settings of the film are beautifully rendered in the production design of Lyle Wheeler and Maurice Ransford, and in Joseph LaShelle's crisp cinematography. The iridescent visual quality of the D'Arceneaux costume ball contrasts with the dark, oppressive *mise-en-scène* of the Maspero tavern, a site of gambling, duelling and slave trading. There is a restrained classicism in the design of Harrow itself. The scene in which Stephen gives an elegant supper to celebrate the opening of the house, and to win over Odalie, has a serene, almost dream-like atmosphere, as his ambitions are finally realised. It is fluidly staged in long-take shots, including an unusually framed tableau in which Odalie is shown at the piano, accompanying her own rendition of a plaintive Creole song, while the gentlemen slowly enter the room behind her, ending with Stephen at her side.

Odalie plays for her guests, including, at her shoulder, her future husband.

Wanda Tuchock's screenplay greatly condenses the original novel by Frank Yerby, and the retained material is extensively reworked. Yerby himself later judged that "at least *five* characters and twenty scenes are missing".[*] The film has Stephen and Odalie losing their young son Etienne in an accident; they separate, and Stephen takes up with the disreputable Desirée, but the couple are later tentatively reunited by a banking

* Quoted in James R. Messenger, "I Think I Liked the Book Better: Nineteen Novelists Look at the Film Versions of Their Work", *Literature/Film Quarterly*, Spring 1978, 125.

crisis which threatens their home and livelihood. In Yerby's original, Odalie dies in childbirth attempting to have a second child, while Etienne grows to a troubled adulthood, extending the family saga into the next generation. In simplifying the teeming world of the novel, the film's pared-down narrative is foregrounding the central couple in the standard mode of Hollywood narrative, but also diluting a treatment of sexuality and race which greatly contravened the guidelines of the Production Code. A report from the time, which commends Stahl as "something of an expert when dealing with censors", due to the subject matter of *Seed*, *Imitation of Life* and other earlier films, notes that the book "treats both adultery and miscegenation", and details the director's discreet handling of Desirée's bi-racial identity.[*]

As with *The Keys of the Kingdom* and *Leave Her to Heaven*, Stahl had been entrusted with transferring an enormously popular property to the screen. Yerby's novel, his first, was among the most successful books of the decade, selling over two million copies within three years of its publication in 1946.[**] The $150,000 deal which Yerby made with Fox also made him the first African American author to sell a novel to a Hollywood studio.[†] He was a contested figure, working with great success in the disreputable field of popular fiction, but regarded with suspicion by the literary establishment for not explicitly engaging with questions of racial identity in the manner of Richard Wright. However, his achievements have since been more widely acknowledged. Addressing previous neglect, and acknowledging some problems of "thematic coherence", Gene Andrew Jarrett argues that the book "does refer to compelling debates about the role of race in in antebellum American society, especially in relation to democracy, slavery, politics, and the Civil War".[‡]

Suzette Harbin
(uncredited on
screen) as Belle

[*] Thomas F. Brady, "Hollywood Briefs: Two Films About President Roosevelt – Censors and The Foxes of Harrow", *New York Times*, 4 May 1947, X5.

[**] "America's Top Negro Authors", in *Color*, June 1949, 28–30, cited in Gene Andrew Jarrett, *Deans and Truants: Race and Realism in African American Literature* (Pennsylvania: University of Pennsylvania Press, 2007), 162.

[†] Sarah N. Roth, *Gender and Race in Antebellum Popular Culture* (Cambridge: Cambridge University Press, 2014), 293.

[‡] Jarrett, 161.

Both novel and film draw parallels between sexual and racial subjugation. Explaining her reluctance to become involved with Stephen, Odalie tells him "perhaps it's the great violence I find in you, the way you look at me as if I were a slave, as if you owned me", and she later makes a startling appearance at the slaves' voodoo ceremony, seeking to protect her future child. The film avoids some of the stereotypical representations of *Gone with the Wind*, but most of the detail and nuance of Yerby's depiction of slavery has been lost. The role of the matriarch Tante Caleen, a slave and voodoo "conjure woman", is greatly reduced, and the curtailed narrative means that Little Inch, the child slave, does not grow to take up the significant role he has in the book, where he functions as a model of masculinity in contrast to the debauched Etienne.

It is Little Inch's mother, Belle, who figures in the film's most vivid and extraordinary scene. She is first seen standing above the traders at a slave auction, a proud and disdainful figure, contemptuous of her surroundings, who is characterised by Stephen as "La Belle Sauvage". Later, when her son is born, she defiantly rejects the suggestion that he become the personal "body slave" for Stephen's child and flees to the river's edge, seemingly intent on drowning herself and her child. As her partner Achille wrestles the child to safety, she disappears into the churning water. While the film overall treats the subject of slavery with some ambiguity, this shocking act of resistance (drawn entirely from Yerby) lays bare the barbarity and exploitation of the system. It is indicative of what Edward Guerrero describes as a "the promise of a revisionist trajectory" in the film's treatment of the subject at a time when Disney's *Song of the South* (Wilfred Jackson, Harve Foster, 1946) was reviving old stereotypes.[*] The sequence, described by George Morris as "one of Stahl's most feverish set pieces", also draws on the potential of melodrama for heightened moments of narrative and stylistic excess .[**] In its simple staging and what Morris terms the "elemental" qualities of the scene, the backdrop of a raging natural landscape, it also evokes the visual style of silent melodrama.

The film received mixed reviews. Noting Stahl's "polished direction" and praising the performances, *Variety* identified some problems of length and structure, but described the film as "a powerful drama". However the *New York Times*, in a report which was, coincidentally, welcoming a revival of *Gone with the Wind*, mocked the "orotund situations and emotional clichés" of what it described as a "plainly imitative drama". Crediting Yerby's contribution, *Time* felt that "the best thing in the picture is a more than ordinary interest in slaves and their lives; but even this feature is drowned in ornateness and theatricality".[†] The film performed well at the box office, making $3.15 million in domestic rentals but lost money due to its high budget of $2.9 million.[‡]

[*] Edward Guerrero, *Framing Blackness: The African American Image in Film* (Philadelphia: Temple University Press, 1993), 28.

[**] George Morris "John M. Stahl: The Man Who Understood Women", *Film Comment*, May/June 1977, 26.

[†] "The Foxes of Harrow", *Variety*, 31 December 1946. Bosley Crowther, " 'Wind' Blows Again: The Current Revival of 'GWTW' Inspires Some Thoughts on Film Classics", *New York Times*, 28 September 1947, X. "The New Pictures: The Foxes of Harrow", *Time*, 13 October 1947.

[‡] See Aubrey Solomon, *Twentieth-Century Fox: A Corporate and Financial History* (New Jersey and London: Scarecrow Press, 1988), 221, 243.

An elegant adaptation with high production values, *The Foxes of Harrow* is a characteristic work of Stahl's late period at Twentieth Century-Fox, which also has some echoes of earlier work. In terms of genre, the film demonstrates his nuanced exploration of emotion alongside flourishes of melodramatic excess. Though not a maternal melodrama, a central theme of maternal separation and loss is evident. The young Stephen is forcibly removed from his mother in the opening moments of the film, while Belle's son is torn away from her just before her death. And the film ends with Stephen and Odalie grieving together at their young son's grave. Reflecting the tensions within Yerby's novel, and the wider cultural concerns of the period, the film is certainly ambivalent in its treatment of race, but in its sympathetic treatment of African American characters, and actors, it raises interesting parallels with *Imitation of Life*.◆

Adrian Garvey

The Walls of Jericho

20th Century-Fox. 4 August 1948. 106 minutes.

D: John M. Stahl. **P**: Darryl F. Zanuck, Lamar Trotti. **Sc**: Lamar Trotti, from the novel [1947] by Paul I. Wellman. **Ph**: Arthur Miller. **Ed**: James B. Clark. **AD**: Lyle R. Wheeler, Maurice Ransford. **M**: Alfred Newman. **Sound**: Alfred Bruzlin, Roger Heman. **Wardrobe**: Kay Nelson, Charles LeMaire.

Cast: Cornel Wilde (Dave Connors), Linda Darnell (Algeria Wedge), Anne Baxter (Julia Norman), Kirk Douglas (Tucker Wedge), Ann Dvorak (Belle Connors), Marjorie Rambeau (Mrs Dunham), Henry Hull (Jefferson Norman), Colleen Townsend (Marjorie Ransome), Barton MacLane (Gotch McCurdy), Griff Barnett (Judge Hutto), William Tracy (Cully Caxton).

Adapted by the Oscar-winning screenwriter-producer Lamar Trotti from a 1947 novel by Paul I. Wellman – whose work was to provide the basis for three unusual westerns, *Apache* (1954), *Jubal* (1956) and *The Comancheros* (1961) – *The Walls of Jericho* is generally regarded, if considered at all, as a footnote in John Stahl's career. It didn't make a huge impact at the box-office, although according to the trade press it did respectable business (in its first month on release in the US it was only beaten by *Easter Parade* and *Key Largo*), and this was in spite of some hostile reviews and a chequered production history.* In terms of its critical reputation, it has been understandably overshadowed by Stahl's previous *Leave Her to Heaven*, with which it shares a number of narrative features: a scheming anti-heroine, a concluding courtroom case with an aggressive prosecutor, a death-bed note of confession designed to ensnare an innocent party, and the revelation of a secret, forbidden love. Although it cannot match that earlier film for melodramatic fervour and visual bravura, its neglect is nonetheless undeserved. *The Walls of Jericho* offers a piquant evocation of small-town Midwest America in the early years of the twentieth century. In that respect it bears some interesting resemblance to two key films of the 1940s, Welles's *The Magnificent Ambersons* (1942) and Minnelli's *Meet Me in St. Louis* (1944), although it is actually much less nostalgic than either of them about the existence of a prelapsarian paradise in the American small town.

The film's opening sequence has all the nostalgic prompts in place – a diegetic pianola rendition of "Shine On Harvest Moon", the iceman making deliveries from his truck, the white picket fences and the neat front lawns– but rather than lingering lovingly on these, the film fixes its attention on the anxious-looking young woman

* *Box Office*, 14 August 1948, 49; *Variety*, 18 August 1948, 8; *Variety*, 1 September 1948, 4.

hurrying through the neighbourhood who, we soon discover, is on her way to seek help in dealing with her alcoholic father. Nostalgia is refused rather than embraced in this rendering of the American past, all the more striking for being the product of a studio which had done so well at the box-office by perpetuating the idea of the 'gay nineties' in a series of Betty Grable period musicals from *Coney Island* (1943) to *Mother Wore Tights* (1947).

Initially, it appears that *The Walls of Jericho* will be essentially about the conflict between legal counsel Dave Connors (Cornel Wilde) and newspaper editor Tucker Wedge (Kirk Douglas), who have been friends since childhood but have become political rivals in their desire to run for Congress. Wedge's ambition is fuelled by his glamorous wife, Algeria (Linda Darnell), a flirtatious manipulator who is determined to aggrandise herself through her husband's political rise, even if it means breaking up his friendship with Connors. By contrast, Connors is held back by an unhappy marriage to the dipsomaniac Belle (Ann Dvorak) with whom he lives at her mother's boarding house, which adds to the marital strain. Connors' life is complicated further when he falls in love with Julia Norman (Anne Baxter), the daughter of his former mentor, who has also become a lawyer. She will ask for Connors' help in the trial of Marjorie Ransome, when the young woman is accused of murdering the town bully, Gotch McCurdy. During the trial, Algeria mischievously ensures that the love between Connors and Julia becomes public knowledge, which in turn will drive Connors' wife to desperate measures.

The adaptation stays fairly close to the novel, omitting a few subplots, simplifying the characterisation, and diluting the novel's denunciation of corporate capitalism, though Trotti, no doubt drawing on his own experience as a newspaper editor, does find room for a jaundiced look at sensationalist journalism. However, what is particularly interesting is the way Stahl will shift the emphasis away from the story's ostensible hero, Connors, who in reality is a passive figure, trapped in his small-minded community but quite without the inner rage at his fate that gnaws away at James Stewart's George Bailey in Capra's *It's a Wonderful Life* (1946). In Stahl's film, the narrative will begin and end with the character of Julia, who starts things rolling when she comes to Connors' house seeking help with her drunken father, and who brings matters to a close when she has to take Connors' place in the trial after he has been shot by his jealous wife. It is an unprecedented sight for the citizens of Jericho (and unusual enough in a Hollywood film) to have the closing argument in a murder trial delivered by a woman, who also has to defend her character to the jury before pleading for justice for the accused. This legal angle was sufficiently novel to be mobilised by exhibitors in promoting the film, with one cinema manager in Syracuse even inviting every woman lawyer in town to its opening night as an attention-grabbing stunt.[*]

Stahl's incisive direction manages to encapsulate Connors' relationship to the three main female characters with just a single gesture pertaining to each: the way his wife angrily snatches her hand away from his when he thoughtlessly embarrasses her at a party they have thrown to celebrate Tucker Wedge's homecoming; Connors' swift withdrawal from Algeria's gesture of seductively taking his arm, a romantic rebuke to which, one feels, she is unaccustomed and which is to prompt

[*] "Syracuse Portias Asked to Showing of 'Jericho'", *Box Office*, 25 September 1948, 47.

her later campaign against him; and the quick kiss on his cheek by the young Julia when saying goodbye with her father at the station, which takes Connors by surprise but which presages their subsequent affair. Another departure scene on a railway platform will occur years later after an anguished period of separation, which has been broken when Connors has called on Julia with a present of a Mr Pickwick figurine she had long ago admired in a store window. By this time she has left Jericho because she felt her love for Connors had no future, and she is surprised when she hears his voice at the door asking to be allowed to come up to her apartment. (A bold touch: before he enters, Julia quickly shuts her bedroom door, as if to ward off temptation.) The

Julia dominant in the courtoom: Anne Baxter, Art Baker (Prosecuting Counsel), Linda Darnell

The *Brief Encounter* moment: Dave (Cornel Wilde) and Julia, interrupted at the railway station

scene that follows between them is Stahl at his best, deep feeling conveyed not by insistent close-up but simply in their awkward posture and pauses and the slightly nervous way they walk around the room, as if both subconsciously realising that proximity might give way to passion. When Connors gives her the present and Julia remembers, all restraint movingly dissolves. At this point in the novel, Wellman goes into rhapsodies of musical metaphor to suggest the consummation of their love. "A mighty theme of unearthly music played through her [...] Slowly at first, then in mounting surges, the tremendous chords swept her. The music began in timid pulsation, soft violin notes of attraction, then mounting in desire and passion, with woods and harps and at last the brasses...etc" (Wellman: 290–1). Stahl insinuates all this with an embrace, but then stages a potent small scene at a station where a poignant farewell between the two as Connors is preparing to return to his joyless marriage is brusquely interrupted by the sudden appearance of a friend of Julia, who insists on accompanying her on her way home. "What an attractive man", the friend says. "Is he married?" It is hard not to think that this is a deliberate homage to *Brief Encounter,* when Dolly Messiter barges into the romantic reverie of the thwarted lovers and reduces their leave-taking to anguished anti-climax. There is no equivalent scene in Wellman's novel.

Stahl can compress a lot of meaning into a single unforced image. There is a medium profile shot of a morose Connors as he sits glumly out on the porch, whilst inside we can hear a furious argument raging between Belle and her mother: domestic misery positively oozes from the screen. McCurdy's attempted rape of Marjorie is powerfully photographed in brooding shadow by Arthur Miller, with – not for the only time in the film – the male coming off second best in a struggle against the female. There is some lively period detail, particularly in the costuming, with Algeria's ostrich plume hat and her 'sheath' skirt slit daringly up to her knee telling you all you need to know about the character's need to be fashionable and her love

of extrovert display. Linda Darnell's brazen performance is up there with *A Letter to Three Wives* (1949) as one of her finest moments on screen. Because she has so enlivened the film, one is almost sorry at the downfall of her schemes, which she marks by striking a key of her mechanical piano in sheer frustration. One also has sympathy with Ann Dvorak's powerfully characterised Belle, whose alcoholism seems to have a lot to do with the way Connors unconsciously but habitually makes her feel socially and intellectually inferior. Apparently neither Cornel Wilde nor Kirk Douglas were enamoured of their roles, and Wilde was suspended from the Fox payroll for initially turning it down before reconsidering his position (Gene Tierney was also suspended for turning down the role of Algeria eventually taken by Darnell).[*] Douglas' and Wilde's reluctance is perhaps not surprising, since both of them play weak husbands in thrall to dominating or damaged wives, although they skilfully deliver what is required of them.

It is Anne Baxter's film, though, both in terms of the quality of her performance and also in the way the character of Julia evolves. It is intriguing that, in her defence of her love for Dave Connors to the jury, she says that she left Jericho because he was a married man, and implicitly denies any impropriety in her behaviour because she has not seen him since until the trial, "with one exception"; that exception is actually rather significant. Still, she carries all before her in the courtroom, and justice is eventually done. She even manages to achieve a muted reconciliation with Dave, although it is unclear what their future will be. Assessing Stahl's oeuvre, Andrew Sarris wrote: "The emotional problems of women no longer seem as trivial and escapist as they once did, and the intensity of a director's gaze no longer seems static and anti-cinematic. Thus Stahl's cinema eminently deserves continuing re-evaluation".[**] Any incitement to re-evaluate the female-focussed work of Stahl has to be a good thing, and *The Walls of Jericho* certainly deserves a more prominent place in that process of re-evaluation than it has hitherto enjoyed. ◆

Melanie Williams and Neil Sinyard

[*] "Wilde Suspended", *Variety*, 8 October 1947, 6.
[**] Andrew Sarris: *You Ain't Heard Nothin' Yet: The American Talking Film, History and Memory, 1927–1949* (New York: Oxford University Press, 1998), 369.

Father Was a Fullback

20th Century-Fox. 30 September 1949. 84 minutes.
D: John M. Stahl. **P**: Fred Kohlmar. **Sc**: Aleen Leslie, Casey Robinson, Mary Loos, Richard Sale, based on the play *Mr Cooper's Left Hand* [1945] by Clifford Goldsmith, and the article "Football Fans Aren't Human" by Mary Stuhldreher [*Saturday Evening Post*, 23 October 1948]. **Ph**: Lloyd Ahern. **Ed**: J. Watson Webb. **AD**: Lyle Wheeler, Chester Gore. **M**: Lionel Newman, Cyril J. Mockridge. **Wardrobe**: Kay Nelson.

Cast: Fred MacMurray (George Cooper), Maureen O'Hara (Elizabeth Cooper), Betty Lynn (Connie Cooper), Natalie Wood (Ellen Cooper), Rudy Vallee (Roger Jessop), Thelma Ritter (Geraldine), Jim Backus (Professor Sullivan), Richard Tyler (Joe Burch).

With his penultimate film, *Father Was a Fullback*, Stahl entered the novel territory for him of Family Comedy. Fulfilling the sub-genre's ideal classical form, the film depicts a stable post-meridian couple, George (Fred MacMurray) and Elizabeth (Maureen O'Hara) Cooper, enjoying – or bemusedly enduring – the task of dealing with the vicissitudes of bringing up not babies, but children old enough to be the developing "human personalities" that the time's most influential sociologist, Talcott Parsons, saw the "factory" of the family producing – here adolescent Connie Cooper (Betty Lynn) and, nearing adolescence, Ellen Cooper (Natalie Wood).[*] As always, the sub-genre's deep structures foreground sexual love's reproductive function, demoted in romantic comedy, favouring diffused family ties over the couple, with the grit of realism added by sub-texts admitting family life's difficulties, but with reconciliatory mechanisms adapting them to the sub-genre's celebratory mode.[**] Such tendencies differ markedly from treatments of the family in Stahl's earlier films.

In *Father Was A Fullback*, George Cooper, 'Coop' in affectionate-ironic allusion to a less domesticated icon of masculinity, coaches the state university football team whose winless season endangers his family's stay in their adopted town. His squad's lack of talent and pressures from the football-crazy Alumni Association plague him constantly. Concurrently, the couple's home life is disrupted by the older daughter Connie's histrionic distress over a total lack of dates, and the mischief of the younger daughter, Ellen, amused spectator of Connie's despairing

[*] Talcott Parsons and Robert E. Bales, et al., *Family Socialization and Interaction Process*, (London: Routledge and Kegan Paul, 1956), 16.

[**] See the definition of the sub-genre's deep structures in Bruce Babington & Peter William Evans, *Affairs to Remember: The Hollywood Comedy of the Sexes* (Manchester: Manchester University Press, 1989), 234–237.

excesses. As the credit sequence cartoons' crossing of family and football prefig-
ure, the narrative cleverly interlinks the two problematics, even finding a single
solution to both dilemmas through "Hercules" Smith, a brilliant high school quar-
terback; falling for Connie, whose attractiveness renders her conviction of terminal
undesirability risible, he chooses State over football-famous Notre Dame, simulta-
neously rescuing Coop from domestic melodrama and from dismissal as coach.
The narrative's coda, however, promises further domestic upheavals as Ellen, seen
earlier inheriting Connie's Pandora's box of cosmetics when her big sister tempo-
rarily renounces them, and applying them avidly, enters suddenly maturely fash-
ionable, and, paralleling Connie at the narrative's beginning, requests her meals in
her room. Coop, having just expressed relief that their troubles are over, is roused
from his supine position on the couch he has been trying to occupy throughout the
narrative, to say resignedly, "here we go again", with Elizabeth's laughter acting as
the closing commentary.

Family Comedy
problematics
post-Sunday
morning church:
Fred MacMurray,
Maureen O'Hara,
Natalie Wood,
Betty Lynn.

Made in 1949, *Father Was a Fullback,* though built around adolescent problems, is
very different from the teenage angst films of the fifties, in which young males
inchoately searched for missing values. However, six years on, the founding
teenage problem film, *Rebel Without a Cause,* has a female parallel to James
Dean's and Sal Mineo's family and father conflicts in Judy, played by a now
sixteen-year-old Natalie Wood, aged ten in *Father Was a Fullback.* Moreover, Jim
Backus, who here plays Sully, is Dean's father in *Rebel.*

Alongside differences between comedy
and melodrama, three points underwrite
the antithesis between these two films.
(1) As elsewhere in the sub-genre, the
parents' perspective is dominant. (2)
MacMurray's well-meaning incompe-
tence is less a serious failure than a
benign modifying of patriarchal power.
His outside world is entirely masculine,
but his home wholly female – wife,
daughters and Geraldine, the maid
(Thelma Ritter). For Parsons the twin
"psychopathological" dangers to the
family were the "authoritarian" father
and the "overprotective" mother,[*]
though *Rebel* indicts the insufficient father and the domineering mother. Happily
for the comedy, Coop and Elizabeth, whose flashes of irreverent wit combine
touches of insubordination with her helpmate's role, avoid all four pitfalls. (3)
Crucially, Connie is not rebelling against the system, but umbilically attached to it,
fearful she doesn't fit it, rather than berating its failure to fit her. The part of it
responsible for the Coopers' domestic turmoil, the regime of high school dating,
was analysed by the anthropologist Margaret Mead in *Male and Female,* published
only a year before the film. For Mead, the "game" of middle-class dating rituals
"has the object of training both sexes in values and restraints valuable in adult life

[*] Parsons, op.cit., 104–105, 243.

and work to come [...] of arriving where one wants to get to, that place being popular and trained in the arts demanded of American middle-class life for both males and females". * This "game" with its socially sanctioned rules chimes nicely with the narrative's other rule-bound game. The only alternative perspective to the genteel factory's is the licensed satiric voice of the working class maid, Thelma Ritter's Geraldine, with her scepticism about the indulgence given to the children – e.g. when Coop says that Connie needs understanding and rest, she replies "what she needs is a quick belt in the chops" – her gambling on the football results, and an implication of unruly associates in the sailor she provides as an unlikely date for Connie.

Two escalating misunderstandings constitute central set pieces of this genial comedy. The first arises from her parents instructing Ellen to be nice to her older sister, which leads her (with some admixture of sibling malice) to invent a "simply devoon" [i.e. divine] boy, the so-called "Joe Burch", who has supposedly ogled Connie in church. After Ellen admits her invention, Coop talks to his next door neighbour, Professor Sullivan, about Connie's problems. "Sully" suggests that Coop should phone her, impersonating a boy, to make her feel desired. Coop demurs, saying she would recognise him, and suggests Sully should do it. Sully, voice disguised, phones as "Joe Burch", unaware that Connie expects him to call round. To rescue the situation, Sully bribes a boy to impersonate "Joe Burch". Unfortunately, unaware of this, Ellen, Sully's daughter Daphne, and Geraldine, all have the same idea. This creates a concatenation of accelerating comic effects that Bergson in *Laughter* (*Le Rire*) called "the Snowball", ** in which in rapid succession, to general consternation and Connie's in particular, various unlikely dates arrive while the first Joe Burch (identified later as "Hercules" Smith) is with Connie; the girls' choices ludicrously young, Geraldine's mature sailor wrong age, wrong class.

The second major sequence of comic misunderstandings is initiated when Connie, researching her projected "I Was a Mother at Fifteen" *Confessions* story, uses her mother's name to request government pamphlets on infant care. Opening them, her father is convinced that Elizabeth is having a late unplanned pregnancy.[†] Initially overwhelmed, then overjoyed, he tells Sully and then, on Sully's advice, Jessop (Rudy Vallee), his annoying fairweather friend, the spokesman for the Alumni Association, because "it may help" by making the Alumni less likely to turn on him. Whistling "Pretty Baby", he greets his wife with great warmth, taking exaggerated care of her until she, puzzled, asks "George, are you under the impression that I'm on the nest?" At this point, though the audience has knowledge that renders comic the parents' dire supposition that their daughter is pregnant, that seems to them to be the case as Ellen reports that Connie has got "a terrible bellyache and she just upchucked". At this moment the false alarm seems very real, but George and Elizabeth's reaction to the seeming disaster is exemplary, worried but compassionate. After a small period of worry, nothing more than a severe case of indigestion is diagnosed.

* Margaret Mead, *Male and Female: A Study of the Sexes in a Changing World* (Harmondsworth: Penguin Books, 1981), 259–270.
** Henri Bergson, 'Laughter', in Wylie Sypher (ed.), *Comedy* (New York: Doubleday Anchor, 1956), 112–114.
† This echoes the comedy scene between the married couple of *When Men Leave Home*, filmed by Stahl 25 years earlier: see page 93.

Earlier, when Coop talks to his next door neighbour, Professor Sullivan, about Connie, Sully is on his front lawn setting a device to catch a mole disturbing its surface. This subterranean threat to that emblem of middle-class domesticity, the manicured front lawn, is prefigured when Ellen, explaining the black eye she got responding physically to a classmate's attack on her father's coaching, relates telling her tormentor, "Dig a hole, mole". Perhaps the fact of Sully's being a (not altogether convincing) English Professor licenses Geraldine's sardonic reference to Connie as "Ophelia". Might Sully remember the "old mole" in *Hamlet*? A criminal called The Mole is also a major antagonist in the Dick Tracy comics that Coop seeks to read in the weekend papers, perhaps investing unconsciously in the cop's ability to decipher mysteries (even ones pertaining to temperamental daughters). The endangered lawn suggests subterranean impulses, checked but occasionally surfacing. The most prominent of these is Connie's writing for *Confessions Stories,* a publication calling on audience knowledge of magazines like *True Confessions*, through which readers, mostly female, safely indulged depravity's fascinations. After considering stories such as "I was a Bigamist: I married Five Husbands" and "I Was a Mother at Fifteen", she eventually publishes her fantasy "I was a Child Bubble Dancer". Alongside this there are the ambiguities of the fathers' design of impersonating a boy ringing up Connie, their impropriety underlined when Sully's daughter, overhearing, misinterprets him as "pitching woo" to some young girl and wonders whether to tell her mother. Both seeming forays into the underworld are, however, rescued. When her father blasts her for her publication, he calls her "this poor man's Sally Rand", Sally Rand being the burlesque performer famous for fan and bubble dances. Films show her bubble dance as considerably less erotic than her fan dance, suggesting that even as she strives to be bad, Connie's transgression remains the not too extreme sexual fantasy of a well brought up daughter. Significantly, though [University] "President Higgins turns on the heat" momentarily, the local community finds her story unthreatening enough to make her a local heroine. Similarly, if hints of married men cradle-snatching are raised by the fathers' actions, they are treated gently enough, as suggesting nothing more than a middle-aged desire to relive in imagination the premarital excitements of pursuing girls (not too unlike Elizabeth's confession about "Joe Burch" arriving, "I'm so excited myself you'd think it was *my* first date!")

What do daughters want? Connie (Betty Lynn) in careerist mode, while Ellen (Natalie Wood) discovers cosmetics

When Elizabeth asks the girls to respect their father's football problems, she observes that "no matter what material he gets to work with, he has to make it good", interpretable as indirectly referring to the studio director's obligations. But clearly Stahl attuned himself creatively to the new opportunities presented. He was probably given the assignment, when Elliott Nugent left the project after three days shooting, because of his reputation, from the days of Dicky Headrick nearly 30 years earlier, of working well with children, and he

certainly shaped fine performances from Natalie Wood and Betty Lynn, drawing out the ten-year-old's precocity and guiding the 23-year-old Betty Lynn into shedding adult traits in playing a teenager. And just as Stahl's marital comedies of the 1920s were thought to have special appeal to marrieds who would particularly respond to their intimate barbs, much of the charm of *Father Was A Fullback* comes from its idealised reflection of recognisable familial experiences. One example is the characters' use of the several names each is known by to signal attitudinal shifts. Thus Coop, always "George" to Elizabeth, can be "coach" (Ellen's breezy term), "Dad", "Father" (both Connie and Ellen's distancing address), "Your Father" (Elizabeth's mock-angry term in front of the children), "Your father" (Elizabeth in a different elevating tone when giving the children a pep talk about the family), and "Your husband" (Connie, angry with her father, to her mother). Or Elizabeth's admonishing "Constance" when her daughter complains her father doesn't understand her, changing to "Connie" as she talks about understanding her father. Full of such pleasant subtleties, *Father Was a Fullback* was quite a commercial and critical success on its release, but has undeservedly disappeared from critical consciousness.◆

Bruce Babington

Oh, You Beautiful Doll

20th Century-Fox. 11 November 1949. Technicolor. 93 minutes.
D: John M. Stahl. **P**: George Jessel. **Sc**: Albert Lewis, Arthur Lewis. **Ph**: Harry Jackson, Ernest Palmer. **Ed**: Louis Loeffler, James B.Clark. **AD**: Lyle Wheeler, Maurice Ransford. **M**: Alfred Newman. **Sound**: E. Clayton Ward, Roger Heman. **Choreography**: Seymour Fells.

Cast: June Haver (Doris Breitenbach), Mark Stevens (Larry Kelly), S.Z. Sakall (Alfred Breitenbach/Fred Fisher), Charlotte Greenwood (Anna Breitenbach), Gale Robbins (Marie Carle), Jay C. Flippen (Lippy Brannigan), Andrew Tombes (Ted Held), Eduard Franz (Gottfried Steiner).

Oh, You Beautiful Doll was Stahl's last film and only musical. Part of Fox's cycle of American popular composers' lives, this biopic of Fred Fisher followed Stephen Foster (Swanee River, Sidney Lanfield, 1939), Paul Dresser (My Gal Sal, Irving Cummings, 1942), Ernest R. Ball (Irish Eyes Are Smiling, Gregory Ratoff, 1944), and Joe Howard (I Wonder Who's Kissing Her Now, Lloyd Bacon, 1947). It shared their nostalgia for an urban pastoral of a popular music sentimental yet modern, proto-industrial yet permeated with individual genius (pace Theodor Adorno – see below), and for an era when homely music shops and sheet music dominated, and "plugging" could appear endearingly naïve.

The only analytical view of the film, in George Custen's study of Hollywood biopics, unrelentingly emphasises studio ideology, crediting the film only to Darryl F. Zanuck, and the producer, George Jessel, wholly ignoring its director who, having overseen Jessel's Lucky Boy (1929), was unlikely to have been marginalised by him.[*] A more complex view balances institutional and generic controls with the director's and his writers' choices. This is particularly so of the genre's fundamental popular/classical music antithesis, which the film more than usually foregrounds.[**]

Stahl's relationship with film music and the musical was longstanding. A photograph of him directing Mildred Harris with a violinist playing mood music (The Picture Show, 3 July 1920, 5) exhibits common practice, as distinct from the report of his speculative idea "to have a complete and individual musical score made for each feature before production is begun" (Exhibitors Herald, 25 December 1920, 199). At the opposite extreme, his 1930s melodramas inventively eschewed non-diegetic musical commentary, using music, with few exceptions, only diegetically. One instance, using diegetic music alone, approaches the musical's condition –

[*] George F. Custen, Bio/Pics: How Hollywood Constructed Public History (New Brunswick, New Jersey: Rutgers University Press, 1992), 47–50, 202.
[**] On the classical/popular music antithesis, see Jane Feuer, The Hollywood Musical (Bloomington: Indiana University Press, 1982), 49–65.

Philippe's piano playing and Helen's singing of Schubert's "Serenade" in *When Tomorrow Comes*. This may seem very distant, at first thought, from, say, "Come, Josephine, in My Flying Machine" in *Doll,* but a scene in *Strictly Dishonorable* which juxtaposes recordings of "The Toreador Song" and "It Happened in Monterey" provides a paradigm of Stahl's interest in both art music and popular song which, it will be argued here, results in some interesting inflections of the genre.[*]

Stahl, far from bypassing the musical until 1949, had a history of connections with it, e.g. his scheduled direction of *The Dolly Sisters* (*LA Times*, 30 June 1944, 20), eventually filmed by Irving Cummings (1945), his uncredited help, with Edmund Goulding, on *The Shocking Miss Pilgrim* (George Seaton, 1947) and other uncredited work on Whale's *Show Boat* (1936) – all according to IMDb. At Tiffany-Stahl he supervised Jessel in *Lucky Boy* and also prioritised theme songs in silents with synchronised music.[**] His last silent, *In Old Kentucky,* is permeated with traditional music demanding specific "accompaniments": "My Old Kentucky Home", "Weep No More, My Lady", "Dixie", etc. Later at Fox he pushed an ambitious, unfulfilled project: "Cavalcade of American Music from the Times of the Pilgrim Fathers up to Modern Song" (*Los Angeles Times*, 17 October 1944, 10).

Is S.Z. Sakall Breitenbach playing one of his arias or Fisher ragging it into a hit?

For the colour version of this image, see page C12.

The Tin Pan Alley composer Fred Fisher, born Alfred Breitenbach in Germany, emigrated to America and, name changed, enjoyed success, his most enduring hits contained in the film, though its title song, Brown and Ayer's "Oh, You Beautiful Doll", was not his. A remark credited to him in the film's *New York Times* review (12 November 1949, 8), "that the reason why most popular songsmiths had trouble getting melodic inspiration was that they didn't know classical music well enough", possibly – if known to Stahl and his scriptwriters Albert and Arthur Lewis – suggested the biographical fiction, extreme even for this sub-genre, whereby Fisher (S.Z. Sakall) becomes an impoverished composer whose arias are recycled into hits.

The narrative turns on the encounter between song "plugger" Larry Kelly (Mark Stevens) and Breitenbach and his daughter, Doris (June Haver). Doris, to endear herself to Kelly, filches one of her father's melodies, which the song-plugger-turned-lyric-writer "rags" into a hit. Breitenbach eventually collaborates on others, despite outbursts of shame at his apostasy, which are modulated, however, by Sakall's irredeemably risible persona. Displacing her "rival", Marie Carle (Gale Robbins), Doris wins the dubious marital prize of Kelly. The angst generated by Breitenbach's guilt is assuaged when his former pupil, the conductor Gottfried Steiner, decides

[*] *Los Angeles Times* (18 January 1948, 57) reported that Roxana Stahl presided over a reception at the Stahls' residence for the conductor Charles Münch.

[**] See page 131 for visual illustration of the integral role of theme songs in Tiffany-Stahl's marketing in the late 1920s.

first-rate popular beats second-rate classical, and celebrates Fisher's works in symphonic-choral arrangements in a concert alongside the classics. Steiner's homily about the excellent in both popular and classical music convinces more than this otiose musical resolution's failure, in practice, to access either mode's virtues.[*] But elsewhere convention is manipulated more persuasively. The director's role in this is intimated when the opening shot travelling the credit sequence's toytown street ends at Stahl's name, associating it with the eye standing above an optometrist's premises.[**]

The narrative opens in the near present – as Fisher's (and Al Bryan's) "Peg o' My Heart" plays on a jukebox, one of three actual 1947 chart revivals.[†] In his bar, "Lippy" Brannigan reminisces about old songwriter-customers, and reads from a newspaper:

> A pretty good thinker named Plato said a long time ago, watch out when the music of your nation changes. A new kind of music affects every department of living, both public and private. He said the beat of the music changes first and everything falls in line with the beat, fashion, language customs or morals.

This is the reporter's erudite expansion on *The Republic*'s "For the modes of music are never disturbed without unsettling of the most fundamental political and social conventions". But in *Doll*, warnings against change become its celebration.

Brannigan, as surrogate author, introduces Fisher in terms as fictional as the larger narrative's, a playful scenario where Fisher murders Breitenbach to steal his songs. This comic-noir Jekyll and Hyde invocation is not irrelevant to a narrative in which Breitenbach is mortified when his music agent, Ted Held, boasts tone deafness (a remark modified later in the film), a discord, like others, within the narrative's intimate texture rather than its broad Zanuckian outline – cf the distinct echoes of Adorno on the "standardization", "pseudo-individuation" and "commodification" of popular music when Held, spokesman for the industry, asserts 'that "Tin Pan Alley is just a huge conspiracy to make people listen, get them so used to it they think they like it and they buy it."[‡] On the one hand, *Doll* cheerfully enacts an art-as-business ideology, impatient with the poverty-stricken artist ignoring mass demands; on the other, it exaggerates moments in its sibling biopics that reveal the popular culture industry as exploitation, e.g. Christy cheating Foster out of "Oh, Susanna" in *Swanee River*, and Sally Elliot stealing Dresser's song in *My Gal Sal*; here, the whole public are the happy victims of "plugging". Through such ambivalences the popular/classical thematic attains a more delicate balance than usual, suggesting their relation is as much symbiotic as oppositional. Even Kelly's simile of putting horseradish on stale beef, underneath its cheery philistinism, shares this, as does Mrs Breitenbach's naïve utterance that "good music is good music, some people like it played slower, some people like it played faster".

[*] Custen describes it as like "the Boston Pops dreadful, bloated renditions of Beatles songs", adding that "Fisher has acted out Adorno's nightmare of how popular music impoverishes the classical" (49–50).

[**] Stahl was well read, and no doubt knew of the eyes of Dr Eckleberg in *The Great Gatsby*. He is likely to have met Scott Fitzgerald during the short time the writer worked on the script of Stahl's unmade project *Bull By The Horns* at Universal in 1939.

[†] Al Bryan and other lyricists disappear into "Larry Kelly".

[‡] Theodor Adorno, "On Popular Music", *Studies in Philosophy and Social Science*, Institute of Social Research, New York, IX, 17–48.

Doll's numbers are small-scale, intimate, unlike, say, Rita Hayworth's stage spectacles in *My Gal Sal*. Excepting the concert finale, they are all solos or duets by Doris (Haver) and Kelly (Stevens), both dubbed, or Marie (Gale Robbins) alone or with Stevens. This summary, though, occludes their variety of staging. Only "Oh, You Beautiful Doll" is theatre-staged. "Come, Josephine" is performed in a restaurant. The others, all danceless, eschew public performance, placed with downbeat inventive-

June Haver and Mark Stevens performing "Come, Josephine, in My Flying Machine". For the colour version of this image, see page C12.

ness in Held's offices or the Breitenbachs' home, where new songs are previewed. (The exception, the reprise of "There's a Broken Heart For Every Light on Broadway", is sung to passers-by on Broadway as Kelly demolishes adjacent streetlights). The play with restriction in the other numbers – no theatre, no chorus lines, confined mundane spaces, everyday costumes – even if it originates in constricted budgeting, turns disadvantage to advantage, as demonstrated below.

Another distinguishing feature, finding charm in modesty, is the film's collection of fragmentary musical miniatures: among them Doris imitating Marie's "Beautiful Doll' performance; Kelly leading the jailbirds singing "There's a Broken Heart"; Breitenbach playing a melody that suggests to Kelly a "Mother" song which is also an "Irish" song, with the cut to the inspired moment when "Ireland Must Be Heaven" is sung by an unhibernian Filipino houseboy with an Afro-American maid… and the witty sequence when Breitenbach, fleeing his alter ego, keeps encountering Fisher's hits.

The song "Oh, You Beautiful Doll" synecdochises the new age of popular music and loosened societal controls, its implications suggested in Saul Bellow's *Humboldt's Gift* where Charlie Citrine asks "Do you know that Woodrow Wilson sang 'Oh, You Beautiful Doll' on the honeymoon train with Edith Bolling? The Pullman porter saw him singing and dancing in the morning when he came out" (*Humboldt's Gift*, Penguin Modern Classics, p. 305). The starchy idealist loosened up by the *Zeitgeist*'s refrain. The number juxtaposes two versions. First, Marie's brazen onstage performance, Breitenbach's opera princess de-pedestalled into a "doll" with mock toy-like gestures, tossing a replica of herself to the male audience and knowingly singing "Come on, hug me, honey, I won't break"; second, Doris, singing it angelically from the auditorium, though afterwards she privately imitates Marie, fusing antithetical femininities.

In "Come, Josephine, in My Flying Machine", Kelly and Doris vigorously celebrate the new machine age, delightfully old-fashioned by 1949, combining the opposites of nostalgia and modernity. Some other numbers, staged in the closeted settings of home and office, use this apparent restriction to foreground intimate psychological relations between the singers and individuals in their intimate onscreen audience, or between duetting singers. An example, involving both categories, is where the showbiz counterfeit love acted by Kelly and Marie Carle as they sing "When I

Get You Alone Tonight" is misread by an unhappy Doris as real. "Peg o' my Heart" is sung by Kelly and Doris in a single take, the only cut made in its last notes to include its listeners. The ingenious delivery of '"There's a Broken Heart for Every Light on Broadway" by telephone to Al Jolson off screen is an uninterrupted take in which Kelly's fluid movements around his accompanist, Held, are captured by discreet camera shifts. In the Breitenbachs' lounge Kelly's singing "I Want You" is an all but single take, with just one close up of Doris's soulful reaction, and a final cut away to include the audience as he finishes. Kelly's and Marie's duet '"When I Get You Alone Tonight" is also performed in a single shot, with at the end the small audience included by the unostentatiously retreating camera, before the cut to Doris watching in unhappy close-up. These relays of looks are most complex when ambiguities are set up between the performance of desire and its reality, with Kelly's solo love song addressed to first Fisher, then Held, before Doris, and then with Doris misinterpreting Kelly's and Marie's performance of love in "When I Get You Alone Tonight" for the real thing.

If Stahl's biographical complexities may inhabit so convention-bound yet intricately worked a film, we might see the Breitenbach/Fisher duality paralleling the Strelitzsky/Stahl dyad, just as Kelly's Italianness is transmogrified to commercial Irishness; Breitenbach's Austrian mother becoming Mother Machree might likewise reflect Stahl's shifting identities, while the tensions between the director's self-projections as box-office expert and constrained experimenter within commercial cinema's boundaries might be recognised as being refracted in Breitenbach/Fisher's doubled identity.◆

Bruce Babington

John M. Stahl Bibliography

1. Film Periodicals and Trade Papers

American Cinematographer

Exhibitors Herald

Exhibitors Trade Review

Film Daily (formerly *Wid's Daily*)

Harrison's Reports

Hollywood Reporter

Motion Picture News

Moving Picture World

New York Clipper

Photoplay

Picture-Play Magazine

Variety

Wid's Daily (became *Film Daily* in 1922)

2. Internet Databases

American Film Institute (AFI) *Catalog of Feature Films*

American Film Institute (AFI) *Catalog: Silent Film Database*

Internet Broadway Database (IBDb)

Internet Movie Database (IMDb)

3. Significant journalistic items 1923–1950

Abend, Hallett, "Days Spent with Great Directors...John M. Stahl", *Los Angeles Times*, 14 November 1923, "The Preview", 5.

Parsons, Louella O., "In and Out of Focus", (New York) *Morning Telegraph*, 17 December 1922, 6.

Reid, Margaret, "Woman's Angle Stressed. Directorial Work of John M. Stahl Marked by Sympathy with Human Emotions", *Los Angeles Times*, 3 May 1931, 44.

Schallert, Edwin, "Stahl Plans Headline Film '$25,000 A Year'", *Los Angeles Times*, 1 May 1942, 39.

Scheuer, Philip K., "Men Who Can Direct Women are in Minority in Hollywood [...]", *Los Angeles Times*, 22 March 1936, 78.

Stahl, John M., "Oh, The Good Old Days", *Hollywood Reporter*, 16 May 1932.

Stahl, John M., "Roadshows and Duals", *Hollywood Reporter*, 30 June 1937.

Stahl, John M., "Most of Our Troubles Never Happened", *Hollywood Reporter*, section 2, 28 October 1939.

Stahl, John M., "World Production Code", *Hollywood Reporter,* section 2, 23 September 1946.

Stahl, John M., "Bank Night, My Eye", *Hollywood Reporter*, 11 October 1948.

Stahl, John M., "Whammy", *Hollywood Reporter*, section 2, 31 October 1949.

Stahl Obituary: *Los Angeles Times*, 13 January 1950.

Stahl Obituary: *New York Times*, 14 January 1950.

Stahl Obituary: Louella O. Parsons, *Los Angeles Examiner*, 14 January 1950.

4. Books with significant material on, and relevant to, Stahl

Bordwell, David, Staiger, Janet and Thompson, Kristin, *The Classical Hollywood Cinema: Film Style and Mode of Production to 1960* (London: Routledge & Kegan Paul, 1985)

Bourget, Jean-Loup, *Le Cinéma Américain, 1895–1980* (Paris: Puf, 1983), 104–105.

Bourget, Jean-Loup, *Le Mélodrame Hollywoodien* (Paris: Stock, 1985), 240–245.

Bradley, Edwin M., *Unsung Hollywood Musicals of the Golden era: 50 Overlooked Films and Their Stars: 1929–1939* (Jefferson, NC: McFarland, 2016). (11–16 on *Lucky Boy*).

Brownlow, Kevin, *The Parade's Gone By* (London: Secker & Warburg, 1968).

Brownlow, Kevin, *Behind The Mask of Innocence: Sex, Violence, Crime: Films of Social Conscience in the Silent Era* (London: Jonathan Cape, 1990).

Crafton, Donald, *The Talkies: American Cinema's Transition to Sound 1926–1931* (Berkeley: University of California Press, 1997).

Crowther, Bosley, *Hollywood Rajah, The Life and Times of Louis B. Mayer* (New York: Holt, 1960).

Custen, George, *Bio/Pics: How Hollywood Constructed Public History* (New Brunswick: Rutgers University Press, 1992).

Eyman, Scott, *Lion of Hollywood: The Life and Legend of Louis B. Mayer* (New York: Simon and Schuster, 2012).

Gledhill, Christine (ed.) *Home is Where The Heart Is: Studies in Melodrama and the Woman's Film* (London: British Film Institute, 1987).

Gomery, Douglas, *The Hollywood Studio System: A History* (London: British Film Institute, 2005).

Gomery, Douglas, *The Coming of Sound: A History* (London: Routledge, 2005).

Harvey, James, "Interview with Irene Dunne (September 1978)" in *Romantic Comedy in Hollywood from Lubitsch to Sturges* (New York: DaCapo Press, 1998), 679–692.

Jacobs, Lea, *The Decline of Sentiment: American Film in the 1920s* (Berkeley: University of California Press, 2008).

Jacobs, Lea, *The Wages of Sin: Censorship and the Fallen Woman Film 1928–1942* (Madison: University of Wisconsin Press, 1991: new edition, Berkeley: University of California Press, 1997).

Koszarski, Richard, *An Evening's Entertainment: The Age of the Silent Feature Picture, 1915–1928* (New York: Scribner, 1990; paperback edition, Berkeley: University of California Press, 1994).

Landy, Marcia (ed.), *Reader on Film and Television Melodrama* (Detroit: Wayne State University Press, 1991).

Marx, Samuel, *Mayer and Thalberg: The Make-Believe Saints* (New York: Random House, 1975).

Neale, Steve, *Genre and Hollywood* (London: Routledge, 2000).

Pawlak, Deborah Ann, *Bringing Up Oscar: The Story of the Men and Women Who Founded the Academy* (Cambridge, England: Pegasus, 2011).

Pitts, Michael R., *Poverty Row Studios, 1929–1940* (Jefferson NC: McFarland, 1997).

Salt, Barry, *Film Style and Technology: History and Analysis* (London: Starword, 1983).

Sarris, Andrew, "John M. Stahl (1886–1950)", in *The American Cinema: Directors and Directions 1929–1968* (New York: E.P. Dutton, 1968), 139–40.

Sarris, Andrew, "John M. Stahl", in Richard Roud (ed.), *Cinema A Critical Dictionary: The Major Film-Makers, vol.2* (London: Secker and Warburg, 1980), 946–949.

Sarris, Andrew, *You Ain't Heard Nothin' Yet: The American Talking Film, History and Memory, 1927–1949* (New York: Oxford University Press, 1998), 365–369.

Schatz, Thomas, *The Genius of the System: Hollywood Filmmaking in the Studio Era* (London: Simon & Schuster, 1988).

Slide, Anthony, *The American Film Industry: A Historical* Dictionary (New York: Greenwood Press, 1986).

Tavernier, Bernard & Coursodon, Jean-Pierre, *50 Ans de Cinema Americain* (Paris: Nathan, 1991).

Thomson, David, "John M. Stahl", in *A Dictionary of the Cinema* (London: Secker and Warburg, 1975), and in a succession of updated editions, including a *A New Biographical Dictionary of Film* (London: Little, Brown, 2010).

Tobin, Yann, "John M. Stahl", in Jean-Pierre Coursodon and Pierre Sauvage (eds.), *American Directors* (New York: McGraw-Hill, 1983), volume 1, 289–300. Translation of article published in French in *Positif*, July/August 1979.

5. Journal articles, mainly on specific films

Bernstein, Matthew H. and White, Dana F., "*Imitation of Life* [1934] in a segregated Atlanta: its Promotion, Distribution and Reception", in *Film History* v.19, 2007, 152–178.

Berthomieu, Pierre, "John Stahl et le démon del'excès", in *Positif*, January 2000, 93–95.

Bourget, Jean-Loup, "*Back Street* (reconsidered)", in *Take One*, February 1972, 33–34.

Brown, Geoff, on *Letter of Introduction*, in "Retrospective", *Monthly Film Bulletin*, November 1981, 230.

Brown, Geoff, on *Magnificent Obsession* (1935), in *Films and Filming*, December 1981, 41–42.

Butler, Jeremy G., "*Imitation of Life* (1934 and 1959): Style and the Domestic Melodrama", in *Jump Cut*, n.32, 1966, 25–32.

Caputi, Jane, and Vann, Helene, "Questions of Race and Place. Comparative Racism in *Imitation of Life* and *Places in the Heart*", in *Cineaste* v.15 n.4, 1987, 16–21.

Cerisuelo, Marc, "Limitations de la vie: Sirk et Stahl", in *Positif*, January 2000, 96–98.

Deutelbaum, Marshall, "Costuming and the Color System of *Leave Her to Heaven*", in *Film Criticism*, Summer 1987, 11–20.

Elsaesser, Thomas, "Tales of Sound and Fury: Observations on the Family Melodrama", in *Monogram,* no. 4, 1972, 2–15. An item much anthologised, for instance in the Gledhill collection in section 4.

Jacobs, Lea, "Melodrama, Modernism and the Problem of Naive Taste", in *Modernism/Modernity,* v.19 n.2, 2012, 303–320. .

Le Fanu, Mark, on *Magnificent Obsession*, in "Retrospective", *Monthly Film Bulletin,* November 1981, 229–230.

Milne, Tom, on *Only Yesterday* and on *When Tomorrow Comes*, in "Retrospective", *Monthly Film Bulletin*, November 1981, 231–232.

Milne, Tom, on *Imitation of Life* (1934), in *Films and Filming*, December 1981, 42–43.

Morris, George, "John M. Stahl: The Man Who Understood Women", in *Film Comment*, May/June 1977, 24–27.

Pulleine, Tim, "Stahl into Sirk'', in *Monthly Film Bulletin*, November 1981, 236.

Pulleine, Tim, on *Imitation of Life*, in "Retrospective", *Monthly Film Bulletin*, November 1981, 229.

Renov, Michael, "*Leave Her to Heaven*: The Double Bind of Post-War Woman", *Journal of the University Film and Video Association*, Winter 1983, 28–36

Viviani, Christian, "John M. Stahl, sans mélo", in *Positif*, January 2000, 88–92.

White, Susan, "I Burn for Him: Female Masochism and the Iconography of Melodrama in Stahl's *Back Street* (1932)", in *Post-Script. Essays in Film and the Humanities*, Winter-Spring 1995, 59–80.

6. More recent articles, most of them accessible online only.

All of these links have been re-checked ahead of publication

Barr, Charles, on *Only Yesterday*, *Movie: A Journal of Film Criticism* 4 (2013):
https://warwick.ac.uk/fac/arts/film/movie/contents/only_yesterday_barr.pdf

Brody, Richard, "John M. Stahl's *When Tomorrow Comes*", the *New Yorker*, 18 September 2014:
https://www.newyorker.com/culture/richard-brody/john-stahl-when-tomorrow-comes

Clark, Juliet, "Melodrama Master: John M. Stahl", in BAMPFA Program Guide [Berkeley Art Museum and Pacific Film Archive], Summer 2015:
https://bampfa.org/program/melodrama-master-john-m-stahl

Jones, Kristin M., "'Melodrama Master: John M. Stahl' Review", *Wall Street Journal*, 17 June 2015: https://www.wsj.com/articles/melodrama-master-john-m-stahl-review-1434574971

Lowry, Ed, "John M. Stahl – Director":
http://www.filmreference.com/Directors-Sc-St/Stahl-John-M.html

Ryan, Tom, "The Adaptation and the Remake: From John M. Stahl's *When Tomorrow Comes* to Douglas Sirk's *Interlude*", in *Senses of Cinema*, March 2014:
http://sensesofcinema.com/2014/feature-articles/the-adaptation-and-the-remake-from-john-m-stahls-when-tomorrow-comes-to-douglas-sirks-interlude/

Ryan, Tom, "Sirk, Hollywood and Genre", in *Senses of Cinema*, March 2013:
http://sensesofcinema.com/2013/feature-articles/sirk-hollywood-and-genre

Ryan, Tom, "Obsessions Imitations & Subversions, Part One – on *Magnificent Obsession*", in *Senses of Cinema*, December 2014:
http://sensesofcinema.com/2014/feature-articles/obsessions-imitations-subversions-on-magnificent-obsession-part-one/

Ryan, Tom, "Obsessions Imitations & Subversions, Part Two – on *Imitation of Life*", in *Senses of Cinema*, December 2015:
http://sensesofcinema.com/2015/feature-articles/imitation-of-life-adaptations/

Smith, Imogen Sara, "Women in Love: Three early '30s Melodramas by John M. Stahl", in *Bright Lights Film Journal*, 24 May 2016:
http://film.com/women-love-three-early-30s-melodramas-john-m-stahl-seed-back-street-yesterday/

7. From *John M. Stahl* (San Sebastian, 1999):

Edited by Valeria Ciompi and Miguel Marias, this handsome large-format 432-page volume – still available – was produced to accompany the Stahl Retrospective of that year at the San Sebastian Film Festival (see pages 11–12), and remains the one substantial publication hitherto to have been devoted to Stahl; all contents are published in both Spanish and English. The book contains reprints of a range of articles, several of which are referenced elsewhere in this volume: these reprints and their sources are listed first, followed by a selection of the new essays.

Borde, Raymond, "Why Melodrama", from *le mélo au cinéma* (Toulouse cinémathèque, 1971).

Bourget, Jean-Loup, *Le mélodrame holywoodien* (Paris: Stock, 1985): the section on Stahl.

Deutelbaum, Marshall, "Costuming and the Color System of *Leave Her to Heaven*", from *Film Criticism*, Summer 1987.

Morris, George, "John M. Stahl: the Man who Understood Women", from *Film Comment*, May/June 1977.

Andrew Sarris, "John M. Stahl", from Richard Roud (ed.), *Cinema: a Critical Dictionary: the Major Film-Makers*, vol 2 (London: Secker and Warburg, 1980).

Tavernier, Bertrand & Coursodon, Jean-Pierre, "John M, Stahl 1886–1950", from *50 Ans de Cinéma Américain* (Paris: Omnibus, 1995).

Viviani, Christian, "Who is Without Sin? The Maternal Melodrama in American Film, 1930–1939", from *Les Cahiers de la cinémathèque*, July 1979.

Tobin Yann, "John M. Stahl: présentation", from *Positif*, July/August 1979.

New material includes:

Adamson, Joe, "El Caso contra John M. Stahl" ("The Case Against John M. Stahl")

Gil, Rafael, "Semilla, La usapadora y Parece que fue ayer" ("John M. Stahl: *Seed*, *Back Street* and *Only Yesterday*").

Llinas, Francisco, "*Letter of Introduction*".

Marias, Miguel,"El desconocido Sr. Stahl" ("The Unknown Mr. Stahl").

Marias, Miguel, "Las extranas comedias de John M. Stahl" ("The Strange Comedies of John M. Stahl").

Marias, Miguel, "Las huelas mudas de Stahl" ("Stahl's Silent Footprints").

Monterde, José Enrique, "Las Llaves del Reino, 1944" ("*The Keys of the Kingdom*, 1944").

Ruiz, Havier Hernandez: "Hacia un melodrama 'desdramatizado' y comprometido socialmente" ("*Only Yesterday*: Towards a Socially Aware and Unmelodramatised Melodrama").

Weinrichter, Antonio: "John M. Stahl: El ayer, el manana y el instante compartido" ("John M.Stahl: Yesterday, Tomorrow and the Shared Instant").

8. and finally … a pioneering work, sadly never published:

McLane, Betsy, *The Woman's Film: A Rhetorical Analysis from the Work of John M. Stahl* (PhD dissertation, University of Southern California, 1982).

Picture credits

The majority of images for the sound films are taken direct from the frame, as are those for four of the silent films: *Her Code of Honor*, *The Woman Under Oath*, *Suspicious Wives* and *Husbands and Lovers*.

These are the sources of production stills and of other photographic images, along with page numbers:

Alamy Limited: front cover

British Film Institute: 3, 43, 44, 49, 52, 70

BFI Stills Library: 140

EYE – Collection EYE Filmmuseum, the Netherlands: 100-104

Hirschfeld – the Al Hirschfeld Foundation: see the full credit given beneath the image on page 119

MOMA – The Museum of Modern Art Film Stills Archive: 22, 38, 57, 62, 76, 77, 80, 85, 89, 90, 96, 107, 110, 116, 117, 120, 148, 151, 152.

New York Public Library: Frontispiece

Photofest, New York: 14, 82, 92, 125, 143, 147, 207, C8, C9, C10

Pordenone – silent fim week: 7

San Sebastian Film Festival: 3

Silent Film Archive, courtesy of Bruce Calvert: 106

Index of Film Titles

Numbers **in bold** refer to the location of sustained entries, or simply of credit titles, for films directed or produced by John M. Stahl.
Numbers *in italics*, at the end of an entry, refer to the location of images.

Index of Names

Numbers **in bold** indicate the naming of an individual in the credit titles of a film directed or produced by John M. Stahl; these numbers are expanded if this individual is mentioned repeatedly in the account of the film that follows, as in the case, early in the list, of Frederick Lewis Allen (for *Only Yesterday*). Credited names are only given an index entry if they also appear at least once in the text itself.

Numbers *in italics* at the end of an entry refer to visual illustrations, within the text or in the colour section.

Stahl, John Malcolm
 Images of Stahl, on and off set. Front cover,
 14-15, 67, 90, 96, 140-141, 143, 144, 147,
 195 (caricature), 207

 Images of Stahl, press publicity. 23, 25, 60,
 125, 129

 **Censorship and the Production Code
 Administration.** Early pronouncements on
 censorship, 24. Silent films: skill in handling
 censorship, 59, 91, 116. Sound films pre-
 1934: softening of birth control theme in
 Seed, 151; negotiations on *Strictly
 Dishonorable*, 155-156; handling of difficult
 themes in *Back Street*, 161, and in *Only
 Yesterday*, 167-168. After 1934: blocking of
 re-release of those two films, 6, 167-168;
 PCA opposition to miscegenation in *Imitation
 of Life*, 173; compromise on political and
 sexual elements in *Parnell*, 190-191;
 negotiations with the OWI on China, and with
 the PCA on Catholicism, in *The Keys of the
 Kingdom*, 224; dilution of racial and sexual
 material in *The Foxes of Harrow*, 244.
 See also Breen, Joseph

Comedy. 1920s reputation for comedy, 24.
Influence of Chaplin and Lubitsch, 110. Family
comedy, 251. Juxtaposition of comedy and
melodrama: *Magnificent Obsession*, 181,
183; *Letter of Introduction*, 192-195. Marital
comedy, 24, 71, 86, 95, 110, 207. Romantic
comedy, 204-208, 209, 270. Satirical
comedy, 24, 97, 193, 253. Sophisticated
comedy, 17, 79, 110, 118, 120, 125, 150,
166.

Family. Mystery of parents and possible sib-
lings, 16; first wife, 16; daughter Sarah
(Appel), 16, 17, 21; second wife, *see* Reels,
Frances Irene; third wife Roxana, 16, 17, 18,
257n; stepchildren from Roxana's first
marriage, 16

Jewish identity. 18, 26, 27-28

Mayer, influence of. *see* Mayer, Louis B.

Melodrama. Critical denigration, and revalu-
ation, of melodrama, 4, 17, and *see* Gledhill,
Christine. Extreme elements of Stahl's early
melodramas, 24, 46, 63, 75, 77; change of
tone, 109-110; understated elements of
sound melodramas, 160-161, 162-3, 181,
190, 195-196, 242-243. *Leave her to Heaven*
as melodrama, 229-241. Maternal melo-
drama, 65-66, and *see* Viviani, Christian. Sirk,
Stahl and melodrama, 7, 172-173, 181, 240-
241

Music and soundtrack. Career-long interest in
music, 257; musical cues in silent film, 257;
sheet music tie-ins, 131, 257, C10; unrealised
project, *Cavalcade of American Music*, 145,
257. Musical episodes: record-playing in
Strictly Dishonorable, 257; dancing in *Letter
of Introduction*, 193; Schubert song in *When
Tomorrow Comes*, 199. Soundtrack: sparing
use of music in 1930s melodramas, 161,
177n, 181, 193; Gracie Fields in *Holy Matri-
mony*, 216; dramatic score for *Leave her to
Heaven*, 231. Stahl's final film a musical, *Oh,
You Beautiful Doll*, 256-60, C11, C12

Pronouncements on cinema. 4, 20, 24-25,
94-95, 126, 261-262

Racial Themes. *The Lincoln Cycle*, 31, 33
n15; the Ku Klux Klan in *One Clear Call*, 79,
81-82; Stepin Fetchit and Carolynne Snowden
in *In Old Kentucky*, 124; in films at Tiffany-
Stahl 132; in *Imitation of Life*, 142, 177-179;
in *The Foxes of Harrow*, 244-246

Theatre. Early stage career and love of thea-
tre, 19-20; acting out scenes on set, 20, 207;
unrealised *King Lear* project, 24. Films based
on plays: *Sowing the Wind* 59, *Why Men
Leave Home* 91; *Fine Clothes* 105; *The Gay
Deceiver* 115, (theatre scene *116*); *In Old
Kentucky* 121; *Parnell* 186; *Our Wife* 204; *The
Eve of St Mark* 219; *Father Was a Fullback*
251

Women's Film. Critical denigration, and re-
valuation, of the 'Women's Film', 4, 17, and